W9-BPS-300

P I C A S S O

PICASSO

Mary Mathews Gedo

Art as Autobiography

The University of Chicago Press • Chicago and London

94-107

The University of Chicago Press, Chicago 60637
The University of Chicago Press, Ltd., London
© 1980 by The University of Chicago
All rights reserved. Published 1980
Printed in the United States of America
98 97 96 95 94 93 92 91 90 89 6 5 4 3 2

MARY MATHEWS GEDO began her career as a specialist
in the care of disturbed children. Later she obtained
her Ph.D. in art history from Northwestern University.
In addition to her interdisciplinary research, she is
preparing a monograph on the pioneer American
Cubist, Manierre Dawson.

Library of Congress Cataloging in Publication Data

Gedo, Mary Mathews
 Picasso, art as autobiography.

 Includes bibliographical references and index.
 1. Picasso, Pablo, 1881–1973. 2. Painters—France—
Biography. I. Title.
ND553.P5G42 709′.2′4 [B] 80–11126
ISBN 0–226–28482–4

Contents

List of Illustrations

This book owes its inception to James D. Breckenridge, professor of art history at Northwestern University. He proposed that I pursue the topic "Picasso's Self-Image" as my dissertation research. Later, he again encouraged me to expand the completed dissertation into the book it has become. I am also indebted to my other dissertation advisor, G. Haydn Huntley, then a helpful, constructive critic, now a dear friend.

Thanks also to George Pollock, M.D., the director of the Institute for Psychoanalysis in Chicago. He invited me to present my ideas about Picasso to the Wednesday Research Meetings for Faculty Members at the Institute. It would be impossible to thank individually each faculty member who made helpful suggestions, but the ideas which grew out of these meetings have been incorporated into the fabric of this book.

My special gratitude to Françoise Gilot, who broke her self-imposed prohibition against discussing Picasso to share her impressions and memories freely and frankly with me. Her intelligence, humor, and above all, her admirable objectivity illuminated our interchange and enormously enriched my book.

My typist, Jacqueline Miller, surely deserves a medal for her valiant—and successful—efforts to surmount my disorderly tendencies and illegible handwriting.

Last, and most important of all, I owe my most profound expression of gratitude to my husband, John. He not only shared his vast knowledge of human behavior and psychoanalytic literature with me, but also encouraged, cajoled, and when necessary, even shamed me into continuing work on my manuscript. Then he crowned his kindnesses with a careful proofreading of the galleys. To him as the deus ex machina of the project, this book is lovingly dedicated.

Introduction

In our age of anxiety, we treasure the individuality of the artist as a precious commodity, a buffer against the impersonality of life. The late critic Harold Rosenberg suggested that this attitude has gradually transformed contemporary art, so that the artist's person, not his product, now preempts our attention. We have reached the age of "post-object art," when connoisseurship consists in admiring the artist as another celebrity, while he deliberately creates banal works that cannot compete for our attention.

The boredom that Warhol and Donald Judd have been content to recommend to spectators of their work was not intended to carry over to their persons. If their work is dull, their mode of self-presentation is radical. In traditional art, the canvas is the key to the painter's experience. In post-object art, the artist is the key to what he has to offer to his audience; in an earthwork, he may be the only factor that distinguishes it from farming or mining.[1]

Pablo Picasso, hailed as the premier artist of the century, seems to occupy a transitional position in this artistic evolution. His stunning innovations, his lifelong dedication to producing works of intrinsic interest link him to the object-oriented artists of the past. Yet his ability to generate publicity about his personality and experiences allies him with the new breed of celebrity artists. Aided by the press, Picasso became the artistic superstar of our era and, ultimately, a kind of living monument in the history of art. The contrasting example provided by Henri Matisse, who managed to maintain his privacy and keep his domestic difficulties from the gossip columnists, suggests that such public exploitation need not be the fate of the great artist, even in our epoch of saturation journalism. The truth is that Picasso's picaresque life style, his colorful love affairs, invited public scrutiny. People who could neither comprehend nor appreciate his stylistic innovations delighted in the erotic content of his art, its references to his amorous adventures. Picasso evidently did not find such curiosity unseemly (at least, not until the last years of his life, when

he began to resent such intrusiveness and withdrew to a more secluded existence). Aware that his own appreciation for artists like Cézanne and van Gogh involved an identification with their anxieties and torments, Picasso apparently expected his audience to react to his expressionistic creations in similar fashion. He emphasized the revelatory nature of his art, comparing his pictures to a painted autobiography which the future would read as if his canvases had been pages in his diary.[2]

Picasso's unique combination of creativity and charisma has attracted not only popular journalists but serious scholars. A comparison of the vast Picasso literature with the more limited bibliography available on Matisse indicates that we art historians also respond to compelling personalities.[3] However, despite the plethora of material which has appeared since it was published in 1946, Alfred H. Barr, Jr.'s, monograph, *Picasso: Fifty Years of His Art,* remains the cornerstone of Picasso scholarship.[4] Many of the fundamental problems in Picasso which Barr identified more than thirty years ago remain unresolved today. For example, we still lack a convincing explanation for the genesis of the artist's blue period (1901–4), for his defection from cubism into representational art (1914 and after), and for the origins of the creative impasse which transformed him from painter to poet (1935–36). The fact that these problems have resisted art-historical solution reveals the need for a new viewpoint, a fresh perspective. Picasso's position as a transitional artist whose personality played such a crucial role in his production suggests that this research should concentrate on elucidating the relationship between his career and his character. To date, no comprehensive study of this type has appeared, no research which demonstrates the relationship between Picasso's art and his life, as Wayne Anderson's valuable monograph on Paul Gauguin illuminated that artist's career.[5]

Picasso's personalized imagery has naturally inspired psychodynamically oriented critics to suggest connections between his art and his life. Without exception, such criticism has been presented in brief essays which examine only a few of the artist's pictures, rather arbitrarily selected from his vast oeuvre. The theoretical constructions proposed by these critics seem too limited to explain Picasso's complex character and career. Typically, such hypotheses focus on the artist's unresolved oedipal problems, which are perceived as crucial to his creative expression. Such formulations ignore the fact that, though we all have oedipal strivings, only Picasso invented cubism. Psychology has not yet advanced to a level which permits us to explain the flowering of artistic genius. Nonetheless, a careful study of the artist's oeuvre should yield vital clues which indicate why he chose cubism rather than some other radical new mode of artistic expression, as well as offering insights into other changes in his style and media.

The present research grew out of my perception of the need for a thoroughgoing exploration of Picasso's self-image, one which would avoid sampling

nd other methodological problems and provide fresh insights. To prevent
ampling errors, I examined the artist's entire production in three major areas
f activity, painting, drawing, and sculpture. Virtually complete catalogues
aisonnés of this oeuvre exist, providing photographic documentation for
housands of works spanning nearly eighty years of creative activity.[6] To
prevent my data from becoming too unwieldy, I studied the artist's prints,
eramics, and writings qualitatively, rather than quantitatively, as indices of
hanges in his psychological status which affected his creative expression. Cer-
ain prints from the 1930s, such as *The Minotauromachy,* which seemed es-
pecially revelatory received special scrutiny.

The method I devised for my investigation followed an outline provided
by Picasso himself.

Why do you think I date everything I do? Because it's not sufficient to
know an artist's works—it is necessary to know when he did them, why,
how, under what circumstances. . . . Some day there will undoubtedly be a
science—it may be called the science of man—which will seek to learn
about man in general through the study of the creative man. I often think
about such a science and I want to leave to posterity a documentation that
will be as complete as possible. That's why I put a date on everything I do.[7]

To aid such research, Picasso included far more than dates for his work. He
directed the efforts of biographers to reconstruct his personal and family
history, and he supervised the construction of his catalogues raisonnés, which
were substantially completed during his lifetime. These sources, plus a number
of more recent biographical and critical studies which amend or expand previ-
ous publications, formed my raw data.[8] Also, I carefully scrutinized David
Douglas Duncan's *Picasso's Picassos*[9]; this photographic essay reproduces five
hundred paintings retained in the artist's personal collection, previously un-
published and unphotographed. It seemed logical to assume that these pictures
possessed a special significance for their creator which might help to illuminate
his character.

Following Picasso's prescription, I studied all his catalogued works in con-
text, paying the closest attention to how, when, where, and why he created
each of them; I carefully noted alterations in his medium or mode of produc-
ion and correlated such changes with events in his life. As a mnemonic device,
I developed simple charts, lists which classified the works of a given period
according to style, medium, and content. These primitive statistical records
quickly revealed changes in Picasso's creativity which I could compare with
corresponding biographical data.

Although I adhere to a psychodynamic viewpoint, I approached this re-
search without any preconceptions concerning Picasso's personality structure
and core problems. Rather, the evidence shaped my conclusions; the hypotheses

I developed fit the visual evidence, providing internally consistent reconstruc
tions of the relationship between the artist's character and his creativity. Art
historical studies have frequently demonstrated how Picasso's knowledge of
great art of the past shaped his artistic evolution. My investigation demon
strates that Picasso's own past history played an equally important role in thi
process: the experiences, emotions, and images of his early childhood rever
berated through his art until the close of his career. For example, he responded
to the tragic events at Guernica with a flood of painful early memories which
strongly colored his initial conception of the mural and his early preparatory
drawings. Eventually, however, his great genius enabled him to transform
these private associations into the powerful public statement which we al
admire. My hypotheses concerning *Guernica,* as well as my conclusions abou
other aspects of Picasso's art, are intended to enrich existing art-historica
formulations, *which they in no way invalidate.* They provide another versior
of the facts, another perception of Picasso's creativity, which should be applied
additively to existing evidence and theories from other sources.

The book which follows puts into discursive language the self-portrai
which Picasso created through his art. It does not attempt to provide a com
prehensive characterological picture of this complex man; those aspects of hi.
behavior and experience which did not affect his work cannot be discerned by
the methods I use.

One central fact emerged from this research: Picasso's art, like his life, de
pended on partnerships. Every change in his productivity, from the evolutior
of a new style to the onset of a period of creative paralysis (and this investiga
tion reveals that he suffered many such paralyses in addition to his famed
fallow period of 1935–36) reflected a corresponding alteration or disruptior
in his most important current relationship. The intimate connection between
Picasso's imagery and his love affairs has been widely recognized, but m
findings suggest that his partnerships were infinitely more varied and com
plex and by no means limited to women. He chose different types of partner
to serve different functions. Whatever their other strengths or liabilities, these
special people all shared one essential quality: a determination or tenacity which
Picasso deeply respected and which probably also constituted an outstanding
characteristic of his mother's personality. Such tenacity characterized even th
most fragile and vulnerable of his female partners, where it often appeared a.
a kind of rigidity or stubbornness that served as one of the central organizing
features of the personality.

The most productive and serene of the artist's special relationships of thi
type involved not women but other men of genius whom Picasso could admire
without reservation. In these men, the required characteristic of tenacity ap
peared transformed as a total dedication to creativity, a dedication certainly
shared by Picasso himself, who always described himself as the perennia
captive of his own artistic drives.

This unusual dependence on partnerships originated in the artist's early childhood, in events now obscure. By the time he had reached school age, Picasso would become quite disorganized whenever he had to separate from his family, especially his empathic father. His entry into first grade was traumatic for the future artist, who reacted with a pervasive, agitated emotional paralysis which was to recur throughout his life whenever a crucial relationship disintegrated or was interrupted by external events and he found himself alone.

The book's organization emphasizes this central theme of partnership. The first two chapters deal with Picasso's years in his primary family; the remaining divisions consider each of his subsequent partnerships in sequence. Despite its chronological format, this text is neither a biography nor an art-historical reconstruction. Rather, it partakes of both approaches to review the chief events in Picasso's long life, but only as these incidents shaped or illuminated his art. The chapter titles come from the writings of the French poet Guillaume Apollinaire, the partner whose support helped to free Picasso to develop into the greatest artist of the twentieth century.

**The Pigeon Who
This Evening
Seemed the Holy Ghost**

Like the lion cub revered in medieval times as a symbol of Christ's resurrection,[1] Picasso appeared to be still-born. He neither breathed nor stirred in response to the midwife's efforts, and she abandoned him for dead to attend to his mother. His alert physician uncle, Salvador, playing the role of the father lion, finally brought the future genius to struggling, screaming consciousness by breathing a puff of acrid cigar smoke into his nostrils.

This connection with a symbol of Christ's triumph over death seems quite appropriate for Picasso. As an adult, he often created fervent crucifixion pictures during times of great personal crisis, suggesting an underlying identification with the suffering Christ which the artist apparently did not find inconsistent with his avowed atheism. Like one resurrected, Picasso bounded back from each of these crises to continue his prodigious work with renewed energy.

Except for this delivery-room drama, Picasso's beginnings seem prosaic enough. He was born in Málaga, Spain, on October 25, 1881, the eldest child and only son of Don José Ruiz Blasco and Maria Picasso Lopez. By the time of Picasso's birth, his father was a settled, middle-aged man. Earlier, he had been famous for his carefree, irregular life as the leader of a group of youthful Bohemians who followed his inspiration in engaging in a series of picaresque adventures.[2]

Don José came from a large, close-knit family in which he was the ninth of eleven children. After his father's death, Don José, although already a mature adult, apparently continued to be financially and emotionally dependent on his elder brother, Pablo, a canon of Málaga cathedral. When Don José showed an interest in art, Pablo gave him financial aid, hoping to wean his playboy brother from his youthful excesses, even by encouraging him in a profession which was not much respected. Don José soon showed surprising seriousness about his painting, and he acquired enough skill to obtain a position in the newly revived school of arts and crafts. When Málaga opened a small museum, he was named conservator and could use the museum restoration room as a

studio in which to paint his academic works. He was fond of executing still lifes of lilacs and other flowers, but especially of portraying pigeons amorously cooing and billing.

Don José's family, encouraged by his changed behavior, urged him to marry and settle down. He finally yielded, although he did rebel to the extent of rejecting the girl his family favored and choosing instead her cousin, Maria Picasso Lopez. Even then, his brother Pablo's sudden death in 1878 caused Don José to postpone the marriage for two more years. When the couple finally did marry, they were burdened with the responsibility of caring for Doña Maria's mother as well as for two maiden aunts.[3]

Pablo Ruiz Picasso was born about a year after his parents had settled into a comfortable apartment facing a tree-lined square, the Plaza de la Merced. In retrospect, the artist described his early childhood in idyllic terms, picturing himself as an infant prodigy whose unusual promise was quickly comprehended by his prescient mother. He recalled that he could draw long before he could talk, that his first word was the insistent demand, "Piz, piz," for *lapiz*, or pencil, and that he learned to walk because he was given a large tin of cookies to push about and realized that the contents would be his reward for success.[4] These memories probably involve little exaggeration. Phyllis Greenacre's researches into the childhood of creatively gifted individuals uncovered evidence of just such unusual sensitivity to one's surroundings and to the relationships between stimuli as Picasso recalled. Neither she nor other investigators interested in genius, however, have encountered parents who matched Picasso's mother in perspicacity.[5] In fact, they found to the contrary, that the formative years of geniuses were usually clouded by parental misunderstandings and fears. Such children puzzle their parents, who do not comprehend the real meaning of their offsprings' atypical behavior and development and often regard them as difficult, slow, or peculiar. Albert Einstein's family, for example, consulted a specialist when the lad turned three and had not yet started to speak. They feared he might be retarded. How could they know that he already was so preoccupied with abstract conceptualization that he simply had not been motivated to master the concrete names of things?[6]

The artist's recollections of his mother, then, may have been more rosy than realistic, more selective than comprehensive. Through Sabartés, Picasso supplied a vague, idealized description of her as an unusually cheerful, stable person who dominated the household by virtue of her common sense and lovableness. She sounds too much like a character out of *Candide*: the best of all possible mothers for the greatest of all possible artists. These happy generalizations simply do not fit the facts of Picasso's later childhood history very well. His reluctance to supply concrete data about his mother suggests that he felt far more conflicted about her than he realized, or at least wished to admit. Many years later, he described his mother to Françoise Gilot as a tiny but tyrannical woman who had dominated the family so completely that he felt

forced to flee Spain in order to escape her.[7] Although he deplored her tyrannical character, the deference Picasso always demonstrated toward people of implacable determination reflects the other aspect of his ambivalence: his admiration for his mother's stubborn dominance. The fact that he repeatedly involved himself with women who demonstrated similarly tenacious, sometimes even tyrannical, behavior indicates that he never succeeded in resolving this basic ambivalence.

By contrast, Picasso always discussed his father quite freely; we know Don José's faults and weaknesses as well as the strong points of his character, and we feel we have a much less selective portrait of him than of Picasso's mother.

If one reviews the women Picasso loved as an adult, hoping to see in them some shadow of his mother's image and influence, a very different picture emerges from that of the Candide-like heroine. Repeatedly, the artist selected women who demonstrated extreme psychological or physical frailty, or who were so much younger that their very youth implied a dependent, unequal cast to the relationship. At least two of the women he loved, Olga Koklova and Dora Maar, apparently suffered psychotic disturbances while associated with him. Françoise Gilot experienced a much milder, but nonetheless crippling, depressive reaction during her last few years with Picasso, while Marie-Thérèse Walter committed suicide in October 1977, shortly before what would have been Picasso's ninety-sixth birthday. Picasso's proclivity for vulnerable or needful women should lead us to question whether his mother may have demonstrated similar personality problems during his early childhood. At least, psychoanalytic experience suggests that men who love psychotic women nearly always have had severely disturbed mothers. Perhaps Picasso's idealizing vagueness about his mother cloaked a less cheerful reality: she may have dominated the family situation not by virtue of her strength, but through her weaknesses, just as Olga Koklova later tyrannized the artist's own household through her brittle tenacity.[8]

This theoretical reconstruction of the mother's personality better fits the historical facts of the artist's later development and the constellation of his mature personality, one of extreme vulnerability in self-esteem. More often than not, people who suffer from this narcissistic defect have had mothers whose own personalities revealed difficulties of a similar kind. Such mothers seem particularly prone to aggrandize their young male children, and to involve them in a kind of symbiotic enmeshment from which the child cannot extricate himself later, when his natural interest in independence asserts itself. This constellation occurs all the more readily if a young mother is married to a man many years her senior, as was the case with Picasso's parents.[9]

The Picasso literature yields only one direct quote from Señora Picasso de Ruiz concerning her son's early childhood, a comment which fits this reconstruction of events quite tidily. She boasted to Gertrude Stein that, as a small

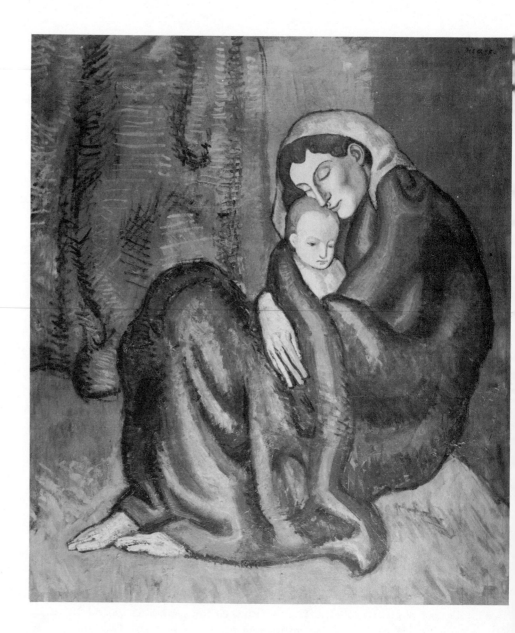

child, Pablo had been "an angel and a devil in beauty, and no one could cease looking at him." The fifty-year-old artist, present during this exchange, quickly inquired whether his mother still found him beautiful. She sweetly replied that he had lost all his beauty—but he was still a perfect son.[10] Since other women by no means found Picasso unattractive, one wonders whether his mother considered him beautiful only while their identities were so merged that for her he functioned as a psychological extension of herself, a mirror in which she could view herself as the cynosure of every eye. Nothing in Picasso's factual history supports his contention that his mother comprehended the ways in which he was really unusual, and this story suggests the opposite. Imagine the bewilderment and frustration of the child who intuitively realized that he possessed great gifts, but whose mother enjoyed him because he was the handsomest boy in the neighborhood, and because the other mothers envied her good fortune!

As one might anticipate, mothers with such extreme symbiotic needs often cannot divide their attention between two children successfully. They bestow their affection on an all-or-none basis, and when a new baby is on the way, they often withdraw their investment from the older child to focus almost exclusively on the newborn, who then becomes the primary object of their interest. Picasso's life and art indicate that he must have experienced a reaction of this sort from his mother following the birth of his sister, Lola. In his paintings of 1901–5, the artist often portrayed a mother and her infant or toddler wrapped in a tender caress; in fact, in some of the blue-period pictures, mothers fold their infants into such a hungry embrace that their bodies seem almost to fuse. By contrast, Picasso seldom portrayed mothers with older children; in one of his rare pictures of this type, a boy and his mother mutually ignore one another as each meditates on his private loneliness. The painting seems almost like an illustration of the estranged relationship which grew up between Picasso and his mother after Lola's arrival. The boy refused to accept the status of second fiddle and withdrew emotionally from his mother to ally himself firmly with his father.

Picasso's reaction to Lola's birth was made all the worse by the circumstances under which it occurred. As he remembered it, at least, the baby arrived shortly after the family had fled to a neighbor's house during a dreadful earthquake which rocked Málaga for three days, from December 25 to 27, 1884, when Picasso was three years old.[11] This unfortunate coincidence must have exaggerated the boy's terror and confusion. The evidence (to be specified below) suggests that he experienced his first emotional paralysis while the world around him trembled and gaped. Like the buildings of Málaga, Picasso felt himself fragment and disintegrate in the face of traumas too powerful to be borne. Perhaps he even believed that he had caused the earthquake. As an adult, Picasso continued to assume many magical connections between his thoughts or actions and external events. His biographies are filled with such

Maternité (*Mother and Child*), 1901, oil on canvas, 109.2 x 97.8 cm. Fogg Art Museum, Harvard University. Bequest-Collection of Maurice Wertheim, class of 1906

anecdotes, but the incident most often described relates how the elderly artist reproached himself for having caused the death of a dear friend. It seems that Picasso had accidentally omitted the friend's name that day from the litany of such names which he recited to himself each morning.

In many of the bullfight pictures he painted during his dark crisis period of the 1930s, Picasso portrayed the enraged bull destroying everything and everybody in his world. Such works may represent a more sophisticated depiction of his childhood belief that he was the earthshaker. By the time he reached adulthood, Picasso surely knew of the mythic connection between the god Poseidon, instigator of earthquakes, and the horses and dark bulls which the Greeks associated with this fierce god and traditionally sacrificed to placate him.[12] Even as a child, Picasso may have established an instinctive association between these animals and the earthquake, for his father began taking him to bullfights soon after the Málaga quake.

Don José apparently made a special effort to provide Pablo with companionship at this time because he noted the child's deep distress, his special need for support following the earthquake. Señor Ruiz began to teach the boy to draw by encouraging him to sketch the pigeons which crowded the shady plaza on which their apartment fronted, and he took the boy with him on strolls about Málaga, as well as to the weekly bullfight. Don José was a true aficionado, and he taught his son to love all the nuances of this ritual, which formed an important portion of Picasso's subject matter, even in works he executed as a child. His first oil painting, completed when he was eight or nine, depicts a mounted picador as he confronts a bull (Z., VI, 3). A falsified memory of Picasso's suggests how much he had idealized his father during childhood. He often glowingly described to Sabartés his personal favorite among Don José's many paintings of pigeons. As Picasso remembered it, this canvas was an enormous one which showed millions of birds flitting about their dovecote. When Sabartés finally unearthed the picture in a dusty corner of the Málaga museum, it proved to be quite modest both in its dimensions and the number of birds it portrayed. Although one psychoanalytic critic has interpreted this anecdote as an oedipal screen memory reflecting the artist's childhood awe of his father, Sabartés's own explanation that Picasso's exaggeration represented "the dovecote of his childhood illusions" seems more accurate. To little Pablo, pigeons symbolized the security and protection his father offered against the outside world, and in 1901, when the adult Picasso found himself alone and depressed in Paris at the onset of the blue period, he painted a poignant picture of a child tenderly coddling a dove.[13]

Through his father's help and the healing powers of his own great talent, Pablo gradually achieved a reintegration, but his new personality organization was a brittle one, with many limitations. He could function effectively only in his father's presence or, failing that, at least in his own home, where the adults were careful not to place too many demands on the child. When events beyond

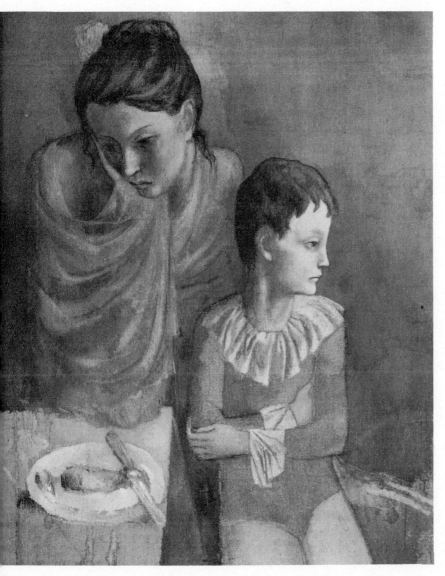

Saltimbanques (*Mother and Child*), 1905, gouache on canvas, 90 x 70 cm. Staatsgalerie, Stuttgart

his control separated him from his father and put him into a strange situation.
Picasso again collapsed and felt fragmented. His enrollment in first grade
precipitated just such a crisis, and he developed a severe school phobia. Another
event, which probably closely coincided with Picasso's entrance into school,
may have aggravated his negative reaction to it: his baby sister, Concepción
(Conchita), was born when the artist was six. Picasso's biographers scarcely
allude to this event, which may reflect the artist's own reticence. It seems logical
to assume that the arrival of a second sister would have reactivated a good deal
of the rage and disorganization with which Picasso had responded to the birth
of the first. Later, as a mature man, he reacted to the birth of his own children
with marked ambivalence, to say the least. During our interview, Gilot con-
firmed my impression that the arrival of his daughters particularly upset the
artist, another indication of how distraught he must have been over the birth
of his sisters.

Picasso described his own phobic behavior about going to school in lively
detail, in an account quite at variance with his description of himself during
the first five years of life. Terrified, mocked, and paralyzed in the school
situation, Picasso hardly sounds like the self-assured, self-willed little prodigy
he had pictured for us earlier. He proved so totally unwilling to attend the
public school that the family withdrew him after being embarrassed repeatedly
by the noisy, terrible scenes he made as the family maid dragged him through
the streets and into school by brute force. He was transferred to a small private
school run by a family friend. Even then he continued to refuse to go to school
unless brought and called for by his father, who dropped him off on his way
to the museum. As often as possible, the child feigned illness or really became
sick and could not leave home.[14] When he did acquiesce and attend school, it
was only after a long, tearful scene, in which he offered a thousand excuses
for staying at home. On the way to school, Pablo clung to his father until Don
José agreed to leave some precious possession as a guarantee that he would
return. The boy preferred his father's paint brushes as collateral or, failing
those, one of the pigeons Don José used as models. When Picasso entered the
classroom late, clutching a pigeon, or perhaps his father's walking stick, every-
one burst into laughter. Pablo was so worried about whether his father would
return for him that he scarcely noticed his schoolmates' derision. He had
trouble staying in his seat and would often leave the classroom and wander
out to the kitchen, where he followed the headmaster's wife about. When he
did stay in class, he was totally paralyzed. He heard nothing, he learned nothing.
All he could do was watch the clock and repeat to himself, "At one o'clock, at
one o'clock." Sometimes he would discover that he had been chanting these
words aloud, to the other pupils' amusement. When Picasso recalled these
scenes for Sabartés, he commented that he had stared at the clock "like an
idiot," and he mocked his own simple expression. Psychoanalytic patients with
narcissistic defects recall similar reactions to the separation from the parent

ney idealized. Like Picasso, these people tend to experience symptoms of physical discomfort (hypochondriasis), feelings of estrangement, and "deadness" in such circumstances.[15]

Picasso's parents recognized the severity of his learning problems and had him tutored at home. In retrospect, he felt that this had not been terribly effective either, and he was unable to remember when or how he had learned to read or write. He counseled Sabartés not to have illusions about the amount of learning the artist had mastered. Although many children with a school phobia learn perfectly normally once they have become settled in the classroom situation, Picasso had *both* a severe school phobia and a severe learning block. His own description suggests that his disorganization when he was separated from his father was simply too severe to permit him to concentrate: "You can't imagine what I suffered trying to pay attention. As soon as I began thinking that I had to pay attention, I'd be distracted by the thought that it was necessary to pay attention, and this would confuse me."[16]

By 1891 Don José was evidently having so much difficulty making ends meet that he realized he would have to seek a post outside his beloved Málaga. He also realized that Pablo, although now ten and old enough to leave elementary school, could never pass the qualifying examination for secondary school anywhere except in Málaga, where Don José had influence. Consequently, before transferring his family to Corunna (La Coruña), where he had accepted a teaching position in a secondary school, Don José arranged to have Pablo take the necessary test, with a friend administering the examination. The entire test, at least as Picasso remembered it, consisted of one mathematical problem. But Picasso was so distracted and anxious that he couldn't solve it until the examiner helped him out by "accidentally" letting the child glimpse the correct total. The artist's description of this incident suggests that his mathematical learning block was aggravated by his inability to assume the abstract attitude. For him, the numbers were not just symbols, but concrete signs, and he could not maintain a neutral attitude toward them. Picasso had been promised the opportunity to paint a picture in oils as a reward for passing the examination. On the way home, he imagined the pigeon he would paint, describing it in terms of the numbers used in the examination: "The little eye of the pigeon is round like a 0. Under the 0 a 6, and under that a 3. The eyes are like 2's, and so are the wings. The little feet rest on the table, as if on a horizontal line . . . underneath it all, the total."[17] This account suggests that he anthropomorphized the numerals and was distracted by his own fantastic perceptual abilities. Later sketches showing other anthropomorphized numbers suggest that this was not just a temporary phenomenon (Z., VI, 49, 162). Such an inability to maintain the abstract attitude might help explain Picasso's uninterest in carrying cubism to its ultimate logical conclusion, complete abstraction. It also sheds light on his marvelous capacity to perceive the hidden potentialities in junk items, which he ingeniously converted into organic sculptural forms.

Shortly before Picasso's tenth birthday, the family left Málaga to make the
long arduous voyage to Corunna, traveling part way by boat, then overland.
Corunna, on the Atlantic coast at the opposite end of Spain from Málaga,
presented a cold, inhospitable face to these newcomers accustomed to the
sunny Mediterranean climate. As Picasso later recalled the sequence of events,
soon after they arrived in Corunna, his little sister, Concepción, contracted
diphtheria and died. Family records now owned by the Museo Picasso reveal
that the girl actually died on January 5, 1895, just before the family *left*
Corunna, rather than shortly after they arrived; he repeated this myth to Gilot,
just as he had earlier to Sabartés and others, even though he correctly remem-
bered that Concepción had been eight when she died (rather than four, as she
would have been in 1891). Gilot noted that the artist continued to seem torn by
guilt and remorse over this tragedy fifty-odd years after the event.[18] His retro-
active disorientation corroborates this impression, suggesting that, at the time,
the boy may have responded with another of those fragmented, dissociated
states similar to the paralysis he had experienced during the Málaga earthquake.
In fact, he always remained rather vague about the Corunna period, perhaps
because he terminated his stay there in such a state of confusion. Sabartés in-
dicated that he never was able to reconstruct the events of these years very
adequately: "Picasso's memory of what he studied aside from his art is dimmed.
I could never figure out what he did in La Coruña apart from what is told by
certain drawings and paintings of his school years, and apart from the recollec-
tions of his surroundings drawn from the streets and especially from his
home."[19]

Despite Sabartés's realization that Picasso's memory for this period seemed
so hazy, the biographer accepted unhesitatingly the artist's version of Don
José's reaction to life in Corunna. According to Sabartés, Don José had dreaded
leaving Málaga, his circle of friends there, and above all, his young brother
Salvador, a successful physician and city official who evidently had replaced
the dead Canon Pablo as Don José's father figure. Conchita's death robbed him
of any vestige of anticipation he might have retained for his new position
and his new life, and he never recovered from the blow. Corunna's foggy, damp
climate exacerbated his feeling that he dwelt in a hateful, alien world, and he
gradually became more and more withdrawn; he refused to go out or enter-
tain, and he even gave up his beloved bullfights rather than mingle with
strangers. Both in Corunna and later in Barcelona, Don José insisted on
living right across from the school buildings in which he taught, so that he
would not have to mingle with these people who did not belong to "his
world."[20]

How much of this account represents fact, how much a retrospective fictional
veil which Picasso drew across reality? We may never know the answer to this
question. No one has attempted to investigate the artist's Corunna period, and
it may be too late to do so. The family lived there briefly, and if Picasso's de-

cription of his father's record as a nonparticipant is at all accurate, they may
ave left too faint an imprint to retrace so many years later.

Once more according to Sabartés, while poor Don José suffered in Corunna,
ttle Picasso prospered. Certainly the family's living situation there permitted
he child to circumvent his school phobia. They resided directly across from
he Instituto Da Guarda, where Picasso's father held a professorship in art, and
vhere Pablo studied in the secondary school. Hence, the boy could accompany
is father to class or run across the street while his mother watched protectively
rom their apartment window. In 1892 Picasso began his studies in the School
f Arts and Crafts at La Guarda, where he evidently spent much of his time
nder his father's tutelage; soon the boy became so skilled at painting that he
vas permitted to execute details of his father's canvases, particularly the feet
f the pigeons in the many paintings Don José devoted to these creatures.

Many of Picasso's sketches from these years (1892–94) have survived, and
hey all demonstrate his precocious powers of observation and understanding
f human foibles. Even his boyish battle scenes show more emphasis on the
oldiers' gestures and expressions than on the combat between them (Z., XXI,
–8). The little newsletters for relatives in Málaga which Picasso started when
e reached thirteen are filled with drawings and commentaries that caricature
Corunna types and customs (Z., XXI, 10–13). Both Picasso's humanist interest
nd his savagery are prefigured in these works. Although the draftsmanship
f these drawings is excellent, it does not really support the artist's often-re-
eated boast that, by the time he was twelve, he could draw like Raphael, a
omment which probably reveals more about the level of Picasso's ambitions
han about the accuracy of his autocritical judgments.

Perhaps it is to such ambition that we should charge another legend from
he Corunna period. Supposedly, sometime during these years, Picasso's father,
oting his son's great progress in painting, handed over his palette and brushes
nd vowed never to paint again. This story has never been questioned, although
Picasso was the sole source for it; its similarity to the Verrocchio-Leonardo da
Vinci legend seems more than coincidental. The story may be yet another chapter
f that personal mythology created by Picasso, showing a retrospective conden-
ation of separate events—recognition by Don José of Pablo's progress occur-
ing along with an aggravation of the father's depression and difficulties about
vorking, unrelated to his son.

In 1895, when Picasso was fourteen, his father got an opportunity to trade
is post in Corunna for one in the Barcelona Academy of Fine Arts (known
amiliarly as La Llonja, after the Casa Llonja, in which it was housed), and
he family pulled up stakes once more. Just before they left Corunna, Picasso
xhibited paintings in a local store, an arrangement which must have been
nade by his father, who probably also saw to the little notice which appeared
n the press. We have no record concerning which works Picasso showed, but a
umber of oil paintings completed during his final year in Corunna survive and

may have formed part of this exhibit. All of them are portraits, such as th
picture of Lola in a mantilla, which makes her look inappropriately matronly fo
a little girl of ten (Z., XXI, 1), or the picture of the family maid, a gypsy-lik
girl, handsome in a brazen sort of way (Z., XXI, 30). The portraits made fro
professional models all feature colorful indigents, reminiscent of types painte
by Velazquez and Ribera (Z., I, 1–4). Picasso's keen observation of charact
makes even these academic works lively, and they appear far less trite an
dated than one might expect. The traditional character of these portraits al
indicates that Picasso continued to conform to his father's artistic standards an
to depend on him for professional guidance.

The story of Picasso's entrance examination for La Llonja formed anoth
chapter in his personal mythology. Supposedly, this test usually required on
month to complete, but Picasso finished it in one day! Josep Palau I Fab
points out that this tale is simply untrue. "The fact is that the two drawing
which have survived from this test bear different dates: the first is of the 25t
of September and the second of the 30th of September 1895." He explains th
the Llonja examination actually consisted of three separate parts: copying fro
prints, from plaster casts, and from the model, or nature. "For this test th
students had to be at least twenty years old. Don José probably managed t
have his son exempted from this condition and from the first two examin
tions."[21] Picasso's success in this examination qualified him for the more ad
vanced classes and meant that he did not have to take elementary general drav
ing. He enrolled in the Llonja for two consecutive academic years. Palau I Fab
claims that the young artist did not make much use of his second enrollment i
1896–97, and changes in both the style and content of Picasso's pictures fro
1897 corroborate this assertion.[22] Retrospectively, Picasso tended to depreciat
the training he received at La Llonja as inferior to the instruction he got fro
his father. In actuality, Picasso probably could learn only from the father he s
idealized.

Around 1896 Don José rented the first independent studio for his son—
little garret room, conveniently located on the short path between the Ru
apartment and La Llonja, so that the senior Ruiz could keep close check on th
boy's progress. The studio was required so that he could carry out a canvas o
heroic proportions, *Science and Charity* (Z., XXI, 56). This work, whic
contrasts the detachment of the attending physician with the warmth of
nursing nun as they aid a sick woman, represented the senior Ruiz's idea o
a proper painting. Don José also purchased (and possibly prepared) the bi
canvas, procured the models, and posed as the physician himself. No doub
he also arranged for the picture to be entered in the National Exhibition o
Fine Arts competition of 1897, where it won an honorable mention. Subse
quently it went to a local Malaguenian competition, where it fared better, cap
turing the gold "first" medal.

Although Pablo painted other religious pictures in 1895–97 which seem to have been suggested and closely supervised by his father, at least one from 1895 apparently stemmed from the artist's own inspiration. Picasso recalled that he painted the *Flight into Egypt,* (Z., XXI, 44) which never left his own collection, right after his family moved from Corunna to Barcelona, when, like the Christ child, he had gone forth into an unknown land.[23] The iconography of this work departs from the conventional interpretation. The baby Jesus sits on his mother's lap, but St. Joseph also takes full part in the action. He kneels at Jesus's feet, and the Child reaches eagerly toward him, obliterating Mary's face with his own. Picasso's Jesus thus emulates the artist's own example in turning from his mother to his father; like Don José, moreover, St. Joseph has a red beard. Although Christian symbolism never developed an important place in Picasso's personal iconography, he did do crucifixion pictures during several major crises in his adult life, and the *Flight into Egypt* merely provides the first indication of his identification with Jesus.

Picasso's portraits from his first Barcelona years show that Don José was his son's favorite subject. How close father and son must have been! From one picture to another, Picasso catches the subtlest changes in Don José's moods. Señor Ruiz is always unsmiling and sad, but sometimes he looks more irritable, sometimes more gentle. The most moving of these pictures, a watercolor of 1895 (Z., XXI, 39) shows Don José seated at a table and leaning his head on his left hand. His right hand lies open on the table, useless and idle. Despite his quiet pose, he seems agitated and troubled. The blotchy background, through which the light shines fitfully, helps convey this feeling of agitation. Another watercolor shows him turned away from the spectator, wearing a blanket wrapped close around him and a tasseled cap. Perhaps Don José had been ill, but the picture suggests a resigned man, old before his time, who has turned his back on life. A poignant oil painting from 1895 shows only Don José's right hand, dangling limp and idle (Z., XXI, 22).

Picasso created no portraits of his mother which parallel these intimate, empathic views of his father. The boy apparently used her as a model much less frequently, and the formal pictures of her which survive typically show her in profile view, turned away from the spectator—and the artist. The most famous of these dates from 1895; Picasso later commented that he had created it at the beginning of his painting career. Carefully executed and quite idealized, it may have commemorated some special occasion or possessed some secret significance to its creator. At any rate, it presents a rather different interpretation of his mother's personality than the little watercolor he executed the following year, which shows her sitting rigidly upright, her mouth turned down in a dour, angry expression.

Most of Picasso's remaining boyhood pictures of his mother consisted of quick, informal little sketches. Nearly all portray her busily absorbed in reading,

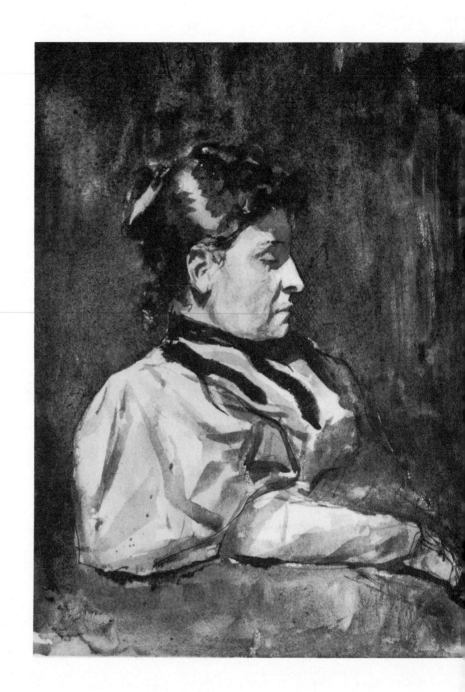

wing, or other household tasks. Often Lola keeps her company, working be-
le her in comfortable intimacy. The mother's industry presents a marked
ntrast to her husband's apparent idleness, but it may be that Picasso really
ked his father to pose formally (a request Don José, so ambitious for his
n, would certainly have treated seriously), whereas the boy usually drew
s mother unawares, while she engaged in her daily routine. In any case, the
nall number and slight quality of the latter sketches suggest that Picasso
ntinued to keep himself relatively detached from his mother. The fact that
any of these drawings seem to have been made without her knowledge sug-
sts that he had already put into practice the pattern of loyal estrangement
hich would later characterize his attitude toward the women he had once
ved but later rejected. After he separated from his first wife, Olga, he con-
nued to maintain a regular, if attenuated contact with her, and he followed
milar procedures with the mistresses who succeeded her. During our con-
rsation, Gilot revealed that while she lived with the artist, he also maintained
rtually daily contact with his sister Lola in Barcelona, the sole surviving
ember of his primary family. He did not write Lola himself; rather he depu-
zed another (either one of Lola's two sons, who had fled to France in 1939,
Gilot herself) to carry out the correspondence. Those adolescent sketches of
s mother may have served a similar purpose: they kept him in touch with her
d her activities, yet interposed the protective buffer of his sketch pad and
tivity between the artist and his subject.
 Picasso's self-portraits from the same period provide a mute history of his
anging self-image and widening horizons. A painting completed shortly
fore the family left Corunna shows a solemn, plump-faced boy (Z., XXI, 45).
is self-concept as reflected in this picture does not differ markedly from the
idence provided in a contemporary photograph. But how his self-concept,
at any rate the level of his aspiration, changed during the next two years!
oth self-portraits from 1896 make him seem older, more suave and handsome
an the reality; in one of them, he gets himself up in the guise of a rococo
p (Z., XXI, 48) with a beautiful white wig and a world-weary expression.
y 1897 Picasso was picturing himself stripped to the waist, his stubby torso
d squarish head transformed into tubular-looking, El Greco-like proportions
hich adumbrate the mannered elegance of his blue-period figures.
 According to Sabartés, by the time the family had moved to Barcelona, Don
osé was so busy planning for Pablo's future and molding his son's talents into
ne shape he believed they should assume that he no longer painted at all.
abartés, in fact, calls Picasso not only Don José's child but his finest work.
on José finally convinced his prosperous physician brother, Salvador, to invest
nancially in Picasso's future so that they could send the boy to study in the
cademy of San Fernando in Madrid, which Don José regarded as the center of
ne artistic universe. According to Penrose, the boy equalled his previous virtu-
so performance at La Llonja by completing the Madrid academy's entrance

The Artist's Mother, 1896, watercolor
on paper, 18 x 12.5 cm. Museo
Picasso, Barcelona. © SPADEM,
Paris / VAGA, New York

examinations in a single day (though he does not indicate how long th
usually took). No one has investigated Picasso's Madrid sojourn with the san
care that Palau I Fabre expended on the Barcelona period, so it is not possib
to judge whether this examination story is fact or myth. In fact, little inform
tion about Picasso's entire stay in Madrid has surfaced. The artist himself alwa
seemed uncertain about how long he remained there, but he was clearly back
Barcelona by June 1898. Perhaps he preferred to forget this period or, mo
likely, really did not recall it clearly because he was too disorganized and co
fused at the time. The meager evidence suggests that he lived a lonely, deprive
disarrayed life in Madrid. He seldom if ever attended classes, claiming that l
"forgot" to go. Probably he would not have been able to absorb anything tl
instructors offered if he had attended. Retrospectively, Picasso always insiste
that Don José was the only effective art instructor he ever had. Such behavi<
provides the evidence for my earlier assertion that Picasso could master ne
material only when his father was present to organize his vulnerable chi
through his benign affirmation of the latter's real capacities.[24]

Picasso evidently worked little during those months in Madrid; some sma
sketch books filled with impressions of life in the streets and a few more car
ful pictures copied after the old masters he studied in the Prado constitute tl
chief artistic souvenirs of his Madrid interlude. Most biographers attribu
this diminished production to Picasso's poverty, but he may have been mo<
emotionally than financially deprived. At one stroke, he had been abrupt
separated both from his protective, supportive family and from his father
professional guidance. Even much later, as a mature man, Picasso could nev<
tolerate solitude well, and his production nearly always suffered when he lacke
a working partnership with a person physically on the spot. How lost he mu
have felt during that lonely winter in Madrid, which must have recalled 1
him the primary-school situation when he had waited helpless and panicky f<
his father to return and rescue him.

Uncle Salvador, disgusted with the poor returns from his investment i
Picasso's education, withdrew his support for the Madrid venture before tl
end of the academic year, and Don José was forced to stretch his meag<
resources to make up the difference. When Picasso discussed this interlude wit
Sabartés years later, he dismissed his relative's contribution as a pittance.

Illness finally delivered Picasso from Madrid. In the spring of 1898, h
caught a mild case of scarlet fever and came back home to recuperate. As soo
as he felt well enough, he left for the mountain village of Horta del Ebro (als
known as Horta de San Juan) with his friend Manuel Pallarés, a native c
Horta. Manuel had been Picasso's first friend in Barcelona; in fact, he probabl
was the first person outside his own family with whom Pablo enjoyed a mear
ingful relationship. As a young child, the artist apparently was too anxiou
when separated from his father to attempt to make contacts outside the home
No one mentions that he ever had any friends or played with any childre

xcept his sisters and cousins. Manuel, five years Picasso's senior, had come to Barcelona to study at La Llonja, where the two fledgling artists met in 1895. Because Manuel was lonely away from home for the first time, Pablo's parents frequently invited him over, and he became almost like one of the family.

Picasso spent eight idyllic months with Manuel in Horta, managing the separation from his family with ease. He had not gotten along well on his own in Madrid and would later experience great difficulties in carrying out his intention to leave his family and live in Paris. This suggests that something special about Horta, or about his relationship with Manuel, permitted Picasso to maintain the separation from his father so comfortably. Obviously Horta comprised a simpler, more manageable world than Madrid or Paris, and Picasso enjoyed its simple pleasures: the mountains, the peasants, the local craftsmen. He always admired artisans who knew their crafts, and worked with such people in an atmosphere of mutual respect. This occurred in Horta, where he learned a lot about farming and wine making, and some of the village crafts, as well. Later he boasted, "All that I know I learnt in the village of Pallarés."[25] Yet, in the past, Pablo had been unable to learn *anything* when separated from his father. Does this mean that Pallarés replaced Don José as an external, idealized person, making Picasso feel complete and competent? We can only guess, lacking sufficient artistic or biographical evidence to solve this mystery.

We do know that Manuel suggested the theme of Picasso's major canvas of 1898, painted in Horta. It seems likely that Pallarés also was responsible for the painting's title, *Aragonese Customs,* since Picasso usually did not name his canvases at that time. We don't know whether Manuel also had a hand in selecting and posing the models. Descriptions of the painting, which has disappeared, make it sound as academic and artificial as *Science and Charity.* Perhaps Manuel not only functioned as a kind of father substitute for Picasso but even thought like Don José. Whatever the exact nature of their friendship, Pallarés and Picasso remained fast friends for the rest of their lives. At the time of Picasso's ninetieth birthday celebration, the ninety-five year old Pallarés traveled to France to join in the homage to his famous friend.

When Picasso finally returned to Barcelona early in 1899, he did not revert to his old place and role in his family. His friendship with Pallarés and the sojourn at Horta had helped the young artist to become more independent. Now less tied to his parents, he blossomed socially and began to participate more in the intellectual and artistic life of Barcelona. Palau I Fabre claims that Picasso even participated in the student riots of 1898–99 at La Llonja (this was a period of upheaval and student rebellions in Catalonia), much to the consternation of his father, who was trying for promotion to a more important position at the academy.[26] In fact, Picasso's altered relationship with his father is apparent even in paintings and drawings which predate the Horta del Ebro interlude. Previously, he had portrayed his father intimately, in close-up interior settings. Now many of his sketches showed his father outdoors, far away,

muffled up in a hat and overcoat or even faceless, as in the very free oil sketch
which the artist retained for his own collection. In 1899 Picasso posed several
of his friends in similar settings in exactly the posture his father had assumed.
Whether consciously or not, the young man may have utilized his father simply
to study the problem of rendering the figure in outdoor light. The most poignant
picture of the father from this period is a study which shows only his clasped
hands intertwined in a tense, twisted position. The implicit *angst* which those
hands convey suggests that the stories about Don José's depression and in-
activity as an artist may not have been totally without foundation.

Picasso's favorite family model during these years was his sister Lola. Not
only was his relationship with her less ambivalent than with his parents, but
Lola had suddenly grown up into an attractive, eminently paintable young girl.
His earlier sketches had portrayed her as a prim little school child or satirized
her as the bratty little sister. From 1898, however, Picasso's portrayals of her
changed abruptly, beginning with a watercolor which shows her as a sullen,
proud adolescent (Z., XXI, 57). During the next few years, he painted and
drew Lola in a wide variety of poses and costumes. He enjoyed portraying her
as *L'Espagnole,* with a mantilla and a rose in her hair, or as a vaguely Lautrec-
ian heroine, with her hair tightly knotted and her features sharpened to give
her a hard appearance (Z., VI, 131; XXI, 80, 102).

Only rarely do Picasso's pictures of Lola reveal much about her as a person.
If they were really close—and Gilot believes they were—his paintings do not
reflect it. One gets the impression, rather, that he used his sister as a model
because she was attractive, available, and did not charge to sit. She is the only
woman who appears in work after work during these Barcelona years, but he
seemed more interested in using her to solve various technical problems, such
as handling the figure as a light or a dark silhouette and the like, than in Lola
as a personality.

Picasso's social, intellectual, and artistic life during this period revolved
around the group of youthful Bohemians who made Els Quatres Gats (The
Four Cats) their headquarters. This arty neo-Gothic tavern, designed by its
owner to serve as the gathering place for Catalonian writers, musicians, and
artists, had opened in 1897. Picasso probably had known about it then, be-
cause his first sketches of fellow Four-Cats habitués were made before he
went to Madrid. According to Sabartés, from 1899 on, Picasso was the "star"
of this group, although the youngest of all the artists who gathered there.
Sabartés, still dazzled fifty years later by the memory of the youthful Picasso,
describes him as seeming like a magus to his companions, because of his aston-
ishing gifts. "We spoke of him as of a legendary hero."[27] Since Picasso could
choose his friends as he wished, he selected them, according to Sabartés, as
he selected the colors of his palette, for a particular time and a particular
purpose. Sabartés classifies himself as the friend with whom Picasso liked to
converse whenever he was bored. Already in 1899 Sabartés was at Picasso's

ck and call. His sketches of Sabartés from 1899 show the latter looking
iff, prissy, and a bit superior (Z., VI, 243, 247). If he really was as proper
nd inhibited as Picasso makes him seem, no wonder the dynamic young
ndalusian appeared like a magus to Sabartés.

If Picasso used Sabartés primarily as a conversationalist, he called upon
her friends to provide him with more concrete aid—the use of their studios.
icasso's relationship with his parents seems to have become, by then, suffi-
ently strained that he dared not ask for much money, and he certainly was
ot earning any through the sale of his works. He solved his problem by
ppropriating studio space from his friends without sharing in much or any
f the cost. Once in a fellow artist's studio, Picasso painted so prodigiously
at he soon used up the available space. Penrose describes how Picasso in-
aded a large studio, rented jointly by several of his friends, and simply took
ver as the rightful owners retreated, finally yielding the total space to him.
Needless to say, Picasso did not last long in anyone's atelier, and he worked
ith at least three different friends before he left for his first trip to Paris in
900.[28]

As the "Benjamin" of the group, Picasso naturally knew less about con-
mporary artistic and literary movements than most of his friends. He learned
uickly, though, and one can soon detect echoes of the Pre-Raphaelites, of
eardsley, Steinlen, Daumier, Lautrec, and even of Nonell, a fellow Four-
ats habitué, in Picasso's works in 1899 and early 1900. It is not the purpose
f this book, however, to focus on such influences. Much more important to
ur purpose is the effect these new associations had upon Picasso's life and
elf-concept. How important the Four-Cats group was for Picasso is suggested
y the fact that during this period he did more portraits of his fellow artists
han any other kind of picture. Although Picasso's serious, romanticized
ortraits of these friends sometimes seem dated, his caricatures appear as fresh
nd pithy today as they did seventy years ago. Even at eighteen, Picasso was
marvelous judge of character, capable of summing up a friend's personality
1 a few choice lines. Sometimes his work seems almost ruthless; his humor
lways had a savage, sadistic turn, often apparent in these caricatures. This is
articularly true of the drawings showing Carlos Casagemas, with whom he
hared a studio in 1900 and who accompanied him on the first Paris trip.
Casagemas's weak chin and big nose made him a natural target for satiric
reatment. Picasso exaggerated these features, as well as his friend's attire;
e is pictured wearing funny little hats or enormous portmanteaus or absurd
igh collars which engulf him up to his chinless chin. By contrast, a straight,
elatively unromanticized portrait of Casagemas shows him vulnerable and
ensitive and really not unattractive full-face. Both the comic and serious
ortraits suggest that Casagemas was the least self-assured of Picasso's friends,
nd it is interesting that he was the person Picasso selected to accompany him
o Paris, where poor Casagemas suffered a terrible disaster.

In contrast to Casagemas, Manuel Pallarés is usually portrayed by Picasso as extremely elegant and poised, and is seldom caricatured or made to appear decadent. This special treatment may be a further indication of Pallarés' special meaning for Picasso. Throughout his life, Picasso treated the portraits of the people most important to him in a manner which set them apart from other associates.

Only one self-caricature from this period survives. It shows Picasso strolling along with Casagemas; both are huddled in too-large coats, and they look small, immature, and seedy. Picasso was kinder to himself, though, for he half-hid his own face in his collar, leaving poor Casagemas's beak shining forth like a light (Z., VI, 219). Nevertheless, this picture forms a refreshing contrast to the aggrandized straight versions of himself Picasso was executing simultaneously (Z., XXI, 109). The most sophisticated of Picasso's caricatures is *Sabartés as a Decadent Poet,* which shows him in a cemetery, wearing a dramatic cape and a wreath, and carrying a lily. Picasso apparently was aware of the artificiality of the current cult of morbidity and aesthetic "purity."

The more ambitious paintings of 1898–99 reflect the same fascination with the seedy side of life suggested by the sketches of friends; once free of his father's influence, Picasso revealed a style far more incisive than one might anticipate on the basis of works like *Science and Charity.* Although his paintings still occasionally got a bit murky and pretentious (such as *The End of the Road,* showing the continuing procession of the poor, old, and weak toward death), he could be grimly realistic, too. He retained the harshest of these pictures for his own collection; it shows a prostitute urinating on herself as she stands on a darkened street. Aside from this indirect reference, very few of these paintings contain clear allusions to sexuality. Prior to his first trip to Paris, Picasso limited his erotic images to small-scale drawings made in bordellos for the amusement of his friends and himself. These pictures remained secreted in the family collection in Barcelona, unknown until the artist donated them to the Museo Picasso there in 1968.[29] This reticence about portraying nudes and sexual scenes disappeared as soon as Picasso visited Paris. Evidently he could not completely throw off the repressive Spanish attitudes toward sexuality so long as he remained in Spain. Occasional rather sentimentalized religious drawings from this time, such as the *Praying Mother* imploring heaven to save her sick child (Z., XXI, 61, 63), reveal that Picasso may not yet have shaken completely free of her religious attitudes either.

In general, the years 1898–99 were years of expansion and growth. Reproductions in Zervos show notebook page after notebook page thickly covered with studies ranging from academic drawings to the wildest caricatures. Even then, Picasso knew the definition of a genius: someone who works harder than anyone else.

The Painter with the
Celestial Blue Hands

Picasso's blue period invaded every area of his art, transforming style, technique, and subject matter alike. The abruptness of this transformation can be measured by comparing three self-portraits painted within six months, a series of images which function like road markers along the route to his blue immersion. The first, the *Yo Picasso* (Z., XXI, 192), was probably painted shortly after the artist arrived in Paris that spring of 1901. The second followed a month or two after, while the last, painted at the end of the year, caught the artist as his blue mood descended. The latter image shows us a Picasso whose very soul seems chilled by the bleak Parisian winter. Wearing a dilapidated black overcoat which envelopes him completely in its shapeless bulk, he confronts us gaunt, hollow-cheeked, and aged. Sad but proud, he hides none of his suffering from our scrutiny, but asks for no pity. The picture is reminiscent of portrayals of Christ as the Man of Sorrows, a comparison the artist may or may not have had in mind.

What a contrast exists between this December portrait and the *Yo Picasso.* That canvas shows the youthful painter, clad in a flamboyant tie and flowing shirt, seated at his easel. Supposedly busy painting, he is really busy staring down the spectator with an expression so brashly self-confident that it recalls the similarly impudent self-portraits of the young Caravaggio. The brushwork of the *Yo Picasso* is thick, free, almost aggressive in its vigorous sweeps, and the artist has dramatically highlighted his face with impasto patches of light. The second image presents a more mature self-concept. The adolescent exuberance of the *Yo Picasso* has faded, and the artist confronts us in a serious, close-up vision so intense and direct that it brings new meaning to that hackneyed phrase, "a speaking likeness." The brushwork of the picture remains bold and loose, but its colors have darkened, and Picasso's image emerges from its glowing depths. An angular aura of deep-blue surrounds his head, while strokes of lighter blue, which seem almost like reflections cast by that dark halo, fall about his shoulders and—more arbitrarily—in calligraphy-like marks along his left arm. In his final self-portrait of 1901, the artist renounces all the sensuous pleasures provided

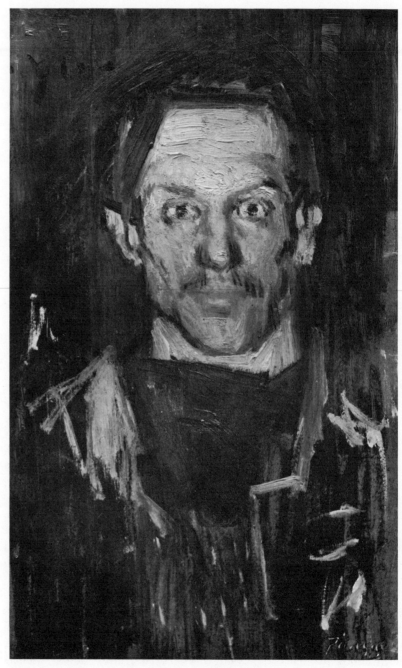

Self-portrait, Paris, winter 1901, oil on canvas, 81 x 60 cm. Musée Picasso, Paris. Cliché des Musées Nationaux, Paris. © SPADEM, Paris / VAGA, New York

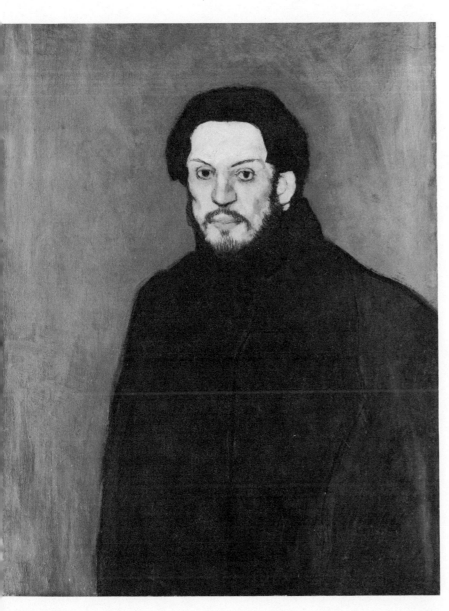

Self-portrait, 1901, oil on cardboard, 54 x 31.8 cm. Private collection, New York

by the rich colors and rough surfaces of the *Yo Picasso*. The dynamism which characterized his second depiction has vanished too, while the blue halo which emanated from his head in that picture has expanded to tinge his whole world with blue. This December image favors cold blue-and-black colors, applied in thin, flat, almost anemic patches, through which we catch glimpses of the bare canvas. The artist has further emphasized his new asceticism by enclosing his silhouette within the constricting confines of a heavy black line and the impasto facial treatment of the *Yo Picasso* has given way to long, dark streakings along the cheeks which emphasize his thin face and grim expression.

The blue period, ushered in by the later portrait, lasted until mid 1904. The enigma of the sudden appearance and long duration of this style has fascinated art critics and psychiatrists alike, and nearly everyone who has written about Picasso has offered his own solution for the blue mystery. The present writer is no exception. In suggesting that the blue phase can best be understood as an expression of the artist's dilemma about growing up and separating from his family, I do not mean to adopt a simplistic solution, nor one which ignores other causes. Such style changes always have several causes and always bear the stamp of the artist's own period and cultural environment. No attempt has been made here to weigh the influence of various nineteenth-century (and earlier) artists who affected the development of Picasso's blue-period style, because that problem has been dealt with exhaustively by other writers. Sir Anthony Blunt and Phoebe Pool, among the most recent critics to study Picasso's formative years, discuss the impact of no fewer than two dozen painters and half-a-dozen literary figures on the formation of Picasso's blue style; the interested reader is referred to this work.[1]

As Barr pointed out many years ago, however, none of these external explanations of the blue period is entirely convincing.[2] Apparently Blunt and Pool concur in this judgment, for they invoke several additional causes, especially the material deprivation which Picasso purportedly suffered during 1901–4. His poverty has frequently been cited as a major catalyst for his blue period, although the factual evidence for this allegation seems questionable. The truth is that Picasso was not seriously deprived during these years. Only during the few months the artist spent with Max Jacob on his third visit to Paris, in late 1902, did he really live precariously. By that time the blue period was firmly established. During the months of its formation, in Paris in 1901, Picasso received a regular monthly stipend and free lodgings in exchange for his artistic output. Whenever he stayed in Barcelona during these years, he apparently lived with his parents. It is doubtful that he paid for room and board. He shared Barcelona studio space with various artist friends, again apparently rent free. Whether he also cadged art supplies from them or obtained them primarily from his father, we are not told, but he did have enough canvas, oil paints, and so forth, to complete a great many important works. The only

ime he seriously lacked materials was during that one brief 1902 Paris inter-
ude. He even had an arrangement with a Barcelona tailor, Soler, to exchange
aintings and drawings of the Soler family for suits, and Sabartés specifically
mentions that Picasso dressed rather elegantly in 1902, going about with a
walking stick, pegged trousers, and fancy vests.[3]

In short, the stories about Picasso's suffering from poverty during these
ears seem grossly exaggerated. He was not successful, but he was not living
 more deprived life than he had during the period just preceding it. Monet,
Renoir, Pissarro, and Sisley suffered far more severe deprivations during the
ears when they brought impressionism into being, yet they turned out the
unniest canvases imaginable. Those stories about Picasso's deprivation form
nother chapter in his personal mythology. If he did not create these legends
imself, he did nothing to correct this misimpression. He certainly suffered
during his blue period, but his misery was seldom if ever triggered or even
ppreciably aggravated by his material circumstances.

Picasso's blue-period pictures illustrate an important chapter in his life,
evealing the story of his desperate attempts to free himself from the ties
which bound him to his parents and to Barcelona. His early experiences had
eft him ill-equipped to function independently; throughout childhood and
dolescence, he had collapsed whenever he was suddenly deprived of regular
ontact with an idealized caretaker. His father served as such a symbiotic
partner until the boy rebelled when the father's limitations became too galling
o him. In 1901, however, Picasso was by no means ready to relinquish the
upport he gained from the more attenuated relationship he continued to
njoy with Don José. Between October 1900 and April 1904, Picasso made
our trips from Barcelona to Paris, but he could not make the visits last, and
hree times he crept back to Barcelona defeated by his inability to maintain
n independent life. Only after he had repeatedly relived his separation prob-
ems in reality (the Paris trips) and symbolically (through his art) could he
ever the ties binding him to Barcelona, stay in Paris, and become a permanent
French resident, though never a naturalized citizen. France drew Picasso
ike a magnet, yet the total amount of time he spent there during his first
hree visits could not have been more than eleven months and may have been
loser to nine. Except for a brief stay in Madrid in early 1901, he spent the
emainder of these four years in Barcelona. Because Picasso moved about
o restlessly, the chronology of his life and works during these years has never
een reconstructed with total reliability.

During the eight or nine months of 1900 preceding his maiden trip to
Paris, Picasso shared a Barcelona studio with Carlos Casagemas. Picasso must
lready have been restive, because he produced less than usual during these
months. Just before his departure for Paris, he revived, to execute a brilliant
eries of pastels of the bullfight. They were carried out in the richest saturated
colors; in them one senses the heat and light of Barcelona's summer sun.

They suggest a Spain as wildly colorful as Bizet's *Carmen* would imply. Apparently they were created expressly to dazzle the French market, because Picasso took them with him to Paris and promptly sold three to the art dealer Berthe Weil. Daix and Boudaille consider these pastels evidence of a new maturity and advance in Picasso's work.[4]

In October, Pallarés, Casagemas, and Picasso set off for Paris. In the Ruiz household, this trip had been preceded by months of haggling over its advisability. In retrospect, Picasso pictured his mother as silent but supportive, while his father advanced all the sensible arguments against this plan. He wanted Picasso to complete his art education, because he knew he could secure his son a good teaching position through his influence, once Pablo had the proper credentials. In the end, the family yielded and paid Picasso's fare to Paris at great personal financial sacrifice. Once in Paris, Picasso and Casagemas were able to take over a furnished studio being vacated by their countryman Isidro Nonell.[5]

Within a few days of his arrival, Picasso not only had sold the three bull-fight scenes to Berthe Weil, but had been introduced by her to a wealthy Catalan industrialist, Petrus Mañach. Interested in becoming an art dealer and impressed with Picasso's talent, Mañach immediately offered the young man 150 francs per month for all the work he produced. Picasso accepted and so began his Paris stay with some measure of financial security.

He responded to the sophisticated, emancipating atmosphere of Paris with an excitement so intense that it still seems to vibrate from the paintings and drawings he executed in his first few months there. As John Richardson points out, Picasso almost instantly managed

> to acquaint himself with the latest developments in French art. The Impressionists, Steinlen, Toulouse-Lautrec, van Gogh, Gauguin, the "Nabis," all had something different to offer him. He also devoured everything he saw in the Louvre. This artistic gorging resulted in a succession of violent oscillations in style and subject (1900–1901). Picasso first lightened his palette, then brightened it and ultimately allowed it to become pervaded by the color blue. He tried Impressionist brushwork, then a divisionist technique and finally composed his pictures out of simplified silhouettes like Gauguin.[6]

But far more than the art scene amazed Picasso; the sexual freedom of the Parisians must have left him breathless. He celebrated his emancipation immediately in a series of portrayals of lovers locked in passionate embraces. In the most intense of these, the lovers seem almost to fuse together in their urgency, and the large size of the man lends a rather brutish air to his sexuality. The work is loosely, lightly painted, almost as though Picasso worked with the same feverishness the lovers express; all is reduced to simple, large shapes, with the big bed featured prominently in the background.[7]

The glittery entertainments of Paris also fascinated the young provincial, and he recorded Lautrecian scenes of can-can girls, exotic Japanese dancers, and a sparkling Pierrot and Columbine, all dramatically illuminated by the eerie gleam of the new electric lights.

A series of quick sketches of hard-faced prostitutes suggests that Picasso sampled other facets of Parisian life as well. One little caricature shows Picasso and Casagemas in an encounter with a pretty young lady, labeled "Rosita" (Z., XXI, 143). Picasso, though ridiculously garbed in a big-brimmed hat, looks prosperous and pleased; he makes expansive gestures. Poor Casagemas, by contrast, looks more seedy and downcast than ever; the way Picasso blackened Casagemas's eye socket and nose tip makes him seem sickly and exhausted.

The diagnostic quality of this sketch of Casegemas was all too accurate; he had conceived a hopeless attachment to a young Parisienne who did not return his affection. He no longer studied or painted, but only drank, brooded, and muttered about suicide. Picasso grew frightened, most likely because he knew about a previous suicide attempt Casegemas had made in Barcelona. To prevent a repetition, Picasso maintained almost constant vigilance.[8] But nothing helped; Casegemas grew steadily more despondent, and Picasso finally hesitated to leave his side even to visit the Louvre. According to Sabartés, as the holiday season approached, Picasso decided to take Casegemas, via Barcelona, to Málaga, where the Ruiz family planned to spend the Christmas season, in the hope that the sunshine and holiday atmosphere of Andalusia would restore him. Whether it was really Casagemas's condition which motivated Picasso's return to Spain is far from clear. His restless period had begun, and for the next several years he was driven back and forth between Spain and France by forces within himself which gave him no peace. In any case, he probably did not have to leave Paris for financial reasons; his arrangement with Mañach took care of basic expenses, and this informal contract continued after Picasso returned to Spain.[9]

The holiday in Málaga proved disastrous. Picasso quarreled with his family and relatives, who disapproved of his new Bohemian style of dress and his long, unkempt hair; furthermore, the change of scenery did Casagemas no good. After following him on a dizzying round of debauchery, Picasso abandoned him and fled alone to Madrid. Casagemas, freed from his guardian, returned to Paris, where he committed suicide on February 17, 1901, in the presence of his beloved and of Pallarés and Manolo (the latter a Barcelona sculptor and friend of Picasso's).[10]

In Madrid, Picasso made his own way, presumably supported by his stipend from Mañach. Soon after he arrived, Picasso ran into several members of the old Four Cats artistic circle, who also had moved to Madrid. Along with his writer friend, Francisco de Assis Soler, Picasso founded a literary review, *Arte Joven* (Young Art), for which he served as art editor. Five issues of this bitingly avant-garde little magazine appeared before it folded for lack of funds in June 1901. Picasso illustrated each issue copiously with works from

his Paris sketchbooks, supplemented by many new sketches created expressly for the magazine; several of the latter showed himself, either alone or with writers associated in the venture. In the most ironic of them, Picasso and his fellow artists are depicted out-of-doors on a winter night. All bundled up against the night chill, they seem an ill-assorted lot, reminding one more of a gathering of a Mafia clan down on its luck than of a group of artists (Z., I, 36). Two naturalistic self-portraits show Picasso looking thin, anxious, and unsure of himself, but defiantly retaining the big hat and long hair which his relatives found so objectionable (Z., I, 45). In an advertisement in *Arte Joven* (for another art magazine they hoped to found) showing the artist with Soler, Picasso glamorized himself a bit; however, the days of the highly romanticized, self-aggrandizing self-portraits were behind him. In Madrid in 1901, Picasso faced the hard world of reality. His self-portraits reveal that he looked toward the future with grim fortitude.

It was in Madrid that Picasso first began to use the brighter palette and divisionist brush strokes to which Richardson alludes. More pertinent to this study is the new savagery apparent in his Madrid paintings and drawings. He took a bitter, unsympathetic view of society, whether he studied the elegant or the down and out. Although incidental portrayals of men were not terribly sympathetic, it was really against women that Picasso directed his rage. A whole series of paintings of prostitutes of various ages, from young, coolly beautiful girls to tough, beefy madams show this mood. Regardless of age or condition, these harlots are all depicted as highly successful at their trade; Picasso dressed them for an evening on the town or at the theater in picture hats trimmed with roses and feathers, and in long, full skirts, covered with sequins or swan's down. These costumes allow full play for Picasso's new colors and free brush work, while the softness of the women's skirts contrasts marvelously with their hard little doll-like faces.

Prostitutes made popular heroines for many fin-de-siècle novels and plays, and they appeared just as often in the paintings of the period. No other artist, however, portrays them with the savagery which Picasso showed in early 1901. Lautrec, who probably served as Picasso's mentor for these works, and even Rouault, sympathized with the poor creatures they painted; moreover, their women never prospered in their profession as Picasso's did; rather, they were ground down by their dreadful lives. Picasso's ladies feed off men, survive, and prosper; painted without mercy, they display the same unsympathetic mood in which they were created (Z., I, 32, 42; XXI, 208, 210–12). They are the spiritual ancestors of a whole series of monster women who people Picasso's later oeuvre. The one female from this Madrid series who seems more a victim than a predator is a hopelessly intoxicated woman in a bar (Z., XXI, 260–61)

Without knowing more about Picasso's exact circumstances during these months, it is difficult to understand what unleashed this torrent of ill will toward women. Daix and Boudaille suggest that Picasso's misogyny resulted from the

Woman in a Plumed Hat, 1901, oil on canvas, 46.5 x 38.5 cm. Marion Koogler McNay Art Institute, San Antonio, Texas

circumstances surrounding Casagemas's suicide.[11] One cannot rule out the
possibility that Picasso was projecting his own guilt about Casagemas onto
women, raging at them rather than experiencing self-reproaches; it seems more
likely, however, that Casagemas's ill-treatment at the hands of a woman simply
served as an excuse for Picasso to be righteously indignant, and to express his
own underlying hostility. One wonders what happened between Picasso and
his mother during that holiday season in Málaga. The family quarrel must
have been severe, but, as usual, we learn only about the father's reaction
according to Penrose (who must have been informed by the artist himself
because this material is not in Sabartés's account), when Don José recognized
that Picasso had broken loose and that his own role as the guiding parent had
come to an end, "he relapsed into old age, disillusioned and sad."[12]

Around March 1901, Picasso returned to Barcelona. He must have patched
things up with his parents, because he lived at home. He saw a great deal of
his old friends again, and Sabartés describes him as unusually excited and ani
mated, stirring up his artist friends with his grand visions of the world.[13] This
elation is not reflected in his paintings, where his hard mood continued; even
his sister Lola was painted with a tough look and veiled glance (Z., XXI, 230).
He did a set of handsome views of the bullfight, daring in their Degas-like
perspective and in their bold, free patches of color, but savage in feeling. The
most masterful of these, the *Bullfight* (Z., VI, 378), features a close-up view
of two dead horses piled one on top of the other. The white horse on top lies
on its back, its head thrown back in its last agony. It has suffered multiple
gorings, and its entrails spill out of the lower left center to the very border of
the picture. Behind the horse's body, we glimpse the matador and his assistant
warily approaching the frenzied bull. Both beautiful and terrible, the dead
horse has a strange nobility. Later in his career, Picasso often used the gored
horse as a symbol for a woman, particularly for his first wife. Perhaps this is
the first instance of the horse-woman equation in his art, as well as the first in
which he so emphasizes the bull's savagery.

In Barcelona, Picasso discontinued his courtesan series, but his portrayal
of women remained quite unsympathetic. The *Old Woman with Jewels* (Z.,
VI, 389), whose setting and clothing seem half-dissolved into a brilliant
shower of vivid pointillist dots, leers out of her framework with a grin as
triumphantly wicked as one of Goya's creatures. *The Dwarf Dancer* (Z., I, 66),
sometimes compared with Velazquez's portraits of court dwarfs, totally lacks
the helpless, pathetic feeling which makes us empathize with the latter's mis
shapen creatures. Picasso's little dancer is tough and defiant; she stands toe-
to-toe with us at the edge of the picture. One again, we are jolted by the con
trast between the soft, rich cerise of her costume and her hard, distorted face
bizarrely accentuated by repeated gleams of this same cerise.

In a more sympathetic vein, Picasso painted the wistful *Child with a Doll*
and a watercolor *Portrait of Julio Gonzales* which emphasized the latter'

melancholy (Z., XXI, 189). Both of these pictures seem like harbingers of the coming blue period, foretelling a change in mood which became apparent only several months later.

Whether on his own initiative or in response to urgings from Mañach, Picasso suddenly returned to Paris around the end of April 1901. One wonders whether thoughts of Paris led him to sketch his parody of the most famous of all courteasans—Manet's *Olympia* (Z., VI, 343). In Picasso's drawing, the black serving maid has been transformed into the heroine of the piece, and she is stretched out on the bed, dusky, nude, and ample; a thin little naked Picasso sits beside her, resolutely not glancing at her. Behind her, his friend Sebastian Junyer, equally thin, unprepossessing, and unclothed, lifts aloft a bowl of fruit in a pose reminiscent of Titian's *Salomé.* A closely related drawing shows Picasso fully clothed but seated on a bed where a nude stretches out on her stomach while he rests his hand on her buttock (Z., XXI, 283). These little pictures mark the beginning of his interest in the creation of art-after-art. More than half a century later, Picasso would become fascinated with that other great *succès-de-scandale* by Manet, *Picnic on the Grass,* which would serve as the inspiration for over two hundred reinterpretations by Picasso.

The artist apparently embarked on his second trip to Paris without encountering much opposition from his family. Maybe he paid for the trip with his salary or with an advance from Mañach. Penrose's statement that the senior Ruiz surrendered his authority after the quarrel in Málaga may well be correct. At least it seems significant that it was in Barcelona in 1901 that Picasso first began signing his pictures *consistently* with only his mother's maiden name. Until his first Paris visit, the artist had signed his canvases "P. Ruiz Picasso." In Paris, and afterward in Madrid, he had wavered between this signature, "P. R. Picasso," and plain "Picasso." Sabartés, who misdates Picasso's change of signature to late 1898, implies that the artist did it as a mark of affection for his more outgoing mother. Instead, the change may mark Picasso's final disappointment with his father, a spiritual denial of affinity with this man who had collapsed and abdicated his authority.[14] On a more practical level, one must admire the soundness of the artist's decision to change his name. One wonders whether he would have become quite as famous with the common name of Pablo Ruiz as with the more melodious and unusual Pablo Picasso!

Picasso recorded his second arrival in Paris (this time with Andeu Bonsons, who had not been a particularly close friend) in a charming little cartoon which one might label "The Landing of the Greenhorns" (Z., VI, 342). Picasso shows himself so bundled up that one can see only his eyes, round and wide with fright and wonder. In Paris he seems to have had little further contact with Bonsons. He moved in with Mañach, taking over one of the industrialist's two rooms as a studio-living space. Mañach arranged for the art dealer, Ambroise Vollard, to give a joint exhibit for Picasso and an older Basque artist, Itirrino, at the end of June 1901. The catalogue for this show has sur-

vived; Daix and Boudaille made a careful attempt to match titles to pictures
and their detective work shows that, although Picasso brought some works fo
the exhibit from Barcelona, he must have painted many of the sixty painting
in the exhibit during the one month he spent in Paris before the opening o
the show.[15] Again, the Parisian atmosphere exerted its healing, exhilaratin
effect on Picasso; his anger softened, and he was fantastically productive. H
started off with a second series of can-can dancers and entertainers. As sum
mer approached, he moved outdoors to paint joyful scenes of children playin
and dancing in the park and of fashionably garbed ladies at the Auteuil races
A dazzling series of flower still lifes also dates from these busy weeks. In a
drawing, Picasso humorously depicted himself ready for outdoor work. H
wears sturdy high shoes, plus fours, and the inevitable broad-brimmed hat. H
is loaded down with every sort of painting equipment which pokes out from
under his arms and fills his hands and pockets (Z., XXI, 250). His serious
sad face strikes a discordant note in this otherwise funny drawing.

Although Picasso still painted an occasional tough harlot, such works wer
more than balanced by sympathetic portrayals of tender mothers and hand
some little girls. In Paris, Picasso felt free to work from the nude, and he
created canvases ranging from the gentle portrayal of a sleeping girl (Z., I
106) to the daring picture of a nude prostitute throwing open her elegant rob
to reveal her flaccid body, clad only in stockings (Z., I, 48). He celebrated hi
liberation from the repressive Spanish sexual mores more directly, too, as in the
caricatured self-portrait showing him suave, worldly, and impeccably garbe
in tails and top hat. Behind him, bare-breasted harlots flaunt their charms, bu
he ignores them to turn his self-satisfied gaze on the spectator (Z., XXI, 251)
A related drawing (Z., XXI, 253) shows him seated next to a young lady
while in the corner the Devil mockingly bows to the viewer.

In the autumn, Picasso's mood changed abruptly, and his pleasure in Pari
vanished. During the months which followed Casagemas's suicide, there ha
been no evidence in Picasso's work that he was brooding over this event, eve
though Casagemas had lived in the same building the painter now occupied
and had shot himself in the café a few doors away.[16] Suddenly Picasso grev
preoccupied with Casagemas's death. Although he had not attended his friend'
funeral nor seen his corpse, Picasso did a series of paintings and drawing
showing Casagemas in his coffin, the wound in his temple realistically depicted
The artist kept three of these paintings in his own collection, which suggest
that they had a special meaning for him (Z., XXI, 177–79). He capped the
series with an ambitious, obscure allegorical depiction of Casagemas's funera
Evocation (Z., I, 55). The complexity of this work indicates the strong feeling
which accompanied it.[17] Picasso probably was already upset before he bega
brooding about his role in Casagemas's death. The artist's lifelong readiness t
assume that his thoughts and actions possess magical destructive powers mad
him, however, particularly vulnerable to such an obsession. This tragedy als

confirmed another secret terror which had haunted Picasso since childhood: to him, separation (from the father) always had seemed like death in miniature. Casagemas's death had demonstrated that such apprehensions could become reality. After all, Casagemas had admired Picasso, had been persuaded to accompany him first to Paris, then to Málaga, where Picasso, disgusted, had abruptly abandoned him to his fate; and Casagemas had killed himself soon after! Manolo claimed, moreover, that Casagemas's mother had died of shock upon being informed of her son's suicide. If this information is correct, Picasso may have considered himself responsible for her death too.[18]

The pictures showing Casagemas in his coffin marked a transition not only in Picasso's mood, but in his style and subject matter as well. He dropped the free pointillist brushwork he had been using in favor of painting large areas of fused color. The silhouettes of figures received more emphasis, with contours heavily outlined in black. His rich, proto-fauvist palette became muted and gradually replaced by a dominant blue which became more and more pervasive until even skin tones were rendered in blues. As the fall deepened into winter, Picasso's blues also deepened, and his painted surfaces became thinner and thinner, until all traces of the rich, van Gogh–like surfaces had disappeared. Gone, too, were the lively children and gay street scenes of his happy summertime. They were replaced by pensive, solitary Harlequins and Pierrots, by lonely women drinkers, and above all, by sad, sentimentalized mothers who clung hungrily to their babies (Z., I, 107–10, 114). A crayon and wash self-portrait from the autumn shows that Picasso recognized his own change in mood. He seems older, sadder, and more intense than in those humorous depictions of himself of the previous summer.

In October, Jaime Sabartés and Mateu F. de Soto joined Picasso in Paris. Sabartés remarks that he came to Paris simply to be near his idol and nowhere indicates that Picasso urged him to come. Still, Sabartés was always so responsive to Picasso's moods that one wonders whether the latter sent some sort of distress signal to the good genie back in Barcelona. In any case, once in Paris, the friends settled near Picasso and spent much of their time with him; Sabartés even describes staying with Picasso while he painted. This suggests that the artist was terribly upset, because time spent at work was usually the one time he could tolerate solitude. After the first weeks, Soto evidently moved into Picasso's minute quarters, sleeping on the studio floor, gypsy style. Sabartés often joined them for lunch, and the three friends spent every evening at a favorite café, often with other members of the Spanish artists' colony in Paris. Sabartés describes how difficult the friends found it to separate at the end of such evenings. As a result, after Picasso and Soto had walked Sabartés home, he would accompany them back to Picasso's, and so on, until they finally parted in exhaustion or until Sabartés joined Soto on Picasso's studio floor for a cold night's sleep.[19]

During these months, Picasso painted two sets of portraits of Sabartés and

Soto, which enable us to measure the rapid advance of the blue period between the late October date of the first set and the late December date of the second. The earlier set remains relatively naturalistic, except for the bluish hue. Only Sabartés's flattened, mannered pose, as he moons alone in a café while dejectedly caressing a huge beer stein, reveals the sentimental sadness which would envelop the full-blown blue-period works (Z., I, 97). Soto, shown carving a small sculpture, concentrates peacefully on his work. Above his head one glimpses a representation of the lower portion of *The Mourners*. The shrouded form of Casagemas, the only element of the painting reproduced, seemingly casts a funereal pall over Soto and his creative efforts (Z., I, 94). The second set of portraits, still more reminiscent of Gauguin, with their simplification and thinly applied paint, shows Picasso's friends sober, reflective, and aged (Z., I, 86, 87). Sabartés could be a man in his forties, to judge from this portrait. Picasso's blue atmosphere has devoured his friends' youth, as it had destroyed the artist's own delight with Paris. Except for the faint reddish gleams still visible on their bluish lips, the young men are portrayed totally in blues.

The arrival of Picasso's friends temporarily improved his spirits, but his more cheerful mood proved transient. As winter approached, he grew increasingly morose, restless, and withdrawn. Finally he became so preoccupied that he stopped working altogether. Friction had developed between Picasso and his employer, Mañach. Sabartés hints strongly that Mañach had conceived an unnatural affection for his young protégé, but this is never quite spelled out.[2] Picasso maintained an absolute silence concerning Mañach, so we have only Sabartés's veiled accounts to guide us. It seems perfectly possible that Picasso really had formed an idealizing partnership with Mañach. This might explain why he was able to live apart from his parents for several months and remain productive and happy. His disenchantment when his protector revealed himself as a would-be seducer might also help to explain Picasso's abrupt change of mood in the autumn of 1901. As an adolescent, Picasso had suffered a profound disappointment when he realized that Don José was merely ordinary, so we can imagine that the artist would have experienced a still more violent wrench if he idealized Mañach, only to learn that the latter was less interested in his genius than in his body. This attitude would have jolted Picasso all the more severely because it repeated his painful childhood experience with a mother who delighted more in his great beauty than his great gifts.

Of course, we cannot rule out the alternative possibility that Picasso may have regarded his relationship with Mañach primarily as a business partnership and that the artist was already getting depressed about being separated from his family before the industrialist aggravated this dark mood by making advances. We simply lack enough evidence to choose among various possible reconstructions of the events. One thing seems quite certain: Mañach's proposals threatened Picasso in a unique manner. At no other time was Picasso

Pedro Mañach, 1901, oil on canvas, 105.5 x 67 cm. National Gallery of Art, Washington. Chester Dale Collection, 1962

Le gourmet, 1901, oil on canvas, 92.8
x 68.3 cm. National Gallery of Art,
Washington. Chester Dale Collec-
tion, 1962

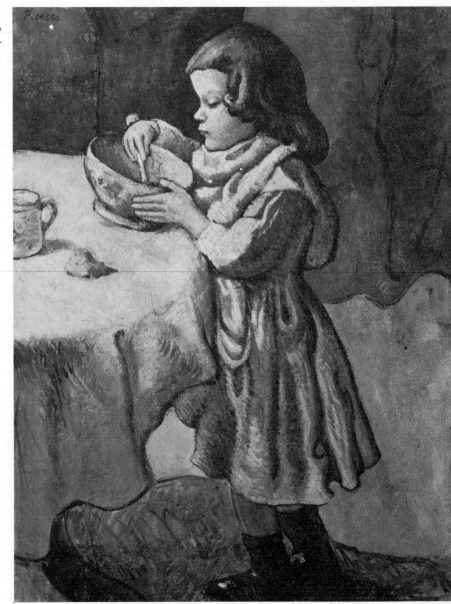

ever nonplussed by the necessity of fending off an infatuated homosexual associate. In 1902 he shared minute living quarters with Max Jacob without apparent discomfort. Later, Picasso parried Jean Cocteau's sustained attempts to seduce him with little apparent reaction other than contemptuous tolerance. The fact that Mañach's admiration threatened Picasso so much indicates that their relationship may have been especially important to him. In the spring of 1901, Picasso had painted Mañach's portrait, using pure van Gogh yellows, reds, and whites, thickly brushed. Despite the cheerful colors, Mañach's silhouette looms up menacingly against the abstract background, outlined by a heavy, choppy, black line. Whether Picasso was conscious of it or not when he created this work, he already regarded the industrialist as an evil person. After viewing this painting, one is not surprised that the relationship ended badly.

If one studies the content of Picasso's work from the time he painted the Casagemas series until the end of 1901, a rather clear picture of the development of his depression emerges. Two pictures depicting young children provide important clues. *Le gourmet* and *The Child with a Dove* both feature his new simplified style and both depict toddlers in situations suggesting nostalgia for home and for the gratification of infantile wishes. *Le gourmet* shows a small child cleaning the bottom of a big bowl with his spoon. He performs with such intensity and concentration that he is oblivious to all else. Like the artist who created him, this is a child of strong appetites and strong motivations. The manner in which Picasso caused rhythmic art-nouveau lines to converge on the child's figure adds to the impression of intensity. The other picture, *The Child with a Dove*, depicts a moment of quiet loneliness. A small child, silhouetted against an abstract two-color background, hugs a dove to his bosom with a wistful, tender expression. The way the child clings to the pigeon reminds one of Picasso clutching one of Don José's birds to comfort himself when he had to separate from his father and enter the classroom in Málaga. In the *Dove* picture, the linear movement of *Le gourmet* is totally missing; Picasso uses large, simple shapes with heavy outlines that give the painting a quiet, timeless quality and emphasize the child's passivity. Only the rich surface of the painting echoes the message of the content. The brushwork invites the touch, just as the child seems to long to be cuddled.[21]

During the final weeks of this Paris stay, Picasso became more and more preoccupied with the female figure. A group of solitary, despairing women drinkers (Z., I, 96, 98–100) gave way to a final series of drooping, Madonna-like mothers who seem to fuse with the infants they press to their bosoms (Z., I, 109, 110, 115). When one pieces all these content clues together, they suggest that the genesis of the blue period lay in Picasso's inability to break away from his family despite his wish to lead an independent adult existence. Whether it was solely a projection of his own feelings or was based on reports from Barcelona, Picasso evidently believed that his mother was depressed over his absence and that he had to return to her.[22] The fact that he never

Plate 1

resolved his earlier problems with his mother following Lola's birth must have made trying to separate from her in maturity much more difficult. It cannot be a coincidence that none of the blue or rose period pictures depict tender interchanges between mothers and school-age children. Only infants and toddlers nestle close to their mothers (Z., I, 170, 175, 282). This contrasts with numerous examples from these same years showing boys who seem as old as ten or eleven cuddling close to fatherly men (Z., I, 170, 175, 282). Such repeated pictorial evidence corroborates the theory I presented earlier that Picasso turned to his father after he rebuffed his mother and that his school phobia and subsequent separation problems were the open wounds resulting from this unhealed breach with her. Consequently, he could no more tolerate living independently as a twenty-year-old in Paris than he had as a sixteen-year-old in Madrid. No wonder he terminated his first three visits to Paris around Christmas time. Holidays make everyone nostalgic, and in Picasso's case, the holiday had a double significance: Lola's birth in 1884 had coincided both with Christmas and with that terrible earthquake.

Picasso's decision to return to Barcelona was reached by the end of December 1901. Making this decision did not end his ambivalence or his agitation, and the last and bluest pictures he painted in Paris were the two portraits of his fellow-Barcelonans, Sabartés and de Soto, and the self-portrait described at the beginning of this chapter. Picasso kept all three of these paintings in his own collection.

Finally, Picasso's father scraped together the train fare his son had requested; when it arrived, Picasso left immediately for Barcelona. He apparently had terminated his stipend arrangement with Mañach on or before December 1, 1901, because the artist carried these last three portraits back to Barcelona with him, and probably some other canvases as well. Mañach did retain control of some works painted earlier in 1900 and 1901 which remained unsold at the time; he showed some of them at an exhibit at Berthe Weil's in April 1902.[23]

Picasso's return to Barcelona and to his family brought no magical cure for his separation problems. His restlessness continued, and 1902 was, by Picasso's standards, not very productive. He spent a lot of time socializing, partly because he wanted to avoid going home until his parents were asleep. Nearly every evening, he visited cabarets or cafés with friends, always parting from them reluctantly:

> He would continue the conversation, begun heaven knows when, with anyone who cared to keep him company, and at the very last moment, in order to postpone the separation, he would accompany the friend back to the Rambla or stop with some friend whom he might have met on his way or found in the corner of the Rambla and the Plaza de Cataluña.[24]

Picasso was so loath to be alone that he invited Sabartés, who had returned to Barcelona shortly after him, to come to his studio and sit with him in silence while he painted.

In his major canvases, Picasso continued the theme of the lonely blue ladies he had begun the previous autumn in Paris. He painted fewer indigent mothers in 1902, focusing on solitary destitutes, prostitutes, and drinkers. These women seem still more mannered, boneless, and El Greco–like than their sisters of 1901. They are all barefoot and wear vaguely classical costumes, often with hoods and mantles. The soft folds of these draperies, accentuated by broad brushstrokes, reinforce the limpness of their emaciated forms. Could it be that the ferocious women of the year before served to disavow a more frightening possibility, that of his independence crushing his mother? These women appear defeated by life; they slump or crouch in almost fetal positions, or turn their backs on the viewer, as though withdrawing from a reality too painful to contemplate. In several of these canvases, the almost monochrome blue of 1901 is diluted by the addition of a sickly yellow green (Z., I, 105, 119, 132, 133; Z., VI, 449).

Some of these subjects derived from studies Picasso had made at the St. Lazare Hospital for female prisoners suffering from venereal infections. The almost maudlin *Two Sisters* was based on a meeting between a nun and her less fortunate sister, which Picasso had witnessed at St. Lazare (Z., I, 163). Although this work seems rather contrived, Picasso was enthusiastic about it and discussed his preparatory drawing for it in a letter to Max Jacob.[25] The conception of womankind as either wanton or saintly implicit in this canvas is one which appeals to many Latin males, and Picasso seemed particularly infected with it. His partiality for painting so many Madonna-mothers suggests that he had never resolved his own early overidealization of his mother. The young child typically overestimates the capacities and virtues of his parents, while simultaneously denying the possibility that they enjoy a sexual relationship with one another. Gradually, as part of the painful process of growing up, the child relinquishes these illusions to recognize parental license, failures, and limitations. Picasso probably never accomplished this necessary disillusionment because his relationship to his mother was permanently disrupted by the birth of his baby sister when he was just three. Once he had recovered from his acute reaction to the mother's sudden shift of interest from him to Lola, Pablo kept himself rather aloof from his mother, investing his affection primarily in the father. As the boy matured, he gradually forgot (repressed) the intensity of his rage toward the mother, retaining only that idealized conception of her which he carefully refrained from testing against reality. Despite the contrary evidence implicit in Picasso's stormy heterosexual history, all of his biographers have accepted the artist's selective conception of his mother and have presented that same vague bland picture of Doña Maria as a cheerful, stable, supportive, "brick" of a mother. In conversations with Gilot, Picasso presented quite a

different view of his mother as a woman so controlling that he finally fled Spain to escape her tyranny. By the time the artist formed his liaison with Gilot, however, his mother had been dead for several years, and he might have felt more comfortable about assessing her personality realistically than he apparently did during her lifetime.[26]

Picasso's second major canvas of 1902, *La soupe* (Z., I, 131), depicts still another of those limp, idealized mothers; this one appears to be pregnant and almost too feeble and depressed to move. She wearily offers a bowl of soup to her child of about three, who runs eagerly toward it. Not only does this picture seem as mannered and artificial as *The Two Sisters,* but the nun's pose in that work is almost identical to the mother's in *La soupe.* In a variant drawing for *The Two Sisters,* hitherto kept unpublished in the artist's private collection, a pregant woman identical to the mother of *La soupe* replaces the Sister of Mercy, an interchange which offers further evidence for the hypothesis that Picasso preferred to think of his mother as such a virginal figure. Of course, this apparent equation of mother and Madonna may represent a partial expression of a still more grandiose phantasy: the artist's underlying identification with Christ. Jesus was immaculately conceived of a virgin who, like the nun, had dedicated her life to chastity and the service of God. Picasso's earlier painting *The Flight into Egypt* also suggested such a Christ identification, and still other instances of it will be noted in his later works.

On another level, the fact that the depressed mother of *La soupe* rouses herself to provide nourishment for her child also applied to Picasso's personal situation. This and other pictorial evidence indicate that he believed his mother was depressed and that only nourishing or caring for her child (her special child Picasso) could help her. Still another study for *La soupe* depicts a man offering food to a woman, revealing that the artist sensed that there were gratifications involved for both parties in his continued dependence.

Several small contemporary watercolors and drawings by Picasso feature lively nudes who contrast vividly with the wan ladies appearing in his more formal canvases of 1902. The generalized features of the latter suggest that they were conjured up from the artist's phantasies or memories, rather than adopted from the faces of living models. The small nudes seem much more specific; maybe they were sketched after some of the fresher girls available in Barcelona bordellos. Two of the most charming of these drawings were retained in the artist's own collection, unknown until recently. A particularly luscious girl bears the scrawled vulgarism, "Cuando tengas ganas de joder, jode." ("When you are in the mood to screw, screw.") Until he left home for good, Picasso continued to find his female companionship in the bordellos, or in transient arrangements with promiscuous girls. Not until he finally settled in Paris was the artist able to form a more durable relationship with a girl who offered him intellectual, as well as sexual, gratifications. Gradually, he seemed to free himself of the Madonna-whore dichotomization of women, although, in his lifelong

tendency to divide them into "goddesses or doormats," he continued, perhaps, to reveal vestiges of his old attitude.

As the summer of 1902 approached, Picasso grew more restive and dissatisfied. He thought about Paris and the enthusiasm his new French friend, the poet Max Jacob, had shown about Picasso's painting. (The two men met because Jacob so admired Picasso's works shown in the Vollard exhibit that he dropped in to meet the artist, beginning a long friendship.) In that same letter to Jacob reproduced by Sabartés, Picasso complained in his faulty French, "I show what I do to my friends the 'artists' here, but they find there is too much soul and not enough form, which is very funny." He enclosed a sketch of himself standing before his beloved bullring, wearing his broad-rimmed hat and pegged trousers, and carrying his walking stick. Probably he wished to impress Max with his elegance, because the latter admired sartorial splendor.

Sebastian Junyer may have comprehended Picasso's new style better than his other Barcelona associates. At least, Picasso drew more affectionate caricatures of Junyer than of anyone else. He always portrayed Junyer by the same set of conventions: small and doll-like, with a high, domed forehead, a mop of curly black hair and a big bushy moustache. Picasso drew him in various glorified roles: as a toreador or as an artist of antiquity, seated toga-clad on a Majorcan rock, surrounded by vaguely Grecian props. In the same escapist vein, Picasso pictured himself on the beach, nude to the waist, imitating the posture of an ancient river god.

Around the time of his twenty-first birthday, Picasso left for Paris again. Always unwilling to undertake this journey alone, this time he persuaded Junyer to accompany him. No biographical source sheds light on how Picasso raised the money for this ticket. Either as they prepared to go or shortly after their arrival, Picasso celebrated their journey in a light-hearted comic-strip sequence depicting Junyer and himself in transit and ending with Junyer presenting himself and his work to the dazzled art dealer Durand-Ruel, who hands over a fat money bag in exchange.

In Paris, Junyer and Picasso evidently separated. (Just what Junyer did and how much Picasso and he saw of one another isn't clear. Junyer must have returned to Barcelona early in 1903, perhaps even with Picasso, because he appears in a number of things executed there during the late spring.) Apparently, Picasso was totally without funds, and he lived precariously. Although Max Jacob was almost as poor, he did have a job and a sleeping room, so he invited Picasso to share his minute quarters. There was only one bed, so they had to sleep in shifts, with Picasso occupying the bed by day and painting at night, while Max slept. In November, Picasso participated in a show at Berthe Weil's, but his new, grim style did not sell. He seems to have worked little, but not necessarily, as Daix and Boudaille suggest, because he could not afford painting materials.[27] To make matters worse, Jacob was fired from his menial job. Whether it really was the grinding poverty which forced Picasso to give

up, or that seasonal restlessness which had overtaken him during the two pre
vious Decembers he had spent in Paris, we do not know, but by January 1903
he had resolved to return to his family. This time, there was no question of get
ting another check from home; he waited in Paris until he had earned the
price of a ticket by selling a painting. Together in their garret, Max and
Picasso dreamed of a better future, and the painter depicted his poet friend
as a great literary light, being accepted into the French Academy. In the fina
sequence of this comic-strip, Max, wearing a Greek toga but carrying an
umbrella, steps forward to receive the laurel crown from Pallas Athena herself

Picasso claims that he had to burn a great number of drawings for fuel on
the last night he spent in Paris. Penrose assumes that "an eloquent part of his
production during these months" was thus sacrificed, and that this explains why
there is so little to show for this third Paris sojourn.[28] This is possible, but Pen
rose always seems loath to believe that Picasso's productivity was as responsive
to his emotional situation as it appears to have been. It is equally likely that
Picasso was too agitated during this Paris visit to accomplish a great deal, and
that he retrospectively exaggerated the number of works he burned. We simply
do not have the facts.

One painting which survives from this trip seems significant as a harbinger
of the direction Picasso's work would take later in 1903. It is the *Mistletoe
Seller* (Z., I, 123), a gouache which depicts an emaciated, angular old man with
a big load of mistletoe, tenderly hugging his small boy helper. The extreme E
Greco–like angularity of this figure would become Picasso's typical mode of fig
ure presentation after mid-1903, when he began to concentrate on painting and
drawing men. One wonders whether this gentle picture of fatherly affection
grew out of Picasso's nostalgia for his father and home during that sad Christ
mas season he spent in Paris.

Soon after he returned to Barcelona at the end of January 1903, Picasso
painted *Barcelona at Night* and *The Roofs of Barcelona* (he never sold the
latter). These two cheerless landscapes leave no doubt that the source of
Picasso's inner blues lay in Barcelona, where he had to face his unresolved
separation problems. *The Roofs of Barcelona* (Z., I, 207), forms a dramatic con
Plate 2 trast with the earlier *The Blue Roofs of Paris* from the spring of 1901, the latter
warm, cheerful and sun filled, despite the blue of its title. From these same week
dates *The Sick Child* (Z., I, 169). Picasso has pushed the destitute mother
right up to the edge of the picture plane so that she and her wan baby directly
confront the viewer, as though pleading for help. She is probably the most
sentimentalized and pitiful of all the blue-period mothers. Yet another Ma
donna figure, she is a *Mater Dolorosa*.

After his last Paris fiasco, Picasso resolved to remain in Barcelona for a
least a year, so that he could accomplish some work, as he wrote Max Jacob
On a deeper level, the artist may have resolved to stay until he had worked
out a solution to his separation problem, because when he left for Paris the

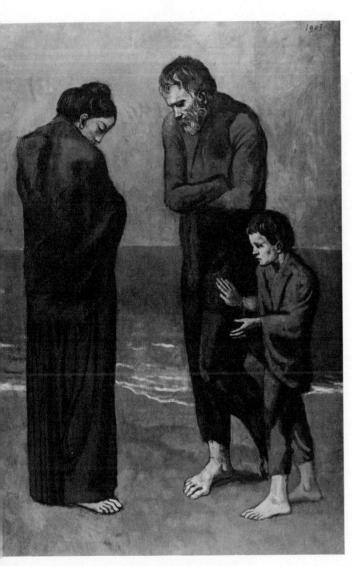

The Tragedy, 1903, oil on wood, 105.4 x 69 cm. National Gallery of Art, Washington. Chester Dale Collection, 1962

next time, fifteen months later, it was forever. Picasso's resolution to "stick it out" in Barcelona had a good effect; he was very creative and productive during 1903. It was the apex of his blue period. The most memorable—and the bluest—of Picasso's blue paintings date from this period. Two of the major oils he painted during the first half of 1903 probably can be understood best as references to the artist's family situation. Toward the end of 1902, he had depicted a number of desolate mothers with their babies, waiting alone by the sea. Now he broadened this theme to include a father. The best of these canvases, *The Tragedy,* shows a mother, father, and pre-adolescent boy standing at the edge of the sea. The parents appear so overcome by grief that they seem divorced from the outer world; their heads are bowed, their arms are folded, their eyes are downcast. Only the bereaved little boy continues to reach out, as he tentatively touches his father with a comforting pat. The death of the painter's little sister Concepción, which Picasso incorrectly remembered as a direct sequel of the voyage to Corunna, may well be the tragedy to which this picture refers. Her loss permanently upset the family balance, since Picasso's father (and perhaps his mother as well) never recovered from this tragedy. Had the little girl lived, she still would have been at home to keep the parents company, since she was six years younger than Picasso.

Although *La vie* has traditionally been interpreted as a depiction of the various roles of women, in the manner of works by Munch and others, it also seems to reflect the artist's personal situation. A large, awkward work, it shows the dead Casagemas, depicted as though alive, but idealized. Clad only in a loin cloth, he stands in the center of his studio. A nude young woman leans against him. Tender and trusting, she puts her head on his shoulder. The center of the picture is occupied by two unframed canvases, stacked vertically against the background wall. The upper canvas shows two sorrowful nudes clinging together for comfort (they probably are both women, although the sex of the more bowed figure is ambiguous). The lower one reveals a nude crouched in a fetal position of dejection. To the right of these canvases stands an older woman in classical garb; she carries a sleeping infant wrapped in her mantle. Tight-lipped and reproachful, she glares at Casagemas, who makes an enigmatic gesture to her, with his index finger slightly pointed. In preliminary studies for this work, Picasso depicted himself nude, but he finally transformed the figure into Casagemas. Perhaps *La vie,* always considered a problem picture by people discussing Picasso's oeuvre, really tells us about Picasso's own dilemma, torn between his desire for a suitable sexual object and his duty toward a sorrowing, unyielding mother who, like the figure in the lower background canvas, might collapse if abandoned. If this is correct, the ambiguous gesture Casagemas makes could be an injunction to the mother to keep her distance and stop interfering with his life.[29]

A number of other works relate to the key work *La vie,* including several studies of the artist alone. These sketches contrast sharply with the idealized

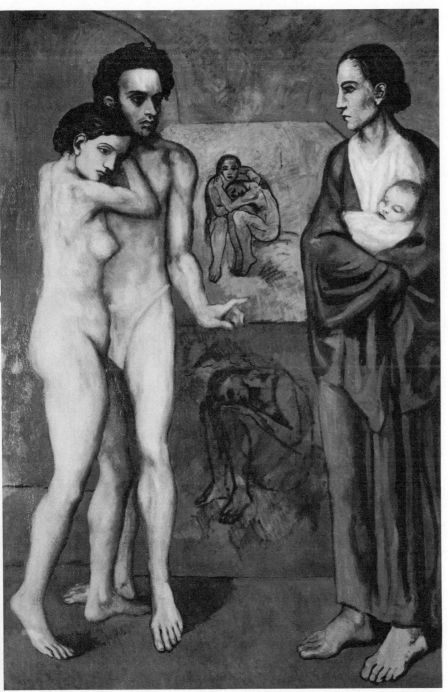

La vie, blue period, oil on canvas, 196.5 x 129.2 cm. The Cleveland Museum of Art. Gift of the Hanna Fund

version of himself which Picasso presented in the more elaborate, nearly final studies. Here he shows himself not as an idealized Grecian nude, but as a realistically naked figure: insignificant, skinny, and vulnerable (Z., VI, 456, 507). *The Embrace,* a gouache repeated in a more extensive pastel version (Z., I, 161, 162), might be a later episode in the lives of the principal characters of *La vie.* The pregnant young woman and her lover, both nude (and rather massive) embrace, burying their faces in one another's shoulders. Their positions suggest that the man either is comforting the woman over her pregnancy, or that both feel guilty because of her condition. The exact meaning of these works is not clear, but they probably also relate to Picasso's guilt and ambivalence about his sexual desires or activities. In the pastel version, the couple's bed looms large in the background. Another drawing possibly related to this series shows a nude young couple seated on the ground, tenderly kissing (Z., VI, 551). The man appears to be a self-portrait of Picasso.

During the months following the completion of *La vie* (probably finished before June 1903), Picasso's mood lightened. He made several portraits of young women who seem more lively and cheerful than their earlier blue-period counterparts and, unlike many of these generalized portrayals, probably depict real people.

In his more outgoing mood, Picasso also painted a number of canvases of friends, including the expressionist portrait of Angel F. de Soto (which seems to prefigure the work of Chaim Soutine) and an allegorical portrayal of Sebastian Junyer (Z., I, 174). Junyer is seated at a café, squeezed into a tight mannerist space. Behind him an emaciated lady of questionable virtue sits sadly holding a little violet-type flower in her mouth. Does she represent the danger of sexual temptations, which might distract the artist? More lightheartedly, Picasso drew Angel de Soto in a similar situation. Characteristically, the debonair Angel seems unruffled by the presence of the luscious blonde who sits beside him, clad only in a picture hat (Z., XXI, 161, dated 1900 by Zervos). Another related caricature, a self-portrait, may be a lesson in how the artist can avoid such temptations by sticking rigorously to business and selecting his models with care. Picasso, clad in a very artistic beret, busily works at his easel, drawing from a model who is a hideous old crow! (Z., XXII, 56).

The gayest picture of friends which Picasso produced in 1903 was his pseudo-serious group portrait of the tailor Soler and his family enjoying a picnic on the grass (Z., I, 203, 204). Rendered in a deliberately naive style which recalls Rousseau's portraits (although Picasso apparently did not know his work till later), the brighter tone and happier spirit which characterize this work show a temporary relaxation from Picasso's blue mood. A series of handsome watercolors of Catalan peasants which date from this period probably records observations made on a holiday in the country.

In the autumn of 1903, Picasso returned to more serious concerns. A group of pitiful new male characters occupied his blue world; their lot seemed even

sadder than that of the earlier female figures, because these men were not only indigent, but blind, psychotic, mentally defective, or elderly as well (Z, I, 168, 170). It was in these figures that Picasso returned more emphatically to the extremely mannered, angular style which he had abandoned temporarily in his portrait work. These figures, among the most celebrated of his blue period canvases, often have been compared with those of El Greco, as well as with twelfth-century Spanish sculptures.

During the first two years of his blue period, Picasso had been preoccupied with pathetic women who seemed to represent concretely the artist's anxiety about separating from his mother and taking up an adult sexual role. In the fall and winter of 1903, Picasso turned his attention to the implications of his changed role for his father. The artist must have realized that he was the embodiment of all of Don José's unfulfilled ambitions for himself. The multiple afflictions which curse the men depicted in these paintings suggest that Picasso felt that his wayward behavior since 1898 had exacerbated the father's depression. In his work, if not in reality, Picasso occasionally represented the lot of these unfortunate beings as lightened by the affectionate companionship of a boy (Z., I, 123, 170, 175). In others, a faithful little dog comforts a beggar with his devotion. One of these studies (Z, VI, 438) also contains a self-portrait (in an Egyptian headdress), facing away from the beggar. There is no reason to suppose this was executed at the same time as the other sketch, but the juxtaposition is provocative and may indicate Picasso's conscious resolve to break away. Three watercolors also done that winter show two middle-sized boys watching in hungry fascination while an emaciated beggar has his skimpy meal (Z., I, 209, 210; Z., VI, 684). Can this represent the other side of the coin, Picasso's secret longing to continue his dependent relationship with the father, no matter how meager the latter's remaining emotional resources were?

Many interpretations have been given for the fact that so many of these men are blind. Perhaps one explanation is that Picasso's father was the equivalent of a blinded artist, a painter too incapacitated to work. John Berger speculates that this motif originated in Picasso's guilt and anxiety over the damaging effects of a venereal disease he had contracted. This may have been a factor, but the motif probably was multidetermined.[30] Abnormal fear of blindness is usually related to early childhood conflicts involving the eyes, and Picasso, with his lively visual curiosity, may have engaged in forbidden peeking at an early age. His famous statement, accepted all too literally by some of his admirers, that painters should all be blinded so that they may paint better, just as finches are blinded to make them sing better, represents a denial of his terror of blindness. No painter ever consciously valued his eyes more or attributed more magical powers to his perceptions than Picasso. He claimed—and this grandiose phantasy was accepted as gospel by his admirers—that he had always been able to look straight at the sun. His friends, especially women friends, all talked wonderingly of the hypnotic, penetrating power of his

The Old Guitarist, 1903, oil on panel, 122.3 x 82.5 cm. The Art Institute of Chicago. Helen Birch Bartlett Memorial Collection

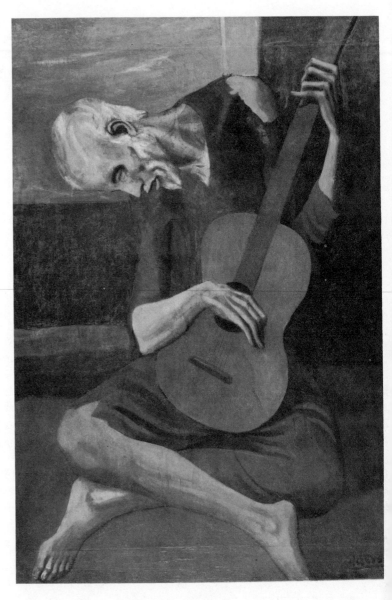

glances. Consequently, we must interpret the allusions to blindness in so many blue period pictures as an expression of fear, a phantasied punishment.

If the inference that the blue period had its origin in Picasso's unresolved separation problems is correct, then the blindness could have yet another meaning. If he were blind, he could not lead an independent life; he could neither paint nor care for himself. This same theme recurs much later in his career, in the beautiful etchings devoted to the blinded Minotaur, done in September 1934, at a time when he was trying to separate from his wife and son to take up a new life with a new love.

It was the experience of viewing a large number of Picasso's blue-period canvases together (at a retrospective exhibition held in Zurich in 1932) that tempted Carl Jung into his famous and ill-considered diagnosis that the blue period constituted an incipient schizophrenic episode on Picasso's part.[31] An occasional peculiar drawing, such as the sketch of a man whose head is being ripped open by a vulture, or another showing a little phantasmagoric figure hovering over a man like an hallucination, indicates that Picasso's anxiety level occasionally got very high during these years (Z., I, 149, 150). Nonetheless, there is nothing here or elsewhere in Picasso's oeuvre to suggest that he was psychotic. Jung's misinterpretation springs both from ignorance about contemporary artistic movements (that is, the general fin-de-siècle fascination with disease and moral deterioration) and his disavowal of the sustaining powers of genius, which protect the possessor's ego in situations in which a less talented person might disintegrate. Yet Jung should have known because, as his autobiography shows, this truth was also applicable to himself![32]

Throughout the winter of 1903–4, the tone of Picasso's pictures seemed very mournful, as he worked through his remaining conflicts about separating from his parents and from his adolescent surroundings and friends. A small crucifixion study recently published may date from these months (Z., XXII, 6). Usually such motifs occurred in Picasso's work during periods of personal conflict, when he temporarily cast aside his atheism to identify with the martyred Savior.

From the beginning of 1904, Picasso made careful, considered plans to return to Paris. This contrasts with his impetuous departures in 1901 and 1902, indicating that this time he intended to make the move permanent. At the beginning of January, he moved into a studio alone, thus separating himself from his old friend, Angel de Soto. Daix and Boudaille state that, at the same time, Picasso moved out of the parental home into a room near his studio.[33] If that is correct, it would imply that he weaned himself from his parents gradually. Sabartés describes one last ambivalent interaction between Picasso and his father: the young man persuaded his father to buy and prepare an extra large panel for him, then he filled up this special surface as rapidly as if it were a cheap bit of canvas. "His need for having a studio unto himself alone, his idea of having a panel prepared as if he were to paint an altarpiece,

and his thirst for solitude were manifestations of his extreme restlessness."[34]

Through a contact in Paris, Picasso rented in advance the space he was to make immortal, his studio in the so-called Bateau-Lavoir. Significantly, one of the last pictures he painted before he left Barcelona was another portrait of Jaime Sabartés. Just as a picture of Sabartés had initiated the intense phase of the blue period, so this portrait marked its waning, as its subject astutely observed.[35]

Four

L'oiseau du Benin

Picasso had cast his lot with Paris, but during his first months as a resident of the Bateau-Lavoir,[1] he must have taken many a nostalgic glance backward. The street boys who had peopled many of his 1903–4 Barcelona pictures re-appeared, but without the elderly blind men or the emaciated beggars who had served as their protectors and companions in the earlier works. The boys now made their way alone in the world or, at best, clung to an older child who seemed too young and frail to understake such a responsibility (Z., I, 218, 219, 227).

Echoes of the themes of still other blue-period pictures recurred. Picasso reverted to portrayals of lonely blind men, brooding women, and despondent couples—themes which suggest that his anxiety about his parents' ability to manage without him had been reactivated by separation. The tentative quality of Picasso's adjustment is further suggested by his reaction to a suicide which occurred in his immediate neighborhood. Although he did not know the victim and did not see his body, Picasso made two drawings of the dead man, showing his emaciated body suspended over the parapet of his building. The artist appended his own self-portrait to one of these sheets, which he then retained in his own collection unpublished until he showed it to Daix and Boudaille more than half a century later. His rather scruffy, unkempt appear-ance in this drawing reinforces the impression of anxiety conveyed by his preoccupation with this suicide, which probably recalled Casagemas's tragic death.[2]

The sombre tone of many of these early 1904 Paris paintings is relieved by modifications in the artist's blue palette which probably paralleled a gradual improvement in his mood. In *The Couple,* for example, (Z., I, 224) warmer rosy tones break through the predominant blue of the figures and ground to suffuse the faces of the pair with a pale golden light. The melancholy painting *Woman with a Crow,* which shows a sad, thin woman lovingly kissing her pet bird's head (it is reminiscent of the *Child with a Dove* of 1901), is also softened by its warmer rose-and-ochre tones; even its blue background has reddish undertones.

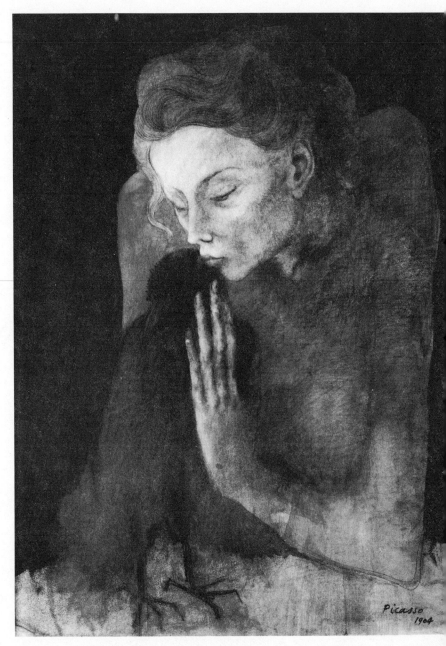

Woman with a Crow, 1904, charcoal,
pastel, and watercolor on paper
mounted on board, 54.6 x 49.5 cm.
The Toledo Museum of Art. Gift of
Edward Drummond Libbey

Picasso may have felt lonely and homesick during those first months in Paris, but he was never really isolated. Many of the artists from his old Barcelona circle had settled in Paris, and as soon as he joined them, they rallied once more around his star. He quickly became the leader of an active group, the so-called *bande Picasso,* whose members inspired several of his caricatures and serious portraits of 1904–5. The Picasso gang watched over their "Benjamin's" welfare with a kind of maternal solicitude; they made certain that he did not go hungry, and they tried to sell his drawings to neighborhood dealers, while he graciously "accepted as due homage anything his friends tried to do to help ease his day-to-day life a little."[3]

After his first year in Paris, Picasso created few pictures of these Spanish friends, a change which mirrored their diminishing importance to him. Thanks to the good offices of his old chum Max Jacob, Picasso soon became acquainted with members of the French literary avant-garde, and the more talented and exciting Alfred Jarry, Pierre Reverdy, Maurice Reynal, and others gradually replaced most of Picasso's Spanish intimates. Max Jacob himself seems to have assumed Jaime Sabartés's vacant post as "attendant genie" to Picasso. Francis Steegmuller defined their relationship as that of the minor genius who adored the major genius who let himself be adored—a summation which seems accurate enough.[4] Jacob usually was the first person to call on the artist every day. Soon he was joining the Spaniards Manolo Hugue and Angel de Soto in their expeditions to sell Picasso's drawings. In 1907 Max Jacob moved to a dingy room just a few doors down from Picasso's studio in the Bateau-Lavoir, simply to be near his idol.[5] In Picasso's circle, he functioned as a kind of minstrel, entertaining the company with readings from literature and plays, predictions of the future (he read palms and horoscopes), and female impersonations of barefoot dancers and chanteuses who specialized in dirty ditties.

Picasso, for his part, seemed genuinely fond of Jacob; indeed, Gilot believes that the kindly, maternal poet played a more significant role in helping Picasso to adjust to his new independence than I have attributed to him. I can only emphasize that Picasso's paintings and drawings fail to corroborate her impression: the visual evidence (cited below) all points to Apollinaire as the key associate of this period. Nonetheless, Gilot may well be correct in asserting that Picasso felt more affectionate toward Jacob. The artist needed Apollinaire more and therefore may have felt more ambivalent toward him while loving Jacob purely for his own sake. Such affection certainly shines forth from the portrait drawing of Jacob which Picasso completed in late 1904 to help decorate the poet's miserable little flat. In this sketch, Jacob appears far more dashing and handsome than in contemporary photos. Penrose claims that Jacob served as the model for Picasso's first major sculpture, *The Jester* of 1905 (Z., I, 322).[6] If so, in this instance the artist idealized and altered Jacob beyond recognition. Perhaps he only served as a generalized substitute for the comedian who had actually inspired the bust.

As long as he had remained dependent on his parents, Picasso had been unable to relate to proper young ladies, and his love life had consisted of transitory meetings with prostitutes. Within a few months of his move to Paris, he had acquired a beautiful and intelligent mistress, Fernande Olivier, the first recorded victim to succumb to Picasso's torrid glances.[7] Her presence in his life was reflected first in a pair of drawings of nude lovers (Z., XXII, 104, 119). Although Picasso did not usually date his early works, both these drawings are dated, one quite precisely to September 7, 1904, suggesting that they commemorate important dates in the progress of his romance; the artist kept the more passionate of the two drawings in his own collection, unpublished until recently, a fact which further suggests that it had great personal meaning to him.

Two watercolors from the same period show us the other side of the coin— Picasso's anxiety over his beloved. Both pictures depict a young man brooding over a luscious sleeping nude (the illustrated version is an overt self-portrait). This "watched sleeper" motif would recur often in Picasso's intimate drawings of the thirties and forties, when his amorous life reached a zenith of complexity; it always seemed to symbolize his concern about the physical welfare of his beloved. Another self-portrait shows the artist continuing this morbid scrutiny of his mistress even when she engaged in such routine bodily activities as taking a sponge bath (Z., XXII, 94). These sketches mirrored the reality of Picasso's terrible jealousy, for he kept Fernande like an odalisque in a harem. He did whatever housekeeping was required and even took care of the shopping, so that Fernande would have no excuse to leave his studio. She lounged on the couch, sipping tea and reading novels. Olivier's account suggests that Picasso treated her rather like a beloved, but over-protected child. Did he reenact with his mistress the kind of passive, dependent relationship he had enjoyed with his own mother during his first few years of life? If so, he reversed roles, for he now assumed the maternal functions while Fernande enacted that of the "prisoner of love."[8]

In the months after he met Fernande, Picasso's style changed and softened and his palette brightened. He painted flower still lifes and tender scenes of young mothers nursing or nuzzling their babies, and *The Madonna with Garland* (Z., I, 229), a sentimentalized Virgin and Child in an aureole of flowers. Daix and Boudaille point out the close resemblance between this Madonna and the bride of the contemporaneous *Pierrette's Wedding* (Z., I, 212).[9] These pictures suggest that Picasso idealized Fernande, to fantasize about her as a Madonna-like figure and Virgin bride. As their romance deepened, the artist discarded these romanticized props and guises, to depict Fernande in more naturalistic, but equally flattering, roles, chiefly as the wife of a young circus performer. How much Fernande's love began to mean to Picasso is suggested by two self-portraits from December 1904 (Z., XXII, 111, 113), which show him looking more youthful and contented than he appeared in any of his self-portraits from 1901–3.

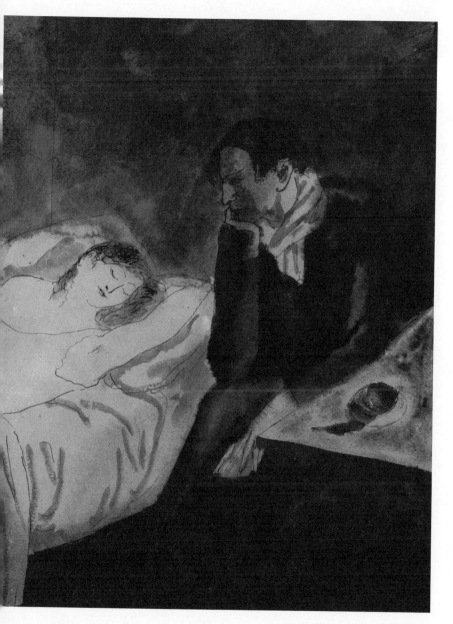

Meditation, 1904, watercolor and pen, 34.6 x 25.7 cm. Collection of Mrs. Bertram Smith, New York

Sometime during 1904 or 1905, Picasso met Guillaume Apollinaire, t‌
young symbolist poet.[10] Certain similarities in their backgrounds (Apollinair‌
too, was a rootless émigré having trouble separating from his mother), inte‌
ests, and personalities predisposed them to friendship. They became intimat‌
practically from the moment they were introduced, and Picasso prompt‌
took Max Jacob to meet his new "find." Soon Apollinaire was joining Jac‌
in daily pilgrimages to Picasso's studio.

Within a few months of their meeting, Apollinaire had assumed the ro‌
of official interpreter of Picasso's art to the Parisian avant-garde public.
April and again in May 1905, writing in short-lived periodicals of his ow‌
creation, Apollinaire explained Picasso's work and defended it against t‌
published criticisms of Charles Morice.[11] The latter, reviewing paintings whi‌
Picasso exhibited in February 1905 at the Galeries Serrurier, criticized Picass‌
"precocious disenchantment." Apollinaire, describing the inhabitants of F‌
casso's canvases as though they were real people, emphasized, by contra‌
their tender vulnerability and, by implication, the similar sentiments of th‌
youthful creator.

With the hindsight born of fifty years of additional experience, Picas‌
later depreciated Apollinaire's perceptiveness as an art critic, while simu‌
taneously confessing how important the poet's writing had seemed to hi‌
at the time of publication.[12] Picasso directed this criticism primarily towa‌
Apollinaire's writings about cubism. Whether Apollinaire really understo‌
cubism or not, he certainly comprehended the iconography of Picasso's circ‌
pictures, and the tone of the review the poet contributed to *La plume* c‌
responds perfectly to the lyrical melancholy which suffuses these paintings. T‌
artist must really have agreed with this assessment, because in 1965, wh‌
Daix and Boudaille showed him the photostatic reproduction of Apollinair‌
La plume review, the aged artist read aloud from it with obvious emotio‌
During his last few years, Picasso seemed preoccupied with Apollinaire, ar‌
often spoke of his poet friend; in the delirium which immediately preced‌
his death, the artist called out Apollinaire's name again and again.[13] All t‌
evidence suggests that both the poet and his writing must have been of gr‌
importance to Picasso. Perhaps he concentrated on Apollinaire's writings‌
cubism because (consciously or unconsciously) Picasso wished to avoid‌
discussion of his blue- and rose-period pictures. He refused to talk about the‌
works at all with John Richardson; when the latter tried to question the art‌
about them, Picasso dismissed the topic, claiming, "All that was just sen‌
ment."[14] Indeed it was! In these pictures, we catch a glimpse of their creato‌
most personal sentiments, feelings which do not seem to have been a tot‌
secret to Guillaume Apollinaire.

During 1905 Picasso's painting underwent several important transform‌
tions which affected both style and content. His development during this pr‌
ductive period can be followed much more logically if we accept Daix ar‌

udaille's careful reclassification of Picasso's oeuvre in 1905 and 1906,
her than that of Zervos, which probably attributes too many works to 1905.[15]
e paintings and drawings which Daix and Boudaille assign to the first half
1905 show a remarkable unanimity of design, color, and sentiment; they
o reveal an almost monothematic utilization of characters from the circus
d commedia dell'arte (a fact which had been lost in the confused chronology
the Zervos catalogues). Their content often represents gentler, prettier
interpretations of certain blue-period themes. The emaciated, mannered
relics who peopled Picasso's blue-period canvases have been replaced by
ore youthful and handsome circus performers, painted in soft roses, greys, and
ues. They seem less hopelessly depressed than their blue counterparts, but
ey remain isolated, self-absorbed, and wistful. The beggars and prostitutes
the blue canvases were at the very bottom of the social ladder, and the
tus of these circus people seems little better. Homeless exiles, they lead a
otless, precarious existence, lacking fixed identities and social roles. Nor
e they able to derive much comfort from their relationships with one an-
her. When Picasso depicts two of these circus people together, he shows
em either ignoring each other in self-preoccupation or, at best, relating in
e most tenuous manner, via a mere exchange of silent glances. In *Au Lapin
gile* (Z., I, 275), Picasso portrays himself as Harlequin, alone and bitter
idst the customers in the bar.

Only babies and small children seem able to elicit a more positive emo-
nal response; the boy not only evokes the most tender reactions from his
other, he also promotes greater intimacy between his parents. In several of
ese paintings and drawings, the young Harlequin father joins with the mother
they admire and care for their offspring. Another drawing from this series,
dicated to Fernande, shows a young woman who resembles her playing
ith her child while her ecstatic Harlequin husband fingers his accordion.
ich sketches suggest that, even though Picasso continued to be preoccupied
ith unresolved problems from earlier developmental levels, he simultane-
ly entertained phantasies more appropriate to his chronological age.

During these same months, Picasso often depicted a little boy Harlequin
., XXII, 237), a wistful, lonely child whose isolation contrasts tellingly
ith the happiness of these circus infants. These small Harlequins seem even
ore pathetic than the little beggar boys Picasso had created during the spring
1904. The latter had at least sometimes enjoyed the companionship of an
der brother whose love lightened their misery. By contrast, when the boy
arlequin appears with an older brother or grown-up, his companion usually
ems oblivious of the child (Z., I, 300; VI, 718). The poignant painting
the circus boy and his mother serves as the quintessential example of the
ctures of this type: although their bodies touch, mother and son turn away
om each other, separated by an unbridgeable gulf which condemns each to
tter loneliness. Among the little Harlequin's companions, only his dog

seems to respond empathically as he nuzzles the wistful child's hand. One
reminded that Picasso, a great animal lover, always owned at least one do
when Fernande Olivier first glimpsed the artist, he was cuddling a kitte
and he even kept a pet white mouse in a drawer in his Bateau-Lavoir studi

Later that same spring of 1905, Picasso enlarged his family of saltimbanqu
to include two new characters. The first, a fat buffoon, soon assumed the ro
of the senior personage, or father, to the group; Barr and Penrose call hi
the "understander." Although this jester figure was based on a real mod
(a sketch (Z., XXII, 217) labeled "Uncle Don José [!] at 40 years of age
survives), he apparently soon became associated in Picasso's mind and wo
with his caricatural representations of Apollinaire. This fusion first occurre
in a bookplate design, created expressly for Apollinaire, which shows the obe
jester garbed as a king and seated at table, raising his wine glass in a roy
toast; Steegmuller believes Picasso paid tribute to Apollinaire's feats of gou
mandism by adopting this setting. A nearly identical king soon appeared
Picasso's etching *Salomé*. Years later the artist told Douglas Cooper, who ha
once owned the bookplate, that he had come to think of it "as representir
Apollinaire as king among poets and as jester—i.e., amuser of painters-
among art critics."[16]

The other new character in Picasso's circus was a youthful strongman giar
He also seems to have symbolized Apollinaire because, during these san
weeks, Picasso drew caricatures of Apollinaire as an enormous, muscle-bour
character. In one drawing (Z., XXII, 286), he holds a scroll inscribed "phys
cal culture." This refers to an actual publication by that name which Apollinai
edited. The caricatures may also function as a witty commentary on the absu
idea that Apollinaire, who resembled an enormous ripe pear and engaged
no exercise more rigorous than lifting his fork, should be involved in pu
lishing a magazine which touted physical fitness. Daix and Boudaille, wl
also associate the strongman image with Apollinaire, note that Picasso w
deeply impressed by Apollinaire's size and corpulence "and the feeling
strength which emanated from him," an impression they presumably derive
from their conversations with the aged Picasso.[17] Picasso created many oth
caricatural roles for Apollinaire: he portrayed him as the pope, as an acad
mician, a man of the world, a carefree sailor, and in other guises which ind
cate that Picasso admired and looked up to his poet friend as a sophisticate
worldly figure.[18]

The connection Picasso repeatedly made between Apollinaire and the
various wise or powerful figures cannot be coincidental. Barr and others wl
labeled the Apollinaire-jester figure "the understander" hit upon the re
truth.[19] Apollinaire *was* Picasso's understander, the good mirror, whose visic
of the painter reflected his best and truest self, and who interpreted to tl
world (and perhaps even to Picasso himself) the iconography of his painting
In many ways, Apollinaire duplicated the role which Picasso's father ha

ayed during the artist's childhood and adolescence. Don José, too, had
omoted and publicized his son's work. Unlike Don José, however, Apol-
naire was not a flawed instrument; his own genius was brilliant and true, and
 never failed Picasso, not even when the latter shockingly betrayed his
endship in 1911.[20] The fact that Picasso refrained from creating naturalistic
rtraits of Apollinaire during their years of greatest intimacy probably is
rther proof of his importance to the artist, who developed a special charac-
ristic mode of portrayal for each of his special partners.

Barr may have been the first to note how Picasso's mood changed in 1905, Plate 3
ding to a more classical, serene style. The critic focused on the *Family of
ltimbanques* as the transitional picture, summarizing the previous period and
ralding the changes to come.[21] This picture, the largest Picasso had painted
 date, is marked as unique by its very dimensions (84″ x 90″). It shares
e aura of mystery which characterized two important earlier pictures, *La vie*
d *The Tragedy,* perhaps because it, too, reveals a new truth about its creator,
supposition reinforced by the widely recognized self-portrait of Picasso
Harlequin.

The painting shows six people in the forefront of a boundless landscape
nsisting of a gently rolling ochre plain which flows to meet the blue horizon.
e five figures occupying the left side of the canvas form a loose J configura-
n. The first person we encounter is Harlequin himself. In his suit of blue,
se, and gray diamonds, he forms the base of the J. Although his back is
rned to the viewer, he shows his Picasso profile. His physique displays a
ature muscular power which contrasts strikingly with the emaciated fig-
e Picasso gave his earlier 1905 self-portrait as the Harlequin of *Au
pin Agile*. He holds by the hand a little girl whose body creates the
 abbreviated curve. An enigmatic, faceless figure, she is completely turned
vay from the viewer. She carries a footed flower basket similar to those
ed to decorate graves. The massive old "understander" in his brick-red
robat's suit stands at the Harlequin's left. He stares intently at Harlequin,
it the latter seems lost in revery as he looks off toward some unseen point
 the distant horizon. The bulky acrobat carries an enormous bundle, big as
Santa Claus's pack, but he balances it effortlessly with one hand. Slightly
hind him, we see an adolescent acrobat with a bedroll on his neck. He is
companied by a younger boy, who wears a vaguely Oriental garb with a
ue-and-rose tunic and sheer violet pantaloons. The boys ignore one an-
her, as well as the remaining figures in the group. Their attention seems
veted on the right foreground corner, where a beautiful lady of mystery
s on the ground, lost in phantasy. She wears a fanciful Majorcan costume with
rose orange skirt and a big, flower-trimmed hat. More thinly painted and less
olumetric than the other figures, she seems like a vision or mirage (the fact
at the figure remains unfinished adds to this hallucinatory quality). A forgot-
n water jug rests on the ground behind her.

Penrose and Barr both concluded that the *Saltimbanques* was devoid of a dramatic or allegorical overtones, but the psychoanalytic critic Daniel Schneic challenged this position, emphasizing the relationship of the figures to t artist's own family and history. Although I disagree with certain details Schneider's interpretation (he believed that the picture revealed Picasso's resolved oedipal problems), I think he was quite correct in perceiving t picture as autobiographical. Edward Lucie Smith evidently would concur, he commented in connection with the *Saltimbanques,* which he consider Picasso's last major symbolist work, "Symbolist art often possessed . . . a c fessional element, and this is plainly the case with the pictures [by Picass in which the figure of Harlequin appears. The melancholy jester who was a an eternal outsider clearly aroused in Picasso strong feelings of self-identifi tion."[22] The *Saltimbanques,* in my opinion, represents an allegorical stateme of the artist's own life and status in 1905. As the rootless Harlequin, he set out on an artistic journey whose directions seem as ambiguous and marked as the landscape which stretches before him. He is confident, howev because he travels under the protection of the wise old buffoon, the leader the family of saltimbanques. Harlequin, concentrating on his unseen go ignores the Majorcan woman. (Indeed, she did not figure in the prelimina study for the painting. Originally, the background showed a horserace, w one rider sprinting ahead while another fell by the wayside, a motif whi probably also had symbolic implications.) Surely, the lady of Majorca rep sents Picasso's Spanish past and the childish dreams which he has relinquish The identity of the three children remains more ambiguous, but they proba also have a highly personal meaning. The faceless girl might be Picasso's de sister, a vague but haunting figure who carries her own funereal flowers, and two boys may symbolize the artist himself at the ages when he undertook t other crucial journeys, to Corunna and then to Barcelona.

The Acrobat on a Ball seems closely related to the *Saltimbanques* both in theme and in its setting of the endless rolling plain. In this work, the mass young strongman substitutes for Apollinaire, whereas the artist is represent by a slender adolescent girl who takes great pleasure in her difficult balanci feat. Two closely related pictures show the strongman assuming a much m active role vis-à-vis the young acrobat as he holds her on high at arm's leng balancing her slender body on his hands. In such works, Picasso seems to c our attention to the fact that Apollinaire (the symbolic strongman) publi supported the artist's paintings, defending them against hostile criticism. cording to this hypothesis, Picasso symbolically represents himself here a girl. If so, he assumes the female role without any apparent anxiety or confl about his passivity. Such an attitude seems quite unusual and may reflect t artist's acceptance of his own passive, dependent role with his father, w mothered Pablo most tenderly. Perhaps it was this feminine, nutritive asp of the father's character which freed Picasso to express such aspects of hims

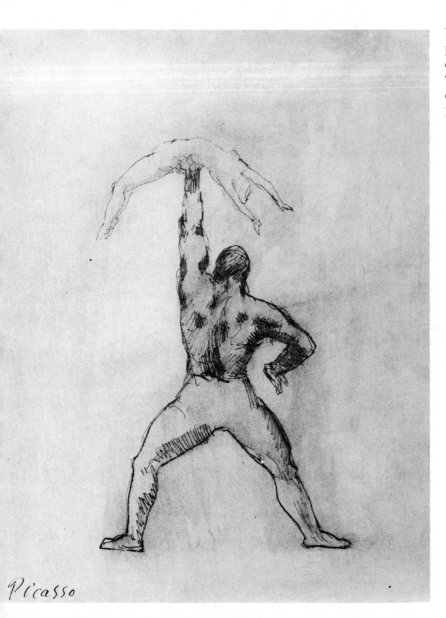

The Strong Man (*L'athlète*), 1905, pen and ink over pastel, 31.8 x 24.1 cm. The Baltimore Museum of Art. The Cone Collection, formed by Dr. Claribel Cone and Miss Etta Cone of Baltimore, Maryland

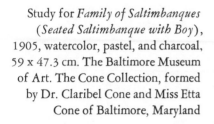

Study for *Family of Saltimbanques*
(*Seated Saltimbanque with Boy*),
1905, watercolor, pastel, and charcoal,
59 x 47.3 cm. The Baltimore Museum
of Art. The Cone Collection, formed
by Dr. Claribel Cone and Miss Etta
Cone of Baltimore, Maryland

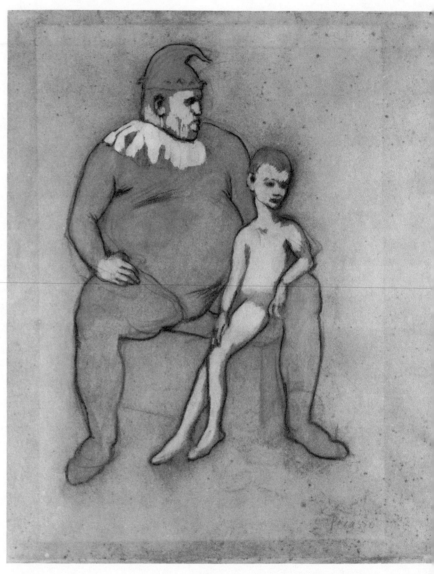

o openly and which made him so tolerant of the homosexuality of such close riends as Max Jacob.

During succeeding months, Picasso's paintings revealed new aspects of his mall Harlequin hero. More spritely and self-confident now, the child appears iding a horse and performing with an older acrobat who rests his hand affec- onately on the boy's shoulder. Backstage, he sometimes melts comfortably into he bulk of his old "understander," the fat jester.

A brief vacation in Holland during the summer of 1905 helped Picasso to onsolidate the gains he had made during the previous months. As Barr points ut, the artist's postvacation works revealed a new solidity which sometimes pproached monumentality.[23] It was probably after he returned from Holland hat Picasso created *The Jester,* the first of several sculptures he would com- •lete during the next few years. Later in his career, Picasso often turned to culpture during periods of special significance in his personal life. Particularly uring times of emotional turmoil, he seemed to derive comfort from the act f fashioning concrete, three-dimensional images. In 1905, however, his in- erest in sculpture seems to have accompanied a diminution of tensions and a eneral blossoming of creativity.

Although Picasso's production of late 1905 and early 1906 mirrored his reater serenity, he had not yet completely laid to rest his conflicts about grow- ng up. Many of his pictures from these months portrayed young boys on the hreshold of adolescence (over fifty percent of the paintings Daix and Boudaille ssign to this period feature such boys). These adrogynous youths, who seem o exist in a private world of dreamy indolence, continue to dress as Harlequins r acrobats, although nothing but their costumes associates them with these dentities. A drawing dated "Paris, December 24, 1905, midnight," shows a nore mature and muscular young Harlequin taking an active pose, his figure urrounded by caricatures of Apollinaire (Z., XXII, 235). Picasso's Christmas nd New Year's drawings usually contain highly personal messages.[24] This ketch, with its implied connection between the presence of Apollinaire and Harlequin's new maturity, probably is no exception. Two other works from 905, which Picasso expressly dedicated to Apollinaire, portray people as- uming adult sexual roles. One of them, a little crayon drawing, depicts Harle- quin holding up his baby and admiring him. The other, an oil executed in the utumn of 1905, shows a copulating couple and bears the inscription, "A mon her ami Guillaume Apollinaire, Picasso, 1905."

The Death of Harlequin, although assigned to the spring of 1905 by both Zervos and Daix and Boudaille, almost certainly belongs rather at the be- inning of 1906. A supplementary volume (XXII) which Zervos issued for hese years includes four previously unpublished studies for *The Death of Harlequin,* and one of them is plainly dated 1906 in Picasso's own hand (Z., XXII, 334–37). This later date makes sense both stylistically and psychologi- ally. The heads of the two boys who attend the dead Harlequin relate closely

to several portraits of boys which Picasso painted during late 1905, and the
theme fits exactly with his work of 1906, when he dropped the guise of
Harlequin altogether and began portraying nude adolescents.

The final version of *The Death of Harlequin* reveals his peaceful figure on
his death bed, his hands folded as if in prayer. Two figures, sketchily rendered,
keep a silent, intent watch over his bier. They are both boys, one an adolescent,
the other a child of nine or ten. These three figures recall the Harlequin and
acrobats in the *Family of Saltimbanques,* previously interpreted as representing
various aspects of Picasso's past and present. *The Death of Harlequin* sug-
gests that Picasso felt ready to relinquish this alter-ego along with his childish
wishes, and to assume a more adult role. Consequently, it is not surprising to
see the painted adolescents of early 1906 suddenly show more maturity and
responsibility. No longer does the artist portray them as languid and andro-
gynous. They have cast aside their indolence with their Harlequin suits. These
more muscular, pubescent boys busily exercise their horses or lead them to a
watering hole (Z., I, 264, 265; XXII, 266).

Picasso's changed style of late 1905 soon attracted the attention of dealers
and buyers. That fall he acquired his first important patrons, Gertrude and Leo
Stein. They began collecting his pictures at an amazing rate, and their in-
terest was like a barometer heralding Picasso's future success. Both Clovis
Sagot and Ambroise Vollard now dealt in Picasso's work; Vollard offered his
etchings and sculptures, as well as paintings and drawings. Within a few years,
Picasso had become fairly prosperous, at least by the standards prevailing in
Montmartre.

In Gertrude Stein, Picasso acquired not only a patron but a lifelong friend.
He was fascinated by her appearance (she seemed as monumental as a figure by
Giotto), and immediately asked her to pose for him. Stein recognized, at least
in retrospect, that this request was an unusual one for Picasso to make, since
he seldom worked from the model in the conventional sense:

> Why did he wish to have a model before him just at this time, this I really
> do not know, but everything pushed him to it, he was completely emptied
> of the inspiration of the harlequin period, being Spanish commenced again
> to be active inside him and I being an American, and in a kind of way,
> America and Spain have something in common, perhaps for all these reasons
> he wished me to pose for him.[25]

During the long winter months of 1905–6, while they labored together
over her portrait, Gertrude Stein and Picasso cemented their friendship. The
picture did not progress as smoothly as their relationship; at the end of eighty
or ninety sittings, Picasso rubbed out Stein's face, told her he could not look
at her anymore, and dismissed her as a model. The frustrations he experienced
over this picture were atypical and probably indicative of the special importance

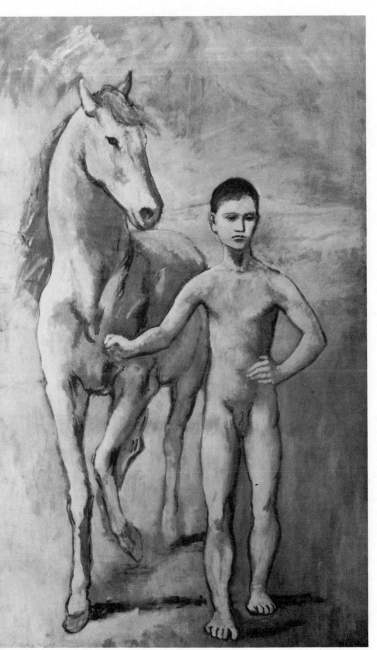

Boy Leading a Horse, 1905–6, oil on canvas, 219.7 x 130.2 cm. Collection, The Museum of Modern Art, New York. Gift of William S. Paley, the donor retaining life interest

of the portrait to him. During these same months, he painted other pictures wit
facility, including portraits of Miss Stein's brother Leo and her nephew Alle
(Z., I, 250, 353).

In the spring of 1906, Picasso abandoned his unfinished portrait of Mis
Stein and left for Gosol, an isolated village in the Spanish Pyrenees, where h
lived for several months with only Fernande for company. During his firs
weeks in Gosol, Picasso completed his series of adolescent boys. At first h
showed the lad, calm and confident, watching over a toddler brother, whor
he carries around piggy-back. Then he transformed both boys into olde
adolescents. In a final version, they both appear as handsome, muscular youn
men, as serene and powerful as Greek gods in their rose-colored world (Z., !
305, 324).

This gradual metamorphosis of Picasso's wistful little Harlequin into a self
confident young demigod no doubt mirrors the artist's own psychologica
changes during 1905–6. Even after he had managed to break the physical tie
binding him to his family in Barcelona, a part of him remained spirituall
bound up in childhood. During 1905 a particularly fortuitous combination o
circumstances, in which his relationship with Apollinaire, his love for hi
mistress, and his increasing financial security all played a part, enabled Picass
to bridge this gap in his emotional development. It probably is no accider
that the final act of this internal drama took place on Spanish soil. Picasso's lif
in Gosol resembles the earlier interlude he had spent with his friend Pallaré
in the latter's native village, Horta del Ebro, which had marked Picasso's firs
successful experiment in living apart from his family. Fernande Olivie
reiterates how comfortable and contented Picasso seemed in Gosol, sharing i
the simple lives of the peasants. To Fernande, Picasso always seemed mor
contented when they were visiting in Spain. She believed he might have bee
happier living in Spain than in France, except that his was a nature whic
"drove him toward everything tormented."[26]

During this Gosol vacation, Picasso painted a great series of canvases glorify
ing the beauty of Fernande as queen of his heart. One of the most magnificer
of these rose-and-ochre oils, *La toilette,* shows the nude, statuesque Fernand
arranging her hair while a graceful female attendant holds a mirror. Bar
compares the Fernande of *La toilette* to a gracious demigoddess and liken
such paintings of her to the art of Praxiteles.[27] One of the last of thes
tributes, *The Harem,* is peopled by four beautiful nudes (all Fernande i
different poses), and guarded over by a benign giant related to the earlie
"physical culture" caricatures of Apollinaire (Z., I, 321). Perhaps thi
picture was a conscious tribute to Apollinaire as the guardian of Picasso's art—
considering the poet's reputation as a ladies' man, he would hardly have bee
the ideal choice for guarding a harem! This work, executed in the warmes
buffs, carnations, and roses, breathes contentment. Here at last, Picasso wa
experiencing the true *vie en rose,* and the forced emotional tone which ha
characterized many of his circus pictures disappeared.[28]

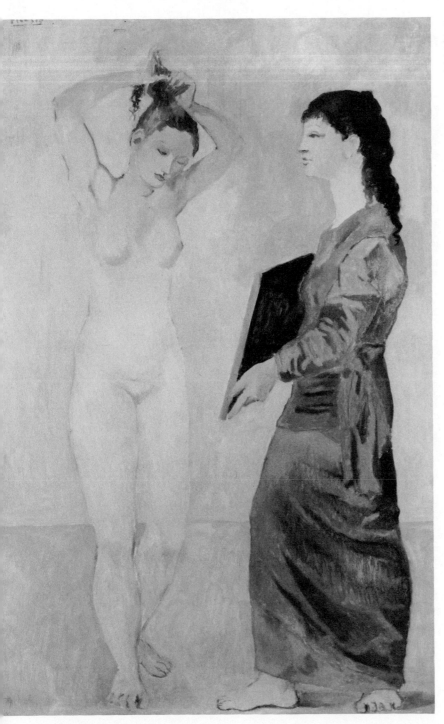

La toilette, 1906, oil on canvas, 151.1 x 99.1 cm. Albright-Knox Art Gallery, Buffalo, New York. Fellows for Life of 1926 Fund

Gertrude Stein, 1906, oil on canvas, 100 x 81.3 cm. The Metropolitan Museum of Art, New York. Bequest of Gertrude Stein, 1946

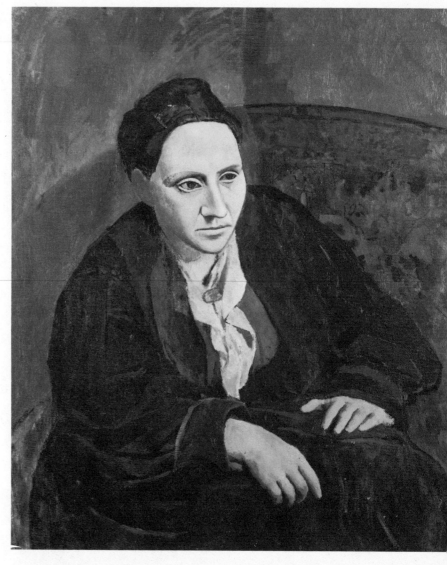

Picasso's new sense of well being was immediately reflected in his new paint-
ing style. No longer so preoccupied with the personal problems which had
intruded on his work, he could now integrate all the stimulating, and sometimes
conflicting, influences from the past and present to which he had been ex-
posed during the formative years, 1900–1906. Barr commented:

But the Blue Period with its belated *fin-de-siècle* desperation, the wistful
acrobats and tranquil classic figures of 1905 and 1906, *all this cumulative
achievement was, so far as the main highway of modern painting was con-
cerned, a personal and private bypath.*
 But during the winter of 1906–07 Picasso changed the direction of his
art and in so doing helped to change to a remarkable extent the character of
modern art as a whole.[29]

One sees the beginnings of this new phase in the last works Picasso completed
at Gosol. He continued to utilize his mistress as the model for these nudes,
but his depictions became more and more subservient to his conscious intellectual
control and less and less self-revelatory.
 A new objectivity, rigorously enforced, also pervades his self-portraits of
1906-7 (Z., I, 3, 75; II, pt. 1, 1). In fact, he probably really used his own
features as the basis for a number of other studies and paintings. Many of these
works are so depersonalized that they cannot be counted as self-portraits in
the usual sense, but merely as instances in which he used himself in lieu of a
paid model. Even when he depicted a much more personal phantasy, as in the
picture which shows figures resembling Fernande and himself with a baby boy,
Picasso utilized his severe new "Iberian" style of painting (Z., II, pt. 2, 587).
This work, which has always remained in the artist's own collection, lacks even
the softening effects of color and is carried out all in grays.
 That autumn, Picasso hurriedly completed the portrait of Stein without
further recourse to his model, transforming her features into an hermetic
mask in his new manner. During succeeding months, he displayed new
reserves of energy, producing a long series of nude studies which would
culminate in the most ambitious project of his youthful career, the creation of
the *Demoiselles d'Avignon*. As though aware in advance that the picture he Plate 4
had in mind would eventually take its place among the great monuments of
art history, Picasso prepared for this painting campaign with the utmost care.
While he worked out the precise details of the composition via copious pre-
liminary drawings, he had a specially reinforced canvas of heroic proportions
prepared.[30] Rather characteristically, once he had completed all these steps,
he apparently carried out much of the work on the actual canvas within a few
days. Many years later he would finally admit a fact that critics had always
surmised: the two right-hand figures were completed several months after the
rest of the picture. During a second campaign, carried out, most likely, during

the autumn of 1907, Picasso replaced the Iberian-type visages these two demoiselles originally possessed with faces based on African masks. (The artist always denied that he had become acquainted with African sculpture prior to making these changes.)[31]

Although he still did not consider the canvas complete even after he had accomplished this repainting, Picasso now began to exhibit it to selected friends. Perhaps their startled reactions to his shocking masterpiece unsettled the artist; whatever his motivation, he abruptly abandoned the picture in its present state.[32] The disjointed effect the picture still creates stems in part from this lack of finish and the resultant lack of integration beween the African and Iberian characteristics of its two parts.[33] Despite its dissonances, the *Demoiselle* ultimately achieved worldwide recognition as *the* great proto-cubist painting, the picture which predicted not only Picasso's own future development but the direction which twentieth-century art in general would follow during the ensuing decades.

Picasso drew not only on Iberian and African sculpture but on many other inspirational sources to fashion his *Demoiselles.* Critics all agree, however, he was most influenced by his study of Cézanne's paintings of bathers.[34] Although many details of Picasso's treatment of both figures and ground strongly reflect his meditations on the art of Cézanne, the younger artist unaccountably transformed the former's benign outdoor revelers into a group of savage whores sequestered in a *maison close.* John Golding and Reff have both suggested that we may owe this transformation to Picasso's fascination with such works by Cézanne as his *Temptation of St. Anthony,* which depicts nudes in more wanton poses, albeit still in an outdoor setting.[35] That may be, but Picasso must have been influenced by more personal motives as well, because his earliest sketches indicate that he initially planned the picture to include not only the five prostitutes who appear in its definitive version, but two male figures, a student and a sailor, both based on self-portraits. His idea of representing himself so prominently among his prostitutes suggests that Picasso may have originally intended the painting to bear a double burden, to serve as both prophecy and revelation, showing not only the direction of his future artistic development but revealing fundamental facts about his private past, specifically facts about the origin of his ambivalent attitude toward women. The hypothesis that the composition possessed such special significance derives not only from the peculiar quality of his two self-images, but also from the knowledge that Picasso did not permit a number of preparatory drawings featuring these figures to be published until shortly before his death. They appear in volume XXVI of the Zervos catalogues raisonnés.

Although Picasso based both male images on self-portraits, he apparently intended them to perform quite different functions in the painting. The sailor initially assumed a central role in the drama; he was portrayed seated at the heart of the painting, directly confronting the spectator and surrounded by the

prostitutes (Z., XXVI, 59). A table placed before him featured crescents of melon and a *porrón* of wine (this characteristic Spanish vessel is used to trickle wine down the drinker's throat). Although the sailor sported a thin little moustache, he otherwise closely resembled Picasso.[36] His attitude, however, seemed quite out of keeping with Picasso's own lively behavior, for this lad seemed shy, modest, even effeminate, characteristics which led Leo Steinberg to propose that the figure represented a timid candidate for sexual initiation.[37]

Until Picasso finally allowed the missing sketchbook to be published, the identity, role, and attributes of the second man seemed even more puzzling than those of the sailor. An enigmatic personage clad in an impeccably tailored business suit, this student carried an obscure object in his right hand, usually identified as a skull, while lifting a curtain with the other, to reveal the bordello and its inhabitants to the spectator (Z., II, pt. 1, 19). Both his position at the far left margin of the picture and his pose made him seem detached from the other figures. All but one of the drawings for this figure known before Picasso released the additional sketchbook showed this man as a faceless entity. The exceptional drawing (Z., II, pt. 1, 20) depicted a shorter, stouter man whose features resembled those of Max Jacob (Steinberg believes that this was the final drawing executed for this figure.)[38] Zervos's catalogue XXVI contained several additional sketches for the student which made it apparent that this man, like the sailor, had been conceived, originally, as a self-portrait and that the object he held was, indeed, a skull. When questioned specifically about this figure, Picasso commented without further explanation that he represented a "medical student."[39]

Probably wisely, the artist soon decided to eliminate both male figures and to reduce his cast of characters to the five prostitutes who appear in the definitive version of the picture. Even after he had eliminated these obvious self-references, Picasso continued to react to his painting in a very personalized manner. He behaved as though his demoiselles were alive, and he and his associates assigned private nicknames and identities to the women.[40] They designated one of the demoiselles as Max Jacob's grandmother, allegedly because she came from Avignon and the painting was set in a mythical brothel in the prostitutes' quarter of Barcelona, the Calle d'Avignon. They dubbed two others "Fernande," for Picasso's own mistress, and "Marie Laurencin," after the young woman destined to become Apollinaire's great love.[41]

Picasso's animistic conception of these creatures he himself had made, as well as his introduction, then suppression, of the two male self-portrait figures, all suggest that this composition possessed very private associations for the artist. Scholars, aware of such implications, have often perceived the painting as a reflection of Picasso's typically Spanish preoccupation with death; according to this view, the student with the skull is a *memento mori,* a preoccupation apparent also in a number of *vanitas* still-life pictures Picasso created contemporaneously (Z., XXVI, 191–93), featuring this same skull, an actual

fixture in his studio at the time.[42] Steinberg, convinced that such stern moral messages about the wages of sin seemed uncharacteristic for the artist, suggests that he intended the two male figures as contrasting symbols of detachment versus engagement, intellectuality versus sensuality. William Rubin, who knew the artist personally, offers the alternative proposal that the two men represent, instead, divergent aspects of Picasso's own personality. For Rubin, the student symbolizes the artist's mind and intelligence, while the sailor, surrounded by food, drink, and flesh, represents the artist's "instinctive sensuous side as established during childhood (sailor suit, surrounded by women in the home)."[43] Rubin's proposal gains additional credence when one recalls that in 1938 Picasso painted a self-portrait depicting himself as a small child clad in a sailor suit with his name embroidered across the cap. Several of the suppressed sketches for the sailor of the *Demoiselles* show him wearing a similar type of cap; these drawings emphasize the sailor's sweet, innocent expression still more strongly than the sketches published earlier.[44] Moreover, the number of women depicted in the picture corresponds exactly to the five women who surrounded Picasso during his first years, when he lived in a matriarchy comprising his mother, grandmother, two aunts and a maid.

The symbolism involving the medical student seems far more complex and enigmatic than that of the sailor, especially when one remembers that Picasso withheld all the sketches for this man which revealed him as a self-portrait. The artist's insistence that this man portrays a medical student also seems rather arbitrary and certainly does not convincingly explain why he carries that skull, not part of the portable equipment of most medical students then or now. If we retrace Picasso's history during his adolescence and early adulthood, we realize that he had two different types of experiences which might have caused him to make this firm association between physicians and prostitutes. During the autumn of 1901, right at the onset of his blue period, the artist had spent several weeks at the St. Lazare Hospital in Paris observing prostitutes who were being treated for venereal infections there. One can well imagine that the debilitated condition of many of these women must have brought home all too forcibly to the artist the message that the sins of the flesh bring terrible punishment in kind, a notion reflected in the *memento mori* aspects of the skull held by the medical student.

Both before and after this 1901 interlude, Picasso interacted with whores on quite another level: as an enthusiastic patron of the *maisons closes* in both Barcelona and Paris. Palau I Fabre claims that Picasso even lived in a bordello for several weeks in 1898 during a period of estrangement from his family.[45] It seems likely that the artist really did undergo his sexual initiation in a bordello, just as Steinberg imagines the sailor is about to do. A number of lively drawings memorializing Picasso's youthful experiences in the brothels survive and formed part of an exhibition entitled "Picasso Erotic" mounted by the Museo Picasso, Barcelona, in 1979.[46] Unfortunately, Picasso also carried away an

her, less pleasant souvenir of these youthful escapades. He picked up a
nereal infection. We do not know the details of his medical history, but the
sistent relationship these preliminary drawings for the *Demoiselles* establish
tween prostitutes, medicine, and himself strongly indicates that he acquired
e disease from a prostitute.[47]

This interpretation of the medical student's symbolism resolves the disparities
hich characterized previous hypotheses. On one level, he represents Picasso
the detached observer, methodically gathering scientific data to inform his
t. On another level, the figure also constitutes a *vanitas* symbol, a reminder
at the wages of sin may indeed involve death, or at least a painful, dangerous
nereal infection. At the same time, the student plays yet another symbolic
le, participating in an allegory dear to the hearts of Renaissance and Baroque
tists. He enacts the part of Father Time, lifting the curtain to unveil the
uth—the latter represented by Picasso, as in earlier versions of the theme, as
undraped female figure.[48] Instead of the universal truths which time always
veals in such Renaissance allegories, Picasso's alter ego initiates his creator's
rivate confessions, for the *Demoiselles d'Avignon* in its original form revealed
e etiology and development of Picasso's misogyny. In this confession, the
ilor represents Picasso's childhood self, the passive, helpless state of his first
ars, when his peculiar relationship with his mother permanently scarred his
ersonality. The effeminate quality of the figure may also represent the artist's
nderlying awareness of his own passivity, the characteristic "weakness" to
hich he later alluded in a conversation with Gertrude Stein.[49]

The fact that the *Demoiselles* merges references to Picasso's childhood with
lusions to his mature sexual relationships (not only his interactions with
rostitutes but also his liaison with Fernande, specifically identified with one of
e demoiselles) suggests that the artist may also have dimly sensed that he
ould always be drawn to women who echoed aspects of his mother's be-
avior. As I reiterate and attempt to demonstrate throughout this text, Picasso
peatedly selected women whose character pathology or life circumstances
quired extraordinary responsive efforts on his part. As an aged man, he
ould describe himself as one who had suffered greatly at the hands of women,
statement borne out by the stormy history of his heterosexual relationships.
erhaps at a deeper level he regarded his suffering, including his venereal in-
ction, as a just punishment for his underlying ambivalence toward women.

The conscious associations Picasso forged between his demoiselles and his
losest friends indicate his allegiance to other men who also suffered greatly
the hands of women. We possess little data about Jacob's grandmother, and
seems likely that the demoiselle called by her name represents, instead, Jacob's
other, who physically abused him throughout his childhood and tacitly en-
ouraged, or at least permitted, his siblings to behave in similar fashion. (Jacob
called that she administered her final slap when he was twenty-four years of
ge, after he had made a spelling error in a piece of writing.)[50] Although

Apollinaire's mother did not abuse him physically, she, too, was a difficult tyrannical woman who never relinquished her hold on her son and continued to bedevil his life even after he had moved away from home. His mistress, Marie Laurencin, possessed an equally domineering mother, who exerted a strong influence on Marie and may also have played a significant role in the dissolution of the Laurencin-Apollinaire liaison.[51]

Unlike Apollinaire and Picasso, Jacob avoided women when he reached manhood, seeking sexual satisfaction in perverted activities involving children. The fact that he was a renowned female impersonator suggests, however, his underlying identification with his all-powerful mother. In this light, it seems interesting that Picasso replaced his self-portrait as a medical student with that of Jacob (Z., II, pt. 1, 20). Perhaps the latter represented not only Picasso's misogyny carried to its extreme degree, but the artist's feminine aspects, also implicit in that passive sailor image. Ultimately, Picasso merged this Jacob-self figure with that of the nearest demoiselle, whom he moved to the left margin of the painting, where only her gesture as she continues the revealing action initiated by the artist himself provides a clue to her origins.

This constitutes the second instance in Picasso's oeuvre in which he depicts himself in female guise. In 1905 he had portrayed himself as a fragile young female acrobat under the protection of the benign circus strong man. In the *Demoiselles,* Picasso arrived at an even more insightful self-revelation, one which refers to an earlier period in his childhood, and reveals his infantile savagery. In her dual role as savage self and revealer of truth, this hideous harridan fixes us with her frontal, all-seeing eye while she turns to unveil the hidden facts about Picasso's history to the world. Only the support which Picasso had experienced in his relationships with Jacob and, especially, Apollinaire, enabled him, finally, to confront the sources of his anger toward women and to recognize, however dimly, that his resulting ambivalence would color his relationships with them throughout his life.

Ultimately, and wisely, Picasso decided to suppress the most obvious of these self-references, veiling the confessional aspects of his painting. Elements of his unresolved conflict about the picture persist, however, in its lack of cohesion and, more obviously, in its savage emotional tone. The *Demoiselles d'Avignon* portrays an imaginary bordello in which each spectator becomes the isolated, helpless customer, alone in a whorehouse of horrors whose inhabitants silently menace him with their intense stares and countenances of Medusa-like power. Locked in this interior, each of us silently relives Picasso's juvenile traumas as a surrogate for the artist himself.

Five

**Let Us Prophesy Together,
O Great Master**

No one found his initial glimpse of the *Demoiselles d'Avignon* more disconcerting than did Georges Braque, who compared the experience to swallowing paraffin or imbibing gasoline in order to "spit fire."[1] The young Norman owed his introduction to Apollinaire, who brought the artist to Picasso's studio to meet his Spanish friend and those strange painted women.

Did Apollinaire arrange this meeting because he sensed that Picasso had embarked on a new artistic course, one which the poet would be able neither to understand adequately nor to describe perceptively, as he had written about the artist's previous work? If so, he returned Picasso a favor in kind. Earlier that year, the artist had introduced Apollinaire to Marie Laurencin with the remark that he had discovered a fiancée for the poet.[2] The exchange of introductions proved equitable indeed. Marie Laurencin became Apollinaire's great love, the inspiration for some of his finest poetry, while Braque became Picasso's great collaborator, the partner with whom he would invent cubism and change the history of twentieth-century art.

Braque rapidly recovered from his initial shocked reaction to the *Demoiselles,* and many critics feel that, during the next two years, he moved toward cubism at a faster pace than the Spanish artist.[3] Picasso, perhaps intimidated by his own daring, retreated temporarily into works which sometimes fragmented the tenuous, yet powerful, integration he had achieved in this canvas into its component influences. Although the disparate pictures which Picasso created during this period are often lumped together as his "Negro period" works, they also reflect his continuing preoccupation with the attainments of Cézanne. As Barr suggests, they might be better labeled protocubist.[4] Certain key paintings which Picasso created during the latter half of 1908—particularly some of the still-life paintings of this period—show that he had progressed beyond the *Demoiselles* on the road toward cubism, but he still could not consistently ignore the bypaths. That step remained to be taken in 1909, after his close association with Braque had begun.

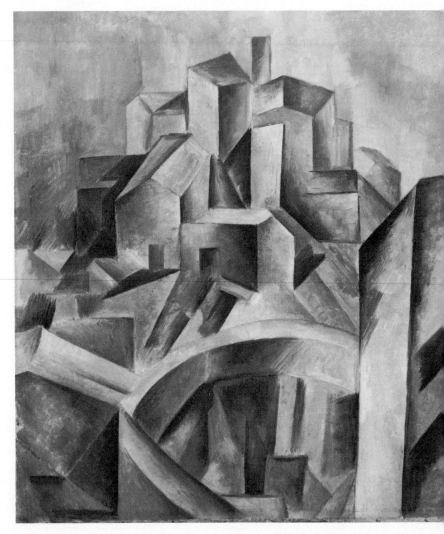

The Reservoir, Horta, 1909, oil on canvas, 60.3 x 50.2 cm. Private collection, New York

During 1908 and the first half of 1909, the friendship between the two artists deepened. By the time they had separated for their summer holidays that year, they had begun to collaborate closely, exchanging frequent visits to examine and discuss one another's work.

That summer, Picasso decided to take Fernande to Spain for a sojourn at Horta de Ebro (or San Juan), where he had lived so happily with Manuel Pallarés and his family ten years earlier. En route, they stopped in Barcelona to visit the artist's family and to join Pallarés, who now lived in the city but planned to accompany them to Horta. Daix calls Picasso's visit there a "pilgrimage" to honor his first friend, a notion which seems entirely plausible.[5] To commemorate their reunion, Picasso painted Pallerés's portrait in a rather conservative style which owed much to Cézanne (Z, XXI, 425). The return to this less radical style reflects the vacillation which characterized Picasso's work during 1908–9, a period which Barr labels a time of exploration, "with much trial and perhaps some error."[6]

Spain soon worked its old magic on Picasso. Relaxed and serene again in his village where he had always felt so happy, buoyed by his reunion with Pallarés, the artist made another giant step toward analytic cubism. The uncertainty which had characterized his work after the *Demoiselles* ended, and in a series of magnificent landscapes showing the rooftops of Horta against their mountainous background, he carried Cézanne's utilization of multiple viewpoints and geometrization of the motif to its ultimate logical conclusion. Critics agree that these pictures initiated Picasso's true analytic cubist style. They were the fruit of two years of experimentation.[7] Meanwhile Braque, working in the Seine valley, made equally exciting discoveries.

No sooner had Picasso and Fernande returned to Paris after this vacation than the artist decided they should move. He chose an elegant new studio-apartment on the Boulevard Clichy, which he furnished with an eclectic mixture of antiques. To complete this change in life style, he even engaged a live-in, uniformed maid. Despite his ambitious plans, Picasso felt ambivalent about leaving the Bateau-Lavoir, where he had been so happy, and Fernande was filled with misgivings about their change of residence and manner of living.[8] Yet she did not permit herself to recognize its true significance: the move demarcated the beginning of Picasso's intense relationship with Braque, and the diminution of Fernande's importance in his life and art. That Max Jacob understood the full import of the change is suggested by the fact that he fell ill immediately afterward and did not recover until Picasso brought him to his new apartment to convalesce. During the following months, Jacob experienced his first visions of Christ and became preoccupied with religious ideas. In later years, Jacob compared his love for Picasso to his love for Christ.[9] Perhaps the latter replaced the former in Jacob's affections after Picasso became so involved with Braque. Subsequently, Picasso almost invariably changed his residence, his furnishings, and his complete mode of life whenever he formed a significant new relationship.

Picasso's new apartment on the Boulevard Clichy was located so near t
Braque's that the two could easily exchange daily visits. Soon they were workin,
so closely in tandem that each felt compelled to see the other's paintings an‹
neither considered a canvas finished until they both agreed it was complete
An anecdote which Picasso himself related many years later provides a measur
of the mutuality which he and Braque ultimately achieved. The Spanish artis
called on Braque one day to find the latter busily at work on a still life con
taining a pipe, a deck of cards, and other objects. (Picasso provides no date
but the incident probably occurred around 1911, during the height of th
hermetic phase of cubism.) While looking at the painting, Picasso experience‹
what he dubbed a "paranoic vision" and saw—or pretended to see—a squirre
among the objects portrayed. Braque immediately saw it too and spent th
next week struggling to eradicate the imaginary creature from his painting. "H
changed the structure, the light, the composition, but the squirrel always cam‹
back, because once it was in our minds, it was almost impossible to get it out. . .
Finally, after eight or ten days, Braque was able to turn the trick and the canva‹
again became a package of tobacco, a pipe, a deck of cards, and above all
cubist painting."[10]

The unique character of the partnership reflected in this anecdote remain‹
one of the marvels and mysteries of art history. Its meaning for Picasso ca‹
be comprehended only in the light of recent psychoanalytic discoveries con
cerning individuals with personality defects originating in earliest childhooc
Apollinaire had helped Picasso to mitigate the legacy of his childhood handi
caps; as a result, the artist learned to behave and respond emotionally in
manner more in keeping with his chronological age. In his association wit‹
Braque, Picasso could move up to a still more mature type of relationship, on‹
involving greater mutuality with an alter ego.[11] In such symbiotic relationship‹
the two participants assist each other through shared enterprises, thus satisfyin
each other's personal requirements.

One often observes similar behavior in genetically identical twins, wh‹
operate as a self-sufficient unit, without requiring or desiring much contac
with anyone outside the twinship. It seems quite appropriate that Picass‹
chose another painter as his special partner; perhaps he was unconsciously in
fluenced to make this choice by his dawning awareness that he stood on th
threshold of a revolutionary artistic innovation, one which he would not hav‹
dared to complete without Braque's support. Years later, Picasso remarked tha
Braque had loved him more tenderly than any woman. This comment doe‹
not mean that their association was eroticized. Rather, Picasso experienced th‹
relationship as so tender because he continually discovered new and admirabl‹
aspects of himself in Braque.[12] One can easily understand why Braque an‹
Picasso responded to each other in that way: theirs was an attraction of o‹
posites, and each complemented the other's attributes perfectly. Physicall‹
Picasso was diminutive and graceful, Braque tall and strapping. Psychologicall‹

icasso was intuitive and impulsive, Braque slow and cautious. Artistically,
o, they meshed ideally: Braque was the more painterly of the two, whereas
icasso excelled in draftsmanship. Braque worked carefully and deliberately,
icasso rapidly and instinctively. Even in their choice of subject matter, the
vo young men complemented each other. The more sociable Picasso liked to
o portraits and the human figure, whereas the more introverted Braque always
referred the impersonal still life. Together, they formed a larger-than-life
omplex, a single superartist. No wonder they could pledge themselves to
reate an anonymous art dedicated to research, from which every individual
retense or vanity would be excluded: all their narcissistic needs were satisfied
n their twinship.

Although I have not attempted to explore the significance of this twinship
or Braque, it must have had as much importance for him as for Picasso.
Jearly half a century later, Braque described their association in the most
noving terms as a unique experience in his life:

> In that period, I was closely linked with Picasso. In spite of our very
> different temperaments, we were guided by a common idea. Picasso is
> Spanish, and I am French—everyone knows the difference that involves;
> but during those years, the differences didn't count . . . [The dots are re-
> produced here as they appear throughout the original text. It is unclear
> whether they actually represent omissions, or merely pauses, in Braque's
> comments.] We lived in Montmartre, we saw each other every day, we
> talked . . . Picasso and I said things to each other during those years that no
> one says anymore, things that no one would know how to say anymore,
> things that no one would understand . . . things that would be incompre-
> hensible and that gave us so much joy . . . and that will end with us. [The
> interviewer reports that Braque's voice trembled a bit here.]
>
> It was a little like being roped together on a mountain . . . We worked
> very hard, the two of us . . . The museums didn't interest us anymore. We
> went to exhibits, but not so much as might be believed. We were above all
> very absorbed.[13]

Perhaps because he was less able to resign himself to the twinship's dissolu-
ion, Picasso never discussed it publicly with the same frankness as Braque.
Rather, he contented himself with calling Braque nicknames ("my wife,"
"Mme. Picasso") which, although intended to be deprecatory and to plant the
alse impression that Braque's attachment to him had been passive and feminine,
nadvertently revealed Picasso's continued affection and sense of loss.

By the time Françoise Gilot knew him, Picasso's relationship with Braque
iad deteriorated until few vestiges of their old intimacy remained. Picasso
poke wistfully to Gilot about Braque's reserved attitude toward him but seemed
nable to suppress the competitive, provocative behavior which caused Braque

to withdraw protectively. That Braque would have behaved quite differently had Picasso bridled these tendencies we may infer from an incident described by Gilot. Shortly before Braque died, she brought her son, Claude Picasso then a boy of fifteen, to meet the elderly Norman. The sight of Claude, who closely resembled his father as a young man, caused Braque to burst into tears. Weeping, he recalled how much he had loved Picasso and how grieved he had been to witness the metamorphosis which fame and time had wrought in his Spanish colleague's character.[14]

Because the human figure always assumed such a significant role in Picasso's art, it seems appropriate that he revealed his major cubist discoveries of the next eighteen months in a series of great portraits. He began at Horta with depictions of Fernande that moved away from his conservative treatment of Pallarés by breaking up the surface of her face into multiple facets (Z., II, pt. 1, 169–72). That autumn in Paris, he executed a three-dimensional version of this new portrait type, the first cubist sculpture. Although this work moves away from the symmetrical depiction of facial features which had always governed sculpture of the past, it still retains something of the aura of nineteenth-century realism. Maybe the artist could not bring himself to subject this more life-like three-dimensional image of his mistress to such radical formal disintegration.

Fittingly enough, it was in a portrait supposedly depicting Braque, Picasso's partner in this great enterprise, that the artist first revealed the "really radical character" of cubism and made explicit the threat it posed to the integrity and unity of the object. Successful as it is, this portrait seems puzzling in one respect: it is far less legible as a likeness of Braque than some of the cubist portraits which Picasso would create later, in 1910. This apparent paradox may be explained by the fact that the canvas does not actually depict Braque. Many years after its completion, Braque explained to John Richardson that the picture was not really a likeness, but only a representation of a man who had resembled him slightly.[15] By this feint of substitution, Picasso could utilize his "twin" to reveal his new discoveries yet preserve what appears to have been a taboo, self imposed, against portraying Braque's features in recognizable form. It seems likely that Picasso actually portrayed Braque many times, either indirectly, via the depiction of objects associated with him, or actually, but so cleverly hidden as a "masked entity" that we do not recognize the personality behind the mask.[1]

Following the completion of his portrait of the pseudo-Braque, Picasso painted Ambrose Vollard (Z., II, pt. 1, 214), Wilhelm Uhde (Z., II, pt. 1, 217), and Daniel Henry Kahnweiler. Although the artist was quite friendly with all three men, none were his intimates. Vollard and Kahnweiler both sold his works, while Uhde was a friendly collector whom Picasso knew less well than the two dealers. One can study the progressive disintegration of form in each of these pictures until, with Kahnweiler's portrait, completed toward the end of 1910, the ultimate vocabulary of analytic cubism is spelled out in a

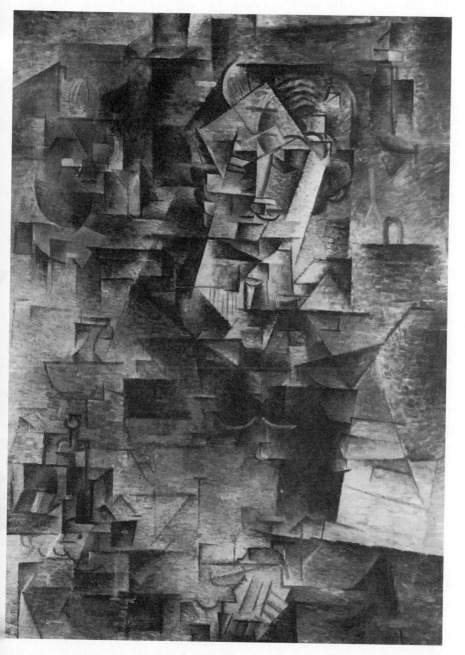

Portrait of Daniel-Henry Kahnweiler,
1910, oil on canvas, 100.6 x 72.8 cm.
The Art Institute of Chicago. Gift of
Mrs. Charles B. Goodspeed

dazzling picture from which all traces of naturalistic perspective have vanished, so that subject and setting are rendered as a series of floating, interpenetrating, faceted planes lacking all traditional indications of depth and volume. Nor did Kahnweiler's importance to Picasso's cubist style end with posing for this picture. He became the chief dealer to Braque, Picasso, and later Juan Gris, he participated in many of the artists' discussions about cubism, and he wrote the best of the early texts dealing with this style.[17]

To create these three portraits, Picasso departed from his usual practice of painting without a formally posed model to require lengthy, repeated sessions with his subjects. We know that the Vollard and Kahnweiler portraits both required months of patient sittings before the artist felt satisfied with his work.[18] Undoubtedly, while devising this radical new style, Picasso needed to check his disintegration of the person against the actual reality of the model so that he would not stray into an arbitrary, inaccurate analysis. On a less conscious level, Picasso also may have wanted the person before him in order to reassure himself that the subject really remained intact while being disassembled on canvas. Even when he was not interested in executing a specific portrait, Picasso sometimes used a live model during this period. For example, the picture called *The Girl with a Mandolin* represents an actual person, Fanny Tellier. It remains unfinished because Mlle. Tellier finally refused to return, disgusted by the excessive number of sittings the artist required. Picasso broke off painting the canvas at that point. In its present state, the portrait retains vestiges of illusionism which Picasso probably would have modified or suppressed had he brought the canvas to completion. Although we lack information concerning his typical procedure during this phase of analytic cubism, it seems likely that he always worked as he did in this case, from the more integrated to the more fractional view of the subject. Barr reproduces a pencil drawing Picasso made in 1915 which reveals the faint trace of his original naturalistic outline of the seated figure beneath the cubist overlay of floating planes with which the artist later masked it. Barr points to this sketch in support of his hypothesis that "from 1910 on cubist structure is itself a scaffolding built around the natural form."[19] In fact, one can often discern vestiges of such scaffolding beneath the surface of analytic cubist canvases. In view of Picasso's need to have the living subject before him while he created his 1910–11 cubist portraits, it seems likely that he also kept the underlying outline of the person's figure clearly visible until the picture neared completion, when he would disguise or eradicate the most obvious traces of this skeleton. Such a procedure would have served a double purpose, offering psychological reassurance concerning the continued integrity of the subject, while simultaneously providing the artist with procedural guidelines.

Many years later, Picasso emphasized to Gilot that he had been very conscious of the need to provide his spectators with concrete clues to the identity and location of the subjects in these early cubist portraits. He specifically cited

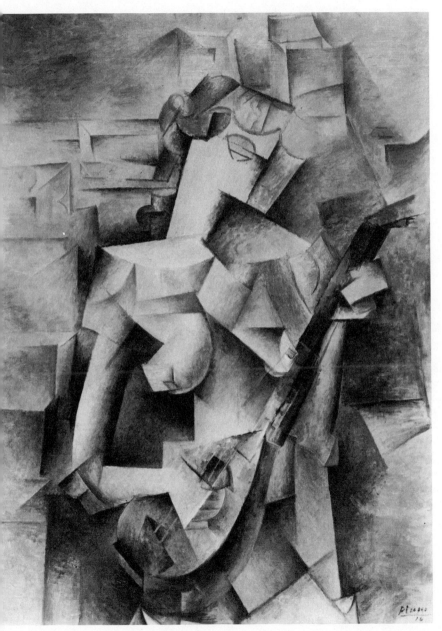

The Girl with a Mandolin (Fanny Tellier), 1910, oil on canvas, 100.3 x 73.7 cm. The Museum of Modern Art, New York. Nelson A. Rockefeller Bequest

the *Portrait of Daniel-Henry Kahnweiler,* commenting that it had looked to him as though it were about to go up in smoke until he added the "attributes— a suggestion of eyes, the wave in the hair, an ear lobe, the clasped hands" to help the observer resolve the gestalt and orientation problems the picture presented.[20]

Golding suggests that Picasso used postal cards, photographs, and other illustrations as additional guidelines and sources of subject matter during 1909.[21] One wonders whether the artist limited the practice to this period. Later in his career, he often used reproductions as compositional aids, and he may have continued to employ such props intermittently throughout his cubist period. Such devices, like the use of the live model, would have helped to reassure the artist concerning the illusory nature of his disintegration of the motif. Picasso was a very literal, magical man, and the act of piercing and disintegrating forms on canvas must have been psychologically quite threatening to him. The fact that he achieved this creative destruction indicates that he adequately controlled such anxiety. Nonetheless, it required the mastery of his most terrifying childhood experience: his propensity for suffering subjective feelings of imminent disintegration. It seems as inevitable as it does marvelous that Picasso, who had been the child who fragmented, should mature into the artist who would invent a radical new art style based on creating the illusion of just such a fragmentation. No wonder he required live models, photographs, and other props to reassure himself that this disintegration occurred only on his canvases and neither within himself nor in his world. Picasso and Braque destroyed more than the concept of closed forms: cubism negated the entire illusionistic basis of Renaissance-tradition painting. This aspect of cubism may have presented more of an emotional challenge to Picasso than to Braque, who came from a family of house painters, while Picasso, the son of a tradition-bound, conservative academic painter, had been taught from childhood to revere and practice the very principles of painting which he now overthrew.

During the summer of 1910 Picasso and Braque again vacationed separately. Without his stolid Norman partner to restrain him, Picasso began a number of advanced analytic paintings, but could not complete them. Perhaps he found this type of creativity too threatening to undertake in isolation, too forcefully reminiscent of his chronic sensations of loss of integration and personal identity. He returned to Paris that autumn in a black mood, dragging along the load of unfinished paintings, all he had to show for weeks of arduous labor. Subsequently, Picasso avoided a repetition of this catastrophe by vacationing with Braque, so that their collaboration could flow without interruption. His reunion with Braque that autumn of 1910 apparently restored Picasso's equanimity; he quickly completed these unfinished pictures and began the portrait of Kahnweiler which would demonstrate his complete mastery of the cubist idiom.

After he completed the Kahnweiler picture, Picasso painted no other identifiable cubist likenesses, an omission which seems especially surprising in view

f the complete success he had achieved with this portrait. Many critics (including even Kahnweiler himself) noting this uncharacteristic change of artistic focus, have assumed that Picasso's high cubist style was simply incompatible with portraiture.[22] Such explanations probably underestimate the complexity of this problem, the extent to which the artist's cubist portrait practices were influenced not only by his current artistic goals but by his magical beliefs in the destructive powers of his own ideas and images. It seems quite likely that he equated the fragmentation depicted in his representations with the possibility that actual harm might come to those so portrayed. As a result, he avoided making—or at least making recognizable—portraits of this type.

Months before he achieved his full-fledged cubist style, Picasso had stopped creating identifiable images of himself and the members of his innermost circle. His final recognizable cubist self-portrait dates from late 1909. At about the same time, he painted his last depiction of Jacob in this style. His final identifiable representations of Fernande date from late 1909 to early 1910, when she apparently inspired a number of seated female nudes (Z., II, pt. 1, 200, 201, 213, 215). No cubist paintings identified as representing Apollinaire or Braque have ever come to light. (Picasso did make a drawing for Apollinaire in 1913, probably at the latter's request. It was designed to serve as a frontispiece for the poet's book of verse, *Alcools*. Although this picture has always been identified as a portrait of Apollinaire, the visage is so faceted and masked that it is unrecognizable. It would seem entirely consistent with Picasso's practices if it were actually a pseudo-portrait, like the earlier representation of Braque.) The special manner in which the artist treated his own image, as well as those of his nearest and dearest, suggests his greater concern with keeping himself and them safe from the potentially destructive forces of his own powerful image magic.[23]

Although Picasso had stopped creating explicit cubist portraits by 1911, he by no means abandoned the representation of the human face and figure in his art. One discerns vestiges of specific images beneath many of his 1911–14 cubist pictures which suggest that they were painted with a certain person in mind. Still others might be called conceptual or symbolic portraits, because they appear to allude to, rather than represent, an actual person. Such pictures occur so frequently that it probably would be more accurate to say that, although Picasso continued to create cubist likenesses, he deliberately stopped adding what he called the "attributes," the characteristics or objects which would help us to discern the sitter's exact identity and pose. The provocative titles bestowed on these canvases, such as *The Poet, The Boxer,* and *The Woman in a Chemise* (or *Seated in an Armchair*), titles listed by Zervos and apparently devised with Picasso's approval, if not his active collaboration, suggest that these canvases portray real individuals, members of the artist's inner circle. Apollinaire, Braque (an avid amateur boxer), and Eva, the mistress who replaced Fernande in Picasso's affections, seem the likely subjects of the pictures cited,

but one might supply many other similar examples from his oeuvre during these years. If such canvases do not constitute literal portraits, they at least refer symbolically to specific people. Rubin's investigation revealed that the *Ma jolie,* or *Woman with a Guitar or Zither,* (Z, II, pt. 1, 244) at the Museum of Modern Art, constitutes just such a symbolic image. Intrigued by the contrast between the highly legible words inscribed on the canvas and the "nearly indecipherable image of the 'pretty one' to whom they appear to refer," Rubin tested his hypothesis that the painting actually represented Eva by questioning the artist. Picasso replied that "the picture was painted from the imagination and that while it was in no way a portrait, he had Eva 'in mind' when he painted it."[24]

It seems likely that Picasso had himself or other close friends equally "in mind" while creating many other pictures of this period. Even his contemporary still-life canvases typically show objects so personalized that they, too, might be described as symbolic or conceptual portraits. It is interesting to note, for example, how often his canvases of 1912–14 combine representations of musical instruments with allusions to "Ma Jolie." Braque liked music very much and played several instruments. It seems likely that such canvases contain bracketed references to both Braque and Eva, the two people at the heart of the artist's contemporary existence. One such still life from 1912, *The Architect's Table* (Z, II, pt. 1, 321), refers not only to Picasso, the "architect" of the piece, but to Eva, saluted once again as "Ma Jolie," to Gertrude Stein, whose calling card (rendered as "Mis Gertrude Stein") appears reproduced at the lower right, and probably also to Braque, symbolized in the form of the music album and the violin scroll. Thanks both to Rubin and to Stein (who described how she had left her calling card when she had visited Picasso's studio one day to discover this—or a very similar—canvas on his easel, but the artist absent), we possess much more information about the iconography of this oil than many of Picasso's other cubist still-life pictures.[25] If we could penetrate their mysteries with equal ease, we would probably discover that they, too, contain such rich mélanges of personal references.

Picasso always loved using codes, secret pseudonyms and special terms comprehensible only to his intimates. The idea of concealing the most personalized representations and references beneath the cubist faceting of these pictures would have been doubly appealing to him. By such devices, he could preserve his apparent prohibition against depicting himself and his loved ones in his full-blown cubist style, yet simultaneously refer to them by various cryptic devices.[26]

Nineteen-eleven marked both the high point of the Braque-Picasso partnership and the acme of analytic cubist severity. The work of the two artists became extremely hermetic, difficult to interpret, and difficult to distinguish from one another's. The latter task was made no easier by their refusal to sign their paintings (following a suggestion of Braque), evidently as a demonstration

of the unity of spirit in which they were achieved. Later, in 1935, Braque explained that Picasso and he had been engaged in a search for "the anonymous personality" during this early cubist period: "We were inclined to efface our own personalities in order to find originality. Thus it often happened that amateurs mistook Picasso's paintings for mine and mine for Picasso's. *This was a matter of indifference to us* because we were primarily interested in our work and in the new problem it presented."[27] Sustained by their twinship and their sacred search, apparently neither Braque nor Picasso required recognition from the outside world. Perhaps they even consciously or unconsciously hoped that their paintings would be confused, because this would constitute objective proof of their experienced unity.

Picasso continued to be extremely productive throughout 1911, despite the radical nature of the experiments in abstraction upon which he and Braque were engaged. Nonetheless, he suffered an exacerbation of the physical and psychic symptoms which had begun to plague him in 1909, during the early stages of the cubist revolution. Olivier describes him during 1911 as restive, glum, and hypochondriacal, constantly fretting about catching some dread disease, especially tuberculosis, and requiring massive reassurance from Fernande and his physician that all was well. Finally, the artist's symptoms of gastric discomfort became so acute that the doctor prescribed a bland, limited diet—fish, vegetables, milk, grapes, rice pudding, and mineral water—to counteract these symptoms (Gilot mentions that the artist suffered from an ulcer intermittently after 1920; maybe this disorder really dates back to 1911). His digestive troubles recall the physical discomforts he suffered during childhood, when he so frequently became ill as the hour to leave for school approached.[28]

Although Picasso was able to continue working, the duplication in his art of the fragmentation he had so often experienced internally obviously was exacting its toll. It cannot be a coincidence that his mental and physical health started to deteriorate as he began his first analytic-cubist experiments and that his symptoms increased dramatically during the very year in which he pushed his cubist discoveries to the very limits of total abstraction. His resulting tensions gnawed at his vitals, and he required the same type of massive reassurance from his intimates that he had earlier elicited from his father before agreeing to remain at school without his protective parent. Both then and during the analytic-cubist epoch, Picasso marched into an unknown terrain fraught with danger, a world in which one might easily experience inner disintegration.

Picasso's anxiety exacted its toll on his interpersonal relationships as well as on his digestive system. His romance with Fernande neared its turbulent close, and she became interested in another man while Picasso indulged in the passing promiscuities he would so often demonstrate during the final stages of a moribund romance. Such behavior indicates that his self-esteem must have

been severely threatened. It suffered another blow that August when he failed to support Apollinaire's story to the police after the latter had been arrested as a possible accomplice in the theft of the *Mona Lisa* from the Louvre. Some sources maintain that Picasso, like the biblical Peter, even denied that he knew Apollinaire when he confronted his distressed friend at police headquarters.[29]

Whatever form Picasso's betrayal assumed, it revealed that the quality of his relationship to Apollinaire had not changed or matured since those crucial days of 1905. In the innermost recesses of Picasso's heart, he expected the poet to function always as his kindly, corpulent jester; Apollinaire's role was to give support and comfort, not require it. On the surface of their relationship scarcely a ripple lingered afterward to mark Picasso's breach of trust, except that the artist believed for weeks that he was being shadowed by the police. He felt apprehensive whenever he had to leave his studio, and he would change cabs several times during the course of a short journey to elude his phantasied pursuers.[30] Did Picasso believe that the police suspected him because, on some more primitive level, he regarded himself as part of Apollinaire? Certainly the artist's infantile behavior vis-à-vis Fernande and Apollinaire contrasts strangely with his apparently more adequate conduct with Braque, Derain, Stein, and others, to whom he showed his more mature self. Like one of his late cubist portraits which simultaneously exhibits profile and full face to the world, Picasso revealed very different aspects of himself to different observers during 1911.

Picasso and Braque vacationed together at Ceret during the summer of 1911. There, sustained by his continual association with his partner, Picasso explored analytic cubism to the limits of interest, fruitfulness, and legibility in a series of canvases of unprecedented asceticism. *The Man with a Pipe* constitutes one of the finest examples of this style, painted in a new oval format devised by Braque (who liked it because it eliminated corners, always a problem in analytic-cubist compositions). This picture reveals far less of the painterly deference still accorded the subject matter in such works as the *Portrait of Daniel Henry Kahnweiler.* In *The Man with a Pipe,* color plays a subordinate role, no longer functioning as a crutch to help the viewer integrate the diced human figure. In the Kahnweiler portrait, by contrast, the subject's facial planes show especially sparkling brushwork, greater variation in placement and size, and more brightness than other areas of the painting. Picasso also used slightly darker bluish-violet shading to differentiate sections of Kahnweiler's shoulders and chest, thus subtly setting the figure apart from the ground. He supplied far fewer clues of this type in *The Man with a Pipe.* The sparkling interplay of facets, which continues to suggest some degree of depth in areas of the Kahnweiler painting, has almost disappeared here. One responds to an underlying sense of structure, but the effect is more severe; the planes tend to be larger, flatter, and less suggestive of oscillation. Despite

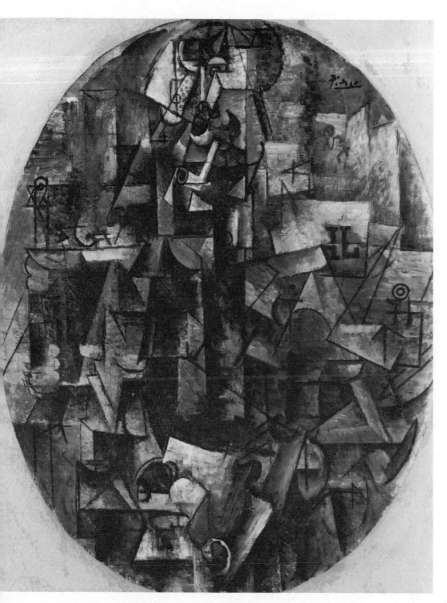

Man with a Pipe, 1911, oil on canvas, 90.7 x 71 cm. Kimbell Art Museum, Fort Worth, Texas. Photograph by Bob Wharton

its apparent severity, the canvas is filled with subtle witticisms. The smoker's head is rendered jauntily, with a V-shaped pointillist area representing one eye, and a hint of a twinkle in the other. His lip and moustache turn up at a jolly angle, and even the impossibly silly, flat position in which he bites his pipe (paradoxically rendered nearly intact) adds to the sense of fun. The words, letters, and symbols scattered over the picture's surface in such an arbitrary way also add to its daring and interest, lightening the effect created by its restricted color scheme. One can combine the two legible but spatially unrelated words *est* and *Il* to form various phrases (*Il est* or *est Il?*). Such reconstructions reflect the spectator's projections, however, which may or may not correspond to the painter's intentions. The identity of the man with a pipe also poses a provocative problem. Guillaume Apollinaire sported a moustache and smoked a pipe during this period, so the smoker may be he. This same visage—or a very similar one—appears in a number of other pictures from this period, such as the two versions of *The Poet* and the *Man with a Guitar* (Z., II, pt. 2, 285, 313; XXVIII, 157).

By the end of 1911 Braque and Picasso had brought analytic cubism to the apogee of its development. The next logical step would have involved extending the style into complete abstraction, but both men recoiled from this alternative. They chose, instead, to develop a more lyrical, integrated variety of cubism generally known today as synthetic cubism. An examination of Braque's motives for rejecting abstraction would take us beyond the scope of this book. Picasso, for his part, showed a lifelong inability to assume and maintain an abstract attitude. Even as a small child, his perceptual abilities were so hyperdeveloped that, for him, abstract symbols immediately transformed themselves into concrete signs. For example, he perceived arithmetic symbols as animalistic signs which distracted him from mastering mathematical reasoning (a fact conveniently overlooked by the art historians who have, from time to time, tried to invent art history by turning the intuitive cubism of Braque and Picasso into deliberate experimentations in representing complex mathematical theories, although Picasso repeatedly insisted that this was not the case). In fact, Picasso was so unable to conceptualize abstractly that he even denied explicitly that nonfigurative art exists: "Everything appears to us in the guise of a 'figure.' "[31] Picasso could never have adopted the abstract, geometric solutions which Malevich and Mondrian later followed. The only course open to Picasso was to enrich cubism, the option Braque also selected.

By the close of 1911, then, Picasso's most hermetic cubist phase was drawing to a close. During this transitional phase, a strange contradiction appeared in his work. In the midst of a group of austere, abstract canvases completed during the late winter and early spring, he suddenly painted a totally representational picture, *The Letter* (Z., II, pt. 1, 293). The small-sized canvas shows only that object: a self-addressed envelope with a real stamp attached. One wonders whether this strange picture contains a hidden message. Around this

me time, Picasso moved his working atelier back to the Bateau-Lavoir, where
e had continued to maintain a storage studio ever since he had moved to the
oulevard Clichy.[32] Was this move designed to gain him privacy from Fer-
ande? This "letter," addressed to himself at his Boulevard Clichy address,
ay have signified his intention to move or the accomplishment of that plan.
is probable that this insignificant little picture (its present whereabouts are
nknown) was actually the first collage, rather than the famous *Still Life with
hair Caning* (Z., II, pt. 1, 294) which Picasso completed later that spring.
e retained the latter painting for his own collection, perhaps not only because
constitutes a famous innovation in art history (he glued a piece of cane-
atterned oilcloth to the surface of the canvas, then "framed" it with a length
f real rope), but also because he owed this invention to memories of his
ather's practice of pinning pieces of painted canvas to works in progress so
at he might try out various effects.[33]

Picasso did not employ this revolutionary new collage technique in any of
he other pictures he completed before going on vacation, but these canvases
ll feature larger, more legible flattened shapes as well as trompe l'oeil effects
reproductions of liquor-bottle labels, cockle shells, and the like) and painted
ords with strongly personal references. For example, the legend "Notre
venir est dans l'air," which appears on several of them (Z., II, pt. 1, 311, 312;
t. 2, 734), was directed to Braque, the "older Wright brother" in the cubist
artnership that had certainly started to take off in wilder directions that
pring.[34] Other canvases contain the enigmatic salutation "Ma Jolie," taken
rom the title of a current popular song. This mysterious reference was cleared
p a few months later when Picasso eloped with his new "Jolie," Eva Gouel,
lso known as Marcelle Humbert.

During the previous year, the Picasso-Fernande relationship had been
narked by increased dissension and mutual infidelity. Nonetheless, Picasso
haracteristically waited for Fernande to make the first move toward separa-
ion. When she ran off with another artist, Picasso immediately eloped with
va.[35] He had lured her away from her love, a minor cubist painter, Louis
1arcoussis, and he called her Eva to designate her position as the first woman
n his affections. The fugitives stayed briefly in Céret—until Fernande appeared
n the scene as the guest of Picasso's old friends, the Pichots. The resulting
inpleasantness caused Picasso and Eva to decamp once again.[36] Eventually,
hey settled at Sorgues, near the spot where Georges Braque was honeymoon-
ng with his bride, a young lady also named—perhaps not so coincidentally—
Marcelle. (Picasso had originally introduced the Braques, just as he had
ntroduced his earlier partner, Apollinaire, to his great love, Marie Lauren-
in). At Sorgues, Picasso's allusions to his mistress in his paintings grew
>older. He wrote "Jolie Eva" across the face of a large handsome still life
eaturing simulated wood graining (Z., II, pt. 1, 342) and "J'aime Eva" on
nother. He painted yet another *Ma jolie* still life directly on a wall of his sum-

mer cottage, then insisted that Kahnweiler have it cut out and shipped to Picasso's studio when he returned to Paris (Z., II, pt. 1, 351).

After an idyllic summer in which he regained both his good humor and his good health, Picasso returned with Eva to a new apartment in a new neighborhood, Montparnasse. This time he did not even set foot in the lodgings he had shared with Fernande: Kahnweiler had accomplished the transfer of Picasso's belongings while the latter vacationed. As usual, Picasso needed to divorce himself from his old associations physically as well as spiritually, and he also relinquished his Bateau-Lavoir studio at this time. His choice of Montparnasse, then a less Bohemian quarter than Montmartre, may have signified an intention to lead a more settled, bourgeois existence. This change also meant that he could not work as intimately with Braque as when they were virtually next-door neighbors. Maybe some unrecorded quarrel or other difficulty had attenuated their intimacy, influencing Picasso's choice of locale for his new home. Or perhaps such a dilution of their intense twinship was inevitable, the natural result of Braque's commitment to his bride and of Picasso's to Eva. Whatever the reasons, the relationship underwent a subtle change: they stopped exchanging daily visits, and their specific works took on more individual characteristics, although their general development followed similar paths.

Eva brought a new stability and order to Picasso's life, which immediately reflected itself in his work. During the next two years, his productivity was matched only by his ingenuity. He utilized his own inventions, the collage and the cubist construction, in a number of new ways; but he made equally daring use of Braque's discoveries, the relief painting (sand, sawdust, and the like added to pigments to provide textural and surface variations) and the papier collé (pasted papers). The latter technique particularly intrigued the artist. He began that fall with a series of paintings employing pasted papers prepainted to simulate wood graining (Braque, originally trained as a house painter, undoubtedly taught him this technique) which he often wittily affixed to the painted musical instruments depicted in these still lifes. Here, as in so many of his contemporaneous inventions, Picasso lightheartedly explored the relationship between illusion and reality (Z., II, pt. 2, 385, 404, 417). In a second set of papiers collés canvases, he employed pieces cut from the same roll of wallpaper to serve a wide variety of functions; sometimes it formed part of the figurative element in a picture, sometimes the ground, and sometimes it served both functions in a single picture (Z., II, pt. 2, 372, 422, 423).

These two types of canvases seem quite decorative, featuring bright colors and large, lyrical shapes, but during the same months, Picasso also invented another type of radically different papier collé. Executed on paper, many of these works might more properly be described as drawings with collage. They often involve little or no painting and consist mainly of a charcoal draw-

ing to which a piece of newspaper is affixed (Z., II, pt. 2, 391, 397, 400, 402). Although these pictures, too, contain subtle witticisms, they appear much more angular and architectonic than the papiers collés executed from other materials. Picasso's unconventional use of newspaper clippings to form fine art reveals that he had discarded yet another premise of traditional painting. Earlier artists had always painted for the ages, employing the most durable materials and techniques they knew. Works composed partially of newspaper carry the seeds of their own destruction—inevitably, they will disintegrate and cannot be restored as a more conventional oil painting can be. Such works proclaimed Picasso's disdain both for artistic tradition and for the survival of his own creations of this type. Since Picasso inaugurated this custom, paintings executed on or employing newspapers have become commonplace. In this, as in so many other instances, he was the great initiator.

Picasso moved from these newspaper pictures to the creation of an even more fragile group of works. He made another series of constructions involving newspaper, plain paper, and cardboard, creations so delicate that most of them disintegrated within a few years of their fabrication (Z., II, pt. 2, 770, and 790 show two that survived long enough to be photographed by Zervos).

Critics have repeatedly engaged in lively debates concerning the proper allocation of credit for all such inventions and refinements which broadened the base of cubism. Their assessments have often downgraded the importance of Picasso's contributions as compared to Braque's, an error which Daix attempts to correct in his new monograph about Picasso's cubist period.[37] The two artists themselves always emphasized that they viewed cubism as a joint effort which neither could have undertaken singlehandedly. If Picasso had struggled toward cubism alone, or if Braque had worked without Picasso, the result could not have been cubism as we know it today. Undoubtedly, some type of anti-illusionistic painting would have appeared, because the time was ripe for it, but it would not have been the Braque-Picasso brand of cubism. To argue about which artist introduced more refinements into synthetic cubism is to rehash the chicken-and-egg debate. Out of their unique partnership, Braque and Picasso created something unique, and the years of their close collaboration were perhaps the finest hours of both artists.

The summer of 1913, which Picasso and Eva spent at Céret with the Braques, Jacob, and Juan Gris, seems to have been peaceful and happy, even though the artist's father had died that spring and Eva's failing health aroused his concern.[38] Most biographers have ignored the death of Picasso's father, an attitude which doubtless reflects the artist's own reticence in discussing his loss. Don José died at the beginning of May; Picasso, summoned by his family, arrived in Barcelona in time to attend the funeral, where he felt completely isolated "from family, friends, everyone." It seems likely that it was really Picasso who isolated himself from the others, in a disavowal of the terrible grief he really must have experienced. He always tended to react to illness and death with

Woman in a Chemise (*The Woman in an Armchair*), 1913, oil on canvas, 148 x 99 cm. Collection of Mr. and Mrs. Victor W. Ganz, New York. Photograph by Eric Pollitzer

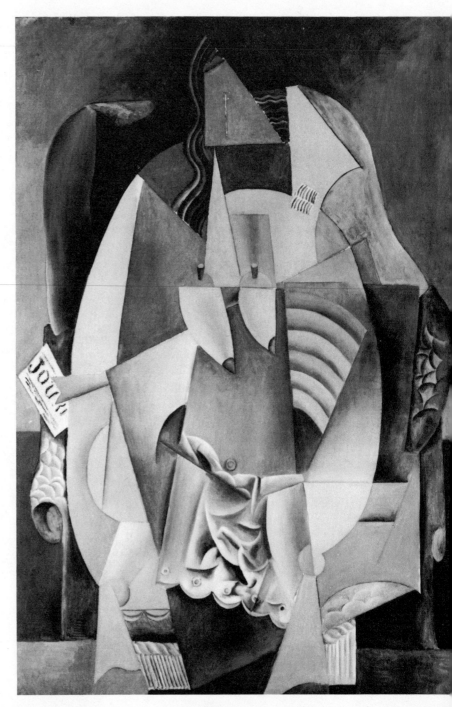

phobic fears and avoidance, particularly when the victim was a man with whom he had enjoyed an unusually close relationship. When Apollinaire died in 1918, Picasso invoked various magical taboos, and he could only attend the poet's wake accompanied by his wife, Olga. After Matisse died, the latter's daughter attempted several times to contact Picasso by telephone, but he would neither acknowledge her calls nor attend the funeral. When the artist's own son, Paulo, suffered a dangerous lung embolism following surgery in 1954, Picasso ignored a summons to the young man's bedside.[39] Propriety required that he attend his father's funeral, but he divorced himself from the proceedings by erecting that protective isolating wall around himself and his feelings. None of the biographical sources indicate that Picasso visited his mother later during the summer of 1913, although he crossed the Spanish border several times to see bullfights and presumably could have gone on to Barcelona. Did he fear that, if he went, his grief-stricken mother would reawaken his old conflicts about separation?

Perhaps as a result of his mourning, Picasso's production diminished a bit during the latter half of 1913, but in his work his gaiety seemed unabated. During the following winter and spring, he painted a number of canvases involving playful games with color, shape, texture, and materials. These culminated in another group of constructions made of all sorts of odds and ends in strange combinations and which so strongly anticipate, not only Dada art, but the neo-Dada experiments of artists like Robert Rauschenberg and Jasper Johns. In creating such hybrids (Z., II, pt. 2, 575–78, 853) Picasso moved beyond the violation of the "sacredness" of the canvas to blur still further the traditional distinction between painting and sculpture. Gertrude Stein later described the beginnings of cubism as a time when pictures commenced to want to leave their frames, a description which seems most appropriate for these cubist still-life constructions, which were neither paintings nor sculptures in the conventional sense.[40]

One picture that Picasso created that winter possessed a more mysterious, evocative quality: the *Woman in a Chemise*, or *The Woman in an Armchair*. It reflects a disturbing contradiction between sensuality and sadism, particularly in the treatment of the fleshy profile breasts, painted so seductively, then incongruously nailed to the figure's torso with outsize pegs. This picture has always been admired by the surrealists, who consider it an outstanding example of surrealism created before its time. While he worked on this picture, Picasso seemed well aware that it would enjoy a special status in his oeuvre. He preceded work on the canvas with a long series of careful preliminary drawings and followed it with a number of pictures of a man or a woman in an armchair which seem derived from this painting.

The picture apparently also possessed some special private meaning for Picasso, who kept many of the compositional drawings sequestered and did not release the last of them until shortly before his death. In 1975 the supplemen-

tary volume of the catalogues raisonnés showing these drawings appeared (Z., XXIX, 1–4). It revealed that Picasso had contemplated rendering the *Woman in a Chemise* with a cubist body but a representational face (albeit a stylized and flattened visage). The fact that Picasso hid these drawings lends further credence to my strong belief that the painting depicts Eva and her chronic invalidism, showing her reclining in an easy chair in a state of attractive dishabille. The nailed breasts have often been interpreted as a sadistic detail instead, they may indicate that this region was the core of Eva's anguish. Picasso lavished a great deal of attention on this area: note the emphasis on the rib cage as well as the ominous red streak which runs from her left breast to her throat. Within two years of the time Picasso completed this canvas, Eva was dead of tuberculosis.

Still more recently, another apparent portrait of Eva has come to light, a completely representative, unfinished painting which the artist began at Avignon in 1914 (and probably worked on subsequently) but never completed. Although Picasso participated actively in the repeated attempts to construct a complete catalogue of his works from this period, he never showed this canvas to anyone. It was found among his studio effects after his death. The secrecy with which he deliberately surrounded this oil strongly supports Daix's hypothesis that this may be the only full-scale portrait of Eva in existence.[41]

Known as *The Artist and His Model,* the picture shows a petite, draped nude standing beside an enormous seated young man who rests his head on his raised left hand. As Daix points out, the latter figure recurs in numerous drawings Picasso created during 1914–15. Although the nude's bodily proportions seem quite peculiar, heralding the mannerist distortions in the artist's style which would become much more evident during the war, her face is both idealized and brought to a much higher state of finish than her torso. She and the man seem oblivious of one another, and it is not clear why the canvas bears the title *The Artist and His Model.* The scene is certainly an artist's studio, but nothing about the hulking young man suggests that he is the artist of the piece.[42]

Picasso's peculiar behavior with respect both to this canvas and to the suppressed drawings for *The Woman with a Chemise* suggests that his image magic never operated more strongly than in the case of his representations of Eva. The world has always believed that the artist, preoccupied with cubism, made no portraits at all of this mistress. Once more, the truth seems more complex. Picasso kept Eva just for himself; she was the only one of his loves he refused to discuss at all with Françoise Gilot, except to affirm that he had loved her very much.[43] His refusal to share her with the world encompassed his refusal to share her portraits with others. Such behavior indicates that those biographers who have speculated that Eva was probably the artist's great love were probably quite correct. He created public images of all his other loves with obsessive frequency, but Eva's picture he retained like a secret icon which he could venerate in private.

The Woman in a Chemise was the only significant work featuring the human figure which Picasso created in the months before he left for that Avignon vacation. The rest of his production that spring was given over to a series of lyrical still-life paintings in which he continued his exploration of the new technical inventions and ramifications of cubism. The things depicted in these pictures from the spring of 1914 tend to be large and quite legible; sometimes certain objects and areas in these canvases are rendered quite realistically, like the numerous fluted glasses and playing cards which populate many of these pictures (Z., II, pt. 2, 347, 508, 534). He continued his exploration of sculptural constructions, too, but now he fashioned these reliefs of more durable materials, primarily wood, which he usually painted (Z., II, pt. 2, 838–40, 848, 849). Deliberately left in a rather crude, unfinished state, these reliefs also incorporate found objects used in witty fashion—an idea which the Dada and neo-Dada artists would exploit further. That spring, for the first time since he had created that cubist head of Fernande in 1909, Picasso also returned to sculpture in the round. He modeled a cubist absinthe glass, which he topped with a real spoon and an imitation sugar lump. The work was immediately cast in bronze (probably Kahnweiler saw to these details), and Picasso painted each cast individually, with pointillist dots, so that six unique works of art resulted. Although ancient and medieval sculptures had been painted to enhance their realism, no one had ever painted bronze casts, much less in completely abstract patterns as Picasso did his *Glass of Absinthe*. Once again, Picasso had invented a technique which served to weaken further the old distinctions between painting and sculpture. As Spies points out, this work, with its sculptured glass, real spoon, and imitation sugar lump, also establishes new links between art and reality.[44]

The fact that Picasso became so interested in sculpture that spring probably is not without significance. Although the surface of his life seemed smooth and he continued to be hyperproductive, many disturbing elements heralded changes to come. Eva grew constantly weaker, and the international situation seemed increasingly ominous. Later, Picasso often turned to sculpture during periods of change or crisis in his personal life. The opportunity to work with concrete, real things, to model an object from clay, may have somehow been reassuring.

Braque's work during that same 1913–14 period seems to have been more restrained and intellectual. He apparently did not share Picasso's need to react so strongly against the austerity of their earlier cubist pictures. This deviation in their styles constitutes further evidence that a gradual cooling of their relationship had been in process even before the war separated them, ending their collaboration.

During the summer of 1914, which Picasso and Eva spent at Avignon with the Braques and Derains, Picasso's playfulness reached its zenith. He created a marvelous series of brightly colored canvases, primarily still lifes, in which he often employed the same type of pointillist dots he had used to decorate the

bronzes of the glass of absinthe. On at least one occasion, he carried out this stippled effect with commercial enamel to enhance the picture's brightness (Z., II, pt. 2, 485). He also continued his "Ma Jolie" references in several of these paintings. The most charming of them, a tender tribute to his mistress, utilizes the silhouette of a guitar, which simultaneously suggests a gingerbread heart he had once bought for Eva (Z., II, pt. 2, 525).

Plate 5 *Vive la France,* perhaps his farewell to Braque and Derain, who had to leave Avignon at the beginning of August for army induction, shows one of Picasso's final bursts of gaiety. Although he always remained one of the wittiest of artists, his humor after 1914 often showed a wry, savage twist and he sometimes employed it in a vein of bitter self-mockery absent during this period.

Picasso saw his friends off at the Avignon station on August 2. Later, he sadly commented that he had little dreamed that day, when he told Braque and Derain goodbye, that it would be forever. In a very real sense, that proved to be the case. For many years after Braque returned from the service, Picasso and he were quite alienated, and they would never again collaborate as they had before the war.

**My Glass Has Shattered
like a Burst of Laughter**

Braque's departure for army service in the late summer of 1914 marked the beginning of a period of terrible isolation for Picasso. Apollinaire was the next to go. Although an alien like Picasso, Apollinaire longed to be accepted as a real Frenchman, and voluntary enlistment in the service provided the way. Eventually he was able to get the stain of his arrest in connection with the Louvre theft erased from his record, and he was granted French citizenship as a volunteer soldier. The painters André Derain, Fernand Léger, and other members of Picasso's circle also entered the army. Picasso's dealer and friend Kahnweiler was forced to flee to Switzerland as an enemy (German) alien. Finally, of Picasso's close associates, only Gertrude Stein and Max Jacob remained in Paris, but Jacob no longer played his role of the good genie with full heart. He was preoccupied with the visions of Christ and the mystical ideas which led to his conversion to Catholicism in 1915. Picasso acted as his godfather, supplying Max's Christian name, Cyprien, from his own long list of baptismal names.

Picasso's changed situation soon led to a strange dichotomy in his artistic production. Although he continued to employ the cubist style for his important "public" oils, his more intimate drawings reflected a renewed interest in exact representation. This style permitted him to capitalize upon his unique skills as a draftsman, and these pictures have often been labeled Ingresque, probably because both the neoclassical flavor and the exquisite quality of Picasso's line seem reminiscent of the art of this earlier master. The fact that Picasso retained many of these Ingresque drawings unpublished in his private collection suggests that this style and these pictures possessed some special significance for him. (After the artist's death, these suppressed sketches appeared in Zervos's volume XXIX.) Without Braque beside him to reassure him, Picasso evidently could not sustain his pure cubist manner. He had to resort to the more integrated, traditional type of draftsmanship in which he had received his early training. His dealer, Kahnweiler, concurred in this hypothesis. Many years later, he remembered how puzzled and disturbed he had been by the sudden

Ambroise Vollard, 1915, pencil on
paper, 46.4 x 31.7 cm. The Metro-
politan Museum of Art, New York.
Elisha Wittelsey Collection, Elisha
Wittelsey Fund, 1947

mergence of this classicizing style. He realized now, as an elderly man, that "everything that was done in those [cubist] years could only have been done through teamwork. Being isolated, being alone must have upset [Picasso] enormously, and it was then that there was this change."[1]

Picasso's renewed interest in representation brought a renewed interest in portraiture, but he reserved such works for his Ingresque style. When he reverted to cubism, he reinvoked his apparent ban against creating identifiable images. His classicizing drawings of friends like Jacob and Vollard have become world famous, but the supplementary catalogue raisonné for 1914–17 reveals that he actually created many additional Ingresque portraits (as well as many more representational still lives). These include a number of self-portraits (Z., XXIX, 163, 213–14) as well as a caricature of Apollinaire as a uniformed military hero, apparently made soon after the poet entered the service in 1914 (Z., XXIX, 116). More interesting still by virtue of its stylistically retrogressive character is his rendition of a melancholy bearded man holding a pipe (Z., XXIX, 77). Executed in a manner reminiscent of the artist's adolescent style, this personage somewhat resembles Picasso's father, reminding us of the artist's frequently repeated statement that all the bearded men he ever created symbolized his father.

A number of the drawings from this period also combine cubist and representational elements in a peculiar manner, like the otherwise cubist sketches of an individual whose rather realistic dog perches beside him.[2] Sometimes the sequence of images suggests that the person or scene depicted is gradually dissolving into cubist fragments or, conversely, reintegrating following such dissolution (Z., VI, 1198–1216). Such metamorphoses, reminiscent of the experiences of small children playing peek-a-boo or hide-and-seek, also recall Picasso's childhood fear of separation and resultant disintegration. The young child controls and masters his fears of desertion through such games. One senses that Picasso's "now you see him, now you don't" sketches may have served a similar function.

The love of gentle little Eva sustained the lonely artist, but soon even she was taken from him. During the latter part of 1915, her tubercular condition worsened rapidly and she had to be sent to a nursing home, where she died. Picasso attended her faithfully until her death on December 14, 1915.[3]

These tragic events led to further transformations in Picasso's art. His production declined sharply, and his major cubist paintings of the period reveal a new severity and feature large, hard-edged geometric shapes. These big, well-organized paintings show none of the childlike charm and ebullience which had characterized the works of his rococo period. Barr christened this new style the classic phase of synthetic cubism, a name well suited to the clarity and precision of these works.[4]

During the succeeding months, Picasso made more and more frequent excursions into his naturalistic mode, which finally invaded his paintings as

Harlequin, 1915, oil on canvas, 183 x 105 cm. The Museum of Modern Art, New York. Aquired through the Lillie P. Bliss Bequest

ell as his drawings. By 1917 his Ingresque period was coming into full flower, nd he produced a number of representational canvases in addition to cubist ils.

Many years later, the artist responded to a questionnaire from Barr by enying that there had been any personal or practical reason for the sudden mergence of his Ingresque style.[5] This is difficult to accept when we study he circumstances in which it developed. According to Olivier, Picasso had lways admired Ingres above all other artists; now he turned to Ingres as a reat fellow-draftsman and admirer of female beauty.[6] Evidently Picasso ad been helped enough by his relationship with Apollinaire and then with raque to utilize a more abstract connection with a great figure from the ast, such as Ingres, to replace the actual symbiosis he had formed with these riends.

In discussing Picasso's unfinished *Girl with a Mandolin* (Fanny Tellier) f 1910, Golding points out that it provides an interesting insight into Picasso's orking methods at the time and the conflicting pull he evidently felt "between he desire to give forms an explicit, volumetric treatment, and the need to atten them up onto the picture plane."[7] Perhaps Picasso continued to experi-nce this conflict between the volumetric and the flat long after 1910. In fact, osenberg's definition of the cubist painting as a "mask covering the model r still life," or as a series of shutters which open and close at the will of the rtist to reveal or conceal the form behind them, seems to fit Picasso's cubism ery well.[8] Perhaps his Ingres-like works can be best understood as a total urrender to the volumetric pull or as a throwing wide of the cubist shutters) reveal the more naturalistic figure or object beneath.

During the weeks which Eva spent in the nursing home, Picasso evidently isited her faithfully, for he wrote Gertrude Stein (who was on holiday in pain) that he spent half his time on the subway, in transit between the nursing ome and his studio.[9] Perhaps partially because these trips consumed so much f his time, he painted few canvases during these months, when his dimin-hed production consisted primarily of drawings and watercolors. A little ketch of a crucified Christ from this period is the most overt evidence of the motions Picasso must have experienced as he watched Eva decline and die. 'or the most part, he contained his grief, and the content of his contemporary roduction reflects his private vicissitudes far less than it ever would in the uture. We can measure his distress more readily by departures in his style and he falling off in his production than through overt content clues. Both his onduct between 1913–16 and the content of his work reveal the extent to vhich his psychic functioning had improved as a result of his relationships with Apollinaire and Braque.

Nonetheless, subtle changes in Picasso's motifs during these months indi-te ongoing fluctuations in his psychological status. During 1915–16, the rtist resurrected his old alter ego, Harlequin, who figures prominently in many

of the smaller works, as well as in a large oil which Picasso specifically men
tioned that he found time to paint between trips to see Eva.[10] The theme o
Harlequin, so intimately associated with the circus period and happier days i
Paris, may symbolize Picasso's nostalgia for the times when he attended the cir
cus with Apollinaire, Braque, and other friends to watch the saltimbanque
perform. Perhaps, too, the theme of Harlequin, the ephemeral being wh
triumphs over all human woes, even mortality, seemed especially reassurin
to the lonely artist.

Eva's funeral was made doubly dreary by the dismal winter weather, th
small number of mourners, and the inappropriate behavior of Max Jacot
who made tasteless witticisms throughout the ceremony. Once more, th
normally joyous Christmas season had become a season of Lenten sorrow fo
Picasso. His tender solicitude for the dying Eva varied so greatly from hi
usual phobic avoidance of sickness and death that one is inclined to agre
with those biographers who speculate that Eva may have been Picasso's grea
love. His relationship with her is the one about which we are least informed
not only because he ostensibly preserved a taboo against painting her feature
in recognizable form, but also because he preserved an uncharacteristicall
discreet silence about their relationship. Gilot, who does not mention Eva i
her book, recently confirmed my speculation that the artist had spurned he
attempts to discuss Eva, beyond affirming that he had loved her very much.*
This nearly total absence of data about Eva probably reflects her unique position
She may have been the only woman Picasso ever loved just for herself, and no
because he also needed her to act on his behalf, either to enhance his self
esteem or to perform some other psychological function. If this hypothesis i
correct, it would constitute additional proof that Picasso had gained ne
strength and maturity from his symbiosis with Apollinaire and Braque.

Although Picasso had been able to abandon Fernande Olivier with scarcel
a backward glance when their affair had burned itself out, he behaved in
much more possessive way with the loves who succeeded Eva. Separatio
was always Picasso's great problem, and Eva's loss may have exaggerate
his basic fear that he would be abandoned and lose all sense of selfhood, thu
reexperiencing those subjective states of disintegration which he had suffere
as a child whenever he was left alone. The death of his mistress may also hav
stirred up his old guilt concerning his little sister Conchita, who had likewis
died of an infectious respiratory disease. As we have seen, he had reacted to thi
tragedy of his childhood with extreme confusion and a kind of permanent am
nesia for its actual chronology and setting. Whatever primitive and half-con
scious fears Eva's death have touched off in Picasso, it certainly made him un
willing to sever completely his ties to future loves.

Early in 1916 Apollinaire returned to Paris, still suffering from the effects o
a severe head wound which would require further hospitalization and surgica
procedures. Two beautiful Ingres-style drawings by Picasso show the cor

lescent Apollinaire ennobled, sad, and solemn. Before the war, during the
ight of their intimacy, the artist had refrained from depicting Apollinaire
alistically. The fact that Picasso relaxed his prohibition in 1916 suggests that
 understood that old relationships, once severed, can never again be re-
nstituted in their original form.

This changed mode of presentation reflected a real change in Apollinaire,
 well as in their association. The poet never totally recovered his prewar
iety, energy, or creativity. He seemed more irritable and sensitive, changes
obably due to the nature of his head injury. He must have brooded about
d wrongs. Picasso's disloyal behavior following the *Mona Lisa* theft had
rt Apollinaire far more than he showed. Now he could not hide his feel-
gs so successfully. In *Le poète assassiné* and *La femme assise,* both contain-
g thinly veiled allusions to Picasso as a false friend and fickle lover, Apol-
naire took his long-delayed revenge.[12]

By the spring of 1917 this partial breach between the two friends had
aled over. Apollinaire's health was better by that time and, during the last
ar of his life, he resumed some of his old functions as Picasso's "under-
nder" and mediator with the outside world. He never recovered enough
rength, however, to permit indulgence in the frantic level of fun and frolic
hich he had enjoyed as a leading member of "*la bande Picasso*" before
e war.

During 1916 Picasso continued to be lonely and bored. He was scarcely
le to work at all following Eva's death, and in an effort to flee the gloomy
emories evoked by the apartment they had shared (which happened to
erlook a cemetery), he moved to the suburb of Montrouge in the autumn
 1916. Unfortunately, Montrouge was so far removed from the center of
tistic activity in Paris (by then located in Montparnasse) that Picasso spent
ost of his time in transit between the two places. He formed a whole new
rcle of friends during these months. Out of this circle, Eric Satie and Jean
octeau were most important for his work and future.

Picasso's friendship with Jean Cocteau, the young poet and man-of-the-
orld, began during the period immediately after Eva's death, when he espe-
ally appreciated the distractions provided by the sophisticated Cocteau, a
zzling conversationalist. According to Cocteau's biographer, Steegmuller,
casso was *the* great encounter for Cocteau: "He fell under Picasso's spell and
mained there for the rest of his days."[13] As a part of his campaign to impress
casso, Cocteau came to his studio dressed as Harlequin. When he saw that
e artist was pleased with this tribute, Cocteau left the costume behind, and
 appears in some of Picasso's later Harlequin pictures.[14] At this time, Picasso
so did an Ingresque portrait of Cocteau which captures his essentially femi-
ne elegance.

Neither the fortuitous appearance of real, live Harlequins nor the novelty
frequent changes in sexual partners revived Picasso's spirits.[15] Consequently,

he was delighted to accept the invitation Cocteau extended to join him ar
the company of the Ballet Russe de Monte Carlo in Rome, to design the se
and costumes for Cocteau's new *ballet réaliste, Parade.* Cocteau had secure
Eric Satie's promise to compose the music, and it probably was the thougl
of collaborating with Satie, whom Picasso admired and respected, which pe
suaded him.

In February 1917 Cocteau and Picasso called on Gertrude Stein, wl
remembered that Picasso was very lively over the prospect of going to Rom
Cocteau's account is more dramatic: "Picasso said to me, 'Well, since we'.
to make a wedding trip, we'll go and tell Gertrude Stein about it.' We calle
on Gertrude Stein in the rue de Fleurus and told her—Voilà—we're leaving c
our wedding trip."[16] Cocteau's prophecy proved wrong in only one detail–
he was not destined to be the bride.

icasso's Roman spring of 1917 revived both his good humor and his crea-
vity, and he soon was further dazzling his enamoured collaborator, Cocteau,
y his good example of hard work.[1] Picasso's sparkling cubist painting
'Italienne (Z., III, 18) reflects his joy in Rome, represented by the back-
rop of St. Peter's, the Palatine Bridge, and the Tiber, against which a peasant
oman in her bright red and blue costume is silhouetted.

Both the opportunity to observe the disciplined, graceful dancers' bodies
nd the exposure to the great art of Italy's past seem to have stimulated Picasso's
enewed interest in representational art.[2] His work for Parade reflected both
spects of his contemporary style, the more realistic and the cubist. The ro-
antic drop curtain, though subtly satiric, is replete with echoes of the circus
eriod in its subject and style. The costumes he created for the managers,
y contrast, carried Picasso's cubist constructions of 1913–14 one step further,
 complete three-dimensional mobility; the dancers functioned as moving
enery.[3]

Cocteau's biographer, Frederick Brown, insists that Picasso attempted to
abotage Cocteau's conception of Parade and to undermine the poet's relation-
hip with Diaghilev.[4] Picasso and Diaghilev did become good friends, but
o other source confirms Brown's additional implications. Kochno, present
 Rome with the company, recalls that the collaboration went smoothly,
xcept that everyone objected to the extraneous sound effects which Cocteau
nsisted on integrating into the musical score. Picasso, Diaghilev, and Leonide
Massine (the choreographer), joined in forcing Cocteau to modify some and
liminate others of these noises.[5] Picasso probably was responsible for one
iece of sabotage against Cocteau: most likely, he suggested Apollinaire to
Diaghilev as the ideal person to write the program note for the première
erformance of Parade in Paris on May 18, 1917. Apollinaire's note focused
o exclusively on Picasso and the revolutionary nature of his work for Parade,
hat one would think the painter had created the ballet practically single-
andedly. Satie rated no mention; Massine received a verbal pat for adapting

113

himself so well to "Picasso's discipline"; and poor Cocteau's contribution w
dismissed with, "Jean Cocteau calls it a realist ballet"! Cocteau ingenuous
considered Apollinaire totally responsible for this slight; however, one su
pects that Picasso's old "understander" reflected his painter friend's view
point—or perhaps more accurately, Picasso's wishful reinterpretation of reality

Parade was not a popular success, but it represented a great personal triump
for Picasso. The publicity attendant on its première launched him as an inte
national art-world figure and introduced him to the café society set, with the
great buying potential. Once more, Picasso, the *"Cher Magnifique"* (as Coctea
obsequiously addressed him), had successfully exploited the admiration
an idealizing "genie" for his own benefit.[7]

It had not been an accident that Harlequin reappeared on Picasso's *Para*
drop curtain. This character haunted his work during the months Picasso spe
with the ballet company. Part of the appeal the ballet held for him probably l
in the opportunity it presented for living out in reality his old phantasy th
he, Harlequin, belonged to a troupe of strolling players. In this setting, I
drew and painted many classicizing versions of Harlequin, Pierrot, and oth
commedia dell'arte characters long before he received the commission to
the costumes and settings for *Pulcinella* in 1920 (Z., III, 1, 26, 28). Drawin
suggest that the androgynous beauty of Leonide Massine inspired many of the
figures, although the final paintings are generalized beyond specific identific
tion. The sentimentalized, slightly wistful *Pierrot* of 1918 exemplies suc
works (Z., III, 137).[8]

Picasso enjoyed his usual popularity with the entire Diaghilev troupe, fro
workmen to impresario. His interest in recording the psychological and phys
cal characteristics of these new associates led to a further spate of portrait draw
ings, some Ingresque and beautiful, others witty and caricatured. The mo
significant friendship which Picasso formed probably was that with the Russia
composer Igor Stravinsky.[9] The dynamic Russian, with his marvelously ug
features, fascinated Picasso, who repeatedly sketched him. The most strikir
of these drawings dates from 1920, when Picasso depicted Stravinsky, Sati
and Manuel de Falla in virtually identical poses and settings. Like three vari
tions on a single theme, the drawings belong to a single family, yet each e
presses the unique personality of its subject to perfection.

Typically, Picasso also discovered a new love interest in the ballet worl
This time, unlike his former Bohemian loves, she was a very proper youn
lady, Olga Koklova, the daughter of a colonel of the Imperial Russian Arm
and a minor dancer in Diaghilev's company. In contrast to the oblique, secr
references to Eva which had appeared in Picasso's paintings a few years earlie
his portraits of Olga are realistic and detailed, emphasizing her good look
and varied hairstyles (Z., III, 36, 78, 83). When one compares survivir
photographs of Olga with these painted versions, one concludes that either sl
photographed badly or Picasso idealized her, creating an aura of beauty whic

as never hers in reality. At any rate, in his pictures of her from 1917–18, he often seemed more preoccupied with demonstrating his own facility as a draftsman than with revealing Olga's personality. Perhaps this preoccupation was self-protective, because when Picasso did create a more penetrating characterization, the famous *Olga in a Mantilla* (Z., III, 40), he revealed a personality apparently rigid, angry, and possessive.[10] One wonders how comfortable Picasso could have been with her. She certainly generated little of the openly erotic material with which he usually celebrated the initiation of a new affair. In place of the typical scenes of coupling lovers, a dynamic series of a bull goring a horse dates from the period when Olga and Picasso openly began to live together (in Barcelona, in the spring of 1917) (Z., III, 50–62). Penrose undoubtedly is correct in suggesting that these drawings show some sort of a complex sexual symbolism.[11] If so, they indicate a profound ambivalence toward Olga and, as Penrose speculates, probably some type of love-death equation or, perhaps more accurately, confusion.

Following the première of *Parade,* Picasso accompanied the ballet troupe on their Barcelona engagement; when the others left, Olga remained behind with Picasso. They visited the artist's mother and sister, whom he had not seen in several years, and he presented the mantilla portrait of Olga to his mother. Perhaps he was able to part with it so readily because he felt uncomfortable about what the picture revealed.

That autumn, Olga accompanied the artist to his home at Montrouge, where they lived until their marriage on July 12, 1918. Two highly discreet little nude studies of Olga commemorate the initiation of this period. Sabartés considers the self-portrait drawing which Picasso made that winter to be the least satisfactory of all the artist's self-images. It looks, comments Sabartés disapprovingly, as though Picasso drew it simply to be busy doing *something.*[12] Perhaps Picasso really did chafe a bit under the tight rein of domesticity which Olga already was drawing. An appealing little bird's-eye sketch of the artist's cluttered dining room at Montrouge shows Olga and Picasso (the latter flanked by his two begging dogs) seated formally at opposite ends of the big dining room table, while the disheveled maid serves lunch. Evidently Olga already had begun to impose a pattern which ill-accorded with her lover's disorderly, informal way of life. After their marriage, the Picassos moved to a much more stylish, tidy apartment on the Rue de la Boëtie, in an area where, instead of struggling young artists living in Bohemian chaos, elegant art and antique dealers were quartered. Once more Picasso had sealed a change in his romantic status with a change of abode and way of life.

Biographers have offered various hypotheses to explain Picasso's abrupt conversion to marriage and an opulent life style, from a desire for bourgeois stability to a fascination with Olga's innocence, as contrasted with the sexual experience of her predecessors. Perhaps Picasso's marriage might best be understood as an emotional step backward on his part, a negative reaction to

the loss of the basic sustaining relationship he had enjoyed with Apollinair
and Braque. Both men had returned from the service debilitated by severe hea
injuries, lacking either the energy or the motivation to resume their old role
with Picasso.[13] When someone like Picasso suffers an interruption in the kin
of symbiotic relationship he requires in order to function at his highest leve
he may slip back or regress in his overall level of integration. Such a retreat ma
result in the selection of a new partner for less sound, less mature reasons.[14]
Had Stravinsky been at liberty to replace Picasso's earlier symbiotic partner
the artist might have been spared what proved to be a disastrous marriag
Unfortunately, the composer was too preoccupied with the problems of carin
for an invalid wife and several young children to be able to supply the emc
tional investment which Picasso required, and Olga triumphed by default.

Many years later, the artist told Gilot that he had married Olga because sh
was pretty and because her family belonged to the Russian nobility, albeit
lower stratum of it. These reasons may seem both superficial and immatur
but if we keep in mind the fragile nature of Picasso's self-esteem, his explana
tion seems convincing. Olga appeared to offer the kind of social stature an
security he had never known; with her, he did move into a fashionable worl
previously closed to him. The artist's mother apparently realized that the love
were basing their relationship on an unsound foundation, for she warned Olg
that Picasso would never make her or any other woman happy, because "he
available for himself, but for no one else." Earlier, I suggested that Picass
withdrew from his mother at age three, in a rageful reaction to the birth c
his younger sister Lola. His mother's comment reveals both her recognitic
of this rejection and her bitterness over her son's resulting egotistical sel
involvement. Characteristically, Olga—who would prove to be quite hea
strong—ignored her future mother-in-law's perceptive warning. On the oth
side, ballet associates of Olga, well aware of her characterological difficultie
tried to dissuade Picasso, with as little success. The young couple proceeded wit
their plans.[15]

The wedding of Picasso's good friend Apollinaire, just two months befo
his own, also may have helped to push the indecisive Picasso toward matr
mony. In view of the coincidence between Braque's marriage and Picasso
elopement with Eva in 1912, some connection between Apollinaire's marria
and Picasso's also seems probable.[16] Each friend served as the other's be
man; the Picassos were married in a Russian Orthodox religious ceremony,
well as in the mandatory civil service.

While the Picassos honeymooned at the villa of a rich patroness in Biarrit
the artist executed a series of frothy drawings featuring Harlequin attendir
a beauty in scenes reminiscent of the commedia dell'arte (Z., III, 199–20
XXIX, 319). This recurrence of the theme in which the beauty admires he
self in a mirror held by a worshipful attendant (sometimes Harlequin hir
self, sometimes an amorino), suggests a personal reference. During his lor

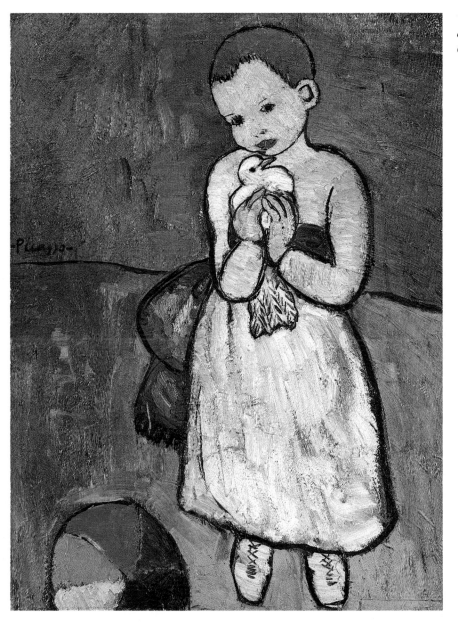

1. *The Child with a Dove,* 1901, oil on canvas, 75 x 54 cm. The National Gallery, London. Anonymous loan

2. *The Blue Roofs of Paris,* 1901, oil on cardboard, 40 x 60 cm. Ashmolean Museum, Oxford

3. *Family of Saltimbanques,* 1905, oil on canvas, 212.8 x 229.6 cm. National Gallery of Art, Washington. Chester Dale Collection

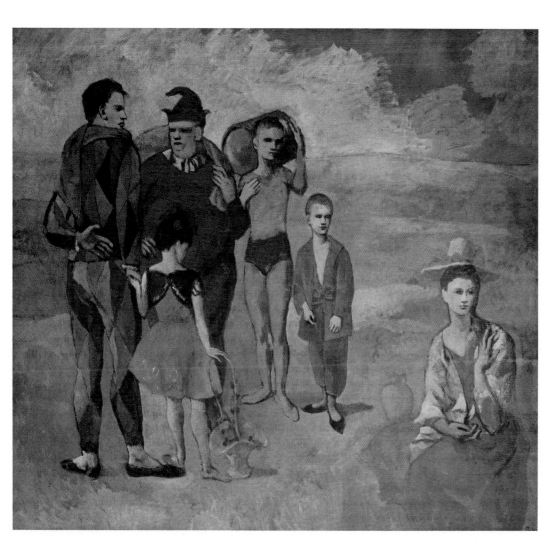

4. *Les demoiselles d'Avignon,* 1907, oil on canvas, 243.8 x 233.7 cm. Collection, The Museum of Modern Art, New York. Acquired through the Lillie P. Bliss Bequest

5. *Vive la France,* 1914, oil on canvas, 51.6 x 63.5 cm. Collection of Mr. and Mrs. Leigh B. Block, Chicago

6. *Girl before a Mirror,* 1932, March 14, oil on canvas, 162.6 x 130.2 cm. Collection, The Museum of Modern Art, New York. Gift of Mrs. Simon Guggenheim

7. *Sylvette (Portrait of Mlle D.),* 1954, oil on canvas, 130.8 x 97.2 cm. The Art Institute of Chicago. Gift of Mr. and Mrs. Leigh B. Block

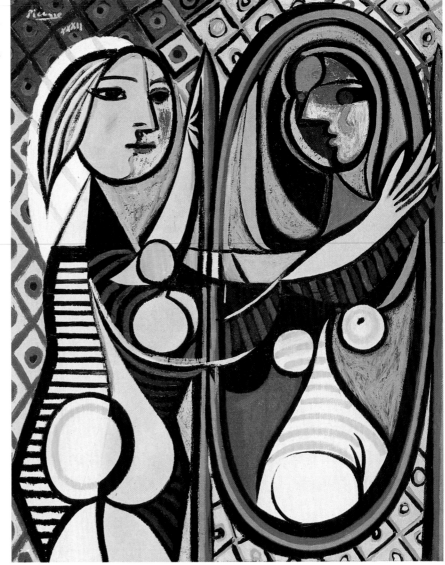

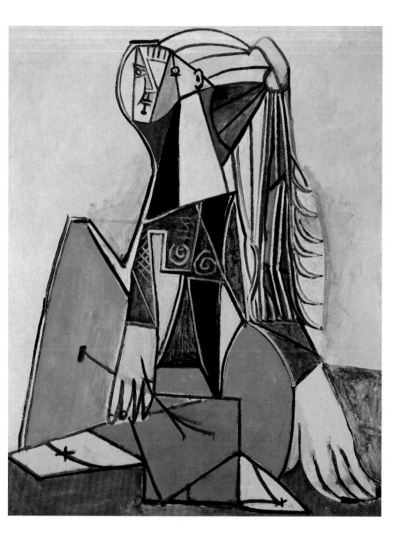

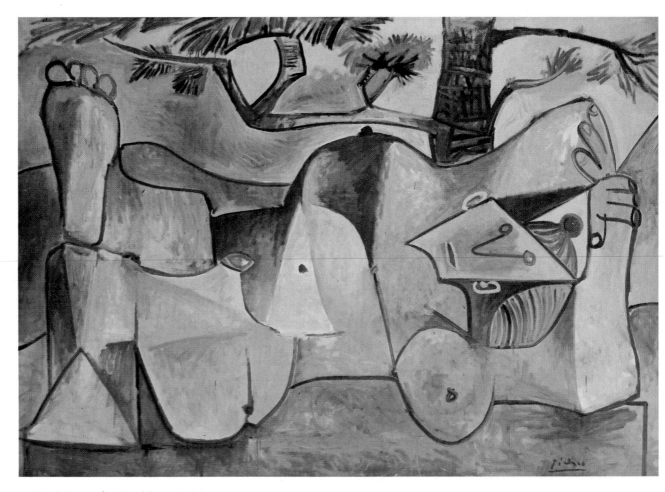

8. *Nude Beneath a Pine Tree*, 1959,
oil on canvas, 194.3 x 279.4 cm. Art
Institute of Chicago. The Grant J.
Pick Collection

reer as an artist and lover, Picasso often used this mirror motif, apparently
a conscious device to symbolize that his heart belonged to the lady currently
favor. In these variations he included a monkey (one of his totem animals)
.d a dog that closely resembled one he owned at the time, as if to call attention
.ecifically to the personal nature of these sketches. Picasso often placed this
.otif in a period setting, but it seems especially fascinating that in the case
Olga he selected the ambiguous, artificial setting of the commedia dell'arte.
.ertainly his life with Olga would have the same sort of stylized unreality and
.sessively repetitive quality which characterizes this Italian theatrical form.[17]
 That autumn, Apollinaire, whose health had remained delicate, contracted
.fluenza; a few days later, he was dead. The telephone call which informed
.icasso interrupted him as he shaved. Immediately afterward, he recorded his
.wn shocked visage as it appeared in his bathroom mirror. Apollinaire had
.inctioned as a kind of psychological mirror for Picasso, so it seems appro-
.riate that the artist's first reaction to the news of Apollinaire's death was to
.eate his own portrait, as if to reassure himself that he could continue to exist
.d function without his old symbiotic partner. After completing this drawing,
.icasso did not publish another undisguised self-portrait for more than twenty
.ars, and most critics concluded that this had been his final self-image. A
.cent Zervos catalogue (Vol. XXX), devoted to previously unpublished works
.y Picasso from 1920–22, reveals that the artist made several additional self-
.ortraits during the years immediately after Apollinaire's death—he merely
.ept their existence secret, retaining the pictures for his private collection (Z.,
.XIX, 340, 413; XXX, 141, 149). Nor did he ever contradict those critics
.ho asserted that the 1918 self-portrait had been his last. Surely this secretive
.ehavior involved some sort of primitive taboo and image magic, some phantasy
.iat revealing these portraits to the world might cause the artist himself to
.iffer Apollinaire's fate. Many years later, after the agony of Picasso's acute
.rief and fear had subsided, he again openly produced self-portraits. Numer-
.us drawings and prints of this type appeared during his last two decades.
 How guilty Picasso must have felt about Apollinaire's untimely demise we
.iay infer from the comment a friend made describing Picasso's behavior near
.he end of his life: "He often talks of van Gogh. And of his poet friends who
.ied young—Apollinaire. But especially van Gogh. He feels it keenly that
.hey never won full recognition in their lifetime while he . . ."[18]
 Apollinaire's death marked only the first of a series of losses which Picasso
.vould suffer during the next few years; his new wife and new way of life
.ventually alienated all his old friends, most importantly Braque, who became
.otally estranged from Picasso until he left Olga.[19] No adequate partner came
.long to fill the void left in the artist's life by the disappearance of Apollinaire
.nd Braque, and Picasso remained socially and artistically somewhat isolated
.hroughout the early twenties. His intimates came, instead, from the ranks of
.Olga's ballet connections or from Cocteau's café society or homosexual friends.

The Bathers, 1918, graphite on white paper, 24.1 x 31.1 cm. Fogg Art Museum, Harvard University. Bequest of Paul J. Sachs, class of 1900. A testimonial to my friend W. G. Russell Allen

All these people suffered from serious flaws which prevented Picasso from responding to them with the kind of unqualified admiration which could have sparked his creativity and contributed to his social well-being. Lacking a true mirror, he inevitably reflected some of the distorted values of his new associates. Olga drew him into a life style which profoundly transformed his old disorderly, free-and-easy ways. She proved to be an extremely conventional, socially ambitious woman, insistent that both her husband and her home be stylish and orderly. Picasso was agreeable about dressing fashionably, for he was in one of his periods of sartorial splendor (which often seemed to coincide with his periods of greatest personal uncertainty).[20] He coped with Olga's insistence on tidiness by renting a second apartment just above their living quarters, where he established his studio in peaceful disorder and solitude.

The artificiality and formality of the Picassos' life style can be measured by the drawings depicting the elegant interiors of their apartment and its environs. Olga's own manner must have matched that of her decor; even Picasso's most intimate sketches of her seldom reveal her in a relaxed, unguarded pose. If she really was the ultimate inspiration for the many nudes Picasso created during the first ten years of their marriage, no identifiable studies for them ever have been published. Even the most sketchy studies of nudes shown in the Zervos reproductions of notebook pages have a generalized quality which does not indicate the inspiration of a particular person as, for example, Marie Thérèse Walter would inspire nearly every nude Picasso created between 1931 and 1935.

Barr notes that many of these neoclassic nudes and other figure compositions from 1918–25 resemble Italian mannerist paintings both in their exaggerations of normal bodily proportions and in their cramped compositional organization.[21] Such artificiality in Picasso's work paralleled the synthetic quality of his private life. Olga seems to have been preoccupied with *manier* in its original meaning of being stylish and elegant. Some of the simpering, elongated, or pneumatic female figures (Barr calls them the "fat and lean" mannerist styles) which Picasso invented during these years appear, in retrospect, the most dated and least effective paintings he created prior to 1945. The slight quality of mockery which critics have noted in some of these neoclassical works may show the artist's underlying distaste for the life he was leading. It is interesting in this regard to note that he retained relatively few of the canvases he painted between 1918 and 1925 for his own collection, although by that time he could afford to keep whatever he considered the best of his work. After 1925, when he started painting very angry pictures, he kept many more of them.

In the absence of a close relationship with an important living artist, Picasso turned to the great artists of the recent and more distant past for inspiration, and one can see hints of Corot, Poussin, and Leonardo in his paintings, as well as more open references to the great works of the Greek and Roman past.

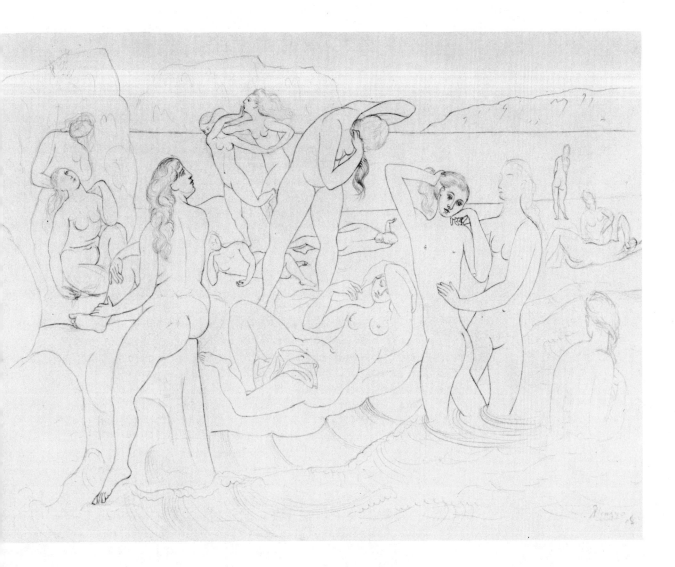

Nessus and Dejanira, 1920, silver-
point on grounded paper, 21.3 x 27
cm. The Art Institute of Chicago.
Clarence Buckingham Collection

especially to Pompeian fresco painting (which he had seen while with the ballet in Italy). He also resorted occasionally to using photographs, postcards and other such sources to suggest subject matter or even stylistic ideas. Ingres continued to be the most important of his sources, however, and Picasso created both relatively straightforward and more exaggerated reinterpretations of Ingres' style. A series in the latter manner from 1919, derived from publicity stills of Olga with other dancers, seems like a parody on both Ingres and the ballet because of the caricatural extremes to which Picasso carried certain typically Ingres-like proportions (elongated arms, necks, and so forth). In three contemporaneous variations after Renoir's painting of Sisley and his wife, Picasso transformed Mme. Sisley into a simpering, porcine creature who may incidentally reveal something of the artist's ambivalent feelings toward his own wife.

During the summer of 1920 Picasso suddenly interrupted such mannered painting to create a series of vigorous, classical interpretations of the rape of Dejanira. Often, the appearance of such drawings in his oeuvre signals the start of a new love affair, but no biographer hints that any clandestine romance began then; the sketches may celebrate, instead, the conception of the artist's first child, Paulo, who was born the following February. Picasso's reaction to Olga's pregnancy was not so unambivalent as these spirited works might suggest, however. During the late summer and winter of 1920, the distortion and giganticism implicit in certain of his drawings from 1918–19 developed until he created a race of ponderous Amazons, some of them fantastically proportioned microcephalics with exaggerated limbs. Penrose speculates that these creatures reflected Picasso's awe over Olga's changing proportions as her pregnancy advanced (Z., IV, 169, 179, 180). This may be partially correct. The style certainly developed along with Olga's pregnancy, but the germinal examples of this particular variety of his mannerism coincided with Picasso's marriage.[22] This suggests that Olga's pregnancy merely increased certain of her characteristics and the resultant discomfort the artist experienced in his dealings with her. The first of the full-blown giantesses (Z., IV, 58) appeared several months before Olga actually conceived. One wonders whether she badgered him into agreeing to have a family just as she may have badgered him about marriage.

As Olga's pregnancy progressed, the Amazons proliferated and became more ponderous. Even though Picasso usually depicted them in placid, vacuous inactivity, they often convey a vaguely eerie, menacing quality (Z., IV, 217; XXX, 126). Technically this may result from the forced modeling he employed to emphasize their sculpturesque quality. The resulting extreme light-dark contrasts create the uncanny, surrealist atmosphere in which these creatures dwell, like so many lumbering dinosaurs. One fears that the slightest noise or movement might startle them and set them stampeding over the spectator. Paradoxically, although these odd pictures make the spectator anxious, the

protagonists themselves seem unruffled and benign. Barry Farrell makes the interesting suggestion that it is the giantesses' very placidity which unnerve us because it "seems based on an inhuman confidence in their own survival." Perhaps this quality reflects the opposition between Olga's inappropriate behavior and lack of insight, and the alarmed reaction of others to those ominous changes which took place in her personality during her pregnancy. One expect a pregnant woman to show a certain increased self-absorption, particularly primipara. But the history of Olga's pregnancy, as recorded through her husband's paintings, suggests that she became unusually upset and that the more advanced her pregnancy, the more remote she became. The fact that Picasso did not produce such distorted figures when Marie-Thérèse Walter and Françoise Gilot were pregnant strengthens the supposition that Olga behaved in an unusual manner while carrying Paulo.

The fantastic proportions of the 1920 giantesses have always fascinate critics. Penrose, Barr, and others have interpreted such canvases as *By the Sea* (Z., IV, 169; formerly misdated as 1923) as demonstrations of the artist interest in transcending the limitations on the portrayal in paint of time, space and motion. One wonders whether Picasso's deepest motivations didn't lie elsewhere. Perhaps the time-transcending elasticity of the women in *By the Sea* reflects the artist's alarm over the distortions he observed in his wife' thinking processes and behavior. If this is true, the fact that nearly all of these creatures suffer from microcephalism in addition to their other deformities reinforces the impression that Olga must have shown severely impaired self critical and practical judgment during these nine months. Perhaps Picasso used the sea shore as a setting for so many of these creatures to indicate the extent of Olga's withdrawal and regression. The ocean, as the primordial source of life, can represent the primitive, dark, and mysterious, and these giantesses sun themselves at the beach like so many giant tortoises.

Picasso's apparent alarm over the ominous change in Olga's mental health indicated more than the usual degree of husbandly solicitude and anxiety. Involved as he was in an intense relationship of fantasied merger with his wife, he must have been terrified that he might go under with her. The terrible flaws revealed by the partner who was supposed to reflect and magnify his self esteem must have seemed to him to be flaws in his own psyche, too. When the dominant person in such a symbiosis becomes psychotic, the more dependent partner may be dragged into a kind of shared psychotic state (technically called a *folie-à-deux*) in which he accepts the dominant partner's delusional reinterpretation of the world. Picasso's artistic productions of 1920 indicate that he comprehended this danger and recognized, too, that his own resources were strained to the breaking point. On yet another level, the magical elasticity of these women may reflect the artist's hope that he could extend his inner resources to infinity, if need be, thus skirting disaster for both Olga and himself

He must have felt the need to transcend all usual boundaries to keep Olga functioning until her child was born.

Picasso's agitation probably was increased because his present situation echoed past traumas from his childhood. Many of the characteristics of these giantesses remind us, at least, of Picasso's own memories about the past; for instance, during these months he departed from his more typical practice of painting a single female figure and showed them in groups of three and four. This recalls Picasso's own family constellation during his first years of life, when three female relatives, as well as his mother and a maid, lived in the tiny Ruiz household in Málaga. There he was the only small person among so many giantesses. So many women must have found it difficult keeping busy in that modest home, and the indolence of the Amazons may recall the indolence of his maternal relatives. Even the abnormally elongated, pneumatic extremities of the figures echo his early childhood experience: as a grown man, he still remembered his childish fascination with the grotesquely swollen limbs of one of his aunts, which he had observed as a little boy by hiding beneath the dining room table to peek at her while she was seated there.[24] In a discussion concerning his preference for dynamic asymmetry in figure proportions, Picasso recalled a related childhood anxiety dream: "I dreamed that my legs and arms grew to an enormous size and then shrank back just as much in the other direction. And all around me, in my dream, I saw other people going through the same transformations, getting huge or very tiny. I felt terribly anguished every time I dreamed about that."[25] Such dreams about bizarre physical transformations usually refer to apprehensions about underlying psychic transformations of an alarming kind. The fact that Picasso saw his deformities mirrored in those around him reveals that, even as a child, he sensed that his well-being depended to an unusual extent on the well-being of the people important to him.

Picasso's anxiety about Olga's mental health by no means terminated with Paulo's birth. Although the artist showed the positive, proud-father aspect of his feelings in a series of tender sketches made during the first months of Paulo's life—sketches which noted charming details of baby behavior ordinarily observed only by doting mothers—Picasso also revealed his continuing concern about Olga in numerous mother-child pictures from 1921. These canvases depict the Amazons as mother giantesses; their bodies no longer exhibit the bizarre proportions nor the space-devouring qualities they had demonstrated while Olga was pregnant. Instead, these women tend their babies in a state of phlegmatic self-containment; nothing seems to exist for them but their infants and their own bodies, as mother and child share an existence from which all else is excluded. Their singleminded concentration on maternity reminds us of Picasso's description of his wife as a woman who could pursue only one idea at a time, but that one with the utmost tenacity.[26] Even Picasso's

echnical handling of these figures emphasizes this monomanic, repetitive quality: Barr has pointed out that these women resemble provincial Hellenistic statuary, rendered according to an increasingly stylized, rigid formula.[27] Again, one senses that Picasso subtly mocks Olga's rigidity. Although these pictures always have been popular with the public, the artist kept none of them for himself.

Olga's social ambitiousness increased after Paulo's birth; she insisted on enlarging the staff of servants and on making elaborate arrangements for vacations.[28] Accordingly, the Picassos spent Paulo's first summer in a rented villa at Fontainebleau, situated in a handsome park-like setting. During his long holiday, the artist created several major pictures, especially the great cubist paintings *Dog and Cock* and both versions of *The Three Musicians*.

Barr points out that both the *Dog and Cock* (Z., IV, 335) and the Philadelphia museum's version of *The Three Musicians* have been forced into formats which seem too narrow for decorative comfort.[29] Perhaps this constriction parallels the artist's own distaste for his elegant quarters. He complained to visitors that he thought he might import a *pissotière* and a Paris streetlamp to disarray the nasty niceness of the grounds a bit. Even the content of these paintings seems to relate to the artist's situation that summer. In the *Dog and Cock* a drama of wry humor unfolds: the hungry airedale, his fur prickly with excitement and his pink tongue flicking in anticipation, eagerly eyes the tightly trussed bird which lies, swooning or dead, on the table above him. One critic, noting that Picasso also featured unplucked slaughtered birds in three other contemporaneous canvases, perceived in this work implications, which would become more explicit in later creations, of the artist's identification with the sacrificial cock.[30] Despite their apparent lightheartedness, both versions of *The Three Musicians* also suggest provocative allusions to the darker aspects of the artist's personal situation, especially when contrasted with *Three Women at the Spring*, painted during this same productive Fontainebleau interlude. The latter painting typifies Picasso's neoclassical style of 1921, with its echoes both of Greek sculpture and of Poussin;[31] but despite their three-dimensional, life-like modeling, these women seem much less real and vital than their flattened male counterparts in the cubist works. The placement of the figures also differs dramatically: two of the three women are pushed right up to the edge of the picture plane, while the musicians reside far back within the depths of their room, protected from the spectator both by the table behind which they sit and by the costumes and masks which disguise their real identity from us. These costumes also seem significant: two of the men appear as Harlequin and Pierrot, respectively, characters from the commedia dell'arte who, as has been observed, demonstrate the ephemeral—yet endlessly repetitive—nature of human relationships. The third man wears the garb of a monk, symbolic of the ascetic life in which one renounces women, wealth, and worldliness in favor of a life of toil and piety. The disproportionately small size of the

Mother and Child, 1921, oil on canvas, 143.6 x 162.6 cm. The Art Institute of Chicago

•*Three Musicians,* 1921, oil on canvas, 200.7 x 222.9 cm. The Museum of Modern Art, New York. Mrs. Simon Guggenheim Fund

Three Women at the Spring, summer 1921, oil on canvas, 203.8 x 174 cm. The Museum of Modern Art, New York. Gift of Mr. and Mrs. Allan D. Emil

musicians' hands, to which attention often has been called, seems the more
remarkable when contrasted with the enormous arms and hands of the women.
The women apparently are unable to make use of this latent power, however,
for they remain passive and phlegmatic, hardly able to lift their heavy arms;
the pitcher, for example, looks ready to slip from the huge fingers of the
middle woman. The men, by contrast, triumph over their handicap to make
beautiful music with their truncated hands and fingers. *The Three Musicians*
and the *Women at the Spring,* like the *Dog and Cock,* suggest a contrast
between self-sacrifice and self-indulgence, between male ingenuity and in-
dustry versus female witlessness and indolence. In the lavish setting of their
Fontainebleau villa, Picasso carried out the role of the tireless worker bee
while Olga acted that of the indolent queen.

During the latter half of 1922, Picasso's art underwent still another
stylistic change. His works once again became serene, idealistic, and beautiful.
He continued to paint in a classicizing manner, but he dropped the rigid Hel-
lenistic stylization in favor of a more limpid painting reminiscent of High
Renaissance works. The women he portrayed changed, too. They no longer
suggested abnormal size and weight or bizarre malproportions; instead, they
recall the Junoesque beauties who people the canvases of Andrea del Sarto
and the youthful Titian.

The vacuous, stupid quality of the women vanished along with their peculiar
proportions; Picasso no longer mocked. He seemed more sentimental, and the
gently melancholy, introspective air of his 1922–23 figures have endeared
these works to the general public. Probably no pictures Picasso ever created
have been reproduced more often than *The Woman in White, The Lovers,*
and the portraits of Paulo from these years.

Although he continued to concentrate on painting women, Picasso again
included men in some canvases (*The Lovers,* for example), and he drew and
painted a series of handsome Harlequins in 1923. Picasso himself considered
the acme of his work in this style to be a picture of two young men, *The Pipes
of Pan,* which he retained in his own collection. It depicts two sculpturesque
youths in a severe setting vaguely suggestive of the seashore. One young man
plays the pipes while the other stands, dreamy and quiet, gazing out to his right.
These rather Grecian youths recall those Picasso painted in his final version
of the *Two Adolescents* in 1906, although the early picture showed more vigor
and a less obvious debt to classical influences.[32]

The new serenity in Picasso's art undoubtedly reflected his positive re-
sponse to the wave of postwar neoclassicism,[33] but more personal determinants
must have been operative as well, for Picasso seldom responded so whole-
heartedly to current artistic fashions unless they also satisfied his private needs.
The change suggests that his family life and his state of mind improved after
Paulo became an active toddler and Olga relaxed her single-minded preoc-
cupation with him. It is difficult to tell whether Picasso experienced this relief

Study for the painting *The Pipes of Pan,* ca. 1923, black chalk, 64 x 49 cm. The Art Institute of Chicago. Bequest of Joseph Winterbotham

because he had been competitive with Paulo for Olga's attention or because he had projected his own fears of being engulfed by a powerful woman onto his son. If the latter were the case, Picasso certainly would have been pleased to see Paulo begin to talk and walk and assert some independence. Whichever factor was operative—and it may well have been both—the mother giantesse who played with their babies with such dim-witted concentration disappeared from Picasso's canvases with Paulo's infancy. Picasso's final statement on the mother-and-child theme, created when Paulo was about eighteen months old, is a delicate, thinly painted work (Z., IV, 370), so idealistically beautiful in its treatment of the figures that one critic compared it, not unreasonably, to Leonardo's *Benois Madonna*.[34] At this time, Picasso also resumed the flattering interpretations of Olga which he had broken off when she was about two months pregnant. Added proof that the Picasso marriage was again on firmer ground can be deduced from his New Year's Eve drawing of 1922, a lovely classical profile of his wife. Picasso's New Year's Eve creations often seemed especially revealing of his personal feelings. Such works functioned like barometers, from which we can take significant readings concerning the state of his relationships. Two years earlier, when Olga was nearly seven months pregnant, Picasso had chosen his friend Stravinsky as the subject of his New Year's Eve sketch, a choice which suggests that the artist needed an idealizable partner more than ever.

Unfortunately, the charming, intimate quality of the drawings which Picasso had created during the first year of his son's life disappeared with his babyhood, and from the time of his first birthday, Paulo's growth and development were recorded only in annual oil paintings. A cluster of three or four handsome canvases, all created within a few weeks of the day, commemorated the child's birthday each year through 1925. After Paulo's fourth birthday, Picasso abruptly terminated this series, perhaps because the boy had now reached the age which recalled too painfully the period of the artist's own childhood vicissitudes.[35] In the canvases of 1924 and 1925, Picasso depicted his son as Harlequin, Pierrot, and a torero—all favorite alter egos for the painter himself, suggesting that he identified positively with his son. The absence of a corresponding set of intimate sketches, however, indicates that the two probably did not actually spend much time together, and Picasso's identification with Paulo may have been more of a conscious, sentimental gesture than an affective one. This might help account for the idealized, romanticized quality of these canvases. Although Picasso always enjoyed the reputation of being an adoring father, there is little evidence that he actually spent much time with any of his children or knew much about their daily routine. Gilot specifically mentions that Claude and Paloma practically never saw their father, and it is difficult to imagine that things were much different as Paulo grew up.[36] Picasso's peculiar life style—he always slept till late morning then painted till nearly dawn—guaranteed that he would see little of his children until they reached an age

anced age. Three drawings from 1923 which show a handsome young man stretched out sleeping while a toddler and his mother play nearby probably parallel Picasso's actual role vis-à-vis his son, with the artist sleeping during much of the period when the child was up and about (Z., V, 173–75).

Picasso retained the classical style evident in the portraits of Paulo through 1923; then his interest in this manner seems to have waned, and he concentrated once again on cubist works, reserving his classical style more and more for prints and drawings. Beginning in 1925, even his interest in cubism gave way before a new unifying force of savagery, frenzy, and distortion which pervaded his art. This mood first became obvious while the artist sojourned in Monte Carlo with Diaghilev, Massine, and the Ballet Russe company in the spring of 1925. Between series of classical drawings of dancers, Picasso suddenly executed the awesome canvas called *The Three Dancers*. Shocking as an open wound, these three distorted harpies cavort with the abandon of madwomen. Paradoxically, their distorted figures are silhouetted against a backdrop of a classical male profile and a cloudless Mediterranean sky.[37] The fact that they seem flat as sheets of cardboard interferes neither with their activity nor with their threateningly lifelike aspects; in fact, the figure on the left, whose body contours have been violated in the most arbitrary fashion, seems the most horrifying. Picasso's season in hell had begun, and he retained this picture for his own collection, perhaps in the spirit of the self-flagellating penitent.

A summer vacation period on the Riviera apparently provided Picasso no relief, and he continued to develop the new expressionist quality of his cubist paintings.[38] In the *Ram's Head* (Z., V, 443), he juxtaposed a severed sheep's head, its open eyes still reflecting the horror of its final agony, with various prickly, pointed, biting forms which radiate out from the center of the picture. *The Studio* (Z., V, 444), not so movement filled, nonetheless suggests a mute plea for help, with its evocation of a classical past now disintegrated and its disturbingly lifelike figure fragments. (In 1937, Picasso would utilize a similar motif in *Guernica* to symbolize a fallen warrior.) Shortly afterward, Picasso painted the first of a series of monster women who agonize silently in small closed rooms. This figure is so totally distorted that without the title it would be difficult to identify its subject matter from a black-and-white reproduction. Finally Picasso's rage spilled over into an incredibly sadistic construction, the *Guitar* of May 1926, a piece of gunnysacking studded with nails, the latter a substitute for the sharp razor-blade edges the artist originally had intended to use, with the idea that anyone who picked up the construction would be cut. This, too, remained in his private collection.

To some extent, Picasso's abrupt change in style and content reflects the influence of surrealism. He had been friendly for some time with André Breton, the poet-founder of this movement, and had made a drypoint portrait of Breton to grace a book of verse the latter published in 1923. Picasso also

The Three Dancers, 1925, oil on canvas, 215 x 140 cm. The Tate Gallery, London

had contact with other literary figures involved in the movement. The surrealist poets Louis Aragon and Paul Eluard eventually became his close friends. During the twenties, however, Picasso was not so intimate with any of these people, although he allowed his work to be exhibited with that of the surrealist painters in their initial exhibit of 1925. It probably is more accurate to say that, although Picasso's art from 1925 on parallels surrealism in its preoccupation with the bizarre and impossible, it seldom is truly surrealistic.

This radical change in Picasso's art certainly reflected a radical upheaval in his private life. From the mid-twenties, his domestic situation deteriorated rapidly, along with his wife's mental health. Descriptions by people who knew her reveal that, by the late 1940s, Mme. Picasso behaved in a manner so aberrant that it does not seem unwarranted to conclude that she suffered from a chronic psychosis. None of Picasso's biographers supply details which might help us to understand what contributed to Olga's overt illness or what form it originally assumed. Penrose merely comments that, around 1925, Picasso's mood changed, and he wanted to get off the social merry-go-round,[39] but he does not specify what precipitated this series of events; we really do not know whether Olga's disintegration had much to do with her husband's behavior at the time. One coincidence should be noted, however: the change in Picasso's attitude began shortly after his son reached the age of three. Picasso apparently suffered his own worst childhood trauma at that same age, when his rage over his sister's birth caused him to withdraw from his mother. Perhaps when Paulo reached three, bitter memories welled up in the artist, causing him to isolate himself from Olga and to stop supplying her with the massive support and narcissistic gratifications which she apparently required to function at all adequately.

During 1923 Picasso created seven related works (Z., IV, 449–55) which contain provocative suggestions about the connection between Olga's mental state and her relationship with her son. The series begins with a painting showing her in an armchair, apparently depressed and preoccupied. Sketched variations on the *La coiffure* theme follow. Instead of the servant girl who dresses the beauty's hair while she gazes in the mirror, a small boy appears alone with the beauty. He perches on her knee and tries to gain her attention, but to no avail. He crowns her with a wreath of flowers, but she has dropped her mirror and, lost in revery, notices neither her little attendant nor her own reflection. The next picture shows the woman seated alone, her back to the spectator. She looks into the mirror, which reflects her poignant expression. In the final painting from this set, the little boy stands on a sofa in order to gain the ear of his beauty. He regards her adoringly, but she again ignores him, staring out to the left with a secretive half-smile. The beauty and child in this series may represent the artist's own family, while the mirror symbolizes the world of outer reality. If so, these works reveal Picasso's sensitivity to the fragile nature of his wife's adjustment as well as to her limitations as a mothering person.[40] The paintings

also suggest that Paulo could not always arouse his mother's interest once he had passed that symbiotic stage of development in which he was totally dependent on her. If incidents in which Olga withdrew from Paulo occurred very often, they might have touched a raw nerve in Picasso, reminding him of the rage he had probably felt when his mother, previously so engulfing, had been too preoccupied with the care of the new baby to lavish attention on him.

Such associations about his mother might easily have been stirred up by the long visit she made to her son and his family in 1923, when she spent several weeks of the summer holiday with them on the Mediterranean. Olga had not yet alienated Gertrude Stein and Alice B. Toklas, and they joined the Picassos for this vacation. Perhaps Picasso consciously invited them as a dilutant for the potentially combustible mixture of Olga and his mother. It is an interesting coincidence that he thereby recreated the female constellation of his own family—when he was the same age as Paulo (two-and-a-half), it may be recalled, the artist had lived in the midst of a harem consisting of a grandmother, mother, and two middleaged maiden aunts. Perhaps, having set the stage so cunningly, Picasso also reexperienced some of the trauma of the period just prior to his third birthday. During his mother's visit, Picasso painted one of his rare formal portraits of her (Z., VI, 1435). This picture, retained in his own collection, shows the artist's mother in three-quarter profile view, facing left. She appears just as formidable and indomitable in this portrait of her old age as she had in the portraits which he created during his adolescence. Although their relationship was the source of many of her son's personality problems, he may also have gained from her the toughness and determination which enabled him to weather so many severe emotional crises successfully.

During that vacation period on the Mediterranean, the artist again explored the theme of the beauty and her admirers, this time in a series of intimate sketches (Z., V, 114–25) showing his heroine surrounded by a Harlequin, who holds her mirror, a youth who plays a serenade on the pipes, and a little amorino, who perches above the group, usually ignored by the other protagonists and frequently seeming peevish about this slight. Perhaps bolstered by so much attention, the woman interests herself in her appearance, studying her reflection in the mirror without the pensiveness which had characterized the beauty in the slightly earlier series with the little boy. One wonders whether Olga required more and more external stimulation in order to function; at any rate, Picasso may have experienced their relationship in those terms. If so, the extremely flattering quality of both the major portraits and the minor sketches of Mme. Picasso which the artist created in 1922–23 reveals that he remained in a giving mood throughout that period. After 1923 he stopped creating such idealized naturalized representations of her forever, a change which doubtless mirrored an underlying shift in his attitude toward his wife, as well as a major change in his artistic style.

Eight

A Song of Love
and Faithlessness

Picasso no longer painted Olga's external appearance, yet her image continued to dominate his art. His preoccupation with her evident deterioration makes his oeuvre from 1924–30 read like a chart of her illness and the horrors he experienced, condemned as he was to observe, indeed to participate in, this process. One type of monstrous female figure follows another in rapid succession in his pictures from these years. Sometimes they exist as mere outline heads (Z., VII, 115–33), bodiless incarnations who seem no less horrifying than their more complete biomorphic counterparts, those harpies whose simultaneously enlarged and atrophied anatomies recall the phantoms that had haunted Picasso's childhood nightmares (Z., VII, 84–109). The prevalence of such imagery suggests that the artist's underlying anxiety about the stability and integrity of his own body image had been reactivated by Olga's disintegration.

These awesome figures reveal not only Picasso's artistic powers, but his powers of empathy as well, for they constitute vivid visual records of the sufferings and delusions which psychotics often experience. This fact has never been recognized in the Picasso literature, where this imagery has usually been interpreted, instead, as evidence of his conflicts with his wife.[1] Such interpretations are understandable, but they ignore both the underlying sympathy which these pictures convey and their intuitive comprehension of such phenomena as the somatic delusions which preoccupy psychotics and which they communicate to others via vague complaints that parts of their bodies are dead or operate under hostile external control. One of the most searching of these portraits of a psychosis, *The Woman in an Armchair*, from 1929, portrays such a wretch alone in a small, closed room; her misshapen body and flaccid, elongated limbs mirror both her delusions and her helplessness. She screams to heaven for deliverance, but no savior arrives, and her cries only echo back at her, as does the upflung arm which encloses her head—and her misery—like a limp parenthesis mark. Although Berger's book contains many perceptive insights into the artist's psychology, the critic fails to comprehend the significance of

this picture, which he labels a failure, allegedly because Picasso communicates his rage and distress to the viewer, but not their cause.[2] One wonders whether Berger actually rejected this canvas, not because Picasso failed to explain the nature of his suffering, but because he communicated it all too forcibly in this powerful, yet repellent, work.

Picasso's sympathy for his wife's plight evidently seldom served to protect him from her irrational attacks. Olga screamed at him all day, endlessly repeating a single idea until he yielded to her demands. Their life together became a mutual hell. She probably even invaded his studio, violating what had been his sacred sanctuary and disrupting work in progress. Indeed, her heckling and invasions did not end even after they had separated; Gilot provides a vivid description of the way Olga trailed Picasso and his mistress through the streets, screaming invectives addressed as much to passersby as to her husband. Even indoors, Picasso could not escape her, for she sent him little needling notes daily, notes which he always read, though they always upset him. She knew his vulnerabilities all too well. A favorite message, Gilot tells us, arrived inscribed on a picture of Rembrandt and read, "If you were like him, you would be a great artist."[3] A recurrent motif in Picasso's pictures from the late twenties shows a beach scene where a harpy struggles in vain to unlock the door of a bathing cabana. She always has the key but seems either too disorganized or too deformed to manipulate the lock. Such pictures seem like metaphors for Olga's bizarre, repetitious behavior as we know it from Gilot's much later descriptions.

Several critics have called attention to the erotic connotations of Picasso's imagery during the late twenties and early thirties, citing his repeated use of the lock and key metaphor, the phallic protuberances of so many of his bizarre female figures, and the like.[4] Such symbolism abounds but, like the manifest content of a dream, probably does not constitute the artist's chief message.

The painting *Sleeping Woman in an Armchair,* for example, is often pointed out as an instance of Picasso's imagery of the phallic woman with her *vagina dentata.* The woman's open, snoring mouth does indeed expose a wicked ring of teeth, but she also possesses an oversized ear which, like her private radar screen, remains alert and receptive as she dozes. Surely Picasso really intends to show us how primitive and paranoid Olga had become: even in her sleep, she could behave like a biting, attacking animal, and she was so suspicious that she seemed to him able to continue her spying activity nonstop, day and night. The canvas *Project for a Monument (Woman's Head)*, from 1929 (Z., VII, 290) often perceived as a sexually menacing figure, again seems to me primarily a symbol of Olga's terrible oral aggressiveness. Like the wolf in Little Red Riding Hood, she is poised to devour everyone and everything in her environment. The depicted statue is really a monument to female monstrosity.

The Woman in an Armchair (Grand nu au fauteuil rouge), 1929, oil on canvas, 195 x 130 cm. Musée Picasso, Paris, Cliché des Musées Nationaux, Paris. © SPADEM, Paris / VAGA, New York

Irrational, perhaps even delusional, Olga may have been; yet her suspicions concerning her husband's fidelity were not groundless, for a new love *had* entered his life, the young Marie-Thérèse Walter. Biographers and critics have usually been vague in dating the beginning of this relationship, which they typically assign, rather tentatively, to 1931 or 1932. In a personal communication, Gilot indicates that Picasso told her he had met Walter much earlier, in 1927.[5] This date correlates with Marie-Thérèse's own recollection of this event: "When I met Picasso, I was 17. I was an innocent gamine. I knew nothing —life, Picasso, nothing. I had gone shopping to the Galeries Lafayette and Picasso saw me coming out of the Metro. He simply grabbed me by the arm and said, 'I'm Picasso! You and I are going to do great things together.' I resisted for six months, but you don't resist Picasso."[6] Marie-Thérèse was sixty-eight when she committed suicide on October 20, 1977, so she would, indeed, have been about seventeen at the beginning of 1927. Her dramatic account of that first meeting recalls the description of the initial encounter between Edouard Manet and Victorine Meurand, a young woman he also selected from the crowd on a Parisian thoroughfare to star in his greatest— and most controversial—masterpieces. Manet was an artist Picasso always admired. As a young man, Picasso created parody versions of the *Olympia*, a picture which had featured Victorine; as an old man, he invented over two hundred versions of another, the *Picnic on the Grass*, in which Victorine also starred. Did Picasso also consciously emulate Manet in approaching Marie-Thérèse so abruptly? Certainly Marie-Thérèse represented for Picasso, just as Victorine had for Manet, the concrete realization of an internalized ideal. No wonder Picasso recognized the girl the moment he caught sight of her: he had created her image in his art before he found her in reality. She represented that dream of classical perfection to which he returned again and again throughout his long career.

Initially, Marie-Thérèse seemed to create little impact on Picasso's imagery. At least, her visage does not appear in easily recognizable form in any of the paintings he created prior to 1931, a fact which doubtless contributes to the confusion about dating the beginning of this liaison. Closer scrutiny of Picasso's oeuvre between 1926 and 1931, however, reveals many covert references to his new love. Figures with marked Greek profiles appear in several pictures from 1927 and 1928, such as the *Seated Woman* of 1927 (Z., VII, 77), now in the Museum of Modern Art; the treatment of these heads prefigures the exaggerated depictions of Marie-Thérèse's features which Picasso would develop more fully in paintings and sculptures from the early thirties. The *Artist and His Model*, from 1928, also apparently contains a hidden reference to Marie-Thérèse. This canvas depicts an artist's atelier where a bizarre painter works with an equally fantastic model. Together they create an artistic miracle: a serene, lovely painting showing a classic female profile accentuated by a fruit. As Rubin observed, the latter resembles a misplaced breast and recalls

Painter and Model, 1928, oil on canvas, 129.9 x 163.2 cm. Collection, The Museum of Modern Art, New York. The Sidney and Harriet Janis Collection, gift to The Museum of Modern Art, New York

the body-imagery vocabulary which Picasso would elaborate in the great series of canvases from 1931–32, modeled after Marie-Thérèse.[7]

Many of Picasso's other paintings from the late twenties utilize a similar motif to show a painting-within-a-painting, a device Picasso seemed to use to compare and contrast Olga and Marie-Thérèse. *The Studio,* for example, reveals a classic profile encased within a picture frame which a savage, biting head threatens to penetrate. In another variation, the monstrous head appears captured within the frame, but the background of this inner picture forms a spear-like phalanx which again threatens a classic profile. Such paintings also suggest that, although art and beauty constituted Picasso's salvation, Olga's aggressiveness threatened the boundaries of even that sacred preserve. The device of the picture within a picture may also be a concrete representation of Picasso's attempts to wall off and protect his new love from Olga.

Although Marie-Thérèse would inspire Picasso to create some of his most magnificent images, even her presence failed to buttress his productivity against the downward spiral which continued, with few respites, from 1926 until the spring of 1937, when the outbreak of the Spanish Civil War would spark his rage—and his creativity—into full flame once more. During much of his career, Picasso executed about three hundred paintings and drawings in a given year; between 1926 and 1936, by contrast, he seldom produced as many as one hundred such works per year (he edged above this level in 1928 and again in 1932). Even if one allows for the fact that Picasso was active as a sculptor and graphic artist during this decade, his annual production throughout remains below par. His so-called fallow period of 1935–36 actually constitutes not a sudden hiatus in productivity but the nadir of an almost continuous decline which began in 1926.

During the late 1920s, possibly in an attempt to counteract such incipient productivity problems, Picasso explored several new avenues of artistic expression. In 1926, for example, he made a series of line drawings which approach a level of abstraction unusual in his oeuvre. (Vollard later utilized many of them as the basis for wood engravings which appeared as endplates in a special edition of Balzac's *Le chef d'oeuvre inconnu,* published in 1931 with etchings by Picasso.)[8] From 1928, Picasso also paid a good deal of attention to sculpture. His renewed interest in three-dimensional work was heralded by the construction he fabricated in 1926, *The Guitar,* the large collage studded with nails described in the previous chapter. Picasso's underlying rage may be measured by the fact that he originally thought to stud the cloth with razor blades inserted so that anyone picking up the collage would be cut.[9]

Early in 1928 Picasso began to collaborate with Julio Gonzalez, an old friend from Barcelona whose technical expertise Picasso tapped to create a series of complex wrought-iron constructions and assemblages. Gonzalez, although a trained metalsmith and craftsman, was then virtually unknown as a fine artist. Relatively little information concerning this collaboration has come to light; even its duration has been vaguely reported, although it apparently lasted

or four years. The arrangement proved fruitful for both participants. As Josephine Withers points out, it transformed Gonzalez from a minor craftsman into a major artist, it made a confirmed sculptor of Picasso (who had previously practiced sculpture only intermittently), and it revolutionized the subsequent course of twentieth-century sculpture.[10]

Despite the success of this collaboration, there is little evidence to suggest that Picasso regarded Gonzalez as anything but a congenial technical assistant. Gonzalez's shy, moody, insecure personality probably prevented Picasso from forming an idealizing partnership with his assistant, for Picasso always required a great show of elan and self-confidence from such partners. Although Gonzalez adored Picasso and considered him his best friend, the metalsmith seems merely to have functioned for Picasso as another of his helpful genies.

The exact date when Picasso completed the "most ambitious and complex" of the constructions which he executed with Gonzalez, *The Woman in the Garden,* remains as insecurely fixed as other details of this association. Spies assigns it to 1929–30, but Gonzalez wrote that it was completed in 1931 after many long months of work. This latter date seems more convincing, for Picasso's activity as a sculptor crested in 1931–32, when he produced a wide range of pieces, including assemblages, plaster reliefs, wooden figurines, and monumental plaster heads later cast in bronze.[11] Moreover, the artist was much less active as a painter and draftsman during 1931, for which year Zervos catalogued only twenty-eight paintings and drawings. The time-consuming complexity of *Woman in the Garden* might partially—although by no means completely—explain the artist's lowered productivity in two-dimensional work.[12]

During the period of his collaboration with Gonzalez, Picasso received a commission to design a monument in honor of Guillaume Apollinaire. The artist had dreamed of receiving such a commission, and he enthusiastically set to work on *The Woman in the Garden,* a sculpture which closely conformed to Apollinaire's own prescient description of the monument which would be erected in his name. However, the municipally appointed committee charged with design selection rejected this piece, which must have seemed radical indeed in 1931, so Picasso kept it for himself. (His stormy negotiations with this committee dragged on until 1959, before all parties agreed to a compromise: the selection of a bronze bust of Dora Maar which Picasso had completed in 1941, a work which bears little relation to Apollinaire.)[13] Picasso probably had very few regrets about the committee's decision, for Gonzalez noted that the artist had made this sculpture "with so much love and tenderness in the memory of his dear friend [that] at the moment he doesn't want to be separated from it, to think of its being at Père Lachaise in that collection of monuments where people seldom go."[14]

Picasso's attachment to this sculpture suggests his nostalgia for his lost partner and, perhaps also, his wish that he might find a new partner of Apollinaire's calibre. During his late career, the artist often became preoccupied with cre-

ating sculpture during periods of acute conflict or anxiety, possibly because he derived special comfort at such times from forming three-dimensional works which seemed more lifelike and enduring. His affection for the aborted Apollinaire monument suggests that his interest in sculpture during 1928–34 sprang from similar sources.

Most of the wrought-iron assemblages which Picasso made with Gonzalez seem more fantastic than frightening, but the artist's paintings and drawings from these same years often appear quite ominous, suggesting his underlying panic. Thus, he started off 1928 with a New Year's Day creation which expressed his premonitions about the year ahead, a collage depicting a fleeing Minotaur which consists solely of an enormous head and a pair of running legs. Picasso pasted a phallic projection between the creature's legs, but this attribute, impressive though it may be, scarcely compensates for the monster's trunkless state. During succeeding months, other mutilated fleeing or falling figures joined the Minotaur, and depictions of monstrous females and fighting, biting couples proliferated. Early in 1930 he created one of his most horrifying images, the *Seated Bather,* a biomorphic bone figure who appears silhouetted against sea and sky in monumental isolation. Her threatening, pincher-like jaws have reminded many viewers of the mandibles of the praying mantis, that insect which devours its partner after mating with him. The appearance of this ogress suggests that Olga's condition may have worsened during 1929.[15]

In November 1929, a few months before he created this *Seated Bather,* Picasso fashioned a figure designed to look right no matter which way one turned it. A more elaborate version of this theme followed (Z., VII, 310), a painting depicting a trunkless acrobat; Picasso retained both works for his private collection. These pictures seem almost like concrete expressions of the artist's hope that he might land on his feet after the dreadful topsy-turvy period in which he found himself.

Right after he painted the bather, Picasso began a series of studies which culminated in a small panel painting of Calvary, a picture he once again kept (Z., VII, 287). Earlier, during periods of special stress, he had made drawings of the crucifixion. This 1930 panel marked his first oil painting of this motif, as well as his first elaboration of it to include the entire Calvary scene, not merely the corpus of Christ. The private, enigmatic nature of its iconography has prompted considerable critical speculation about this painting.[16] Its specific meaning remains obscure, but the savage, biting figures who surround Christ, seemingly threatening to devour him even as he expires on the cross, eloquently convey Picasso's desperation as well as his identification with the martyred Savior. As I have observed previously, this identification cropped up many times during the course of this avowed atheist's long life.

Perhaps the creation of this crucifixion painting provided Picasso with a cathartic release; perhaps it represented the resolution of an acute crisis rather

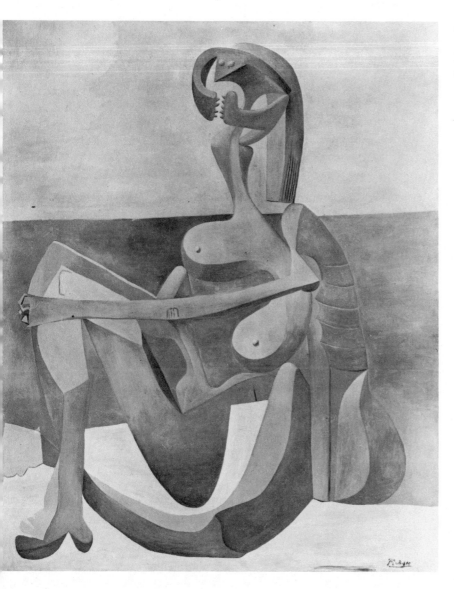

Seated Bather, 1930, oil on canvas, 163.2 x 129.5 cm. The Museum of Modern Art, New York. Mrs. Simon Guggenheim Fund

than its climax. Whatever the reasons, his production during subsequent months, though no more prolific, turned more serene. Still life motifs (then as later, probably associated in Picasso's mind with Marie-Thérèse, whose luscious body so often evoked comparisons with fruit and plant forms in his art) appeared in a number of pictures completed during the early months of 1931. Indeed, Picasso reverted to this same theme during the same period of the ensuing year; perhaps his mistress' fecund form stimulated phantasies about Persephone's annual resurrection. So lively do many of these canvases appear that the generic term *still life* seems a misnomer for pictures so implicit with generation, movement, and life.

Picasso's more cheerful frame of mind might have resulted, in part, from a change in his physical situation: he had purchased the large château of Boisgeloup, about forty miles from Paris. This estate not only contained the spacious quarters and grounds he required for the large-scale sculptures he had in mind, it also provided another, covert bonus: a secluded meeting spot where he could dally with his young mistress in blissful solitude, shielded from Olga's spying eyes. Throughout his long career as artist and lover, Picasso usually moved to a new abode whenever he had wholeheartedly committed himself to a new love. Typically, however, he always retained control of his old quarters as well, just as he maintained contact with all his discarded loves. He never established a joint household with Marie-Thérèse, but the acquisition of Boisgeloup might have had a similar significance for the artist, not yet willing to dissolve his marriage or the household he shared with Olga. Marie-Thérèse obviously visited there frequently, for she appears in numerous works created at the château. Moreover, the artist lost interest in this abode when he lost interest in Marie-Thérèse, and he eventually consigned the estate to Olga as part of the property settlement which followed their legal separation of 1935.

As soon as Picasso had established his new atelier, he began a series of idyllic paintings—many of them completed at Boisgeloup—which show a beautiful nude as she abandons herself to sleep with the tender grace of a flower opening its petals to the sun. Although these pictures (Z., VII, 331–33) depict Marie-Thérèse as she enjoys the rapturous sleep of satiation, they have yet another connotation: Marie-Thérèse sleeps, but Picasso remains awake to paint and protect her. Thus, they really constitute another variation on that theme which Leo Steinberg aptly christened the "watched sleeper." (Whether Picasso actually painted his mistress while she slept or merely recorded his memory of the way she looked while sleeping does not change the import of this motif.) This theme of the watched sleeper occurred initially in a watercolor Picasso made during 1904 which shows him brooding jealously over Fernande Olivier as she slumbers. During the decades of the early thirties and forties, the motif cropped up frequently, but he no longer depicted himself undisguised as the sleeper's guardian. Sometimes one must

Grande nature morte au guéridon (Large Still Life on a Pedestal Table), March 2, 1931, oil on canvas, 194 x 130 cm. Musée Picasso, Paris. Cliché des Musées Nationaux, Paris. © SPADEM, Paris / VAGA, New York

infer his presence, as in those canvases which show Marie-Thérèse sleeping alone. When the sleeper's guardian appears beside her—a variation Picasso usually reserved for his drawings and prints—the artist sometimes disguised himself, or more properly, transformed himself, into an idealized youth who gently pipes his nude to sleep with music. In other sketches, a man of grizzled visage, a figure closer to the actual persona of the artist, assumes the role of watcher-musician. Occasionally, the male's intentions seem less protective than predatory, as in those variations which depict a faun or Minotaur who steals upon the sleeping nymph. At other times, the motif involves two men or a woman watching a sleeping man.

Steinberg suggests that the artist's peculiar life style, his proclivity for working late at night while others slept, probably predisposed him to this theme.[17] This theory seems valid enough, but it does not clarify the fundamental meaning of this motif, which was that Picasso watched over people while they slept in order to assure himself that they would not die while in this vulnerable state. His own nocturnal wakefulness probably began as a complementary protective measure which became habitual: he slept only as dawn approached and others awoke to protect him.

None of the artist's biographers provides any clues concerning the etiology of Picasso's reversal of the usual sleep-work cycle, nor of his interest in guarding those who sleep. His childhood history, however, strongly suggests that this behavior originated soon after Lola's birth. Earlier I speculated that, as a child, Picasso believed that he had caused the earthquake which devastated Málaga and precipitated Lola's birth—an event which left him fragmented with impotent rage. Because he so heartily wished Lola dead, the little boy doubtless anxiously watched over his baby sister while she slept. His parents, like most parents, may have blinded themselves to the real motivation which led to this hypersolicitous behavior, and regarded it, instead, as proof of little Pablo's love for his sib. His own nocturnal wakefulness probably also had its origin in the earthquake, which had required his family to evacuate their home by night. Because he began to attend the bullfights regularly soon after the earthquake occurred, Picasso probably unconsciously confused the destructive rage of the bull with his own destructiveness. Later, he would turn this confusion to magnificent account with the invention of his awesome alter ego, the bull-Minotaur (by the time he developed this imagery fully, the artist was a mature man and doubtless aware of the Greek myths and dramas which describe the bull as the totem animal—and sometime assistant earthshaker—to Poseidon, the god the Greeks held responsible for earthquakes).[18] The death of Picasso's second sister, Conchita, who succumbed to diphtheria when he was fourteen, must have reactivated all of his beliefs in the destructive powers of his hostile wishes; perhaps she died at night, reinforcing his primitive associations between darkness and death. At any rate, by the time Sabartés

first knew Picasso, when both were in late adolescence, the artist habitually stayed out until late at night, then drew and read till dawn, when he finally fell asleep. Fernande Olivier recalls that, during her early years with Picasso, he always worked till five or six A.M., then slept till late afternoon.[19]

During Picasso's mature adult life, when things went well and he felt reasonably comfortable, he probably could substitute the act of painting or drawing his loved one asleep for the actual activity of watching the sleeper. When he became too anxious, such substitutions failed to reassure, and he actually had to stand guard over the loved one himself or, preferably, deputize another to act in his stead. Gilot presents a vivid description of her deputization as the watcher during the infancy of the two children she bore Picasso. According to her account, the artist would frequently awaken late at night, panicked by the idea that the baby had smothered to death in its crib. Until Gilot arose, checked on the infant's well-being and reassured the artist, he could neither fall back asleep himself nor permit Gilot to do so. Sometimes he forced her to check on the baby as often as six times in a single night! She also notes, without making any apparent connection between these two activities, that Picasso loved to watch Paloma as she slept and spent long hours sketching and painting her while she napped. Since both the artist's younger siblings were girls, it is easy to imagine that the birth of his girl child caused him much more ambivalence and required much stronger compensatory guarding measures. In Paloma's case, the artist both employed an assistant sleep-watcher and carried out certain of these duties himself.[20]

When Picasso watched over the sleeping Marie-Thérèse and Paloma, he displayed the same maternal attitude with them that he had adopted earlier vis-à-vis Fernande, whose shopping and household chores he had assumed, as though she were a beloved child. In such instances, Picasso treated his beloved as he longed to be treated, indeed, as he probably had been treated during his childhood by his mother and the other women of his household, who may well have kept vigil at his bedside because he suffered from nightmares or other sleep disturbances. In those more infrequent drawings which depict a young woman watching over a sleeping man, Picasso gave more direct, undisguised expression to the wish that his mistress (mother) devote every moment to him, even standing guard while he slept. Those creations which show the predatory Minotaur stealing upon the sleeping girl, by contrast, come much closer to presenting the underlying feeling which required the reactive compensatory "good" behavior. By the time Gilot lived with the artist, his infantile wishes had become more explicit (or, more likely, fatherhood caused him to revert to a more childlike state). He seldom assumed his more parental stance with her—except to instruct her, in rather lofty fashion, concerning the principles of painting in general and his own painting in particular—while she devoted much of her time and energy to fulfill-

ing slavey tasks for him, such as lighting the morning fire in his studio, tasks which he certainly could have delegated to servants but which he preferred to have his mistress carry out for him while he assumed a helpless, yet demanding attitude.[21]

• During the latter half of 1932, Picasso seemed especially preoccupied with the motif of the watched sleeper. He spent much of this period at Boisgeloup, where Marie-Thérèse frequently joined him. In their hidden retreat, he portrayed his sleeping mistress again and again, both in that series of magnificent canvases which show her alone and in the series of more intimate drawings which portray her watcher beside her. Beginning in August of that year, the content of all of Picasso's drawings assumed a highly personalized, enigmatic character indicative of a growing anxiety about Marie-Thérèse's well-being, her physical or psychological safety. (That this concern initially focused primarily on his mistress, not himself, we may assume from the fact that, for the first time in several years, Picasso's production had dramatically increased; he completed a number of major sculptures and prints as well as 132 works on canvas or paper during 1932.)

A close study of the iconography of the pictures he created between August 1932 and the following April (see especially the first ninety-two entries in Z., VIII) reveals this growing anxiety. In the initial drawings recorded in this catalogue, Marie-Thérèse appears in close proximity to a potted plant which covers her face like a transparent hand. The sun appears right behind her, and a bird soon emerges, as it were, from this orb, to hover right above the girl's head. Initially, the creature seems benign, resembling a white dove, but his color soon changes from white to black, a transformation accompanied by diffuse, smeary shading which spills over from the bird's body into the surrounding areas, including the girl's hair. Finally, the bird changes into a much larger crow, which alights atop Marie-Thérèse's head as aggressively as a dive-bomber; once again the bird's shading spills over onto her hair.

The scene next abruptly changes to the seashore, where Marie-Thérèse appears as a sun bather. Again, however, the mood turns ominous as an infernal machine worthy of Bosch appears, a long knife-like object (it may actually be a canoe), poised on a launching machine propelled by a pair of over-sized human ears which replace its wheels. Marie-Thérèse perches near the sharp end of this object, holding a kind of balancing staff, perhaps a leafy bough. In the shadows of this drawing, covered with dense cross-hatching, lurk ogre-like figures who seem to menace her. The next eight sketches show Marie-Thérèse asleep; but the disturbing note soon recurs, and she is shown awake once more, running in headlong flight, sometimes with another figure in pursuit. The drawing again becomes dark, diffuse, undisciplined, and a detached ear appears in the right margin of one of these sketches (Z., VIII, 22). After this interlude, the long series of watched sleeper drawings

intervenes, ushered in by sketches which show a clarinetist serenading the still wakeful beauty seated beside him. Gradually, she is transformed into a sleeper; the clarinetist into a flutist. In the midst of these tranquil sketches, the threatening bird makes a single reappearance (Z., VIII, 40) in a drawing again covered with dense, diffuse shading. The watched-sleeper motif continues once more, only to be interrupted by a set of crucifixion studies, allegedly modeled after one of the most awesome representations of this motif, the *Isenheim Altarpiece* of Matthias Grünewald, its protagonists transformed into surreal bone fragments silhouetted against an impenetrably inky sky.[22]

Picasso next developed a rescue theme in sketches and paintings showing a drowning swimmer being discovered or saved by another. Usually, both figures are female and both resemble Marie-Thérèse. The rescuer often shouts for help with her head thrown back in a gesture which prefigures the screaming female heads of *Guernica*. Once again these drawings contain heavy shading applied in a smeary fashion unusual in Picasso's oeuvre. A series of closely related oil paintings portray what one might label "failed-rescue" themes. They show trapeze artists as they perform; but instead of catching one another when they release the bar, these hapless aerialists fall freely through space, like stars.

In the light of Marie-Thérèse's eventual suicide, the imagery in these works from 1932–33, with their themes of danger, suffering, disaster, and death, acquire new significance. Something must have happened during that summer of 1932 which made Picasso painfully aware of his mistress' underlying fragility, her need for constant support, frequent rescue operations. Penrose, the only one of Picasso's friends who seems to have known Marie-Thérèse, notes that she behaved in totally unpredictable ways, "as though controlled by the influence of the moon or by some even less calculable force."[23] Perhaps she was seized by such an episode of moon madness that summer; perhaps she even attempted suicide. People who die by their own hand seldom do so in one perfect attempt; usually, their deaths are preceded by several failed suicidal efforts.[24] The strange content of all these drawings even suggests a possible reason for Marie-Thérèse's upset, although it is a possibility based solely on my interpretation of the iconography of these works. Could Marie-Thérèse have become pregnant that summer, an act of God terminated either by a miscarriage—or, more likely—an abortion? At least such a chain of events seems compatible with Picasso's imagery of the period. Those drawings suggestive of Marie-Thérèse's plant-like qualities, followed by the benign, then attacking sun-bird (the bird is a traditional Latin simile for the male organ, and a symbol with connotations of the Holy Ghost and the annunciation to the Virgin as well, especially when the bird is coupled with the sun, as in these sketches). I suggest the possibility of an abortion both because of that mysterious canoe-knife, drawn on its ear cart (an al-

lusion to van Gogh's mutilated ear, or to Peter's action in the Garden of
Gethsemane?), as well as to the "bloody" quality which frequently character-
izes Picasso's shading in those August sketches.

During the early spring of 1932 Picasso had certainly been especially
preoccupied with fertility imagery in conjunction with Marie-Thérèse. Such
ideas become quite explicit in paintings like *The Young Girl before a Mirror*
and the *Nude on a Black Couch;* in the latter, a giant philodendron seems
to sprout from the slumbering Marie-Thérèse's body, as though she were
a modern Jesse (Z., VII, 377).[25] These pictures are merely the most cele-
brated among a host of similar paintings and drawings Picasso composed that
spring. Did the artist—perhaps seduced by his own potent imagery—im-
pregnate his young mistress, then persuade her to secure an abortion? Cer-
tainly some disaster occurred which impressed Picasso with her vulnerability
and his own responsibility to watch over, reassure, and rescue her. The pe-
culiar blood-like shading as well as the content of so many of these work
suggests that, once again, the artist participated in the anxiety and fragmen-
tation of his beloved partner.

Although no one has previously suggested that Marie-Thérèse might have
become pregnant in 1932, many critics have commented on the explicitly
erotic quality which characterizes so many of those depictions of Marie-Thérèse
Plate 6 For Berger, pictures like *The Young Girl before a Mirror* primarily "praise
the sex they have enjoyed."[26] Such an equation of the sexual symbolism
which abounds in this picture with recollections of concrete erotic experiences
seems over-simplified. Picasso may have represented Marie-Thérèse in this
fashion not only as a testimonial to their happy sexual relationship but because
she symbolized his own magical fecundity. She so perfectly embodied his
ideal of classical beauty that it must often have seemed to the artist that he
had invented her himself. Perhaps she symbolized for Picasso all sorts of
unexpressed grandiose phantasies about himself as a god-like being, capable
of summoning up a perfect creature from the void.

That the notion of the artist as divine creator consciously occurred to
Picasso at this time is at least suggested by a drawing from August 1931
(Z., VII, 336), which shows an older sculptor as he instructs a student while
making a gesture towards his beautiful female statue similar to that made
by the God of Michelangelo's Sistine ceiling as he infuses Adam with the
spark of life. Other drawings and prints emphasize the sculptor's rapturous
expression as he intently scrutinizes his beautiful statue, seemingly awed by the
miracle he himself has wrought.

Phantasies about the mystical bond which unites creator and creature proba-
bly also underlie the enigmatic symbolism of the *Young Girl before a Mirror*
As many critics have observed, this figure seems to possess the attributes of
both sexes, of life and death, of generation and decay. However, she can also
be read both as a concrete expression of the merger between the artist and his

use, and as a symbol of the triumph of art over death. Berger has speculated that "in time the ideal of Marie-Thérèse came to mean more to the artist than she herself."[27] Pictures like the *Young Girl before a Mirror* suggest, on the contrary, that if Picasso came to love Marie-Thérèse, it was because he had created her, as Pygmalion created Galatea, only to fall in love with the concrete projection of his own ideal.

It may be that such phantasies of himself as a modern Pygmalion influenced the transformation in Picasso's sculptural style which occurred in 1931–2. As he became preoccupied with imagery involving Marie-Thérèse, he abandoned the relatively abstract style of his wrought-iron pieces to create more representational figures; this phase culminated in a series of monumental plaster heads which explore the plasticity of Marie-Thérèse's features. The artist began the series with a bust so classical and tranquil that it might represent Athena; he terminated with a radically altered version in which the model's facial features seem to assume independent patterns of life and growth. These heads recall Matisse's series after *Jeanette*, but Picasso's variations retain a more earthy, sensuous quality. Berger suggests that the nose and mouth of the most radically transformed heads are metaphors for the male and female sexual organs.[28] Perhaps, as Berger contends, the artist consciously had such play of shapes and functions in mind. Nonetheless, I remain convinced that such imagery does not primarily memorialize Picasso's sexual experiences, but represents him as the autogenic creator. He served as both mother and father to his art; alone, he conceived, nourished, and bore the children of his fancy. This figure with its bisexual attributes may really represent the artist himself as Zeus: from this head, Athena could spring forth in her mature beauty.

In the forty-five etchings which comprise the "Sculptor's Studio" segment of the Vollard Suite, Picasso addressed himself directly to the question of the relationship—and possible conflict—between creativity and sexuality.[29] More than half these prints show a bearded sculptor with his beautiful, nude young model. He concentrates his attention critically and exclusively on the sculpture he has just completed, while she reclines beside him, ignored, half-forgotten, her role as creative stimulus ended. Sometimes the sculptor reaches out to touch or caress her, much as one might absently pet a faithful dog seated at one's side, but his art—not his model—occupies the sculptor's attention.

Immediately after he completed these etchings, Picasso began another series in which the Minotaur invades the sculptor's studio. The beast, unrestrained by any sublimation of his baser instincts, leers suggestively as he clutches at the lovely models. Finally, the sculptor joins him in an orgy, his expression becoming almost as brutish as the Minotaur's. It is the Minotaur, however, and not the sculptor, who ravishes the sleeping nude, only to die soon after in the bullfight arena, slain by a youth of androgynous beauty and purity of expression. Like Harlequin, the Minotaur is soon magically resur-

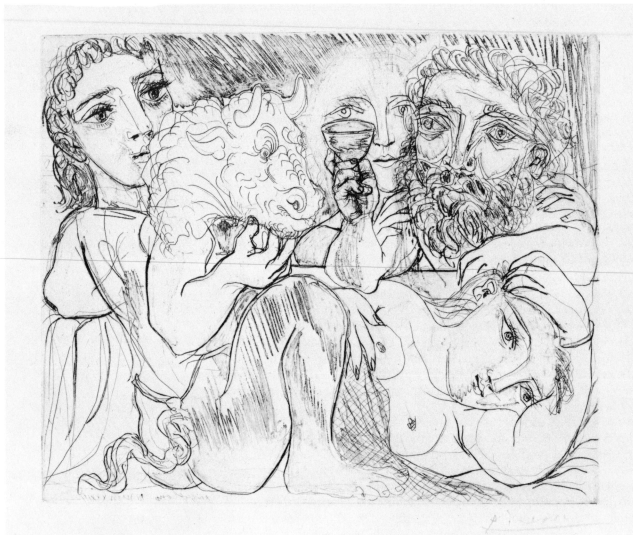

rected; he lives to sin again, returning to the sculptor's studio for another round of drinking and lovemaking. In the Minotaur group, Picasso seems to suggest that sexuality involves a reversion to lower-order, animal-like behavior. For the artist, it can only serve as a kind of recess between periods of higher creativity; after the sculptor satisfies his bestial instincts, he returns to his one true passion—art.

During the same period, Picasso executed a number of drawings which also reiterate this implied equation between sexuality and animality. Thus, in a pair of sketches from 1933, he depicted the copulation of a primitive humanoid couple whose underdeveloped crania and overdeveloped genitalia reveal that they remain in thralldom to their sexual urges. In a set of clever parodies on modern mechanization, he transformed another pair of primitive copulators into a fornication machine. In its ultimate form, the machine has become so schematized that it might be difficult to guess its components and function without knowing the previous drawings. However, Picasso immediately followed this mechanical fornicator with a rapist Minotaur all too human in his passionate frenzy (Z., VIII, 100–12). Such preoccupations suggest that, for the first time in his life and career, Picasso felt less tolerant about his own sexuality. In the past, his works had always demonstrated his sympathetic comprehension of all types of sexual motivations and expressions; one can note this attitude even in pictures he created as a mere boy. Now, as a middle-aged man, he suddenly seemed resentful of his own sexuality. He undoubtedly blamed his sexual needs for the difficult situation in which he found himself, although to the skeptical observer it seems most unlikely that sexual factors played a crucial role in motivating him to make his complex dual relationship with Olga and Marie-Thérèse. Sex is the invariable part of all such relationships, so the partner is *always* chosen on some other basis. But Picasso did not realize this; it must have seemed to him that his sexual appetite had entangled him in the morass in which he struggled, saddled with a mad wife and a young mistress whose family remained ignorant of her liaison with a married man more than thirty years her senior. Picasso had boxed himself into a situation which could only be resolved through unpleasant means. No wonder he felt disgusted and wished that he could turn his sexual needs on and off, like a machine, or satisfy them without involving himself in problematic entanglements, like the Minotaur, who rapes and runs.

By July 1934, Picasso's personal situation had dramatically worsened. We do not know precisely what triggered this reaction, but he suddenly felt swamped by a rage so primitive and so pervasive that it threatened to destroy everything he held dear. He revealed his anxieties in a set of pictures of the bullfight, representations probably directly inspired by a visit he had made to Spain, but executed later in his studio at Boisgeloup. One of the most terrible of these pictures portrays a mortally wounded bull engaging in his last savagery as he devours the entrails of the horse he has just disemboweled (Z.,

Minotaur, Drinking Sculptor, and Three Models, June 18, 1933, etching and dry point, 29.7 x 36.7 cm. Collection of Dr. Eugene A. Solow. Photograph courtesy of the Art Institute of Chicago

VIII, 217). In related sketches, an angelic figure based on Marie-Thérèse appears in the arena, holding a lighted candle as though to illuminate the artist's way out of the darkness of the bloody conflict in which he found himself. Another drawing from this period shows a terrible female figure stabbing a young girl who resembles Marie-Thérèse (Z., VIII, 216, 222). This sketch suggests that the artist worried that Olga might attack or harm his young mistress. On another level, however, the attacking harpy surely represents his own rage, which he feared would destroy his mistress. He soon revealed this obsession more openly in a series of pictures and prints depicting Marie-Thérèse as a wounded matador, slung over the back of a disemboweled horse. In one such drawing (Z., VIII, 226), the bull, undeterred by the sword protruding from his shoulders, surveys the mortally wounded girl and horse with a grin of sadistic pleasure. (It seems likely that the horse in these pictures represents Olga, so often symbolized in Picasso's art by this creature.) The climactic picture in this series, the *Bullfight* of September 9, 1934 (Z., VIII, 233), depicts a confused haze of blood, dust, and fragmented intestines as the maddened, dying bull destroys all before him, grinding his victims into shapeless elements beneath his pounding hooves. During succeeding months, the artist's production floundered. Indeed, that fall he virtually dried up, except to produce the four beautiful etchings included in the Vollard Suite as *The Blinded Minotaur*.

What triggered Picasso's rage, rage which seemed to be directed more at Marie-Thérèse than at Olga? We can only guess from the pictorial evidence, which suggests that his mistress suddenly ceased to fascinate the artist, who was becoming painfully aware of her psychological limitations.[30] Palau I Fabre states that when the artist vacationed in Spain in 1933 and 1934, his wife and son went along. Other biographers insist that Marie-Thérèse accompanied him on these trips. Both sources may be correct: during the late 1930s, Marie-Thérèse, Dora Maar, and Olga regularly appear in pictures which Picasso created on vacation, suggesting that they all followed him to his holiday spot, undoubtedly because he communicated his destination to them. During the summer of 1945 Picasso vainly attempted to persuade Gilot to join him on the Riviera, where he was staying with Dora Maar, then recovering from a psychotic episode! Consequently, it seems entirely plausible that Picasso arranged for Marie-Thérèse to travel in his wake while he journeyed in Spain with his family.[31]

That 1934 trip to Spain was fairly extensive, involving multiple stopovers before the artist reached Barcelona to visit with his mother and sister. The fact that he took such a trip in itself suggests his restlessness, for he usually preferred to vacation by the sea in a single place where he could work with scarcely an interruption, except to sea bathe. The fact that he planned a journey which prevented him from accomplishing much suggests that he was already feeling too agitated to concentrate optimally on his art. Whether he traveled

lone with Marie-Thérèse, or with his legal family in tow as well, Picasso returned from this journey enraged and soon produced those pictures of the murderous, dying bull. During the course of this vacation he probably spent more leisure time with his mistress than ever before. To his sorrow, he must have discovered that her sensuous beauty constituted not merely her chief asset, but her only asset. Picasso's close friend, Roland Penrose, later described Marie-Thérèse as the "only truly non-intelligent woman, the only really vulgar woman to have been part of Picasso's life."[32] And Mlle. Walter's own glowing retrospective account of her romance with the artist substantiates this impression. She sounds, to say the least, ingenuous: "I was living with my family, and I had to lie to them more and more. I would say I was spending the afternoon with a girl friend, and I would come to Picasso. We would joke and laugh together all day, so happy with our secret, living a totally non-bourgeois love, a bohemian love away from those people Picasso knew then. You know what it is to be really in love? Well, who needs anything else then? We spent our time worrying about nothing, doing what every couple does when they're in love."[33] That summer—perhaps during that Spanish vacation—Marie-Thérèse's unvarying combination of sex and giggles began to pall on Picasso. The evolution of her image in Picasso's art reveals that he eventually became aware that she could offer him nothing but her beauty; hence, she could never transcend being his creature. Eventually she must have seemed to the artist one of his less happy inventions.

One wonders why Picasso couldn't sever his relationship with Marie-Thérèse at this juncture. Though furious, he clearly felt he could not desert her, just as he had been unable to part from his mother, just as he could not separate from Olga, just as he would prove unable to cut himself off definitively from Dora Maar once their affair had ended. The maddened bull who invaded Picasso's imagery that autumn represented his own reaction to the dilemma in which he found himself, chained to a foolish, fatuous girl who no longer fascinated him, whose luscious body no longer interested him or stimulated him to paint marvelous pictures. Nonetheless, Picasso remained loyal—if estranged—probably because he sensed that to abandon Marie-Thérèse would destroy her. Many years later, she terminated her own life in a gesture which revealed that Picasso had been quite prescient in perceiving her as so fragile. As I suggested above, he may have had more concrete evidence of this fragility: she may have threatened suicide or even attempted it more than once during the period of her romance with Picasso. We simply do not know about such details of her day-to-day behavior. Picasso never lived with her on a regular basis, and he never introduced her to most of his friends (quite possibly because she embarrassed him), so we lack such information, except for Penrose's negative assessment.

Certainly by the time Frank Perls met her in 1969, Marie-Thérèse behaved bizarrely: "We sat at a square dining-room table. And she talked about him

Blind Minotaur Led through the Night by Girl with Fluttering Dove, 1935, aquatint, 24.7 x 34.7 cm. Collection of Dr. Eugene A. Solow. Photograph courtesy of the Art Institute of Chicago

[Picasso]. She did not tell me a love story, or the story of a scorned woman. There were not even tears, but an unhappy woman trying to appear happy. Each story relived the past from their first encounter to the time spent together; from Maya's birth, Maya's youth, Picasso's visits, which became rarer and rarer. How he left and sometimes returned." Perls then relates how she brought out all the letters she had ever received from the artist, reading from them for hours while he shivered in her badly heated flat. Finally, as the pièce de résistance, she introduced several neatly wrapped little packages which proved to contain Picasso's fingernail parings, carefully conserved from the long-ago time when he enjoyed having Marie-Thérèse clip his nails. Perls observed, "She was a woman in love, determined to stay in love with the man she was never to see again. A woman in love with her past, she was Queen Victoria talking about her *Liebling* long after Albert had gone. That is how it was with Marie-Thérèse Walter that cold day in January, 1969." His account recalls Gilot's rather similar description of how Olga pretended to herself and others that she still lived with Picasso.[34] He seemed to be attracted to women who found it as difficult to separate from him as he from them. Even in death, Marie-Thérèse maintained her tenuous connection to the artist, for she committed suicide on October 20, 1977, just a few days before the ninety-sixth anniversary of Picasso's birth.

Whatever his reasons or his premonitions, Picasso did not break with Marie-Thérèse. Instead, he virtually stopped working for several months, except to produce the four etchings comprising *The Blind Minotaur* sector of the Vollard Suite, completed during September and October 1934. Penrose suggests, quite plausibly, that the blindness which afflicts the Minotaur in these prints represents an act of symbolic penance on Picasso's part, which somehow related to the frequent references to blindness during the artist's blue period. Penrose's corollary hypothesis that this motif meant that Picasso had temporarily turned his back on painting in favor of sculpture is not, however, borne out by Spies's more recent catalogue raisonné, which indicates that Picasso completed only four minor-scale sculptures during 1934.[35] The crossed-out painting depicted in the upper left corner of the first of these four etchings refers not only to David's *Death of Marat* (Penrose interprets this gesture as evidence for Picasso's rejection of painting), but also to the sketch the artist himself had completed a few months earlier which depicts the murder of Marie-Thérèse. In truth, it was not Picasso's preoccupation with sculpture, but his rage and guilt, which "blinded" him and prevented him from creating *either* paintings or sculptures. He must have felt that Marie-Thérèse was destroying him, just as Marat had been destroyed by Charlotte Corday. Picasso longed to slash out defensively; he succeeded in staying his hand, but he bottled up his creativity along with his aggression.

All four of the etchings depict the blinded Minotaur as he gropes his way along a quay. One assumes he has just been discharged from the boat

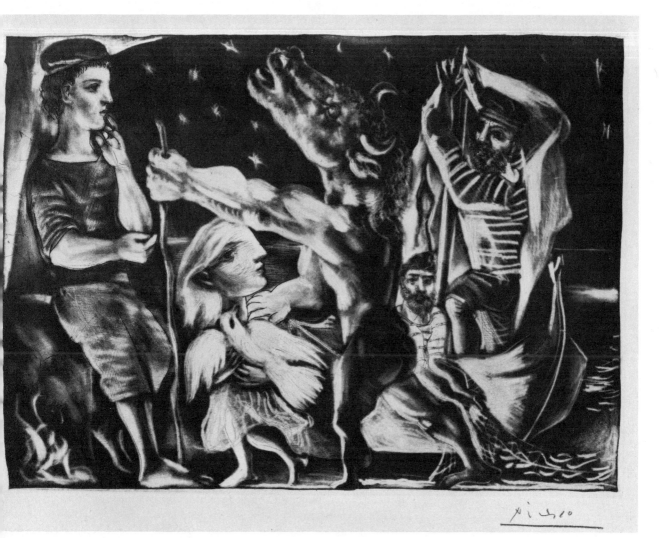

which lingers offshore; the bearded fishermen on board the craft watch the drama in silent fascination. A beautiful little girl who resembles Marie-Thérèse takes the monster by the hand to guide him, as Antigone guided the exiled Oedipus. On one level, she probably represents the artist's muse, his highest sublimated impulses, just as the beautiful androgynous youth who appears in all four prints represents the artist's lost youthful innocence and idealism.

The fact that the little girl habitually clutches a fluttering dove suggests that she may possess another hidden identity, one which the artist may have found less acceptable—or believed that his audience would find less acceptable—and which he disguised. She must represent an aspect of the artist himself, his nostalgia for his tender childhood relationship with his father, represented by the dove. Both the history of that childhood and many clues in Picasso's art indicate that, as a child, the artist felt more like Don José's little girl than his little boy. Nineteenth-century society permitted girls to express their passive, dependent needs openly, whereas little boys—especially those in Latin cultures—were expected to be sturdy and self-reliant. Picasso simply could not manage that boyish show of independence. He was too fragile, too damaged; he needed his father's loving protection too much. Moreover, his father, an unusually gentle, maternal person (just as Picasso's mother seems to have been a domineering, masculine woman) did not find this behavior threatening. He realized that his most important task was to foster his son's great gifts, utilizing whatever crutches he could to help support the boy. In his later relationships with women, Picasso often behaved with his beloved as his father had behaved with him. Thus, he played the nurturing, mothering role with Marie-Thérèse, while she enacted that of the little girl. Of course, as is always the case with such role reversals, Picasso soon tired of his assumed role, for his underlying wish to be the beloved child himself bubbled just beneath the surface. The imagery he created in response to Marie-Thérèse reveals that he possessed considerable insight into the real meaning of his attachment to her, but not enough to permit him to interrupt the vicious cycle he seemed doomed forever to repeat with one woman after another. It seems likely that Picasso's vulnerable women represented not only his (disturbed) mother but his own disintegrated childhood state. He could never completely abandon his women, even after they had ceased to interest him, because *they represented his own fragile core.* To Picasso, Marie-Thérèse must now have seemed doubly his own creature: she represented not only his ideal of beauty but his own core deficiencies as well.

Typically, then, Picasso continued to cling both to Marie-Thérèse and to Olga. Despite his declining productivity and increasing desperation, he could not bring himself to decide between wife and mistress, but enacted, once more, the entitlement of the damaged child to continuing protection. His seeming inertia regarding Olga probably reflected, not his weakness, but the

strength of the ties which bound him to his past. Olga represented far more to him than the memory of a shared love now lost. She had functioned, she continued to function, as an integral part of his own being. Her illness continued to traumatize him, not only because he felt culpable, but because he vicariously suffered her disintegration as his own. Nonetheless, sometime during the winter or early spring of 1934–35, Picasso apparently steeled himself to agree to a separation. A new complication forced his hand: Marie-Thérèse was pregnant, expecting a child early in October. Most biographers assume that this pregnancy was accidental, ignoring the likelihood that Picasso may have required just such an act of God as a sign that he must reorder his loyalties, deserting wife for mistress, false symbol for true. Furthermore, if he had insisted that Marie-Thérèse submit to an abortion in 1932, as I have speculated, he may have impregnated the girl again as an act of reparation. He may also have hoped against hope that the pregnancy would heal his underlying ambivalence toward his mistress. Later, when he was associated with Françoise Gilot, he repeatedly urged her to become pregnant as a solution to their interpersonal difficulties. Although she had many reservations about the soundness of this program, Gilot twice yielded to Picasso's arguments. Marie-Thérèse may have responded in similar fashion to a similarly seductive line of reasoning.

Even after he had received confirmation of Marie-Thérèse's pregnancy, Picasso evidently hesitated to take the definitive step and walk out on Olga, and it was she who finally stormed out of their apartment in July 1935, with their fourteen-year-old son in tow. Picasso remained behind in their Rue de la Boëtie home, paralyzed, making no attempt either to leave for his usual summer vacation or to underscore the termination of his marriage by moving with his mistress to a new residence, a ritual he usually faithfully followed with each change of ladies. Instead, he reacted as he had during his childhood, when separation from his father caused him to become paralyzed with doubt and anxiety.

After innumerable disagreeable conferences with lawyers, the Picassos finally agreed to a legal separation which provided Olga with an allowance, the deed to Boisgeloup, and custody of their son. Picasso's biographers have all accepted at face value the claim that complications caused by Picasso's foreign citizenship made it impossible for him to secure a divorce. Surely, had he really wished to be free, he could have managed a divorce somehow, somewhere (perhaps, for example, by applying to become a French citizen or seeking a Mexican decree). The truth may be that he did not really want a divorce, because the arrangement with Olga provided him with the best of both worlds: he had ridden himself of Olga's daily presence, but she remained his wife in absentia. Consequently, he could not marry Marie-Thérèse, and he was thus protected against making an alliance which might have been even more difficult to dissolve than his marriage to Olga.[36]

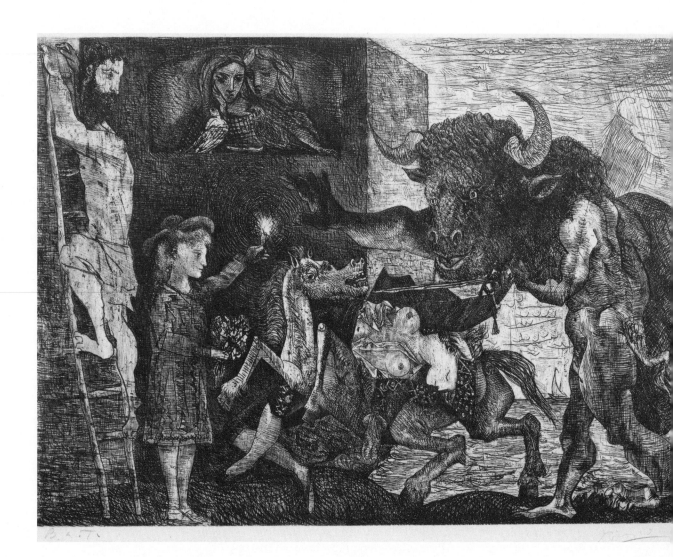

The content of Picasso's very scanty production from 1935 suggests that it is as much Marie-Thérèse's pregnancy as Olga's departure which undid him. Most of the twenty-six catalogued paintings and drawings which Picasso produced in 1935 date from the first few months of the year, especially from February—when Marie-Thérèse probably received confirmation that she was nearly two months pregnant—and reflect his preoccupation with her pregnancy. At least, it is difficult to find any other interpretation for the three drawings from February 5, 1935, which represent a woman seated on the floor, facing a large standing mirror. We glimpse a relatively naturalistic mirror-reflection of Marie-Thérèse as she draws or writes on the pad held in her lap. The "real" Marie-Thérèse in the room, by contrast, appears as a surrealistic apparition: an enormous, swelling seed pod. The spiraling, burgeoning motion of the pod suggests the feelings of germination and transformation which Marie-Thérèse must have been experiencing (and perhaps communicating to the artist via letter?) during this first trimester of her pregnancy. Later that month, Picasso created several studies and paintings showing two young girls in an interior; one girl writes or sketches while her companion, who resembles Marie-Thérèse, dozes with her head on the table. Picasso's mistress had a sister who knew about her liaison with the artist and even accompanied Marie-Thérèse to some of their trysts. No evidence suggests that Picasso spent much or any time with his mistress during her pregnancy, and he may have relied on this sister to keep him informed. After February, Picasso did very little. A pair of drawings from April depicting a horse and bull in angry confrontation may reflect an actual flair-up of hostility between Olga and Picasso, or may even mark the date when he finally confessed the fact of Marie-Thérèse's pregnancy to his wife.

Aside from these angry drawings, the artist produced virtually nothing during the remainder of 1935. Only the beautiful *Minotauromachy* etching appeared, like a miraculous oasis in that desert which Picasso's creative life had become. Much more complex than the blinded Minotaur etchings from the previous autumn, the *Minotauromachy* shows the exiled monster once again arriving from the sea, a gigantic pack on his back. No longer blind, he appears most fierce and savage, with an enormous, shaggy head. The beast's restored vision may symbolize the artist's pride that he had at last broken with Olga and assumed some responsibility for his own destiny, however dark that might appear at the moment.

A female matador, once again modeled on Marie-Thérèse, appears, slung across the back of her disemboweled but still agonizing horse. She bears no visible wound, but her garments have been rent revealing both breasts, and she seems to be either unconscious or dead. She continues to grasp her sword, but its handle also appears contiguous with the monster's paw. One wonders whether he will seize the weapon and administer the coup-de-grâce to these poor creatures whom he has so grievously injured.

At the left, the little girl who figured in the blind Minotaur etchings re-

Minotauromachy, 1935, etching, 57 x 77.3 cm. The Art Institute of Chicago. Gift of Mrs. P. Donnelley

enters, but her profile now seems closer to that of Picasso himself than to
that of Marie-Thérèse. She carries a lighted candle and a bouquet of flowers.
The Minotaur holds up his hand, as though to ward off the radiance of this
vision, but he continues to advance toward the child. Curt G. Seckel, a Jungian
psychoanalyst, suggested that she represents man's highest self and holds the
shining light of innocence. On one level, such an interpretation seems quite
correct.[37] She remains calm as she confronts the Minotaur, perhaps because
she is confident that the artist's noble impulses will win out over his baser
drives, and he will turn tame.

At the far left, a bearded man flees up a ladder. He may symbolize the
artist's father, but probably also reveals characteristics of the artist himself.
His resemblance to Picasso has been noted by many observers, and he may
symbolize that other side of his personality, his self-diagnosed weakness
or timidity. On another level, the little girl also suggests such an interpre-
tation, for she probably again represents Picasso's longing to retreat once
more to the security of being daddy's little "girl."

Above the street, two young women contemplate the drama from the
safety of their window ledge, where two doves perch. The young women
may allude to Picasso's sisters, but they also recall those paintings of Marie-
Thérèse and her sister from the previous February.

Many critics have noted the similarity between the imagery of this print
and that of the *Guernica* mural which Picasso would create a few years later.
The humanized bull, the ladder, the gored horse, and a young woman leaning
from a window all recur in the mural. We probably deal, in both instances,
with a basic vocabulary of images which reflects the impact of certain early
experiences indelibly imprinted on Picasso's memory which surfaced in his
art whenever he became particularly impassioned and, thus, even more em-
phatically autobiographical in his references.

Such associations to Picasso's family and his early experiences would cer-
tainly have been quite natural at this time. His extreme reaction to Marie-
Thérèse's pregnancy indicates that, from the beginning, he connected this event
with his mother's second pregnancy. If so, his apprehensions proved well
founded; for the unfortunate Marie-Thérèse did, indeed, give birth to a
daughter the following October 5th. They named the baby Maya de
Concepción, after Picasso's dead sister, a fact which suggests that, from the
first, this was her symbolic identity for the artist.

According to Brassaï, who claims that he witnessed their introduction,
Picasso "made the acquaintance of Dora Maar one day in the autumn of 1935,
at almost the same time Marie-Thérèse gave birth to his daughter, Maya."
Although other authorities place this meeting many months later, Brassaï's
story seems convincing, for it seems logical that Picasso might have begun
window shopping for Marie-Thérèse's successor as soon as she had given birth
to his daughter.

Picasso was not yet ready to embark on another full-scale love affair, however, and his serious romance with Dora Maar did not commence until almost a year later. In fact, his behavior immediately after Maya's birth repeated his reaction to Lola's arrival, when he had turned to his father for comfort and support. A happy coincidence once more provided him with the company of another kindly, supportive man: Jaime Sabartés had just returned to Barcelona after a prolonged sojourn in South America. When Picasso learned of Sabartés's return, he wrote a pathetic letter begging the poet to join him in Paris. As usual, the good genie instantly obeyed his master's summons. Officially, the poet acted as Picasso's secretary-receptionist, but his true role probably more closely approximated that of a caretaker or parental surrogate. Too anxious to tolerate solitude, Picasso detained Sabartés every evening after dinner for as long as possible, chatting with him about little nothings to postpone the inevitable moment when they must part to sleep.[39] Indeed, Sabartés's description of these incidents recalls his account of Picasso's quite similar behavior during the onset of the blue period, thirty-four years earlier. Then, too, Sabartés had hastened to his troubled friend's side. Then, too, Picasso could not bear to separate and face a lonely night. It seems clear that, whenever he became especially upset, Picasso's childhood fears returned, making it almost impossible for him to tolerate solitude, which surely seemed to him a little death.

Every morning, Sabartés faced a Herculean assignment: coaxing Picasso to rise. Picasso's emotional paralysis made it exceedingly difficult for him to initiate his day; consequently, he remained in bed for an hour or more while poor Sabartés struggled to convince him to get up. We have no information concerning whether Picasso showed this behavior earlier in his adult life, but we do know from Gilot's account that the difficulty persisted long after his 1935 crisis had ebbed. She understood better than Sabartés the nature of the problem, but she enjoyed little more success in abbreviating these bizarre *levée* rituals. It seems likely that this behavior pattern began in Picasso's childhood, when he feigned illness or actually became ill in order to avoid going to school. Whatever the origin or duration of this problem, Picasso required massive reassurance to begin his day. Although he endlessly asked Sabartés the time in a teasing tone, Picasso's difficulty was all too real and quite involuntary.[40]

Eventually Sabartés succeeded in getting Picasso up, but not even the poet's soothing presence could stimulate the artist to begin painting once again. Rather his growing intimacy with the surrealist poets and the presence of his poet friend seem to have stimulated him to continue the efforts at poetry writing he had begun soon after Olga departed. For several months he busied himself writing blank verse in Spanish. Sabartés duly corrected, transcribed, and eventually translated these verses into French (Picasso's idiosyncratic spelling and grammatic usage certainly support his contention that he suffered a learning disability in childhood). Executed in a stream-of-consciousness rush, these hermetic verses bristle with rich visual imagery but lack both discipline and

polish. They were eventually published with an introduction by Breton, who
enthusiastic response to Picasso as a poet typified the reactions of the surreal
literati. Gertrude Stein's pithy evaluation seems more accurate, if less flattering
"He who could write so well with drawings and with colors knew very we
that to write with words was, for him not to write at all." When they met, s
bluntly informed Picasso, "words annoy you more than they do anything el
so how can you write you know better you yourself know better. . . . all righ
you are doing this to get rid of everything that has been too much for you .
you will go on until you are more cheerful or less dismal and then you wi
yes he said, and then you will paint a very beautiful picture and then mo
of them, I kissed him again, yes said he."[41]

Stein proved to be an accurate prophet. The charms of composing and r
citing poetry soon palled on Picasso, whose restlessness daily increased. Su
denly, at the end of March 1936, he left Paris for a hidden retreat at Juan-le
Pins on the French Riviera. Maya and Marie-Thérèse accompanied hi
Whether because he feared that Olga might pursue them or because he ente
tained other, less rational apprehensions, Picasso behaved quite secretively abo
this trip and instructed Sabartés to forward all mail to "Pablo Ruiz." Th
decision to resume his paternal name at a time when he was so angry wi
women surely cannot be coincidental.[42]

In his Riviera retreat, Picasso experienced a sudden remission of his creati
paralysis; between April 2 and May 2, 1936, he completed twenty-three pair
ings and a number of drawings. For more than twenty-five years thereaft
Picasso kept these canvases unpublished, secreted in his private collection,
that no one knew about this fertile interlude in his fallow period until he r
vealed these pictures to David Douglas Duncan while the latter was preparir
Picasso's Picassos. The artist evidently withheld his secret even from Zerv
his official cataloguer; at any rate, Zervos did not catalogue them. With cha
acteristically consistent inconsistency, however, Picasso showed Zervos t
drawings he completed at Juan-les-Pins, and they appear in the catalogue
the period, their place of origin falsified as Paris (Z., VIII, 274–83).

Why did Picasso's demon depart from him so swiftly at Juan-les-Pins, on
to return a month later? The pictures themselves reveal the motivations f
this reversible transformation. He certainly did not begin the vacation in
forgiving mood, as the canvas he painted on April 6 reveals clearly enough.
shows a youthful, vigorous Minotaur pulling a heavy cart in which all of h
belongings have been tossed, willy-nilly. (The preparatory drawing, Z., VI
276, has always been known, appropriately enough, as *The Minotaur Mor
His House.*) In the midst of a disorderly heap, including a ladder and a lar
canvas, a poor suffering horse lies, foaling a colt. Although the horse appea
to be dying, the artist reacted indignantly when Duncan suggested such an i
terpretation, insisting that she was not dying, she was merely having a baby
In fact, the mare appears both to be expiring *and* foaling a colt, and one cann

elp feeling that the artist had forgotten—or repressed—the original mean-
ing of this painting, perhaps because he found its implied death wishes too
discomforting. The head of the semicomatose horse dangles from the cart,
and one fears that the next jolt will dislodge her altogether from her precarious
perch. The Minotaur turns to stare at her with detached curiosity, but he takes
no steps to make her more secure or comfortable. The content of this work
suggests that Marie-Thérèse's indiscretion in giving birth to a baby girl landed
her on the discard heap. Picasso dared not dislodge her from his life by force,
but he seemed to hope that fate would rid him of his cumbersome baggage.

Once Picasso had settled into his Riviera retreat with his little family, his
hard mood softened; as he reexplored the joys of using Marie-Thérèse as a
model, she began to seem worthwhile to him once again. He painted her in
various moods and guises, reinterpreting her features now in his late cubist,
now in his surrealist mode. Then, as abruptly as it had vanished, his black
mood redescended. The charms of sea, sand, and mistress faded. Once more,
Picasso proved unable to tolerate a prolonged, undiluted dose of Marie-Thérèse's
company, and the limits of his patience and her intelligence soon combined to
set him on edge. His portraits of her grew less flattering; unpleasant references
to her pregnancy recurred, notably in the painting of April 17, which portrays
a microcephalic pregnant creature who sniffs at a flower with a vacuous ex-
pression. The evolution of his Juan-les-pins drawings reflects his altered feel-
ings still more emphatically. An early sketch shows a classical male figure
who holds a Minotaur or faun mask but whose own face is that of a mature, yet
still virile male. A few days later, although he continues to keep his mask
lowered, horns sprout from his own head. By April 10 he has been transformed
into an enraged Minotaur, who paws the ground in fury as he watches a blowsy
blonde bounce a beach ball. Since Marie-Thérèse was a physical-fitness fanatic,
the ballplayer undoubtedly represents her.[44] A drawing completed on April
27 depicts two grotesque old men who cackle maliciously, a sketch which
graphically conveys Picasso's bitter mood of self-ridicule.

On April 29 the artist again reverted to the rescue motif which had fre-
quently preoccupied him during 1932, creating a canvas in which both the
drowner and the rescuer resemble Marie-Thérèse. Undoubtedly, this picture
refers to his mistress' distressed reaction to the inexplicable change in her
lover's attitude. On a deeper level, however, the motif must refer to the artist
himself, to his desperate need for rescue, and to his wish that Marie-Thérèse
possessed the strength and power to save him. The picture he painted the fol-
lowing day more openly revealed his feelings of helplessness and entrapment.
It depicts a pathetic woman whose awkward, disjointed body parallels her psy-
chological crippling. Like a Madonna of Humility gone awry, she perches
awkwardly on a floor cushion in a little room whose walls seem as out-of-plumb
as her life; the chamber's low ceiling threatens to close in on her, but she
appears as oblivious to this danger as to the other elements of her surroundings.

Wearing a wreath of faded yellow flowers in her hair, she peers sadly into a mirror, which reflects only a dark shadow. Two days later, Picasso created a sequel to this painting, which shows the woman in a deeper psychotic state. Her wristwatch and wreath have disappeared, her mirror has turned quite black, and she has shrunk in relation to her chamber, which now appears quite tall and even more alarmingly askew. An enormous female attendant or keeper has appeared at the psychotic's side. We know that this personage is nude, because we glimpse her breasts and genitalia, but she seems to be simultaneously covered with—or perhaps composed of—head-to-toe wrappings or bandages. Like the pregnant microcephalic that Picasso had created on April 17, this attendant's curves suggest fertility, but her head reveals a faceless blank.

Although the psychotic woman in these two canvases reminds one of the artist's earlier visions of Olga as a madwoman, Picasso's emotional confession to Duncan that the painting of April 30 commemorated the worst period of his life makes it clear that the patient must represent Picasso himself.[45] After all, Olga had finally acted, and it was the artist who had spent the months immediately following their separation in a paralyzed state. Even the expression on the psychotic's face as she stares into her dark mirror recalls Picasso's self-mockery, his description of the way he had stared at the clock like an idiot when, as a child, he had waited, terrified, for his father to return and rescue him from school. The faceless keeper must represent Marie-Thérèse, who lacked the required intelligence and discrimination to provide the kind of empathic, exciting companionship the artist required. She—and their child—had become part of the cumbersome baggage of Picasso's life, baggage he felt condemned to drag along behind him forever, like the Minotaur with his cart.

That second painting of the psychotic woman was the last canvas Picasso created at Juan-les-Pins. Before the canvas had dried, he had returned to Paris as abruptly as he had departed. Sabartés, although sympathetic, still seemed puzzled years later about the significance of this chain of events. Commenting about a drawing from Juan-les-Pins showing the father of the family seated with his young mistress and baby, he wrote, "Though the child plays on the knee of the woman, the stubbornness of the old man in hiding behind his mask opens an abyss between him and his family."[46] Sabartés failed to comprehend that the Jekyll-Hyde metamorphosis which transformed the artist into a snorting beast was quite involuntary, triggered by uncontrollable rage. Picasso went to Juan-les-Pins hoping to reconcile himself to Marie-Thérèse and his situation. During the first days they spent there, he successfully recaptured his positive feelings for her. He painted her tenderly, he treated her tenderly, but she failed to measure up. The picture of the pregnant microcephalic records Picasso's crucial mood change. From that time on, the sojourn at Juan-les-Pins was doomed. Poor Marie-Thérèse was too limited to transcend merely being Picasso's creature; when the novelty of her beauty and sensuality waned, she had no reserve assets with which to recapture Picasso's interest and respect.

Femmes dans un intérieur (Women in an Interior), May 2, 1936, oil on canvas, 61 x 50 cm. Musée Picasso, Paris. Cliché des Musées Nationaux, Paris. © SPADEM, Paris / VAGA, New York

Back in Paris, Picasso virtually dried up once again, but he was able to keep on drawing. Several of the sketches he completed during the late spring again show Marie-Thérèse in a more sympathetic vein, revealing his recognition that his behavior puzzled and distressed the poor girl. In a sketch dated May 8 (Z. VIII, 285), he imagined Marie-Thérèse taking her revenge as the mounted matador who slays the Minotaur in the bull ring. From the sidelines, another Marie-Thérèse figure and a bearded man reminiscent of the artist's father watch the slaughter in silent horror. In the next drawing, the wounded Minotaur, stabbed through with a knife, lies on the seashore while Marie-Thérèse and a little boy fish from a boat which floats offshore. The following sketch (later employed as a curtain for Romain Rolland's play *Le 14 Juillet*) shows the Minotaur dead, his Harlequin-clad corpse being carried off by a humanoid with a griffon head. Once again, Marie-Thérèse and the bearded man look on sorrowfully; this time the father, clad in a horse's hide, carries a woman on his back. This pictorial sequence suggests that the artist regarded his hardhearted treatment of Marie-Thérèse as a species of self-destructiveness, but that he simply could not bring himself to accept the sympathetic help she might have offered. The repetition of images reminiscent of Don José may constitute references to the latter's role as Picasso's childhood rescuer, although the paternal expression of disapproval suggests that he also represents the artist's externalized self-reproaches. The father's appearance in the final drawing of this series as the horse with a female rider probably indicates Picasso's admiration for his father's ability to bear his fate—dealing with Picasso's mother and the other female relatives with whom he was saddled—more stoically than the artist himself.

Nine

Each Flower That Fades . . .
Is a Love That Dies

During his first days at Juan-les-Pins, Picasso's creative paralysis had dissipated like the morning mist, burned away by the sun's warm rays. Like that mist, his rage soon recurred, stopping his hand once more. Apart from the paintings and drawings he produced so prodigally during that month on the Riviera, Picasso created only a handful of small-scale works on paper between January 1 and July 31, 1936, when he again went on vacation. Significantly, among those drawings was a portrait study of the poet Paul Eluard (Z., VIII, 273).

Picasso had always been the friend and playfellow of poets, and in his distress, he turned not only to his old poet-genie Jaime Sabartés, but, increasingly, to Paul Eluard, dean of the French surrealist literary group. Eluard, for his part, loved art passionately and considered himself fortunate "to be alive in this troubled century above all because he had met Picasso," whom he regarded as the man who had liberated the arts and brought them back into contact with reality.[1] That spring, Picasso spent a great deal of time with Eluard and his fragile young wife, Nush. Picasso and Eluard composed poems dedicated to one another, and Picasso illustrated Eluard's "La barre d'appui" with a four-part etching filled with intimate self-references, including the imprint of the artist's hand.[2] Next, the two men created a joint etching, with Eluard inscribing his poem "Grand air" directly on the plate, while Picasso decorated its margin with flowers and figures.

Picasso and Eluard shared political as well as artistic goals. Eluard enthusiastically supported the Spanish Republican cause. Picasso had always been apolitical, but the Spanish Civil War politicized him at last. He, too, became a Republican partisan and demonstrated his pro-Republican sentiments by permitting a special exhibition of his art to tour Spanish Republican cities. Eluard accompanied the exhibition as Picasso's spokesman, interpreting his art to his countrymen, much less familiar with his paintings than other western Europeans. As a Communist poet, Eluard enjoyed great renown in Republican Spain, and the eloquence of his statements about Picasso's art testified to the sincerity of his admiration.

Eluard performed another important service for Picasso that year: he introduced the artist to Dora Maar, a photographer, painter, and bluestocking member of the surrealist circle. Brassaï places this event four months earlier than other biographers, but most sources agree that Picasso became fascinated when he observed Dora at a favorite café, where she sat throwing a knife between her fingers into the wooden table top on which her hand rested. Periodically, she missed the table and knicked a finger but continued her intent game without a pause. Picasso, impressed by her combination of beauty and bravery, demanded an immediate introduction.[3] This tale may well be apocryphal; even so, it accurately captures the flavor of Dora's eccentric personality. If true, it constitutes yet another proof of the validity of Fernande Olivier's contention that Picasso possessed a nature which sought its own torment. He later told many friends that Dora always represented the weeping woman to him, and that his tortured renditions of her face resulted from this vision which imposed itself on him. If he had selected Marie-Thérèse Walter out of the crowd because her features recalled to him the serenity of the classical past, he chose Dora Maar because she symbolized the tortured anxiety of our contemporary world.

During the summer of 1936 Picasso vacationed on the French Riviera with a close-knit group which included Eluard, Zervos, and Penrose, along with their wives. The artist apparently brought no female companion. Despite his attraction to Dora, he had not rushed into this new liaison. However, when she appeared on the scene as the house guest of mutual friends located at nearby St. Tropez, Picasso probably interpreted it as a magical sign to proceed. He soon invited her to join his group at Mougins, carefully briefing her first about the nature and extent of his domestic complications. Penrose, present on the spot, asserts that a drawing which Picasso completed on August 1, 1936 (Z., VIII, 295), recorded the moment of Dora's arrival at Picasso's hotel.[4] Apparently quite aware of the discrepancy in their ages and experience, the artist depicted himself on this occasion as a bearded seer, while Dora, a timid pilgrim, peeps uncertainly through the open door of his inner sanctum. Events moved rapidly after that, and a month later, Picasso was completing another sketch which portrayed him in his more aggressive identification: as the Minotaur who ravishes a maiden resembling Dora. The latter appears cool, collected, and somewhat unresponsive to this passionate onslaught (Z., VIII, 296).

Picasso's new love succeeded in exorcising his resident devils. His work paralysis thawed; his hand rediscovered its magic. He soon started to draw regularly (Z., VIII, 289–300) and, by November, he was painting once again. Naturally, Dora formed his chief subject (Z., VIII, 301–10). Those tortured renditions of her face which would ensure her immortality lay many months ahead, and Picasso's first portraits were tender and affectionate, like the drawing which shows her as a dear little bird, or the canvas which portrays her

with all the idealized romanticism of a Botticelli heroine (Z., VIII, 347).

Before the year ended, Picasso felt so mellow that he forgave Marie-Thérèse, whom he apparently started to see again regularly; she, not Dora, figured as his most important subject during 1937, when he created a lyrical series of idealized visions of Marie-Thérèse wearing a wreath of white spring blossoms in her hair, pictures which seem quite classical despite their mild neocubist distortions. The pleasure with which Picasso again regarded both his subject and his creations may be gauged by the fact that he retained thirty-eight of these portraits of Marie-Thérèse from 1936–37 for his own collection. By contrast, during the same period he painted Dora less frequently and kept only twelve pictures of her.[5]

Whether Picasso also resumed his old sexual intimacy with Marie-Thérèse seems less clear; the fact that he now portrayed her clothed, seated, and alert, rather than nude, supine, and slumbering implies that their old intimacy had been attenuated. However Picasso may have managed his intimate domestic arrangements, he did not share daily living quarters with either mistress. In fact, he continued to reside at his old apartment on the Rue la Boëtie until Dora found him a spacious new studio in a seventeenth-century dwelling on the Rue des Augustins. She lived nearby with her family, while Marie-Thérèse and little Maya were installed in a suburban dwelling at Tremblay-sur-Mauldre which belonged to Vollard.[6] The artist nonetheless evidently visited them regularly, for Marie-Thérèse often appears as the heroine of paintings from this period which bear successive dates. Olga, though relegated to the sidelines, had by no means relinquished her claims on Picasso nor abandoned her campaign of persecution. When Picasso remained indoors, she continued her assault by postal card; when he ventured out—especially if Dora Maar accompanied him—Olga often followed, making her usual inappropriate remarks. She apparently also trailed along—as did Marie-Thérèse—wherever the artist vacationed. No one has explained how Olga magically divined Picasso's whereabouts, but she clearly possessed up-to-the-minute information. One can only assume that the artist himself must have acted as her informant, perhaps indirectly, through their son, Paulo.

As though all these tortured romantic entanglements did not complicate his life enough, Picasso evidently began an affair with Nush Eluard during the summer of 1937; thus, he lived out in reality the phantasy he had expressed so many years earlier in the painting *The Harem,* of 1906, which showed four beautiful captive odalisques guarded by slaves. Gilot reports that Picasso repeatedly boasted to her about the pleasure he derived from observing Dora and Marie-Thérèse compete—and even come to blows—in their struggle for first place in his affections.[7] A drawing which Picasso made in February 1937 (Z., IX, 97), showing a youthful Minotaur carrying a limp nude off to his boat while distressed nereids hover about him, may be a commentary on the plethora of females the artist had at his disposal at this time.

Just one week prior to the period when Marie-Thérèse reappeared in his paintings, Picasso created the first of a long series of still-life pictures which he would repeat with only minor variations throughout 1937–38. Typically, these pictures contrast the shapes, textures, and colors of two disparate sets of objects, such as a dish of fruit and a tall pitcher (Z., VIII, 325–29), or a lighted candle and a bottle (Z., VIII, 330–34). Several clues, including the fact that the artist retained the majority of these canvases, suggest that these still-life paintings were, in fact, coded representations of his two mistresses which describe their contrasting characters and temperaments: Marie-Thérèse, soft and luscious, bright and glowing, versus Dora, angular and brittle, hard and impenetrable. Picasso eventually broke this code himself by painting a variant which shows the blonde Marie-Thérèse seated before a dark-colored pitcher (Dora had brunette coloring) filled with spiky leaves, and another which shows a wistful girl outdoors peeping into a room where a pitcher reigns alone on a table (Z., VIII, 353). A canvas which depicts a pair of doves, one black, one white, crowded together into one small cage probably also is a hidden comparison of this type. (Z., VIII, 363).

The strange, surreal painting *Girls with a Toy Boat* (Z., VIII, 344) may actually constitute yet another of these comparative studies of Picasso's mistresses, here presented as a pair of biomorphic bathers whose smooth limbs and erect breasts seem to have been carved from marble. Their large bodies, small heads, and vacuous expressions recall the similar features which characterize the race of giantesses Picasso created in 1920. The rounded curves of these two females imply a physical maturity which ill accords with their childish activity as they fondle their tiny craft with a rapt attention which borders on veneration, recalling Renaissance portrayals of the adoration of the Christ child. From the far horizon, a third vacuous head, perhaps symbolizing Olga, peers intently across the water. Did Picasso himself sometimes feel like that little boat, a helpless pawn in the hands of these powerful women, all so mindlessly monomaniacal in their devotion to him, but all dedicated to disrupting his privacy and peace of mind?

Other, less tranquil confrontations between Picasso's women also occurred during this same period. The *Girls with a Toy Boat* is sandwiched in the midst of a series of much more horrifying female bathers who often comb the ocean with their phallic limbs searching out primitive sea creatures to gobble (see Z., VIII, 336–45). One of these sketches (339) depicts a sweet, dewey-eyed Dora Maar in a terrified confrontation with one of these sea monsters with an ant-eater-like snout and a gaping cloaca. Gilot claims that Olga regarded Marie-Thérèse as a nonentity but was passionately jealous of Dora. Does this drawing record an actual unpleasant confrontation between wife and mistress, or is the monster-heroine of this drawing once again the artist's primitive self? He created several of these visions of bathers at Temblay-sur-Mauldre, where Marie-Thérèse and little Maya lived on an old farm. Picasso evidently spent a few days

ıch week with his family in this suburban retreat, which possessed a large barn ıat he converted into a studio. One wonders whether Picasso also tacitly or vertly encouraged Dora Maar and Olga to trail along on some of these week- ıds. While he was still married to Olga, he had often installed Marie-Thérèse ınveniently nearby when he vacationed with his wife. Perhaps he now re- ersed this procedure and installed Dora and Olga close to Marie-Thérèse's ome. Such tactics certainly would have led to unpleasant confrontations among ıe women involved, and the visual evidence suggests that this was, indeed, ıe case.[8]

On April 26, 1937, a tragedy of international dimensions diverted Picasso's ıtention from his harem and their conflicts: General Franco ordered the satura- ıon bombing of the defenseless Basque village of Guernica. Picasso, who had een appointed to the honorary post of director of the Prado Museum by the panish Republican government, had also been commissioned to paint a large ıural for their pavilion at the Paris International Exposition of Arts and 'echniques scheduled to open that summer. He had procrastinated about begin- ıing this vast project until the tragedy at Guernica mobilized him. As soon as ıe news reached Paris, Picasso began the studies for his mural; he finished the ırst six preparatory drawings on May first. No one knows exactly when he ompleted the seventh, definitive version of the mural proper, but it was ready ıd in place in the pavilion by the time the exposition opened.

Forty-odd years after its completion, *Guernica* remains at once Picasso's ıost powerful and most enigmatic picture. Painted in the heat of passion, it ıresents a miraculous blend of personal and political feeling. Only when such fusion occurs can an artist create potent propaganda which is also great art. ater in his career, Picasso tried several times to rediscover the magical formula e applied so effectively in *Guernica.* He never succeeded, and his subsequent ttempts to create propaganda art which promoted the official Communist iewpoint, like his *Massacre in Korea,* remain stilted failures, effective neither s propaganda nor as painting.

In its style, *Guernica* employs Picasso's late cubist vocabulary, but these eatures exist like an overlay on its solidly classical underpinnings, which lend ıe composition great stability, for the mural is constructed like a High Ren- ıissance altarpiece, with a pronounced pyramidal shape that stretches its broad ːiangular base to the very borders of the mural. Around this fulcrum, all is ısposed with rigid symmetry; every figure, every object has its counterpart. 'his symmetry provides the viewer with an orientation, a stable vantage point ːom which to survey the rapid alternations of indoor and outdoor settings, attened and illusionistic space, and double-faced views of figures.

Anyone familiar with Picasso's art recognizes many old friends among ʒuernica's cast of characters, especially the bull and horse, central figures in ıe mural and fixtures in Picasso's art from the time he created his first oil ·ainting at the age of eight or nine. Yet the symbolic meaning which Picasso

The Dream and Lie of Franco, 1937, etching and aquatint, 38 x 56.5 cm. The Art Institute of Chicago

attached to these figures in the mural, especially the bull, is by no means clear- as the varied interpretations offered in the numerous publications devoted this painting attest. Most critics tend to perceive the bull as a sympathetic figur but in the only public statement Picasso ever made about the mural, he su gested, without elaborating, that the bull represented brutality and darknes the horse the suffering people.[9] This explanation confuses rather than e lightens, for the bull had so often served as the artist's pictorial alter ego that h identification of it as one of the agents of Spain's destruction seems inexplicabl

The bull certainly played no such ignoble role in the etching suite *Drea and Lie of Franco,* which Picasso composed with the intention that it be r produced and sold to benefit the Spanish Republican Relief Fund. Eventual this etching and aquatint comprised eighteen scenes, set in a format reminisce of a comic-book page, plus a companion poem, a hermetic work filled wi punchy metaphors directed at the hated general. Picasso completed this etchir while he worked on *Guernica,* and the imagery of the final four scenes bears close relationship to that of the mural.

Yet, in the etching, the bull plays a consistently noble role. In a final scer from the suite, the heroic, humanized bull confronts and gores the Franc monster, a horse-like being with a polyp head. Roland Penrose made an ama ing observation about Picasso's relationship to this polyp image:

> The Spanish war had made itself felt so acutely to Picasso that he could n avoid becoming personally involved. The loathsome shape he had invente for Franco came from a personal image of a monster which he understoc as lurking within himself. Not long after he had finished the series, I aske him to sign a copy I had bought. He did so, but when he had written n name beginning with a small p, I was astonished to see that the capital lett with which he commenced his own signature had fundamentally the san form as the twisted grotesque head [the polyp] that he had invented f the man he hated most. The strength he gave to the image borrowed su consciously from so intimate a source was an indication of the degree which he felt himself involved. The desire to implicate himself by mear of his own initial could not be more convincing. Just as formerly he ha often based the image of the hero, Harlequin, on an idealized self-portrai here, in reverse, the subconscious origin of the shape he gave to the ma he most hated was equally personal.[10]

Does the bull of *Guernica,* then, represent the artist's underlying dual identit as a Shiva, god of destruction as well as god of creation?

The preparatory drawings for *Guernica* suggest that Picasso did not begi with a set conception of the bull's role, for its nature and activity underwer many metamorphoses as the mural progressed. Sometimes it appears youthfu ennobled, and humanized (Z., IX, 22, 23), wearing an open, even innocer

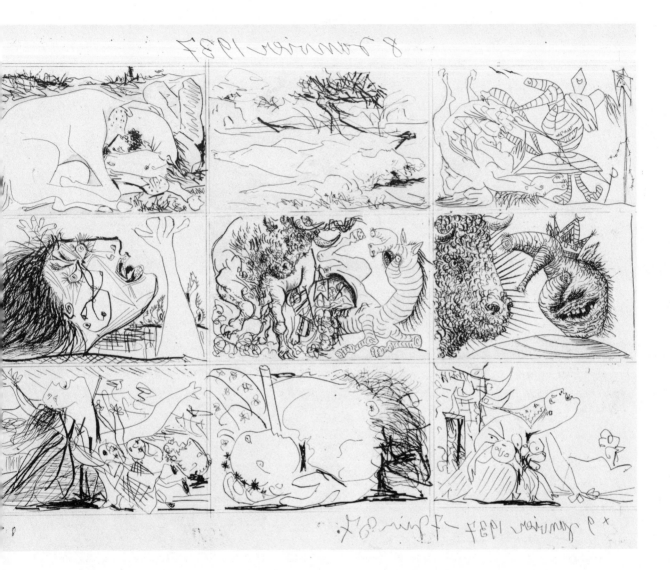

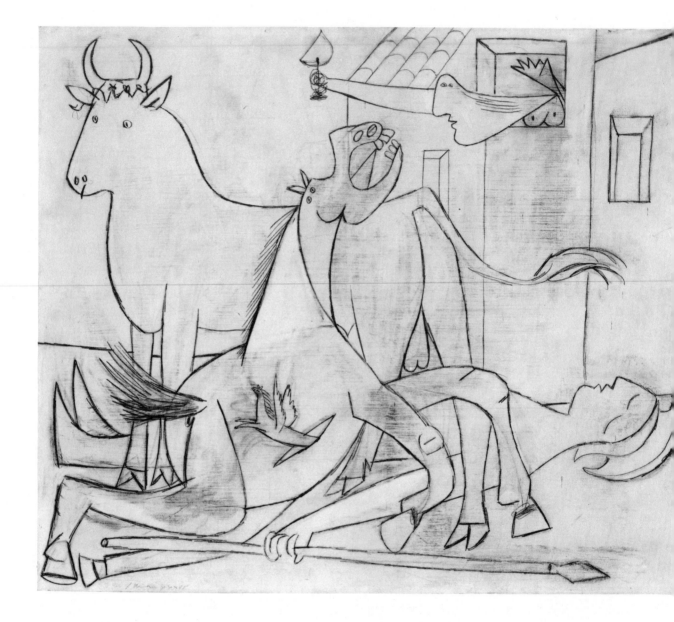

xpression; other sketches show him as more mature, powerful, and awesome, though always humanized (Z., IX, 28, 29). The changing relationships between the bull and other characters from *Guernica* further emphasize Picasso's initial uncertainties. The bull appears in the artist's very first compositional sketch, a schematic drawing which also shows two other figures retained in the final stage of the mural: the woman with the lamp and the dead or dying horse. In the next sketch, the bull stands at the left, already approximating the pose he would finally assume, while a bird alights on his back. In the third sketch of May 1, Picasso transformed the bird into a little Pegasus, who perches confidently on the back of the bull, portrayed standing quietly, harnessed and bridled. The ambiguity of the bull's role and position continued in the final study from the first day, where the artist depicted him staring out of the picture, apparently unconcerned with the dreadful events which swirl about him. He persisted in his cheerful unconcern in a large study made May 2, which showed him leaping along behind the scene of carnage rather like the nursery-rhyme cow who jumped over the moon (Z., IX, 8). In only one sketch of the entire *Guernica* series did Picasso portray the bull about to gore the horse (Z., IX, 9), and this drawing does not begin to duplicate the savagery the bull displayed in those brutal bullfight scenes from 1934 which show the beast destroying his universe.

Picasso struggled with details of the horse's pose and location until the mural neared completion, but he never varied its emotional state: the horse always symbolized suffering and death, and the beautiful fifth preparatory drawing the artist made on May 1 already contained the essence of his final vision of the horse and its place (Z., IX, 5). He subsequently experimented with other depictions of the animal, only to return to this idea in the definitive stage of the painting, where the horse is shown in an almost exact mirror image of the poses it assumes in this early drawing.

Picasso's sixth and final study of May 1 was not only larger and more elaborate, it also introduced a dramatic new idea. He depicted the horse giving birth to a tiny Pegasus, who emerges from the wound in her side, a detail which contains a vital clue to Guernica's private significance for Picasso. Herschel B. Chipp perceptively related this drawing to the 1936 sketch for *The Minotaur Moves His House,* which shows a horse foaling her colt in a cart pulled by the Minotaur, an image which Chipp interpreted as a revelation of the artist's painful rejection of Marie-Thérèse following Maya's birth.[11] Picasso had no sooner devised this Pegasus imagery than he suppressed it. None of the subsequent drawings refer to the Pegasus, but in the final stages of the evolution of the mural, Picasso suddenly included a flying bird, which may have represented his ultimate transformation of this imagery.

The third key figure to the iconography of the mural, the mother holding the dead child, did not make her initial appearance until May 8. Rudolph Arnheim correctly noted that the closest conceptual and compositional links

Composition study for *Guernica,* May 1, 1937, pencil on gesso on wood, 53.7 x 64.8 cm. The Museum of Modern Art, New York. On extended loan from the estate of the artist

Horse and Mother with Dead Child
(study for *Guernica*), May 8, 1937,
pencil on white paper, 24.1 x 45.4 cm.
The Museum of Modern Art, New
York. On extended loan from the
estate of the artist

unite the figure of the mother with that of the horse in the artist's first t
drawings of the woman. Picasso soon succeeded in differentiating their po
and roles, but that underlying fusion—or confusion—lingered in the full co
positional sketch from May 9 which shows the mother plunging her right a
into the wound in the horse's side, almost as though the woman's limb wer
tree trunk, the horse's body its root system.[12]

Picasso's earliest sketches of the mother endow her with two unique featu
which provide the clue to her identity and significance: she wears an elab
ately patterned kerchief on her head, and her infant, as Arnheim astutely
served, appears in the process of being born. "The child's head, as thou
still half unborn, is enclosed in a diamond-shaped shaded cavity; and althou
the child continues to show vaginal connotations, it is now animated by
alarm of its own. Two ripe breasts, ready to offer nourishment, rest on t
baby's body, yet are separated from it by dark blood."[13] Picasso's ensuing tre
ment of this feature makes it clear that the blood spurts from the baby's o
body, which seems to have been ripped asunder. The child is one gaping, bloc
wound from neck to groin.

While Picasso worked on the figure of the mother with the child, he s
pressed that of the woman with the lamp. At one point, he even posed t
woman with the baby in the position on the ladder eventually occupied
yet another figure in the final stage of the mural. Arnheim suggests t
Picasso, slow to accept "the splitting of the female element into several figure
could only transfer, not multiply, this imagery.[14] By the time Picasso h
sketched in his preliminary outline on the great canvas (May 11, 1937),
mother with the dead child had assumed her final position just beneath
bull's head. Picasso subsequently moved the bull's body a full 180 degrees,
by turning the animal's head back toward the right, he preserved the cl
relationship he had established between the open mouth of the screaming mot
and the muzzle of the roaring bull just above her. In fact, the mother see
almost to merge with the bull's dark bulk, which pushes forward against
light-colored figure.

As several critics have suggested, Picasso may have derived some of
imagery for *Guernica* from photographs of the ravaged city. However,
possessed a source deep within himself for this imagery, for he had once w
nessed a tragedy which paralleled the devastation of Guernica: the earthqua
which rocked Málaga for three days in 1884, when the artist was three. Fif
seven years later, Picasso vividly described this event to Sabartés, recalling h
his father rushed home when the earthquake began in order to evacuate
little family to the greater safety of a friend's abode which backed up agai
the base of the rocks near the seashore.

*"My mother was wearing a kerchief on her head. I had never seen her l
that.* My father grabbed his cape from the rack, threw it over himself, pick
me up in his arms, and wrapped me in its folds leaving only my head

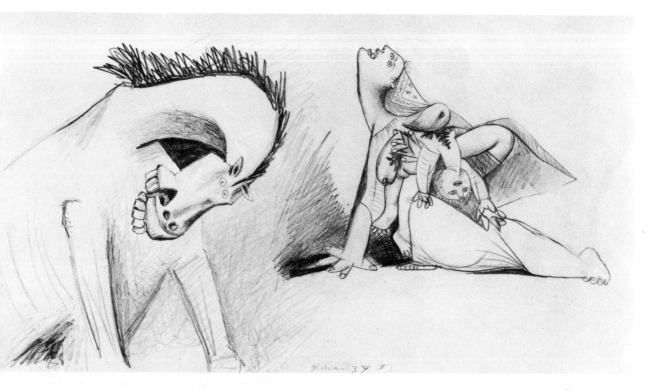

posed." That night of the earthquake was a night of anguish for Málaga, and Christmas was not "Merry" that year. But in the midst of all these trials, Picasso's sister was born.[15]

If one studies the mural and its evolution with this story in mind, all the eces fall into place. The screams, the confusions, the destruction, the flames, e sudden transitions from indoors to outdoors—all these must have been part the artist's own confused recollection of that night in Málaga. That he cerinly connected the tragedy of 1937 with that of 1884 is suggested by several his earliest drawings for the mural, especially his third and fourth sketches om May 1. Many critics have commented about the peculiar, childlike quality these drawings without offering any very plausible explanation for this laracteristic. Perhaps the real explanation is that the artist, forcibly reminded the terrible trauma he had suffered at age three, began to draw as if he were ace again a three year old. The content of these two drawings seems especially gnificant. Sketch four (Z., IX, 4) shows the gravid horse standing intact, wounded, its belly great with foal. Does it represent Picasso's mother at the ginning of their journey that night, the journey which terminated in Lola's irth? The other drawing (Z., IX, 3) is much more complex and difficult to ravel. It presents five figures, but only one of them can be identified with se: the woman with the lamp, who already bears a close resemblance to Marie- hérèse Walter. Just below, Picasso depicted a perplexing scene, here inter- reted as the moment of the baby horse's birth. The larger horse on the lower ft bends back. A circular line connects its body with a smaller figure (also a orse?). From the latter's central cavity, curling lines emanate. Arnheim in- rpreted this mass as the entrails of the disemboweled horse.[16] Instead, it may present the placenta, and the line connecting the two figures, the uncut mbilical cord. This visual evidence suggests that Picasso witnessed his sister's elivery; the bloody newborn baby may well have seemed dead to her terrified rother, just as the baby appears dead in his initial sketch of it for *Guernica*.

Another significant figure appears in this enigmatic third drawing: the nimal which occupies the upper left corner. Its identity seems unclear. Arnheim iterprets it as a horse,[17] but neither he nor other critics commented on the fact iat the animal appears airborne. It functions as an animated bomber, for s side has a clearly defined rectangular opening like the bomb bay of an air- lane, and the artist drew a sharply descending arcing line from the center of iis aperture, as though depicting the path of a bomb. This motif cannot be nrelated to that of the levitating bull of May 2 (Z., IX, 8), where the animal aps high over a heap of dead bodies. This imagery, which suggests com- lex equations between horse, bull, and bombers, was subsequently suppressed.

Picasso's final compositional study from May 1 summarized the personal ssociations implicit in those childish drawings which had preceded it, for it ctually shows the horse at the moment of giving birth to the Pegasus. The bull,

Composition study for *Guernica*, May 1, 1937, pencil on blue paper, 21 x 26.7 cm. The Museum of Modern Art, New York. On extended loan from the estate of the artist

Guernica, May to early June, 1937, oil on canvas, 349.3 x 776.6 cm. The Museum of Modern Art, New York. On extended loan from the estate of the artist

standing immediately behind the mare, turns away from this painful scene. H face seems innocent and empty; his forehead is wreathed in flowers. Does represent the artist as the helpless toddler of 1884, vainly trying to carry some childish activity (represented by the wreath) but paralyzed by the tra matic events in which he participates?

No wonder Picasso immediately suppressed the Pegasus imagery: as Chi surmised, that motif was overloaded with painful personal recollections. T reference to Lola—and by implication to the artist's little daughter, Maya remains, however, in the theme of the mother with the dead child.[18]

Arnheim realized that the artist's initial conception of the mother grew o of imagery devised for the horse. Indeed, for the artist, apparently, both figur initially represented the same person, the same events, the same trauma. T underlying unity of all the female figures in the mural probably also reflect those early memories of the time when the artist's mother was the only signi cant, real woman for him: by extension, all other women shared her identi The final state of the mural, by contrast, may well apportion to different figu visual memories all originally associated with the artist's mother. For examp she may have held the lamp to light their way that night in Málaga wh Picasso's father carried Pablo; the other two women may also represent h just before and just after Lola's birth.

That horse-woman fusion, so explicit in those first sketches of the moth probably was fixed in Picasso's mind shortly after the earthquake. Accordi to Sabartés, Don José started taking his son to the bullfights soon after t boy reached three; there, his first glimpse of a disemboweled horse may ha recalled to him the traumatic vision of Lola's birth, thus forever fixing in l unconscious mind an equation between death and birth, horse and woma which he utilized so tellingly in *Guernica.*[19]

This reconstruction of the genesis of *Guernica* resolves the seeming myste with which it began: the bull does, indeed, represent both the artist a brutality and darkness, reflecting the confusion he experienced at age thr between internal rage and external devastation, a confusion which may ha led him to believe that he had caused the earthquake. The bull of *Guerni* then, represents the artist as earthshaker, trumpeting the earthquake into bein Thus, he simultaneously represents his country—caught in the destructive vi of a civil war—and himself as both the innocent victim of destruction and t causative agent of that same destruction.

Though *Guernica* derives, ultimately, from the artist's memories of that nig in Málaga, one character suffers a far different fate in the mural than she d in reality. In the painting, the baby is dead! Ironically, while he created I chef d'oeuvre, Picasso simultaneously accomplished on canvas what he h been too small and impotent to carry out in reality: the murder of the bat How brutally he disposed of the infant in those initial drawings, depicting as one terrible wound (which may have been the way Lola seemed to him wh

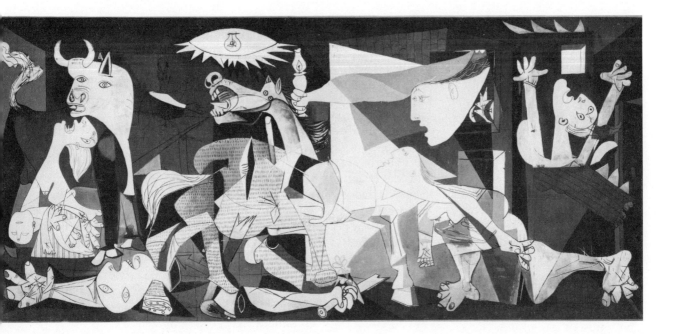

she arrived, covered with blood)! Eventually the artist suppressed this grisl
feature, to render the baby seemingly intact, but lifeless.

Even his final substitution of the little bird for the Pegasus probably ha
highly personal associations. Picasso later vaguely identified the bird as "
pigeon or a chicken." The pigeon seems a much more likely choice; that bir
always symbolized the artist's father, who thus secures his symbolic place i
the mural along with the other members of his family.

If the bull represents aspects of the artist's childhood savagery, the dismem
bered figure which occupies the front plane of the painting may portray th
other side of the coin, the fragmentation the child Picasso suffered during an
after the Málaga earthquake. Like the other figures in *Guernica,* this warrio
conveys a more universal symbolism to the average viewer, for he recalls
disintegrated marble statue which suggests the classical past, the cultural herit
age which war decimates. Yet he, too, had his analogues in the artist's persona
memories. Picasso, the child who fragmented, remained an adult constantl
threatened with disintegration.

Far from abandoning his usual autobiographical style in *Guernica,* then
Picasso actually tapped the well-spring of his most terrifying experiences
Fortunately, again like Shiva, he could create as well as destroy, and fror
his darkest memory he fashioned his greatest masterpiece.

The effort of creating *Guernica* left Picasso drained. He continued to b
haunted by the image of the weeping woman, which he conjured up agai
and again in the months that followed. Still, that face would not leave him
Even the interruption that his vacation period brought did not lay this ghos
and he returned repeatedly to the motif again in the autumn (Z., IX, 73–77)
until these representations, which may have had their origin in recollection
of his mother's anguished expression during that long-ago night in Málaga
finally merged with his perception of Dora Maar's tragic visage, and he coul
finally release his vision.

During the summer of 1937 Picasso and Dora again vacationed with th
Eluards at Mougins. For once, the artist devoted his holiday primarily to re
laxation, and his affair with Nush Eluard probably began at this time. If sc
he proceeded with Paul Eluard's tacit approval, perhaps even his active en
couragement; at least Picasso later explained to Gilot, "I only did it to mak
him happy. I didn't want him to think I didn't like his wife."[20] Eluard cer
tainly demonstrated a proclivity for sharing his woman with Spanish painters
He had lost his first wife, Gala, to Salvador Dali; now he handed his secon
over to Picasso.

While the artist dallied with Nush, he painted a series of variations afte
van Gogh's *L'Arlésienne,* depicting Eluard as a transvestite reincarnation o
the Dutch painter's heroine (Z., VIII, 370–73). In the final, most bizarr
canvas of the set, Eluard appears smiling a hideous smile while nursing a littl
cat-like creature at his bare breast. With typical Spanish contempt for th

weakness of others, Picasso thus portrayed Eluard as the castrated cuckold. Whether the creature at Eluard's breast represents Nush (and thus comments upon her dependency) or the poet's own inner demon seems ambiguous. Whatever the exact meaning, Picasso clearly believed that Eluard nourished a viper of his own creation. Since Picasso's secret reaction was one of disgust, one wonders whether he did not experience his friendship with Eluard as a corrupting influence. Certainly the poet did not exhibit the character strength which Picasso demanded from those he admired. That autumn, he painted a scene showing a young horse tamer, who resembles an idealized self-image, putting a horse through its paces in a ring (Z., IX, 83). It seems likely that the horse refers to Eluard, here represented as a docile, feminine animal. Around the same time that Picasso created the *L'Arlésienne* series, he painted Dora as a street flower vendor (Z., VIII, 376). Disturbed and downcast, she appears to be a seller who lacks interested buyers for her wares. Yet another contender for Picasso's time, attention, and affection had entered the list, and Dora must have felt unequal to all this competition.

Back in Paris, Picasso apparently saw Nush only irregularly—at least, rather wide time gaps separate his portraits of her, which seem quite devoid of the probing analytic quality with which he examined Dora Maar (Z., IX, 207, 209). His characterizations of Nush never investigate her psyche; they only reflect his admiration for her charm and chic, as in his depiction of her with the laughing fish-shaped eyes, or wearing an absurd, yet delightful, anvil-shaped hat. He retained many of these canvases for his own collection, a sure indication of the important role their subject played in his life. Their idealizing quality suggests that Nush must have successfully maintained a certain distance from her artist lover, who never lost his almost boyish admiration for her. Most likely, theirs was an episodic romance, pursued more vigorously during their joint vacations at Mougins than back in Paris, where Marie-Thérèse and Dora continued to dominate Picasso's art and life.

Picasso's interpretations of Dora Maar's face underwent a transformation after he completed *Guernica*. He later claimed that he had always associated Dora with the weeping woman, but this interpretation really seems to have fixed itself in his mind while he created *Guernica,* with Dora at his side every moment, recording in photographs the evolution of the mural. Long after he terminated the series of postscript pictures of weeping women which followed *Guernica,* Picasso continued to emphasize the drama of Dora's inner torture. Beginning in February 1938 he gradually devised a new painting style initially devoted to expressionistic treatments of Dora's features (Z., IX, 118–57). This style, often compared with the works of Arcimboldo, reminds one of basketry or caning work. Picasso used it to distort Dora's face in strange new ways (Z., IX, 158–69). Such distortions undoubtedly reflected his changing artistic interests, but they may also have mirrored changes in Dora's emotional state. All observers have described her as a highly labile person subject to

frequent emotional crises. One can almost reconstruct the timing and duration of such crises via Picasso's portraits of her.

Throughout this period, Picasso continued to paint Marie-Thérèse and to retain a large number of her portraits for his own collection. Of the 991 works listed in the two Zervos catalogues which cover the mid-1937 to mid-1940 period, 67 percent were devoted to the female form or face, most of them modeled after his two mistresses, past and present. Intermittently, he reverted once more to those disguised still-life representations of the women which he typically again retained in his personal collection.

As 1937 drew to a close, Picasso reintroduced his old alter ego, the Minotaur. In a picture completed on New Year's Eve, the monster appears sprawled on a beach, apparently fatally wounded by an arrow penetrating his chest. Three young nudes from a nearby boat stretch toward him; compassionate but helpless, they cannot reach him. The following day, Picasso showed the Minotaur recovering from this wound. Still seated on the beach, he is now attended by a beautiful Nereid who resembles Marie-Thérèse. She offers him a glass of champagne and a reassuring glimpse of himself in her hand mirror. By the drawing of January 2, the monster seems fully recovered. All signs of the arrow have disappeared, and he sits alertly on the beach gazing into the distance. Just off shore, one glimpses the spectral head of the Nereid as she floats nearby although the Minotaur ignores her presence. Like all of Picasso's New Year productions, these pictures must refer to intimate details of his private life. Perhaps in this instance they reflect the final cooling of his crippling anger toward Marie-Thérèse and the resumption of a completely harmonious, although attenuated, relationship with her.

Early in 1938 a new female figure entered Picasso's painted world: his little daughter, Maya, now nearly three (Z., IX, 97–101). The fact that Picasso kept so many of these portraits suggests that he had not only become reconciled to Maya's existence, but was even fond of her. She looked remarkably like him, and his old animosity seems gradually to have been replaced by an identification with her (an attitude which may be reflected in that drawing which showed the Minotaur studying his own features in the mirror). His portraits of Maya were quite unlike the idealized, romanticized portraits which Picasso had created for his first born, Paulo. Maya had a short, squarish torso rather like her father's, and he utilized neocubist techniques and condensations to exaggerate her shape. Only once, when he painted Maya as she enjoyed her first snowfall, did Picasso revert to that idealized style he had always employed for Paulo.

Around the time he painted his first portraits of Maya, Picasso completed two canvases usually interpreted as self-portraits, *The Butterfly Hunter* and *The Woman with a Cock* (Z., IX, 104, 109). The former canvas depicts a truncated little being whose flattened limbs seem to emerge directly and stiffly from his shoulders. Like Maya, he appears to be about three; however, his large head

and coarse lips recall photographs of the adult Toulouse-Lautrec. Clad in a sailor suit and hat, the latter emblazoned *Picasso,* the child perches on a log clasping a butterfly net in a vestigial fist. Although a butterfly hovers before his nose, he makes no move to catch it, but stares at it cross-eyed with wonder. A young American soldier, Jerome Seckler, who interviewed Picasso in 1945, questioned him closely about this painting, determined to elicit confirmation for his predetermined conviction that the butterfly was a political symbol. Picasso freely admitted that the little sailor represented himself, but he denied any political implications in the picture. He had portrayed himself as a sailor, he explained, because he habitually wore the same type of striped undershirt which French sailors affect (he showed Seckler the one he wore that day). Picasso did not succeed in convincing Seckler, but he undoubtedly was quite candid when he insisted that *The Butterfly Hunter* was without political symbolism. Rather, it is a private, personalized statement. For the first time since the autumn of 1901, when he had painted *The Child with a Dove,* Picasso overtly portrayed himself as a child, moreover, a child of about the same age as his own little daughter.[21] Did Maya's presence remind him once again of the terrible trauma he had suffered when he was three? Picasso's original imagery for *Guernica* had included another little winged creature, not a butterfly but a Pegasus, and in one of his first sketches, he had portrayed the little creature securely seated on the back of the bridled bull. Like *The Butterfly Hunter* hypnotized by the butterfly, the bull appears humbled and subdued by Pegasus. Several critics of *Guernica* have interpreted this Pegasus figure as a representation of the soul or psyche—a figure whose standard imagery includes butterfly wings. It seems likely that Picasso, too, had made this association and that the butterfly and the Pegasus really symbolize the same person. If so, the butterfly's red color probably refers, not to the Communist party, as Seckler evidently assumed, but to Picasso's baby sister Lola, as he first saw her, covered with blood, and as the dead infant appeared in his first conception of this figure for *Guernica.* Significantly, Picasso retained this canvas for his private collection.

A few weeks earlier, he had painted *The Woman with a Cock,* a representation of a bizarre woman seated on the floor, grasping a trussed cock in one hand, a bleeding bowl in the other. Meyer Schapiro has observed that this woman's head resembles Picasso's own more than that of any woman, with his left profile accentuated by the characteristic lock of hair which the artist wore combed down on his temple during the 1930s. Misfeldt rejects this idea, offering instead the hypothesis that "this fearsome creature" represents an amalgamation of the three women—Olga, Dora, and Marie-Thérèse—who posed "a threat to Picasso's male role as symbolized by the cock."[22] He points to the similarity between this female figure and that of the monster-woman featured in one of the artist's contemporary drawings as she stabs a bound goat laid out on a table. This sketch, however, also recalls the quite similar drawing Picasso

created in 1934 depicting the murder of Marie-Thérèse, a work I interpreted
as indicative of Picasso's own enraged reaction to his mistress' limitations. In
the light of this hypothesis, supported by such related images as that of the
psychotic woman staring into her darkened mirror, which Picasso had specifi-
cally identified with himself, I would like to suggest that *The Woman with the
Cock* represents the artist both as the murderer and the victim. The painting
memorializes his masochism, his need to invent his own torments. Picasso
completed this painting at a time when Marie-Thérèse and Maya were much
in evidence in his art and, presumably, in his life. He sandwiched several of
those coded still-life pictures constrasting the natures of Dora and Marie-
Thérèse between the execution of *The Woman with the Cock* and *The Butter-
fly Hunter* (Z., IX, 105–7). No doubt he had been unable to restrain himself
from stimulating the rivalry between his two mistresses, a competition in which
he may also have involved Olga, who continued to circulate around the peri-
phery of his world. Surrounded by his mad women with their conflicting, in-
satiable needs, Picasso may well have felt as endangered and helpless as the
cock and goat he depicted so poignantly. On another level, however, these
harpies represent his own childhood savagery, so forcibly reactivated by the
varied traumata he suffered during this decade.

As a kind of postscript to the cock painting, Picasso created a series of pastel
drawings which showed a lone cock crowing (Z., IX, 110–14). Misfeldt
observed: "Here the cock's shrill clarion suggests not the herald of the dawn
but rather a watchman sounding an alarm filled with horror and premonition."[2]
Alas, no one could rescue the artist from the morass in which he had im-
mured himself.

During the summer of 1938 Picasso and Dora once again vacationed with
the Eluards at Mougins; they all dashed off for the Riviera by car one night in
July with only an hour's notice.[24] This precipitate departure apparently did
not prevent Olga and Marie-Thérèse from following soon after, for repeated
references to all the women involved in the artist's life can be discerned in
the drawings he created that summer, and one can only assume that Olga and
Marie-Thérèse were actually on hand along with Dora and Nush. Ominous
characters from his beach paintings of the late twenties returned to haunt his
pictorial world during this vacation; those monstrous bathers appear both in
groups (Z., IX, 171–72, 182, 217) and singly (Z., IX, 162–69), the latter
often depicted in the familiar struggle with a locked cabana. The reappearance
of this theme, once intimately associated with Olga, suggests that the artist felt
that his privacy, perhaps even his integrity, were again under threat. His ink
drawings that summer were often marred by smeary shading and thick blots;
such features, relatively rare in his work, probably also reflect the tension and
anxiety under which he labored. Even the male figures Picasso envisioned that
summer often possess a frightening intensity. Highly worked in his new
basketry style, they munch ice cream or lollipops with a fervor quite inap-

ropriate to their benign activity (Z., IX, 187–90, 203–6). Do they represent
he artist's own childhood savagery, which had threatened to swamp him
ver since Maya's birth? Further evidence of his disturbed state may be inferred
rom the brutal crucifixion drawing of August 21, a sketch which portrays
ituals more appropriate for a Dionysiac rite than those usually associated with
Christ. The Magdalen grasps Christ's genitals, while simultaneously bending
back until her head touches her anus. Christ's mother, meanwhile, greedily
gulps the blood which spurts from His side. Perhaps the artist felt that not
ven the sacrifice of his life would satisfy all these primitive women who
hreatened to tear and devour him psychologically, just as the victims of
Bacchic rites were devoured physically. From this point until late in his life,
when his second wife isolated him from most contacts with the outside world,
Picasso expended a great deal of his time and energy in efforts to maintain all
is ladies in equilibrium. The effort gradually ground him down, and during
938–39 one can sense the onset of a decline in the originality and quality of
is art which would not become clearly evident for many years. *Guernica* had
ormed the apex of his career, the peak of the artistic mountain for that veteran
limber who had ascended it in tandem with his fellow cubist, Braque. A
ong, arduous descent from the clouds lay between the aging artist and distant
eath.

The Spanish Republican forces suffered their final defeat during the winter
f 1938–39; at about the same time, Picasso's eighty-one year old mother
ied. There could be no question of returning for the funeral, but Picasso
evealed his grief over his twin losses in a number of powerful still-life can-
ases depicting a table where an artist's palette rests on an open book beside a
ull's head on a plinth. Some versions also include a stylized sun, magically
ransported indoors (Z., IX, 235–40). Although Picasso treats the bull's head
s though it were a statue, its glowering, lively expression makes its inclusion
a a still life seems somewhat incongruous. A variant which the artist retained
epicts the bull's head still more humanized, and painted a bright, glowing
ed. Sabartés (recently reconciled with Picasso after a period of estrangement)
ividly described the painful sciatica attack the artist suffered soon after paint-
ng this still life. Penrose suggests a causal relationship between the "flayed
live" appearance of its bull and Picasso's illness.[25] This interpretation may
e valid, but that pulsating bull's head surely also represented the underlying
nger and frustration which seemed to be Picasso's constant companion during
hese years. Seckler, who studied one of these still-life paintings in the same
xhibition in which he viewed *The Butterfly Hunter*, was convinced that the bull
epresented fascism. Picasso, polite but firm, insisted that *Guernica* constituted
is only attempt at political allegory.[26] As usual, Seckler remained unconvinced,
espite the fact that Picasso obviously told the truth. These bull heads really
ortray his own unleashed savagery, which now frequently threatened the
oundations on which he had erected his life and art, as symbolized by the

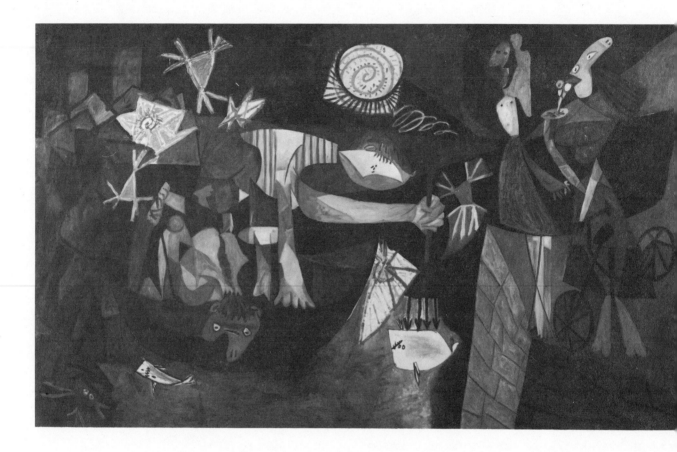

palette, book, and candle. One's impression of the highly personalized nature of these works is reinforced by a careful study of their sequence in the Zervos catalogues. While the artist worked on these still lifes, he busily executed drawings of Maya (see Z., IX, 229–43 for this sequence). There can be little question that she reminded him of himself as a child, reminiscences which must have been intensified by the twin deaths of his mother and of his hopes for Spanish freedom.

At the height of his sciatica—and his fury—Picasso took to his bed for a week. The hiatus in his productivity was fully justified by his condition, but it probably really constituted yet another of those recurring creative paralyses which so often afflicted him between 1934 and 1954. Sabartés hovered anxiously about, waiting on the artist hand and foot. Many ailments respond well to bed rest and tender, loving care, ailments which pinch the soul as well as the sciatic nerve. After a week, Picasso again felt well enough to face the workaday world, and following a magical cure (effected by having his nose cauterized!), he resumed his series of expressionist still-life paintings.[27]

Picasso's creations that spring continued to reflect an inner desperation often perceived by critics as a kind of premonition of the approaching world conflict. Nonetheless, we must accept the artist's assertion that *Guernica* and only *Guernica* was intended as a political allegory and symbolized his conscious response to the brutality of the war. That August, he suddenly broke off a series of horror portraits to create *Night Fishing at Antibes,* perhaps his last great masterpiece. As Barr points out, this picture seems unique in the artist's oeuvre.[28] The strange phosphorescent glow of sky and water, the ominous quality of the whirling moon—or is it a great falling star—the whole drama of waiting which this picture conveys makes it the most poetic, yet sinister and dramatic, of Picasso's great paintings. In its quality of utter stillness, it recalls *The Family of Saltimbanques.* Once again the artist stood poised on the brink of the unknown, but now the lyricism of youth and hope was gone.

A few weeks later, Picasso's premonitions were realized, and France entered the war. The artist reacted as though these terrible events had been directed at him personally. Only half joking, he complained to Sabartés:

If it's to annoy me that they make wars, they're carrying it too far, don't you think? They might at least have told me. Why should they kill so many people for such a small matter. . . . But, honestly, don't you think this is fate? First Vollard [Picasso's dealer, who had been killed in an automobile accident a few weeks earlier] and then—just as I was beginning to do something. I swear that now I'm afraid to work. That's why I can't take anything altogether seriously. You saw what I was doing. . . . It's nothing; of course I know that. But it seems to me I was warming up. I was just beginning to see something clearly, and now this. But don't think it's the first time. Every year it's the same story.[29]

Night Fishing at Antibes, August 1939, oil on canvas, 206 x 345 cm. The Museum of Modern Art, New York. Mrs. Simon Guggenheim Fund

Frightened both for his personal safety and that of his works, Picasso moved restlessly back and forth between the Atlantic resort city of Royan, which he considered physically more secure, and Paris, where his paintings and sculptures were stored in various studios. Dora, Sabartés, and Kasbec, the artist's Afghan, accompanied him on these journeys, usually carried out gypsy-caravan style in his chauffeur-driven car, piled high with equipment and luggage. Both the anxious way Picasso shuttled back and forth between the two cities and his constant need for company during the journeys recall his similarly indecisive moves between Barcelona and Paris at the beginning of the century. References to Marie-Thérèse, Maya, and Olga in drawings labeled Royan suggest that the other members of his entourage continued, as usual, to trail in his wake.

Picasso's unsettled mode of life made it impossible for him to paint large scale canvases during 1940, yet he worked with greater compulsive fervor than usual, filling sketchbook after sketchbook with rapid pencil drawings. He surely set a new production record even for himself when he completed seventy-one drawings in a single two-day period in January 1940 (Z., X 303–73). The strange sights Picasso sometimes encountered on the road—such as the long procession of horses conscripted for military duty—invaded some of these sketches, but his oeuvre generally continued seemingly unaffected by the catastrophe which raged about him. Roughly 70 percent of the pictures he completed during 1939–40 again depicted distorted female heads and figures, the latter often nude. A few of these bizarre heads resolve into equally misshapen skulls, perhaps indicative of his heightened anxiety level, an inference also supported by his increased attention to the motif of the watched sleeper. Nonetheless, the number of such anxiety-index pictures remains small in terms of his total production, and Barr's impression that "Picasso's art during the war years developed without any obvious reference to the catastrophe"[30] seems much more accurate than the attempts to read so much political significance into his wartime work.

After France fell, Picasso settled down in Paris for the duration, residing in his studio at 7 Rue des Augustins. Wartime conditions prescribed an austere, uncomfortable mode of life, but Picasso always thrived under such conditions. Interludes such as his café-society period with Olga or his playboy summer on the Riviera constituted isolated instances of self-indulgence in a basically austere life style.

Picasso's astonishing productivity continued throughout World War II; the Zervos catalogues list 1,473 paintings and drawings for the period between September 1939 and August 24, 1944, when Paris was liberated. This figure includes neither sculptures nor graphics, and Picasso was active in both media during the war. He lived quietly, surrounded by friends, for Paul Eluard and other intimates had been released from service following France's capitulation. Sabartés, who continued as secretary-receptionist, saw to it that Picasso's life functioned smoothly, with few interruptions. Barr credits Picasso's wartime

roductivity to this quiet existence, free from the interruptions and diversions o which his fame had increasingly subjected him.[31] His contacts with the arem of ladies who plagued him so during 1937–38 probably also were reduced, for references to Olga, Nush, and Marie-Thérèse occur infrequently during the war years. Olga probably saw little of him during the occupation and was forced to rely on the mails to carry her barbed comments. He continued to see Nush from time to time, as his occasional portraits of her attest, but the fact that they could not share intimate vacation interludes acted to dilute the intensity of this relationship. By the time the war ended, Picasso was deeply involved with Françoise Gilot, and he apparently did not renew his affair with Nush prior to her sudden death in 1946.

After 1938 Marie-Thérèse gradually ceased to interest Picasso either as a subject or as a woman, although he continued to see her frequently, primarily because he visited his daughter faithfully twice a week. He followed Maya's growth and progress with real interest, a fact documented by the frequent naturalistic drawings he made of her, much as a less gifted parent might use a camera to record his child's maturation. These sketches suggest that Maya was a quiet, insecure child; she continued to suck her thumb long after she reached school age, and she often seemed uncomfortably aware of her father's close scrutiny as he sketched her. Her poignant expression makes one wonder whether the irregularities of her family's domestic arrangements weighed heavily on her young life.

The first lady of Picasso's harem between 1940 and 1942 was undoubtedly Dora Maar. Even during the war, however, Picasso continued to live apart from her, perhaps because he needed periodic relief from her labile temperament. Their arrangement afforded him the best of both worlds, privacy plus companionship, for Dora faithfully awaited the artist's summons in her nearby apartment. During these years, she also served as his principal subject, as he created her image to a series of transformations which lent new expressive powers to his late cubist style. In many of these paintings he seemed obsessed with her nose, which he twisted into exaggerated shapes and positions as though it were made of taffy. In one of these sets of canvases he fused Dora's face with that of his Afghan, Kasbec. Picasso loved to repeat the aphorism that one woman is as much like another as two poodle dogs. These dog-faced portraits of Dora suggest that he regarded her fidelity as positively canine in its servility; like Kasbec, she came whenever he whistled.

Dora was at Picasso's side when he painted a number of his finest wartime canvases, such as the *Woman Dressing Her Hair* from 1940, a powerful, yet hideous, rendition of a monstrous humanoid, a wingless bird-like creature who happily preens herself, apparently unaware of her deformity. In a lighter vein, he imagined Dora as a kind of mythical horned bird-woman with star-like eyes (Z., XI, 103, 104).

In January 1941 Picasso enlarged the range of his renditions of Dora to

include a literary interpretation in his first play, *Desire Caught by the Tail*.[32] He had begun his literary activities as a kind of occupational therapy to engage him when he could no longer create art, but he had continued to write after his facility in the visual arts had been restored. During those months at Royan, he had frequently sandwiched poetry writing periods between drawing sessions. Now he expanded his literary repertoire to include this enigmatic play, a work which may reflect his early association with Alfred Jarry, the father of the theater of the absurd, and a member of Picasso's inner circle during his first years as a resident of France.

The heroine of this play, in whom Picasso's intimates recognized traits derived from Dora Maar, was called La Tarte, a term which, in French as well as in English, can refer either to food or to a prostitute. Critics who have discussed Picasso's play all emphasize the preoccupation with cold and hunger registered in this work, and usually interpret it as a reflection of the artist's wartime deprivations. This may be, but Picasso's visual works never shared this intensely "oral" character, not even during this period—unless one counts those still-life renditions of leeks and tomato plants as evidence for such preoccupations. Perhaps this emphasis reflected, instead, his perception of Dora's great needfulness. His insight into her emotional instability is also reflected in many of his portraits of her. That he recognized the inherent dangers in this situation is suggested by one of the verbal exchanges in the play. The Tart warns Big Foot—a writer who dwells in an attic studio and seems partly modeled on Picasso himself—that he will be caught in the trap of his own desire for her. As she leaves, another character remarks: "A beautiful girl, intelligent but bizarre—all that will end badly." This forecast proved quite accurate: the relationship terminated in tragedy for Dora, who suffered a psychotic break in 1945.

Picasso accompanied the text of his play with an overt self-portrait drawing, the first in many years, depicting himself as he wrote the manuscript. He utilized a peculiar bird's-eye vantage point for this sketch, one which emphasized the fact that he was balding and now required glasses for close work. The uncertain, quavery lines of this drawing remain unique in his oeuvre, adding to the impression of age and infirmity conveyed by the imagery. Picasso had celebrated his sixtieth birthday just a few months earlier; this self-portrait suggests that he was acutely aware that he had passed a milestone on the way to mortality.

Picasso's debut as a playwright prefigured a change in the focus on his work as a visual artist. Between 1934 and 1940 he had shown little interest in sculpture, creating only minor pieces, little dolls and other small constructions assembled from found objects. In 1941 he returned to monumental sculpture, beginning with a large plaster head of Dora, later cast in bronze and used for the monument to Guillaume Apollinaire. During succeeding months, he completed more relatively naturalistic drawings than he had done in years. The

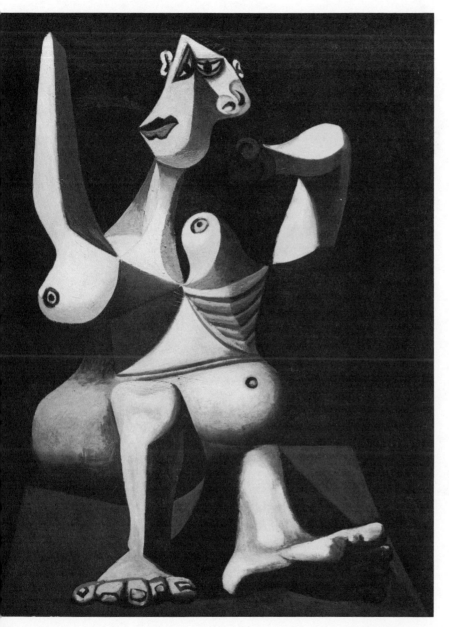

Woman Dressing Her Hair, June 1940, oil on canvas, 130.2 x 97.2 cm. Collection of Mrs. Bertram Smith, New York

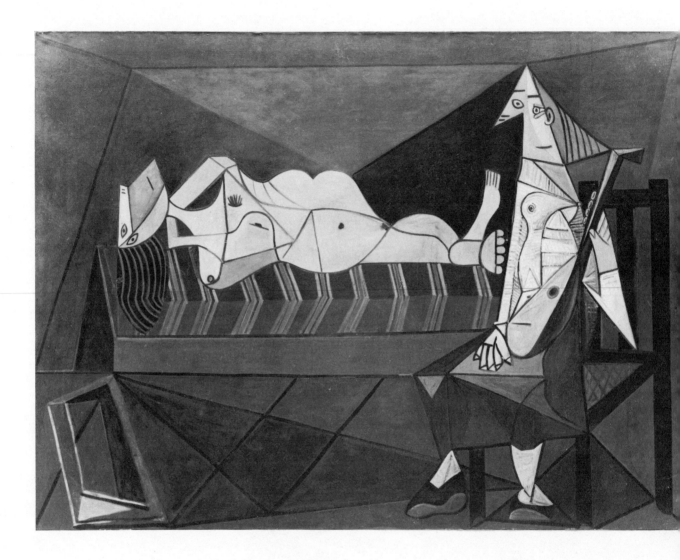

fraction of his production devoted to depictions of the female figure declined to just under 50 percent during 1942 and the first half of 1943 (see Z., XIII).

The artist's mounting interest in sculpture partially explains this shift in the content of his two-dimensional work, but it probably also mirrored a personality change which his principal model underwent. During 1941 Picasso began to depict Dora more formally than previously, often showing her clothed and seated in a small, closed room. The extreme distortion of her features, as well as the oppressive quality of the space Picasso created for her, arouse an empathic reaction of discomfort in the viewer; they recall, as well, those horrifying visions of Olga which the artist created during the late twenties. This new imagery culminated in *L'aubade,* or *The Nude with a Musician,* of May 1942, which depicts a reclining nude as she lies upon a hard, unyielding couch. Her form, flattened and angular, reminds one of an assembled puzzle with joinure lines demarcating the body parts, the whole rendered in Picasso's complex, inconsistent perspective. A diamond-shaped wedge which contains the nude's mouth is inserted between her asymmetric eyes as though driven in by force, and her thin, ribbon-like arms have been tightly tucked behind her neck, like those of a trussed bird awaiting the roasting pan. Her legs and feet also seem constrained, although no ropes or other bindings are visible. A misshapen attendant, as insecurely perched as a figure in a mannerist painting, sits in a chair next to the couch. She possesses traces of illusionistic treatment in her hands and feet, but this seems all the more inharmonious with her generally flattened figure. Although she wears clothing, her bosom is bare, or her blouse transparent, revealing her breasts, one in frontal position, the other swung about to provide a profile view. Her hard-edged face repeats this double viewpoint and is crowned by a triangle of spaghetti-like green hair. Despite her odd appearance, the attendant seems cheerful and bustly, recalling the annoying hardiness nurses sometimes display with the seriously ill. She holds a lute, as though about to begin a serenade to her tortured charge. At the far left, an angled mirror rests on the floor, reflecting nothing.

L'aubade seems like a grisly, dizzying reinterpretation of Ingres' *Odalisque with a Slave.* In place of the bright, soft, sensuous atmosphere which the nineteenth-century master created, Picasso provides an aggressively angular, confusing climate in which the depressing effect of the deeply saturated colors is compounded by jolting distortions of perspective and bizarre lighting. The spectator, like Alice in the court of the Queen of Hearts, becomes an unwilling participant in a cruel, confusing world. Both in its mood and its subject matter, *L'aubade* recalls the earlier vision of the psychotic and her keeper which Picasso created just before he fled Juan-les-Pins in May 1936. Perhaps he felt especially desperate once again. Julio Gonzalez had died on March 27, 1942, after a long illness; Picasso somehow magically blamed himself for this

L'aubade (The Nude with a Musician), 1942, oil on canvas, 92 x 73 cm. Musée National d'Art Moderne, Centre National d'Art et de Culture G. Pompidou, Paris. Cliché des Musées Nationaux, Paris. © SPADEM, Paris / VAGA, New York

event and confided to a Spanish friend, "I'm the one who killed him." Had Picasso inadvertently omitted Gonzalez's name from that litany of friends recited each morning to insure the well being of his intimates for the day? Or did his enigmatic statement betray some deeper guilt, perhaps related to the much earlier suicide of Casagemas, like Gonzalez a native of Barcelona and friend of Picasso's youth? Whatever Picasso's line of reasoning (or lack of reasoning), Gonzalez's death and funeral profoundly moved him. During succeeding weeks, he created several austere still-life drawings and paintings allegedly symbolizing the death of Gonzalez. One of the most dramatic of these features a bull's skull silhouetted against a severely geometric, jewel-toned background inspired by the play of light through the stained-glass windows of the little chapel where Gonzalez's funeral was held. With their dark tones and sharp angles, as well as their presentation of the dead bull as victim, these pictures seem closely allied with *L'aubade* and its helpless heroine.[33]

Another death invaded Picasso's world later that same year: Dora Maar's mother died in October, after a severe illness. A painted record of her daughter's deep distress survives, a magnificent, yet mournful portrait which shows Dora in a striped bodice, seated in a room now more or less back in plumb, but bare, severe, and coldly lit (Z., XII, 154). Her large, beautiful, slightly asymmetrical eyes reflect an almost unbearable sadness; one senses that her composure has been purchased at the cost of great inhibition of feelings. This is Picasso's most famous portrait of Dora, and it presents a moving contrast to those wispy gamine pictures of her which he had created at the beginning of their relationship.

Picasso was very active as a sculptor during 1942–43, when he completed seventy-six sculptures, including what is probably his single most famous piece, the *Bull's Head*, created from an old bicycle seat and handlebars. During these same months, however, he made an enormous series of preparatory drawings for a single sculpture, *The Man with a Sheep*. At the end of this long incubation period, Picasso abruptly built up the clay model for this statue in a single day, employing a previously prepared armature. (According to Spies, this initial clay version collapsed and another was done later, a fact which probably accounts for the fact that Brassaï, who photographed the first version, dates this piece several months earlier than everyone else.) In his drawings, Picasso devoted as much attention to the lamb's position and expression as he did to that of the man, a slender, bearded figure. Barr points out that this sculpture is unique in Picasso's work, and so unlike the rest of his oeuvre "that it may have some special significance which we do not yet know."[34] Earlier, I suggested that a connection often existed between Picasso's activity as a sculptor and a heightened anxiety level. If this theory is correct, it might help to explain his renewed interest in sculpture at this time as well as his particular choice of subject matter. He began his initial studies for *The Man with a Sheep*

Man with Sheep, 1944, bronze, 220 x 78 x 72 cm. Philadelphia Museum of Art. Given by R. Sturgis and Marion B. F. Ingersoll

not long after Gonzalez's death, an event which had particularly upset Picasso's equilibrium. Also, during 1942–43 the outcome of the war appeared quite uncertain; the Allies were not faring well against the Axis, and an early end to the occupation of Paris seemed less and less likely.

While Picasso worked on his shepherd, he not only finished a number of other sculptures, he even utilized underground connections to obtain bronze illegally, and he was able to have a number of pieces cast. His sculptural output during 1943 included a series of skulls; he had the largest and most impressive of these heads cast both in bronze and in copper—all this in the midst of the German occupation.

Steinberg connects these heads with a prophecy which Max Jacob had made long before when reading Picasso's palm: the artist's lifeline, the poet suggested, would terminate when he was sixty-three, an age Picasso reached in 1944. The fact that Picasso created these sculptures in 1943, rather than in 1944, as Steinberg believed when he wrote his essay, need not negate the validity of this interpretation. Picasso, the most magical of men, undoubtedly would have remained mindful of Jacob's dire prophecy, and the death of Gonzalez may well have served to jog his memory.[35]

Picasso may also have conceived *The Man with a Sheep* in reaction to Jacob's prophecy; the figure may originally have been intended as a magical protector. Many observers have noted similarities between this statue and images of Christ as the Good Shepherd, but the tall, slim, bearded figure also bears a general resemblance to Picasso's father. In many of the preparatory drawings, this resemblance is more striking and the shepherd's attitude toward the lamb much more tender and protective than the ambiguous relationship which finally evolved between the two figures. Sketches of doves, the animal Picasso so intimately associated with his father, recurred while the artist worked on his statue, further confirmation that he did, indeed, associate his shepherd with Don José.

The psychoanalytic investigator Oscar Legault, who utilized slides of *The Man with a Sheep* during research into the psychology of perception, noted that his viewers surprisingly ignored the fact that this statue, although ostensibly nude, possesses no genitalia. Earlier, I suggested that Picasso had perceived his father as the more tender, maternal parent. Perhaps, then, in this statue, he transforms his father quite literally into an asexual maternal figure.[36]

If Picasso unconsciously fashioned his *Man with a Sheep* to fulfill a magical, protective role, the statue functioned well. The artist's oeuvre during 1942–43 often seemed quite serene and lyrical; many tender studies of Maya appear, along with a series of realistic male heads derived from a Renaissance painting which Picasso surely studied from photographs. Such an output suggests that Picasso may have enjoyed a symbolic renewal of his phantasied merger with his father, a merger which comforted and sustained him once again as it had during childhood. In August 1942 a series of horror women (Z., XII, 111–

14) intruded upon Picasso's art, briefly interrupting the dialogue between the artist and his shepherd and perhaps offering additional evidence that Dora Maar was very disturbed during this period.

The theory that Picasso associated his shepherd with his father gains further credence from the appearance of tall, bearded artists in other pictures he created during these months. The most ambitious of these, an oil on wood panel variously titled *The Three Ages of Man* and *The Artist's Studio,* actually might more accurately be titled "The Three Ages of the Artist" (Z., XII, 153). It shows a short, squat figure sleeping on his studio floor before an easel. Except for his beard, this man closely resembles Picasso as he appears in photographs of this period (he was somewhat heavier than usual, probably because he led a more sedentary life). Behind him, a graceful, nude adolescent boy sits in a window seat playing a little trumpet. The only person who looks out at the spectator is the tall, slim, bearded man who stands at the left of the painting. Like Picasso's Minotaur, this man carries a long staff, but he is neither monstrous nor blind, although he does hold a mask in his right hand which resembles a rather prettified version of the Minotaur's face. Calm, self-confident, beautiful, he reminds one of Picasso's earliest, most idealized portraits of Don José, although an idealized self-image is probably also involved. The cheerful little trumpeter may recall Picasso's career as a child prodigy, tenderly protected by his loving father.

A few weeks later, Picasso created another series of watched-sleeper drawings in which Marie-Thérèse suddenly reappeared as a young girl watching a sleeping man who ages in appearance while she remains youthful. Sometimes she alternates in these sketches with a figure resembling Dora Maar. Both study the sleeping man with tender solicitude, rather like proud mothers. These drawings, like the *Three Ages of Man,* suggest that Picasso, nearing his mid-sixties but still vigorous, was tentatively beginning to think of himself as middle aged and to recognize that he might not always sustain the interest of younger women. These watched-sleeper drawings continued through the New Year and into the first months of 1943. Many of them contained a new twist, for several drawings showed one young woman watching another. One wonders whether any of them referred to Dora Maar watching a possible successor, who was, indeed, on her way.

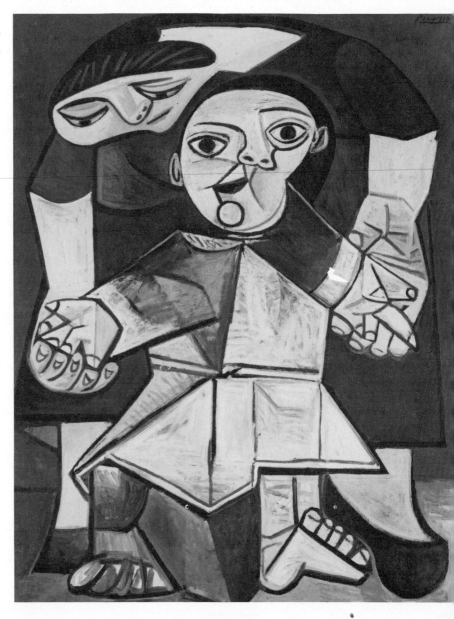

First Steps, 1943, oil on canvas, 130.2 x 97.1 cm. Yale University Art Gallery. Gift of Stephen Carlton Clark, B. A., 1930

**My Heart Was Born Again
like a Tree in Spring**

A bewildering array of new feminine forms and faces paraded through
Picasso's pictures during the late winter and early spring of 1943, a sure in-
dication that Dora Maar's status in his life and art had become precarious. Her
reign ended one night in May 1943, when he spied the lovely young Françoise
Gilot dining at his favorite restaurant with a mutual friend. Picasso rushed up
to offer a bowl of fresh cherries as his excuse to obtain an introduction. Thus,
he embarked on his last great romance, a liaison which would profoundly affect
his art and life during the ensuing years.

Sixty-two years of age though he was, Picasso reacted to this budding romance
with a girl forty years his junior as though he were a mere broth of a boy.
Themes which had first appeared in his painting almost forty years ago during
the early stages of his romance with Fernande Olivier recurred during the
following months, such as the motif of the beauty who completes her toilette
while an attendant respectfully holds the mirror (Z., XIII, 200). Maternity
themes cropped up again, too (though now interpreted with an almost savage
intensity quite lacking during the circus period), scenes of mothers feeding
and caring for their infants. *First Steps,* an oil he completed in late May 1943,
depicts Picasso's maid, Inez, tenderly supervising her toddler son as he learns
to walk alone. Barr, who considers this one of Picasso's top wartime canvases,
noted that the artist chose to emphasize "the momentous drama of the scene, not
its charm."[1] It surely cannot be a coincidence that Picasso painted this motif
during the same month in which he also took his own first steps toward a
momentous new adventure.

That summer, Picasso became interested in landscape painting again for the
first time in years. About a month after he met Françoise, he completed several
drawings and two oil paintings of the statue of Henri IV, the so-called *Le vert
galant,* in its park-like setting on the Ile de la Cité (Z., XIII, 59–64). These
works seem almost like a visual pun, for Picasso himself was the *vert galant,*
wooing a girl young enough to be his granddaughter. A park also served as

203

the setting for a series of schematized, cartoon-like drawings of an embracing couple which Picasso created the following autumn and winter as his interest in Françoise deepened.

More ominous themes emerged, too, drawings and paintings of grotesque female heads probably inspired by Dora. One such set of drawings (Z., XIII, 4–9), shows these heads interspersed with drawings of insects—the latter always associated with Dora, according to the accounts of several friends, who report that Picasso often drew insects on her apartment walls. By April 1944 he had reverted to a theme reminiscent of his last years with Olga, when he so often showed a ghastly nude attempting to unlock a beach cabana. Now he moved the scene indoors to portray a female figure seated stiffly in a chair which seems to imprison her. A nude stands beside her, whose form can barely be discerned in the flood of light which almost dissolves her schematized figure. This same unnatural light, which begins as a broad-based triangle at the window, gradually resolves into a narrow pinpoint focussed on the key of an armoire. The next canvas develops these ideas still further, and the chiaroscuro pattern becomes still more complex, with the broad base of triangular light emanating from the armoire and resolving into a narrow apex at the window. This time the seated figure appears on the verge of disintegration; meanwhile, the form and identity of the standing figure have become clearer as she assumes the swirling, plant-like forms which Picasso associated with Françoise, whom he would soon paint as *Femme fleur*. In this second canvas, the key to the armoire has become more prominent, perhaps indicative of the secret which Picasso feared he could no longer conceal from Dora (Z., XIII, 252, 253).

Although Dora and Françoise both appeared in the pictures Picasso created during this period, he devoted a smaller than usual proportion of his output to such imagery of the female figure, perhaps because he was in a state of transition in his romantic attachments, less interested in Dora but not yet definitely committed to sharing his life with Françoise. Not only landscapes, but still lifes assumed new importance to his art, and between June 1943 and December 1946, more than a quarter of his pictures consisted of still-life representations, many of them effective and varied in style. Several of the still lifes which Picasso completed shortly after he met Françoise feature a bowl of cherries, probably another of his coded references to his new romantic interest (Z., XIII, 51–58). Others continue that old dialogue between a glass and pitcher or a pitcher and a lighted candle (Z., XIV, 1–11, 67–71), while still others explore new subject matter, such as the curving vines of the tomato plant which the artist cultivated in his studio window during the summer of 1944.

The memento mori theme first expressed in Picasso's sculptures of 1943 entered his painting that year, too, and became even more prominent during 1944 (Z., XIII, 88–92). Usually interpreted as an index of Picasso's discouragement over the lengthy war, this theme soon became strongly associated with Françoise in the artist's mind, and he would revert to it repeatedly during

paintings created during the years of their liaison (Z., XIV, 340–41; XV, 198–201). Did this apparent association between thoughts of Françoise and those of death reflect his misgivings about this May-December romance? Or was the truth the other way about: did he become involved with Françoise as part of his effort to deny the approach of old age and death, particularly as 1944 approached, which Jacob had prophesied would be the year of Picasso's demise? Whatever the exact nature of his association between Françoise and the death's head, this motif virtually disappeared from his work after she left him in 1953.

Although both Picasso's paintings and his play, *Desire Caught by the Tail,* reveal his underlying constant awareness of Dora's fragile personality integration, he nonetheless seemed terribly shaken when she became floridly psychotic during the spring of 1946. This crisis also precipitated a rift between Picasso and Françoise which lasted for several months and contributed to Picasso's distress.

While Dora unraveled that spring, Picasso addressed himself to studies for that gruesome painting *The Charnel House,* a picture probably inspired in part by Max Jacob's tragic death in a concentration camp the previous year, as well as by the photographs of concentration camp atrocities published in the wake of the German defeat. This large canvas, like *Guernica,* painted only in grisaille, portrays a group of broken corpses heaped beneath the table which served as their sacrificial altar.[2] Picasso interspersed work on *The Charnel House* with grim pictures of distorted female heads and austere still-life canvases featuring a skull and pitcher (Z., XIV, 72–100). Since Picasso so often utilized a pitcher as a symbol for Dora, these still-life pictures probably refer to her, a supposition reinforced by the fact that one of his grotesque female portraits seems to fuse a death's head with the woman's own face (Z., XIV, 77).

Gilot observed that Picasso was disgusted by Dora's breakdown, which he regarded as an inexcusable sign of weakness that had "the smell of death" for him.[3] His preoccupation with the motif of *The Charnel House* may thus have been overdetermined, reflecting not only his indignation over the Nazi atrocities (especially the death of Jacob) but his disgust over the way Dora had collapsed in a heap, a collapse which undoubtedly aroused his guilt as well as his disdain, since her complete breakdown may well have been precipitated by his changed behavior toward her.

Whatever his private feelings, Picasso assumed the financial and moral responsibility for Dora's care. He engaged Jacques Lacan, an eminent psychoanalyst, who hospitalized her briefly, then treated her on an outpatient basis. That summer, Picasso took her with him for a vacation in Ménerbes, where they stayed at a villa which he purchased in trade for a painting. Gilot, meanwhile, took her holiday in Brittany, steadfastly refusing to join the artist, although he wrote repeatedly pleading boredom and begging her to join him.[4]

The artist's production record that summer was dismal. He accomplished

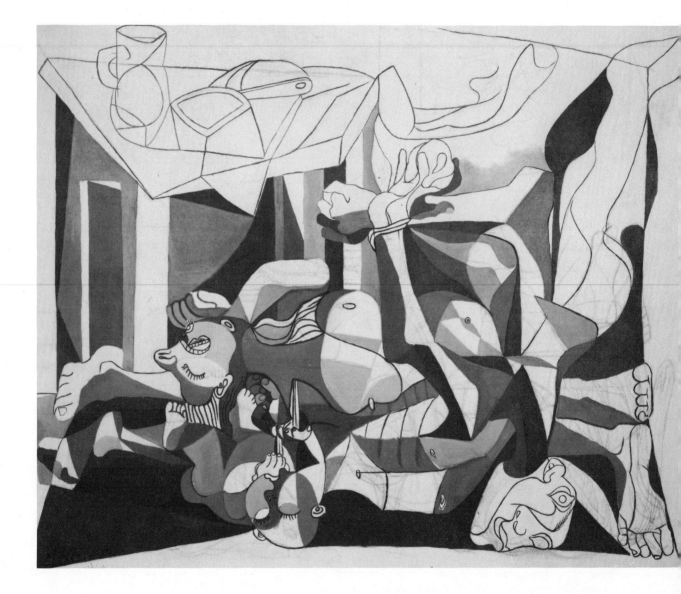

irtually nothing between June 4, when he painted a still life of cherries, robably another wistful reference to Françoise, and the late autumn when he ook up lithography again. Only after Gilot was reconciled with him in late November 1945 did he begin to draw and paint once more. Isolated in Ménerbes with poor broken Dora, Picasso apparently suffered the first of several work aralyses which would punctuate his relationship with Françoise. Intermittently hroughout the summer, he continued his efforts to complete *The Charnel House* nly to abandon it finally in the unfinished state in which it can be seen today.[5] vidently the relatively impersonal compassion which had motivated him to egin this canvas proved insufficient to sustain him throughout its course. enrose calls this painting an epilogue to the war, just as *Guernica* had been prologue of the carnage to come.[6] These same two paintings served to elineate the beginning and ending phases of Picasso's relationship with Dora Maar. Just as he did not finish *The Charnel House,* so Picasso could not ear to cut off all ties to Dora. He gave her the deed to that villa at Ménerbes, nd he continued to visit her occasionally in Paris, as well as to attend her xhibitions. Unlike Olga and Marie-Thérèse, Dora did not intrude aggres- ively upon Picasso's life with Gilot, and she disappeared forever from his euvre after 1946. His final portraits of her occurred during the course of a ong set of lithographs which he completed during that autumn and winter f 1945–46. Lonely and sad in Paris, as Gilot remained estranged from im, Picasso finally responded to an invitation that the printer Fernand Mourlot had extended to him earlier to use his excellent facilities to create new series of lithographs, a printing technique which Picasso had virtually gnored for a number of years. Among the many prints he completed, he in- luded a series of watched sleepers with Françoise looking on as Dora Maar lumbered. Thus, Dora dreamed away her final moments in Picasso's art.

During the course of that winter, Picasso finally effected a satisfactory econciliation with his young love; by spring, Françoise had agreed to share is life, even though that would mean total estrangement from her family. Françoise's stubborn strength in rebelling against paternal dictates probably helped attract Picasso to her. Cabanne indicates that Picasso was delighted by Brassaï's account of the verve with which Françoise defended herself and her deas about art against her father's attacks during the course of a dinner Bras- aï had enjoyed with the Gilot family. Picasso had experienced so much diffi- ulty in emancipating himself from an equally domineering mother that he must ave especially admired Françoise's behavior toward her father. Later he eproached her for being the woman who always said no, but one senses the espect which underlay such rebukes.[7]

When Françoise joined the artist in his studio dwelling, he demonstrated his delight by transforming her pictorially into a long-stemmed flower. To accom- pany his *Femme fleur,* Picasso created a race of fauns and centaurs. Although he mood expressed in many of these drawings—which served as studies for

The Charnel House, 1944–45, oil and charcoal on canvas, 78.6 x 110.5 cm. Collection, The Museum of Modern Art, New York, New York. Acquired through the Mrs. Sam A. Lewisohn Bequest (by exchange), and Mrs. Marya Bernard in memory of her hus- band, Dr. B. Bernard, William Rubin, and Anonymous Funds

Portrait of Picasso, a Study in Grey,
by Françoise Gilot, 1945, tempera on
paper, 50.8 x 66 cm. Collection of
Mme. Françoise Gilot-Salk

Françoise Gilot, 1946, lithograph, 65
x 50 cm. The Art Institute of Chicago.
Gift of Joseph R. Shapiro

similar lithographs—is vigorous and charming, an ominous note was occasionally sounded. One series of this type shows a youthful and an older centaur engaged in a struggle to the death (Z., XIV, 203–24). Usually the younger protagonist triumphs and claims the nymph over whom they have struggled. In his conversations with Gilot, Picasso often voiced the anxiety which these drawings imply: the fear that a younger man would come along and claim her affection.[8]

Such anxieties do not fully explain all these drawings, for certain of them suggest more complex attitudes. Sometimes, for example, the younger centaur sports a Minotaur head, always a symbol for the artist himself. Did his relationship with Françoise stimulate Picasso's guilt about his own past competitiveness with older men, including his father? We can only speculate about the hidden meanings which such references contain; the fact that the artist produced a set of watched-sleeper drawings that spring, with mythological creatures enacting the principal roles, suggests that his anxiety level was, indeed, elevated.

Picasso had reason to be troubled; his relationship with Gilot continued to be stormy and uncertain. As a solution to their problems, he proposed that she have a baby, an experience which he claimed would transform her and put her into tune with nature.[9] She agreed, and while she carried their son, Claude, Picasso drew frolicking centaur families (Z., XIV, 265–67, 270–79). They spent the last half of 1946 in the south of France, chiefly in Antibes, where city officials put the enormous space known as the Musée Grimaldi at the artist's disposal, inviting him to utilize it as a studio. There he created additional paintings of sporting fauns and centaurs. The largest of these works, the so-called *Joie de vivre*, depicts Françoise as a nymph dancing on a beach to the tune of a centaur band. The entire painting is carried out in an extremely simplified technique, with the figures drawn in outline and filled with colors, while the landscape is composed simply of broad bands of color which suggest hill, beach, and sea. The picture created chiefly in pastel tones, thinly applied, today appears rather faded and anemic. Blunt describes it as gay and relaxed, but adds that he can imagine critics labeling it superficial.[10] Indeed, it does seem to be a minor effort, filled with forced gaiety as though the aging artist were trying to reassure himself concerning his youth, vitality, and ability to continue sporting with his nymph.

Claude Picasso was born on May 15, 1947, in Paris, where the family was once more in residence. During the latter half of Françoise's pregnancy Picasso's cheerful mood of the previous autumn deserted him. His production declined, and his work revealed a more pessimistic, even angry frame of mind. In January 1947 he painted a set of austere still-life canvases featuring the human skull, then a group of pictures showing an angry owl defensively perched on a chair back. A month later, he added a pair of oils depicting a rooster stretched out on a table top, its throat neatly cut, its head dangling

over the table edge. He followed these pictures with another portrait of the little owl, now incarcerated in a constricting cage (Z., XV, 26–43). Just prior to Claude's birth, Picasso turned to a happier motif, a group of delightful canvases depicting the concierge's baby (Z., XV, 55–58). Perhaps these more cheery pictures represented Picasso's conscious effort to deny his underlying apprehensions. At any rate, Claude's arrival created an uproar in his father's world, not only because the studio-dwelling proved quite unsuitable for family living, but because both Sabartés (who continued to act as Picasso's secretary-receptionist) and the chambermaid, Inez, resented Claude's presence. One suspects that they reflected their employer's disgruntlement, because even after the little family moved back to the Riviera, leaving Sabartés and Inez behind in Paris, Picasso remained extremely tense, restless, and disinclined to undertake sustained work. The Zervos volume XV indicates that the artist completed only fifty-eight drawings and paintings during all of 1947, all but three of them executed before Claude's birth.[11]

Picasso's fallow period ended abruptly the following autumn, when he discovered a new outlet for his creative energies: the making and decoration of ceramics. He worked at a pottery in Vallauris, altering and reshaping pots thrown by the chief potter, then decorating them with his own motifs. Eventually Picasso also created a series of molds, primarily animal figures, which could be utilized to cast small ceramics. He also began to experiment with colors and glazes in his usual free fashion, until he achieved results which pleased him. This work continued to fascinate him throughout the winter of 1947–48 and may help to explain why he did so little painting and drawing during that period. Not only did the ceramic sculpture permit him to exercise affecting magical metamorphoses—as in the series of amphora jars which he transformed into charming female figures by making slight alterations in their shapes and adding appropriate glaze patterns—but it thrust him into the midst of a busy workshop. He had always valued such contacts, and he may have derived special support and comfort that winter from the company of his fellow ceramicists. His ceramic production rapidly transformed Vallauris from a sleepy spot into a boom town, and the other potters must have responded with admiration and gratitude.

Picasso produced a vast body of ceramics at Vallauris; although all perfectly delightful, they can hardly be considered on the same level as his major paintings, sculptures, and prints. The ceramics tapped all his ingenuity in producing transformations, but none of the core of his creative genius. Berger compares Picasso as a ceramicist to a child prodigy playing with forms which others have created for his amusement.[12] Certainly, no matter how appealing Picasso's ceramics may be, they represent a regression from his highest level of creativity and constitute yet another measure of the disturbance or diminution of his self-image. The artist who had convulsed the world with the *Demoiselles d'Avignon* and *Guernica* had become a mere decorator of pots fashioned by

other hands. One can only conclude that, once again, Picasso had reacted quite
negatively to fatherhood, an assumption also verified by the sleep disturbances
he suffered during the months after Claude's birth, when he would awaken,
often many times in a single night, convinced the boy had smothered. A few
years later, when Paloma was born, Picasso began another round of this
anxious, repetitive behavior. Such activities, evidently designed to ward off
from consciousness the artist's own destructive wishes toward his offspring,
offer further proof that he found fatherhood a traumatic experience.[13]

During the months following Claude's birth, the relationship between
Françoise and Picasso deteriorated steadily; nonetheless, Françoise acquiesced
when the artist again urged her to become pregnant. His insistence on repeating
such a painful event may seem puzzling, even incredible. Yet his life was filled
with such repetitions, demonstrating anew that the person who does not under-
stand his conflicts is doomed to repeat them. One recalls again Olivier's per-
ceptive dictum that Picasso possessed a nature which sought its own torment.

The birth of Picasso's second daughter, Paloma, on April 19, 1949, had the
disastrous effects upon his life and work which one might anticipate from his
reaction to the birth of Maya. The Zervos catalogue reveals that Picasso stopped
working about three weeks before Paloma's birth and did not start drawing
or painting regularly again until early the following year. Nor was he active as
a sculptor that year, when he produced only a handful of small-scale works.
By early summer he felt too restless even to dabble in ceramics, and he abruptly
terminated that activity, to Gilot's amazement.[14]

Apparently too agitated to concentrate on anything, the artist spent the
summer searching for a suitable new location for his studio. He finally
found what he sought in an abandoned perfume factory in Vallauris. It was
large enough to function as both a painting and a sculpture studio, and once
he had arranged it to meet his needs, Picasso settled down to work again. Dur-
ing 1950–51 he fashioned a number of charming sculptures, many of them
constructed from found objects. Daix, who points out that several of these
pieces deal with fecundity (*Pregnant Woman, Goat Big with Kid,* and
Baboon with Young), innocently assumes that such works reflect the heartfelt
happiness of a father with young children. More likely, they represent
Picasso's efforts to master the deep disturbance and ambivalence toward Fran-
çoise which the children's arrival engendered. At least, Gilot dates the final
deterioration of her relationship with Picasso to the period following Paloma's
birth, when the artist became restless, withdrawn, and finally unfaithful.[15]
Gilot, for her part, felt depressed and physically ill after Paloma's arrival.
Her behavior further enraged Picasso, and the situation became a disaster for
both parties. How heavy a toll it exacted from Picasso we can measure quickly
and exactly. Normally, each Zervos volume covers about one year to eighteen
months, including about 300 to 350 paintings and drawings. During the seven
plus years when Picasso actually lived with Gilot, he produced fewer than

00 works in these media (see Z., XIV, 167–352; all of Z., XV and the first 13 tries in Z., XVI). Although Picasso produced many sculptures and ceramics ring this period, his activity in these areas by no means compensated for e dearth of paintings and drawings; rather, the paucity of entries by Zervos presents a marked curtailment of Picasso's creativity. He suffered one cre- ive paralysis after another during the years he spent with Gilot, a fact she scribes graphically in *Life with Picasso*.

Picasso had managed to identify with his eldest child, Paulo, like himself, e first-born son. He could not integrate his subsequent offspring into his lf-image in this manner, and their births simply repeated the trauma he had perienced when his two younger sisters arrived. He may actually have tempted such an identification with little Claude; at least, Gilot reports at he wanted to name the child Pablo, but that she refused because his elder n already bore a variation of this name. As one might anticipate, Picasso ver repeated those tender drawings in which he recorded Paulo's early velopment with any of the children who followed. Indeed, far from en- ying the burst of creativity with which he had responded to Paulo's birth, icasso experienced a creative freeze. After Maya's birth, he seemed to be mobilized, physically as well as psychologically, and spent weeks, even onths, in a daze. He responded to the two younger children differently, ith an outburst of restless behavior, devoting himself to busywork which ten had little or nothing to do with creating art. Although he had not par- cularly invested himself in Communist affairs after joining the party in 1945, began to take an active interest in these matters now, and attended the first o World Communist Peace Congresses, accompanied by Paul Eluard.

Increasingly alienated from Françoise, Picasso desperately needed a new derstander, and his active participation in Communist party doings probably rang from his desire to establish closer ties to Paul Eluard and Louis Aragon e had known Aragon, like Eluard, for many years, and they had been tive in surrealist literary circles together). Unfortunately, neither poet tted Picasso's needs exactly. He had drawn closer to Eluard after Nush's dden death in 1946, but this intimacy abated when Eluard was remarried 1950 to an independent young woman who apparently did not share the et's affection for Picasso. Picasso's relationship with Aragon had always en a more uncertain, ambivalent one. He complained of the latter, "I can't ve friends if they're not capable of sleeping with me. Not that I require it f the women or want it from the men—but there should at least be that eling of warmth and intimacy one experiences in sleeping with someone." was Aragon who prodded the artist into drawing the infamous posthumous rtrait of Stalin which was severely criticized by the Communist press. In a ppier inspiration, Aragon also selected Picasso's lithograph of a white dove— t originally designed with any specific purpose in mind—to symbolize the ommunist World Peace Congress of 1949.[16]

Goat Skull with Bottle, 1951–52, painted bronze (cast 1954), 78.7 x 95.6 x 54.6 cm. The Museum of Modern Art, New York. Mrs. Simon Guggenheim Fund

During the Korean War, Picasso painted three pictures so different from his usual work that they seem to have been designed primarily as propaganda machines: *Massacre in Korea* (Z., XV, 173), from 1951, and the two large murals, *War* and *Peace,* which Picasso created in 1952 to fit the vaulting of a deconsecrated chapel in Vallauris. Politicized critics seem convinced that these paintings reflected the artist's genuine distress over the Korean War. Since Picasso's work during World War II showed scarcely any reaction to the conflict being conducted virtually on his doorstep, it seems inconceivable that he really empathized deeply with a people from the other side of the world. Whatever the nature of his motivation, Picasso's efforts to create propaganda pieces which would command the respect of Communist party officials came to naught. They found the *Massacre* too abstract and lacking in emotional appeal, while professional critics considered it sterile and arid, and the general public compared all three of these works unfavorably with *Guernica.*

Only when Picasso painted from his heart could he create effective propaganda which was also great art. When he created *Massacre* and the *War* and *Peace* murals, he proceeded without passion, an attitude reflected in the tepid results he achieved. The compositional weaknesses of the *Massacre in Korea* seem all the more amazing because it depends from Goya's masterpiece *The Third of May, 1808.* Although Picasso followed the Goya canvas very closely, he managed to eliminate the very devices which Goya employed to bind the two halves of his composition together. As a result, Picasso's picture falls apart in the middle, where the viewer is left dangling like that puny little ruin which hangs from the side of the hill, doing its inadequate best to fill the hiatus Picasso has left at the heart of the painting. The figures he substitutes for Goya's martyrs seem no more adequate than the background details. Perhaps in an effort to add to the martyrs' pathos as victims of Capitalist oppression, Picasso transformed Goya's group of male victims into young women and children. The woman who corresponds to the principal white-shirted figure in Goya's canvas wears such a vacuous expression that she recalls third-rate images of a Baroque saint in ecstacy, while the young girl on her left stares vacantly at the spectator as she modestly assumes the pose of the Venus Pudica. She seems a foolish virgin, indeed, to worry about modesty—and the reaction of her audience—at such a moment. Goya presented his soldiers as anonymous assassins, but Picasso substituted a knotted group of male nudes, helmeted like ancient Greeks. He probably intended to suggest a race of deadly robot men, automatons who could mindlessly carry out such a massacre. Unfortunately, they merely appear ridiculous, an impression reinforced by the preposterous multibarreled rifles, which seem incapable of hitting a target. As a final insult to the Goya, Picasso has substituted unattractive metallic colors for the exquisite nocturnal light and soft earth colors of *The Third of May.*

Although certainly consciously intended as a criticism of American military

policy, Picasso's *Massacre in Korea* has overtones which seemed to apply t
Gilot and his children: his victims are all young women, infants, and toddler
The two pregnant women closely resemble Picasso's sculpture *The Pregnar
Woman,* modeled after Françoise, who comments that Picasso created it whil
he was urging her to undertake yet a third pregnancy![17] During 1951 Picass
often portrayed page boys with helmeted knights whose gear recalls that wor
by the assassins in *Massacre.* Gilot believes that these armoured figures cor
stituted Picasso's ironic commentary on her tendency to withdraw when sh
felt upset, rather than have a good fight, as Picasso would have preferred.
It seems more likely that these figures reflected the artist's own belligerer
attitude, for he consistently linked such gear with male images. For exampl
his Paris in a contemporary drawing of *The Judgment of Paris* wears a simila
suit of armour, and a defensive tuft of nails crowns the head of the goat—on
of Picasso's many totem animals—in the *Goat Skull with Bottle,* a powerfu
sculpture of 1951.

Certainly 1951 was a year of hostile confrontations for the embattled coupl
Their domestic difficulties were compounded by external problems, such as th
lingering illness and death of Françoise's beloved grandmother, an event whic
surely deepened her depression. Finally Picasso became depressed, too. Ex
ternal circumstances forced the family to spend the winter in Paris, wher
Picasso and the children suffered prolonged bronchial infections. Gilot de
scribes how he fell into "a very black mood" and simply sat for weeks on end
morosely watching her paint "but not lifting a brush or pencil himself."[19] Th
Zervos catalogue corroborates her account, for most of the paintings Picass
completed that year were executed during the first three months of 1951
Zervos lists no works at all between mid-June and mid-December, a hiatu
which corresponds with Gilot's recollection and reveals that Picasso no
suffered the fourth creative paralysis which marked his association with he
When he finally started to work again, he created two austere wash drawing
of a goat's skull—a motif right out of a late still life by Goya (Z., XV, 19:
193).

During the final year they spent together, Gilot and Picasso reached
strained accord, treating each other with distant, excessive consideratio
Picasso continued to experience creative difficulties throughout the spring c
1952, but he no longer sat about glowering darkly; now he flitted aroun
engaging in passing promiscuities. Gilot, still disapproving many years late
comments that, for the first time since she knew him, Picasso wasted preciou
energy hitherto reserved for his art in frivolous activities and superficial er
counters. She attributes this behavior to a kind of delayed reaction he suffere
to his seventieth birthday, with its intimations of mortality. Whether th
deterioration of his relationship with Gilot or his fear of death played th
primary role, Picasso certainly functioned poorly from mid-1951 until mic
1952. His playboy behavior that spring was part and parcel of the same ur

happy state which had prevented him from working the previous winter. This was the longest paralysis he had experienced since 1935.[20]

That summer, he finally settled down again to create the long series of preparatory studies for *War* and *Peace* (Z., XV, 196–97). He finished these two enormous paintings in exactly two months, and they were shown at a major Picasso exhibition in Rome prior to their installation in the chapel at Vallauris. Most critics shared the opinion voiced by Blunt, who concluded that these murals could not sustain a comparison with *Guernica* "either in intensity of feeling or in coherence of execution."[21]

Picasso responded to such criticism with poignant requests that these panels not be judged by the standards applied to *Guernica*. He explained to Boeck that he had intended that they been seen in situ in the chapel, by the flickering light of candles held by visitors. Boeck comments, "A certain independence of the parts in relation to the whole was in accord with the painter's new conception, which aimed at preserving the spontaneous character of the record of his ideas without burdening it with compositional considerations."[22] Obviously Picasso himself recognized that the paintings lacked coherence. In fact, they have little real organization but consist of nearly autonomous segments which recall the continuous narration technique of medieval altarpieces. Both these panels and the *Massacre in Korea* exposed a serious deterioration of the elderly artist's organizational skills. Their critical failure must have been a terrible blow to his self-esteem, for he never again attempted such ambitious propaganda art. Indeed, for many years after he had completed these three pictures, Picasso addressed himself chiefly to the creation of art-after-art, painted reinterpretations of great chefs d'oeuvre of the past, preorganized for him by the masters who had originally invented the compositions.

During 1952–53 Picasso painted a number of more personalized, private paintings, portraits of the children alone and with Françoise. These family pictures all seem much more successful than his big machine pictures of 1951–52. Paloma, now three, an age filled with significance for Picasso, particularly interested him, and he retained many of these portraits for his own collection (Duncan, pp. 244–46). However, he painted proportionately fewer renditions of the female form and face than usual, a measure of the gulf which now divided him from Gilot. She still served as his model in an occasional painting, as in the two canvases which show her romping aggressively with Picasso's powerful male Boxer dog (Z., XV, 245–46). The dog's helplessness as he lies pinned to the floor may reflect Picasso's own felt impotence in coping with his mistress. Other portraits depict her looking thin and sad; nonetheless, a tenderness pervades these canvases, as though the artist, knowing the end to be very near, treasured these final moments with his mistress. Françoise always respected Picasso as an artist, and when she posed for him, he must have felt much more in command of the situation and himself.

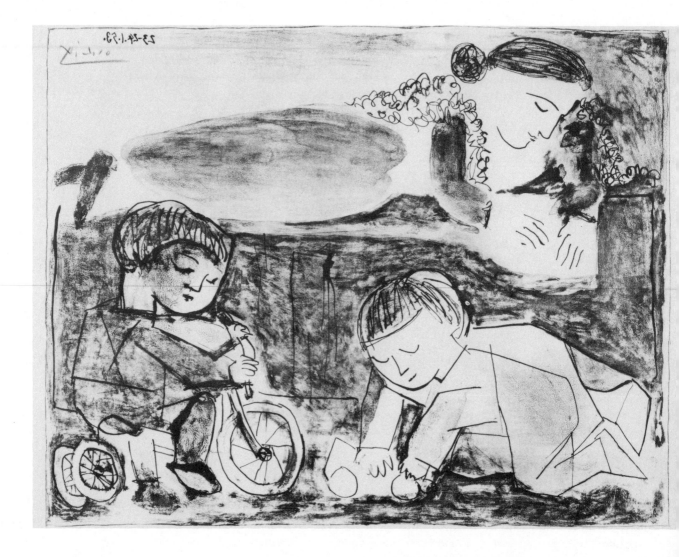

During their final months together, Picasso again devoted himself primarily to still-life painting. One of his final works that summer, a *Still Life with Cherries,* constitutes a wistful reference to the circumstances in which he first encountered his estranged mistress. By October 1953 it was all over. Françoise had left, but not until Picasso had precipitated her flight by announcing to one and all that she was about to abandon him. This kind of frankness about the details of his private life was quite atypical for the artist and may have constituted a frantic attempt to ward off the very disaster it provoked.

Picasso again reacted to the end of this relationship with immobility; the Zervos catalogue reveals another gap in the artist's oeuvre which lasted from July until the end of September 1953. He completed twenty-six rather minor sculptures that year, but only one of these can be assigned to these months: the figure of a shrilly angry owl whose defensive stance no doubt mirrors the artist's own feelings.

Picasso's helpless reaction scarcely seems surprising. He had always responded to separations with paralysis; even the dissolution of his marriage to Olga immobilized him, although he heartily wished to be rid of her. This time, his feelings must have been much more intense; for the first time, the other person had initiated the rupture. The worst fears of the phobic child had finally been realized: he had been deserted! It was a shattering blow to his self-esteem, made all the more bitter because it received eager news coverage around the world.

When he finally started to work again, Picasso's art took an even more intensely personal turn; the first 260 works he created—all drawings— primarily reflect facets of his feelings about Françoise (Z., XVI, 1–260). Within this long series, several subthemes can be discerned. The first (Z., XVI, 15–31) deals with the final defeat of the old Minotaur (at least that is what Zervos calls the figure, although it combines a bird's beak and wings with a bull's horns and a human body) by a beautiful young warrior who carries the scales of justice as he confronts the older figure. Although the Minotaur is armed and the youth makes no threatening gesture, the old monster flees. A bit later, his knife broken, he lies on the ground holding his head in agony, while a young female amour ruthlessly reveals his image to him in a mirror. This drawing recalls *The End of a Monster* from 1937; then the monster, though wounded, still seemed filled with vitality and soon magically recovered. Next, a dove who replaces the amour (no. 19) continues to threaten the Minotaur who cowers on the ground and cannot face the bird. Sometimes the dove appears to merge with, or be enclosed by, the sun. Although variations occur in each of these seventeen drawings, they are all united thematically. The protagonist, the Minotaur-bird, appears aged, broken (like his knife), and ashamed. Life has castrated and vanquished him. Forces symbolic of reproving society crowd in upon him, including the dove, his father's totem animal, here portrayed for the first time in a threatening or reproving role. At the conclusion

Les yeux et la lecture, 1953, lithograph, 50.5 x 66 cm. The Art Institute of Chicago

of the series, the old Minotaur lies face down, alone; all the symbolic figure
have disappeared, and he has been abandoned to his shame and despair.

In mid-December, Picasso began a set of depictions of a cat and rooster
a motif always associated with his feelings of powerlessness at the hands o
women. Once again the poor rooster appears as the victim, passively carrie
off in the cat's mouth (Z., XVI, 55, 58, 59). In another variation, th
rooster lies bound and helpless on a table, with knife and bleeding bow
beside him. But the female cat arrives and spirits him away before the absen
cook, the official executioner, returns to act. Although these drawings un
doubtedly refer to Françoise, they may involve a still more complex symbolism
Gilot claims that Jacqueline Roque, a divorcée of twenty-seven and a relativ
of the family who owned the ceramic factory in Vallauris where Picasso ha
worked, "had taken over" Picasso by the end of October, explaining, "On
can't leave that poor man alone like that at his age. I must look after him."[2]
Certainly Jacqueline was very much involved in Picasso's life by December 11
1953, when he painted his first clearly recognizable portrait of her (Z., XVI
53). Consequently, one must at least consider the possibility that the cat whe
kidnaps the rooster before the cook can finish him off may represent Jacquelin
as she steals the march on Françoise before the latter can dispose of the coc
herself.

With the drawing numbered 60 in Zervos's volume XVI, Picasso com
menced the famous series of 180 works later grouped together and publishe
in a special issue of *Verve* as "The Human Comedy." Although they are al
closely related in theme and chronology, there is no evidence that Picass
originally consciously planned them as a series. He simply ventilated his feel
ings through his work, and when he obtained enough relief, he stopped. Th
chief characters in the drawings appear in a variety of settings and disguises
but the protagonists are typically a little old gentleman and a beautiful youn
woman. Often their relationship is that of artist and model (eighty-nine o
the sketches show a painter at work; he is not inevitably elderly, nor is hi
model inevitably present, but that is usually the case). A strong element o
caricature prevails in these drawings, particularly in their treatment of old men
Many of these sketches appear to be self-portraits, quite merciless in thei
depiction of the artist as an uncertain-looking little figure with a flabb
body and atrophied genitals. Despite their self-flaying quality, these drawing
reveal a very high level of artistic excellence; indeed, they seem far mor
successful than many of the more ambitious paintings he created betwee
1946 and 1953, demonstrating once again that Picasso was always at hi
artistic best when worked up to fever pitch over very personal concerns.

Not only the excellence of these sketches, but their frankly autobiographica
content focused attention on them. Critics agreed about the meaning of cer
tain particulars, such as the fact that the beautiful young model symbolize
life and nature, but the generalizations the critics formed concerning the mean
ing of the series as a whole differed markedly. At one extreme, Daix rea

this message as: "the art of man can bring beauty to old age, youth to ugliness, life to the void." At the other end of the scale, Berger interpreted these drawings pessimistically as a tragic confession of Picasso's failure as a person, a sexual being, and an artist.[24] The bitterness which Berger discerned is certainly a feature of these drawings; however, he exaggerates Picasso's pessimism by failing to give sufficient weight to his wit and the good-humored quality of his self-mockery. Boeck, who appears to be more familiar with Picasso's total oeuvre than Berger, correctly points out that the artist had frequently utilized such ridicule and sarcasm to depict relationships between the sexes. In 1901–02, for example, he depicted seductive young demimondaines with absurd old patrons who could not possibly interest them sexually. This production dried up when Picasso acquired a real-life mistress. Their reappearance in 1954 need not mean, as Berger speculates, that Picasso experienced his sexual needs as obscene because he was old. They do suggest that, having been abandoned by his mistress, the artist was once again uncertain about his sexual magnetism, just as he had been before he met Fernande Olivier.[25]

Surprisingly, no one has drawn detailed comparisons between the Human Comedy series and the earlier work of Picasso which it most closely resembles, the forty-five etchings from the Vollard Suite known as "The Sculptor's Studio." In both series, the artist addressed himself to the conflict between his creativity and his sexuality. Striking differences in the way he depicts himself in the two series suggest corresponding changes in his self-evaluation and, most likely, his self-esteem. Earlier etchings reveal him as supremely self-assured, with no doubts about his sexual magnetism. The model is invariably totally absorbed in the artist and his world; no matter how much he neglects her for his art, there can be no question concerning her total fidelity to him. In the 1954 drawings, by contrast, even the younger artists appear rather ridiculous and pedantic. In place of the rapt attention which the models of the Vollard Suite display toward the artist, the big, handsome girls who people these late drawings often treat the old men with a kind of amused tolerance. In the Vollard Suite, sexuality is depicted as a force which disrupted the sculptor's creativity. In this late series, the truth seems to be the other way around: art distracts the old man from his problems; he can lose himself in his painting, to regard the model with objectivity. He seems much more single-minded in ignoring her sexuality than in the 1933 series, where the artist often was shown absent-mindedly fondling his mistress while he studied his work. In the 1954 drawings, he sometimes regards the model drily, severely, disapprovingly, like a schoolmaster who must deal with a wayward pupil. This severity suggests that, as an elderly man, Picasso found his sexual needs far more bothersome and distracting than he had earlier.

In the Vollard Suite, the Minotaur served as the sculptor's alter ego, representing his unsublimated sexual drives. In the "Human Comedy," the male protagonist also changes identity frequently, but he now accomplishes this feat by means of exchanging masks with the other characters in the

series. Behind his "new" identity as putto or model, he really remains the same little old man. Gilot recounts that whenever Claude went to visit his father after she had separated from the artist, Picasso took articles of the boy's clothing or "traded" items with him. Gilot viewed this activity as a magical attempt by Picasso to steal some of Claude's youthfulness. It certainly suggests a pretty overt wish to change places with the child, who continued to enjoy his mother's affection. Thus, for the first time in his long life, the artist found himself bested in competition with another male.[26]

Both the photographic evidence and eye-witness accounts indicate that, during the last years of his life, Picasso actually played the mask game alluded to in the "Human Comedy" drawings. He was often photographed as he acted out various roles, from that of charging bull to mincing ballerina, aided by masks and other props. Michel Leiris points out how fundamental to Picasso's life and work the concept of metamorphosis was; he cites the artist's identification with creatures like fauns and minotaurs as instances of this, as well as his creation of sculptures employing found objects, his late variations on paintings by great artists of the past, and so forth. According to Leiris, these mask drawings make fun of Picasso's fascination with metamorphoses. They probably have yet another meaning: they allude to the God-like aspect of the artist as creator. Like God, the artist fashions creatures made in his own image; like God, he participates in the lives and identities of all his creatures. He is the little putto, the beautiful model, the sad clown who observes the tragicomedy of life.[27]

In his depictions of artists, Picasso continues this obsession with fluid, changing identities. If he is everyman, he is every artist, and he gently ridicules them all: the dry old painter peering over his spectacles at the luscious nude model, the pedantic young artist who lacks the fundamental juices for creativity, the homely female painter who could never succeed as a sexual being and who doesn't look as though she possesses the skill to succeed as an artist either. Sometimes, beneath this veil of ridicule, one discerns a more respectful reference to another artist of the past. A few of the figures resemble the painter's father, while others recall Matisse and Renoir. Like Picasso, these two painters were great celebrators of female beauty. Unlike Picasso, however, they both enjoyed serene old ages, despite the serious physical handicaps under which they labored.

The final three drawings of the Human Comedy series present variations on a single theme: a masked, nude model poses before the painter (who wears a disguise, which he removes in the last drawing). In each case, we see the artist's canvas and learn that he has painted not the model but himself. In the last sketch, this painted self-portrait leers out at the "real" artist and the spectator. What better proof could one present to indicate that Picasso realized that, no matter what the outside stimulus, he really always painted himself, his own emotions, his inner world?

Eleven

My Eternal Autumn

Picasso interrupted his Human Comedy series in April 1954 to turn to less painfully personal themes. One cannot determine whether this change resulted from the restorative value of the work itself—the high quality of these drawings must have helped to repair his self-esteem—or from the reappearance of Françoise Gilot, who accompanied her children when they came south to spend the Easter holidays with their father. According to her account, she got along well with Picasso during this period, and he repeatedly begged her to return to him on a new basis, as friend rather than lover, so that she could "help him with his work and continue our conversations on painting which, he said, had become a necessity for him."[1]

With Françoise again beside him, Picasso completed portraits of Claude and Paloma, then began the series of canvases after the beautiful young blonde, Sylvette David. Gilot suggests that Picasso undertook this series partly to arouse her jealousy.[2] She may well be correct, but it seems more difficult to accept her concomitant suggestion that the artist soon lost interest in his self-appointed task. On the contrary, the portraits of Sylvette mark one of the last instances in which Picasso sustained his inspiration throughout a long series of paintings. Moreover, he devised a new type of sculpture for her—the folded, painted metal cut-out which originated as an ongoing part of his variations on Sylvette's head. He fashioned these busts with the aid of a young Plate 7 artisan who translated the master's cardboard maquettes into metal versions, which Picasso then modified and painted. Soon afterward he used this method to create a few similar portraits of Jacqueline, then dropped it till 1960 and after, when it became his dominant sculptural technique.[3]

After Gilot returned to Paris, the lonely artist searched in vain for a motif which would fire his imagination and provide the impetus to start him on a new campaign of painting. He attempted his first variations after Edouard Manet's *Picnic on the Grass,* a painting which would haunt him between 1960 and 1961; but that spring, Manet failed to inspire. Picasso's reinterpretations after a Delacroix self-portrait proved no more rewarding. In fact, nothing bore 223

fruit for Picasso that spring, neither his attempts to initiate a dialogue with these great French predecessors nor his continued search for a new partner who could eradicate his memories of Françoise Gilot. She had promised to return when the children would come to spend the month of July; as the time for their visit approached, Picasso dried up completely. Between the end of June and the beginning of October 1954, he finished only a single work, a drawing. He spent July in an agitated state, entertaining an entourage which included both Françoise and Jacqueline Roque—for the latter had by no means retired from the lists. After Gilot went back to Paris, Picasso continued on an endless round of excursions and parties which left him little time or energy for his art; thus he suffered yet another creative paralysis triggered by the loss of Gilot.[4]

Picasso's final fling died with the summer; when the band of merrymakers who had assembled around him at Perpignan (where he was the houseguest of old friends, the Lazermes) dispersed, the artist surprised everyone by returning meekly to Vallauris with Jacqueline Roque in tow. Or perhaps one should phrase it the other way about, for it appears that it was Jacqueline who scored the triumph. At least eyewitnesses agree that during those last weeks at Perpignan, she clung to him devotedly and submissively, while he treated her with rude disdain.[5] Beneath this surface behavior, a far different drama was evidently taking place. Picasso finally abandoned the struggle, surrendered to his fate, and lived out the remainder of his life as the prize of a woman who tyrannized him through idolatry. In the transition from Gilot to Roque, Picasso had been quite paralyzed. Without a close partnership, he could no longer function at all. Now he embarked on a relationship with a woman whose needs for such a merger matched or exceeded his own. Perhaps Picasso yielded precisely because he understood how needful Jacqueline was. According to Cabanne, earlier in the interlude at Perpignan, she had threatened to commit suicide when Picasso dismissed her following a bitter quarrel. When she returned, unbidden, to the home of his hosts, he had permitted her to remain, although continuing to treat her scornfully. Perhaps he yielded because he now understood the depth of her desperation, the true extent of her needfulness. After all, she was not the first potentially suicidal woman with whom he had dealt. We may measure the seriousness of her threat to destroy herself by the utter devastation with which she reacted to Picasso's death some eighteen years later. For many days, she kept a lonely vigil beside his body until the physical deterioration of his corpse finally forced her to bury his remains. Subsequently she withdrew into what she herself later labeled a "nervous breakdown." When she finally reemerged into society several years later, she posed for the cameras before an enormous photograph of her beloved "master."[6] Between the day when Picasso took her back to Vallauris and the day of his death, Jacqueline lived through Picasso. He became the source of all her satisfactions, her motivation for living, but also the instrument through

which she exacted a fanatical control; like the artist's mother, who had once possessed the most beautiful child in the neighborhood, Jacqueline could claim the world's most famous artist—albeit he was now a geriatric prodigy rather than the *Wunderkind* he had once been.

Picasso settled down at La Galloise with Jacqueline and immediately started to paint again; by November, he had hit full stride once more. Many of the more personalized paintings and drawings he created during those first months with Jacqueline suggest that he continued to experience secret reservations and ambivalences about his new partner. Did he dimly realize that he had embarked on a course which could only culminate in his extreme regression? That may be; at least, it seems interesting that the first work to which he set his hand that autumn was to retouch the commercial engraving of his own early painting, *The Woman of Majorca*. He had created this canvas in 1905, soon after he succeeded in making an independent life for himself in Paris. This image of the Majorcan woman—later incorporated into *The Family of Saltimbanques*—originally seemed to symbolize Spain and the mother he had left behind. Now he had embarked on a path which would lead him, once again, to a child-like state of dependence on a caretaking woman.

Even after a year with Jacqueline, Picasso's art continued to show residuals of his ambivalence. During the autumn of 1955, he turned to a favorite theme: the Bacchic revel, a motif he was wont to interpret during the zenith of a love affair. In this late version, a rather microcephalic-looking giant appears as the hero who carries off a dancing nymph. Once he has abducted her, however, he doesn't seem to know what to do with his prize. On the basis of his previous treatments of this theme, one would anticipate the depiction of scenes of rape or wild lovemaking. Instead, the giant simply sits stupidly, holding the upended girl in his lap. Not until four months later, in March of 1956, did the customary scenes of a couple making love appear, and Picasso by no means brought his usual zest to these depictions. (See Z., XVI, 449 intermittently to 503, and XVII, 37–38.)

Whatever the nature of his private reservations, Jacqueline's place in Picasso's art and life had evidently been secured by the close of 1955, when she appeared in a profile view, wearing a determined expression, in the drawing he made on New Year's Eve (Z., XVI, 525). Early in 1956 he formalized his commitment by moving with Jacqueline to a large villa outside Cannes, La Californie, giving La Galloise over to Françoise and the children; thus he followed his traditional custom of shedding his old surroundings with his old relationship. The remainder of Picasso's oeuvre, all the art he completed between the beginning of 1956 and the day of his death, a little over seventeen years later, bears the indelible stamp of this relationship. Posterity alone can decide whether Jacqueline exerted a constructive influence on the aged master. Blind adoration, however, seldom produces clear-sighted

The Women of Algiers (after Dela-
croix), February 14, 1955, oil on can-
vas, 114 x 146 cm. Collection of Mr.
and Mrs. Victor Ganz. Photograph
by Eric Pollitzer

self-appraisal in the venerated object, and my own opinion is that Jacqueline
unwittingly exercised a negative influence on Picasso's final years, an influ-
ence which contributed to the inferior quality of so much of his late oeuvre.

In the light of its extreme repetitiousness, it seems pointless to subject
Picasso's late art to the same intense psychological scrutiny directed at his
earlier production. Moreover, owing to the isolation in which he spent these
years, we often lack the detailed information about his life which might
reveal the special significance of such prominent themes as the musketeer.
With the passage of the years, Jacqueline exerted increasing control over
Picasso's contacts with the outside world, providing a serene but bland environ-
ment conducive to nearly uninterrupted productivity, yet quite lacking in the
dramatic incidents which might have fired his passion—and his imagination.
Eventually, not only the artist's ex-mistresses, but his three illegitimate children
were denied all access to him. Finally this ban was extended to include even his
grandchildren, the offspring of his legitimate son, Paulo.[7] Perhaps all these
exclusions occurred with the artist's blessing or even at his instigation; none-
theless, the result was that Jacqueline wielded a much stronger influence, and
her control became quite absolute following their marriage in 1961. Subse-
quently, no one gained access to the artist who did not first win Jacqueline's
approval, a fact which may help to account for the unrealistic flattery which
cloaks so much of the prose written about the Picassos during this phase of his
life.

During his first years with Jacqueline, Picasso directed much of his energy
and effort toward the reconsideration of great masterpieces from the history
of painting. Earlier in his career, he had often created a variation or two on a
famous canvas, such as his reinterpretation of Courbet's *Young Women on
the Banks of the Seine,* but he had never before devoted himself to the art
of the past with the singlemindedness he demonstrated between 1954 and
1962.

The death of Matisse apparently acted as the catalyst which originally set
Picasso on this new course. During the French artist's last years, he and
Picasso had established close affectionate and artistic ties. Matisse was so
unfailingly gracious and courteous that the wary Picasso even felt comfortable
enough to bring his latest pictures to show the French master, and the two
spent long hours discussing art.[8] Matisse was too elderly, too infirm, and
probably too famous to function as a full-fledged understander, but he as-
sumed many aspects of that role for Picasso. His death must have been a
terrible blow, and Picasso refused even to go to the telephone when Matisse's
daughter repeatedly called him in a vain attempt to inform him of the funeral
arrangements.[9] He neither attended these services nor mourned in the con-
ventional manner. Rather, he forestalled his grief by a magical identification
mechanism—he began to paint in the manner of Matisse. As his vehicle for
this venture, Picasso chose Eugene Delacroix's *Women of Algiers,* which he

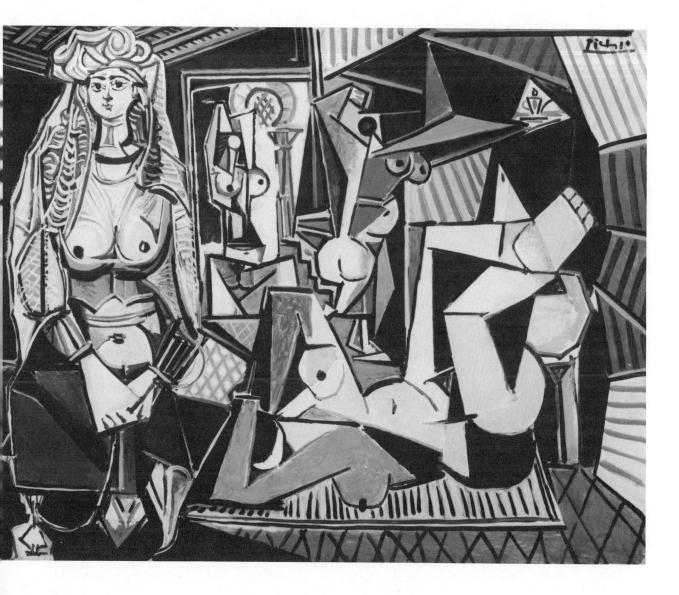

reinterpreted fifteen times, substituting the bright colors and bold patterns of Matisse for the more subtle characteristics of the original, while adding a running commentary of his own as he subjected the figures and their settings to neocubist readjustments. The close resemblance which joins Picasso's Algerians to Matisse's odalisques was immediately obvious to everyone; Picasso himself clearly understood this connection, for he confided to Penrose, "When Matisse died, he left his odalisques to me as a legacy."[10]

Although the creation of his series of Algerians undoubtedly comforted Picasso, insulating him from his bereavement, few critics outside his intimate circle have considered these canvases worthy to rank beside his major paintings. Even John Lucas, more enthusiastic than most about Picasso's late oeuvre, admits that the variations contain no masterpieces. For Blunt, they represent the onset of "a certain dilution of imaginative powers and a certain monotony of ideas under the apparent variety." The most significant favorable assessment came from Leo Steinberg, whose charming essay, "The Algerian Women and Picasso at Large," seems more inventive than the paintings it praises.[11]

Picasso followed his variations after Delacroix with a group of canvases which more accurately capture the flavor of Matisse's art, perhaps because they did not derive from any set prototype but grew, instead, from Picasso's meditations on a favorite motif of Matisse: the artist's studio. Picasso began these canvases early in 1955, soon after Jacqueline and he had moved to La Californie, an art-nouveau villa with extravagant decorative detailing and grand interior spaces. Ensconced in an enormous new atelier there, Picasso created a series of canvases providing a simultaneous view of his studio and the villa's park-like setting framed in the elaborate leaf-shaped windows and door panels of its rooms. The vista, with its lush tropical plantings, could scarcely compete with the simultaneous glimpse the painter provided of the splendid disorder prevailing within his atelier, where he had already produced the state of planned chaos which he required in order to function. In several of the canvases, one observes Jacqueline, proudly presiding over this cluttered kingdom, immobile and decorative as a statue. In further adaptations of the studio motif, Picasso experimented with devices designed to tame both the indoor and the outdoor views, fitting the play of the palm trees' branches more tightly into the shape of the window moldings, while simultaneously simplifying and ordering the conglomeration within his studio.

The brilliance with which Picasso handled the studio theme—never before a major preoccupation for him—suggests that his magical identification with Matisse had reached its zenith. This emulation affected the formal elements of Picasso's art even more profoundly than its content: the lyrical rhythms, bright colors, bold patterns, and above all, the careful control which he exercised over these compositions—all these features testify to the potency of his identification with Matisse.

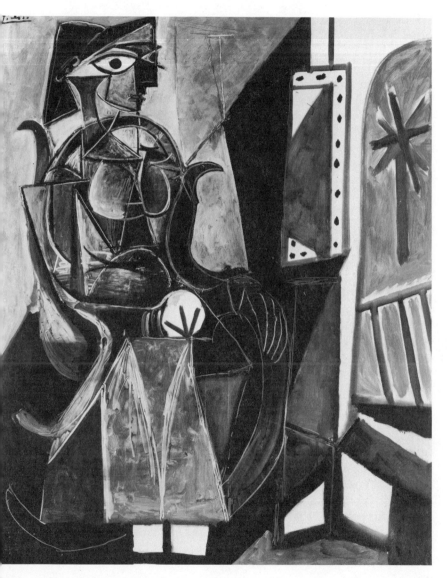

Woman by a Window, June 11, 1956, oil on canvas, 161.9 x 130.2 cm. The Museum of Modern Art, New York. Mrs. Simon Guggenheim Fund

Picasso continued his homage to Matisse through the closing months of 1955, when he painted nine different versions of Jacqueline in a Turkish costume, a notion again derived from the odalisques of Matisse (Z., XVI, 528–35). Unlike the exotic voluptuaries who appear in the French master's canvases, Picasso's model seems uncomfortable with her assumed role of Oriental sex symbol. A charming canvas which shows her nude except for an absurd little turban seems especially amusing for the contrast between her garb—or rather lack of it—and her tense posture and expression. This characteristic expression may have reflected physical rather than psychological unease, however, for Richardson notes that Jacqueline was in ill-health from the time she met Picasso until 1957 or 1958, "hence the numerous portraits in which her features are twisted into a grimace of suffering."[12] A pair of ribald sketches which Picasso executed several years later (Z., XIX, 107, 109)—one shows a physician listening gravely through his stethoscope, its diaphragm inserted into a nude female's rectum; the other depicts his victim holding her smarting rear—suggests that Jacqueline's disorder may have been intestinal. The amused attitude implicit in these sketches also indicates that Picasso may have taken his mate's health problems far more lightly than he ever treated his own bodily symptoms.

After Picasso completed his set of odalisques, the power of Matisse's influence seemed to wane, yet no new idea compelled Picasso's interest, and his inspiration flagged for the next twenty months, though he continued to produce with his usual diligence. He turned once again to the theme of the painter's studio, which had proven so successful a few months earlier. This time he featured Jacqueline and her ubiquitous bentwood rocker as a more prominent element, but these pictures by no means match the robust vigor of the previous set. Gradually, his focus changed from the studio setting to Jacqueline and her large dark eyes. In a series of ink drawings, which apparently owe less to memories of Matisse than to archaizing reminiscences of Cretan frescoes, Picasso portrayed his model in profile view with an enormous frontal eye. Sometimes this eye not only gazes at the canvas shown on the painter's easel but actually merges with it physically. Gradually, the orb becomes more and more enormous until it finally dominates Jacqueline's simplified body and, ultimately, the entire studio (Z., XVII, 110–17).

Admiring intimates have all described how Jacqueline loved to sit at Picasso's side for hours on end, watching with silent devotion while he painted. These sketches may reflect another aspect of the situation: the artist's underlying resentment over such a wholesale invasion of his privacy. He probably invited Jacqueline to watch him work, but he may have seethed inwardly about her intrusiveness all the same. Both Gilot and Perls describe incidents in which Jacqueline spied from a secret hiding place during meetings each held with the artist. The Perls interview literally terminated with a bang when Jacqueline burst forth from her hiding place exploding with rage because Perls had

asked Picasso to sign a group of works belonging to the impoverished Marie-Thérèse Walter, so that they would be more salable.[13] Many of the 347 etchings the artist created during 1968 also allude to the theme of secret peeking and voyeurism. Such motifs undoubtedly have complex sources, but on one level they may also refer to Jacqueline's practice of keeping Picasso under constant surveillance.

Perhaps because he realized he had arrived at a minor impasse in his work, Picasso now turned once again to sculpture to execute a group of bathers originally made from odds and ends of lumber but later transformed into bronze. The large scale of these figures—the biggest is nearly nine feet tall—contrasts strangely with their rather frivolous, even empty, character. Jean Sutherland Boggs, responding to this quality, comments that one would consider the pieces something of a lark, were it not clear from the detailed studies for them "that Picasso took the sculptures very seriously and, from one drawing of the circular-faced figure [the child] struggling to avoid drowning, that he saw the work as a grave commentary on survival." (Z., XVII, 159–74)[14]

Picasso carried over this motif of the bathing figures, as well as the underlying preoccupation with survival, into the big public commission he completed early in 1958, the mural for the UNESCO headquarters in Paris. The enormous scale this project demanded temporarily defeated the elderly painter, until he devised a solution which obviated the need for the scaffolding which he considered himself too old to mount: he divided the mural into forty panels, which he painted in small groups; the entire mural was assembled in situ after it was completed. Although he did not finish this project until 1958, it shows the strongest affinity with *The Bathers;* both share the same pessimism as well as the preoccupation with drowning. The motif of the mural, the fall of Icarus, can scarcely be considered a happy one at best. As Boggs again notes, however, Picasso chose to emphasize the innate pessimism of the story by portraying "a dessicated Icarus, already a white skeleton," as he plunges into the sea off Cannes, "a victim of hubris and imagination." She suggests that this theme seems a particularly cynical choice to represent "an organization with the hopes of UNESCO in the 1950s."[15]

Picasso's choice of this particular motif surely must also have had deeply personal connotations. Icarus, after all, is the prototype of the lad too big for his britches, the youth who refuses to heed his father's good advice and suffers a fatal failure as a consequence. Picasso must have felt that his own aim exceeded his grasp in this ambitious UNESCO project, a prescient reading of the critical and popular reaction which greeted the mural when it was unveiled. Indeed, this was but one of a series of humiliating artistic failures he suffered during the last twenty-five years of his life when, like his Icarus, Picasso began to seem a burnt-out, ghostly skeleton of his once robust genius.

The subject Picasso selected next may have represented his attempt to find an antidote for this negative self-assessment, for he immersed himself in a

painting intimately associated with the bright promise of his youth and posi-
tive memories of his own father: the *Las meninas* of Diego Velazquez. Before
he embarked on his long series of variations after this masterpiece, Picasso
created a special studio for the project in a hitherto unused space at La Cali-
fornie, an enormous room at the top of the chateau which opened onto the
dovecotes he had established there and revealed a magnificent view of the
bay of Cannes. Once settled in his new quarters, Picasso started off boldly;
without making any preliminary drawings, he executed forty-four variations
after *Las meninas* between August 20 and November 17, 1957, when he
terminated with a flourish, dashing off the final six oils of the set in a single
day. On December 30, he added yet another postscript canvas to round out
the set and the year (Z., XXVII, 351–93, 404).

Only eight of Picasso's forty-five canvases reproduce the entire cast of
characters from Velazquez' original canvas. For the most part, Picasso con-
centrated on paintings representing a single figure from the original, chiefly
the little Infanta, who particularly fascinated him, perhaps as much because of
her age (she appears to be about four or five) as her pivotal role in the original
work. Fourteen of the canvases portray the little princess, whose form and
face the artist subjected to an amazing series of metamorphoses.

Many critics have suggested that Picasso might have been particularly at-
tracted to the Delacroix and Velazquez masterpieces because both present an
ambiguous situation which the spectator must resolve for himself. In the case
of the Velazquez, this mystery is heightened by the painter's action in including
himself in his canvas. Indeed, his action, his role, even the actual subject of
his painting presents an intriguing enigma. In those variations in which he
included the entire cast of characters, Picasso addressed himself to these
ambiguities. Thus, in his first variation, he made the space seem almost end-
less, like the vistas in certain early Italian Renaissance altarpieces. In another,
he substituted vertical Oriental spatial devices for Velazquez's subtle illu-
sionism (Z., XVII, 372). Picasso also rearranged Velazquez's personae, mov-
ing them about in a manner which altered their psychological and physical
interrelationships. The Baroque master's dusky, velvety light also fascinated
Picasso, and in his initial variation, he opened Velazquez's tall shutters, flood-
ing his interior with a bright, even light. In yet another canvas, Picasso
treated both figures and setting as though all had been fashioned of stained
glass, then set it aglow with light (Z., XVII, 374). He conducted other
experiments with Velazquez's subtle color schemes. At one extreme, the
modern master removed all color, to render *Las meninas* as a grisaille; at the
other, he substituted a palette featuring deep, saturated colors far more insistent
than the muted tones of Velazquez.

Picasso also extended his space-and-color experiments to the canvases which
involve single figures or small groups of figures. In several of the latter varia-
tions, the personages appear as simplified brilliant green or yellow shapes—

sometimes they are even reduced to a series of line-connected dots on a lipstick-red ground. These paintings, vaguely reminiscent of such Matisse canvases as *The Red Studio,* suggest that Picasso's lingering identification with Matisse occasionally invaded his meditations on the art of Velazquez.

Picasso's long *Las meninas* series contains many delightful canvases, bright, witty pictures which invite the spectator to participate in a three-way dialogue with the original painter and his twentieth-century reinterpreter. Nonetheless, it is difficult to disagree with Boggs, who maintains that Velazquez emerges remarkably unscathed from the series of Alice in Wonderland trials to which Picasso subjects the artist and his masterpiece.[16] The real questions then become: What benefits did Picasso himself derive from creating these paintings? What private meaning did this long exercise have for him? Many critics have concluded that Picasso's attitude as the copyist of Velazquez was disrespectful, if not downright hostile. Even Penrose, Picasso's intimate friend, speaks of his ruthless parody of Velazquez. Berger compares Picasso's actions to that of a thief who honors Velazquez while robbing him, while Lucie-Smith, even more vehement, likens Picasso's handiworks to a series of rapes or dismemberments which show his hostility to the great achievements of the past.[17]

If one examines Picasso's history carefully, these speculations seem unconvincing. During World War I, when fate simultaneously deprived him of his beloved mistress and his closest friends, the artist successfully restored himself by an immersion in the art of Ingres. In 1954, after he lost Matisse, Picasso assumed aspects of the French master's identity; in fact, in another marvelous illustration of psychic economy, Picasso effected a two-for-the-price-of-one merger with both Delacroix and Matisse, simultaneously incorporating elements derived from both painters into his variations on the *Women of Algiers.*

His reinterpretation of *Las meninas* also involved a double identification: a reunion simultaneously effected both with Velazquez and with his own father, Don José. Berger recognized this phenomenon but perceived it as an indication of Picasso's remorse or guilt: "In his own painting, Velazquez is so effortlessly himself, and in Picasso's painting he is so overwhelmingly large, that he might be a father. It may be that as an old man Picasso here returns as a prodigal to give back the palette and brushes he had acquired too easily at the age of fourteen."[18]

Surely Picasso did not show Velazquez as a giant in reparation for taking his father's paint brushes; that incident probably belongs to the realm of myth, anyway. Rather, his giganticized rendition of Velazquez probably should be recognized as a very literal statement: Velazquez *was* a giant among painters, possibly the most famous artist in Spanish history. Moreover, Picasso's father had introduced his son to *Las meninas* personally during the course of the fourteen-year-old boy's initial visit to the Prado museum. What could be more natural than Picasso's choice of this painting as the vehicle through which he

Los pichones (number 23), September 11, 1957, oil on canvas, 129 x 97 cm. Museo Picasso, Barcelona. © SPADEM, Paris / VAGA, New York

renewed his partnership with his first understander and teacher, his father? The fact that the artist chose a pigeon-loft studio as the setting for this dialogue constitutes further proof of the intimate association he had established between this painting and memories of Don José. After Picasso finished his first seventeen variations on *Las meninas,* he interrupted the series to treat another theme: eight views of the dovecotes at La Californie and their inhabitants. One of his fondest childhood memories concerned a similar canvas his father had painted, that picture which the artist recalled as so much larger and more splendid than the reality that Sabartés dubbed the painting the dovecote of Picasso's childhood illusions.[19] When Picasso donated the entire series of *Las meninas* reinterpretations to the Museo Picasso in Barcelona—a gift which formed part of the bequest the artist made in memory of Sabartés—he included these canvases of the dovecotes, another certain indication that he considered this motif part and parcel of his response to Velazquez.

According to my hypothesis, Picasso's variations after Delacroix, Velazquez, and the others revealed neither hostility nor invidiousness, but loneliness, the nostalgia for lost relationships which the artist simulated by creating painted links to the great artists of the past. Hélène Parmelin, a member of Picasso's intimate circle during this period, provides ample evidence that while he created his variations after these great artists, they became, for all practical purposes, living members of Picasso's household. She observes:

> Picasso often says that when he paints, all the painters are with him in his studio. Or rather behind him. And they are watching him. Yesterday's and today's. Velazquez never left him the whole time he painted *The Maids of Honor.* Delacroix had his eye on him while he was doing all the *Women of Algiers.* And he wondered what Delacroix thought, whether he was pleased or not. . . . A solitary painter is never alone.[20]

The reinterpretations of these great masterpieces may have served yet another function for Picasso: they may have helped to reassure him concerning the value and permanence of his own work. In 1946 Picasso had presented several important paintings to the French state. Before they went to their permanent home in what is now the Musée Pompidou, Georges Halles, then the director of the Louvre, had them hung in the great galleries of that museum, first among the French masters—including Delacroix—then in the Spanish galleries,

where they could be seen beside Goya, Velazquez, and Zurbaran. Picasso was even more worried this time as his pictures were placed beside the work of his countrymen, but they again held their own through the vigor of their execution and the reality of the life they contain. Having regained his confidence, he repeated excitedly, "You see it's the same thing! It's the same thing!"

Perhaps as Picasso painted his variations after the *Women of Algiers* and *Las meninas,* Delacroix and Velazquez stood beside him whispering, "You see it's the same thing."[21]

Picasso's passion for masterpieces of the past culminated in a prolonged dialogue with Edouard Manet and his *Picnic on the Grass,* a dialogue which extended over many years and eventually involved variations in several media: paintings, drawings, sculptures, and graphics. Picasso created his initial commentaries on this painting in 1954, when he made 4 drawings after it. He returned to the picture again in 1959, when he added a series of drawings directly derived from it (Z., XXIX, 35–43), as well as numerous pictures of bathers examining their toes, and other nudes that seemed intimately related to the Manet canvas. One of the most successful of these, the large-scale painting *Nude beneath a Pine Tree,* portrays an enormous, recumbent female; her artfully contorted posture enables her to display every aspect of her anatomy —front, back, and sides—simultaneously, without appearing to disconcert herself in the least.

Plate 8

In 1960–61 Picasso renewed his obsessive interest in the *Déjeuner,* and his painted and drawn commentaries about it occupy most of Zervos's volume XX. In 1962 Picasso created another 92 drawings after the painting. Douglas Cooper's *Pablo Picasso: Les Déjeuners* appeared that year, and its publication may well have stimulated Picasso to add to his *Picnic* progeny. Also, many of his seemingly independent creations from these years probably grew out of his meditations on the Manet canvas, or were later incorporated into the variations after it. For example, both the blowsy nudes intently studying their toes in those 1959 drawings and the protagonists who people a series of watched-sleeper drawings from the same year subsequently reappeared among the personae of the artist's *Picnic* variations.

No matter how one attempts to sort them, Picasso's *Picnic* adaptations do not readily lend themselves to a tidy, logical reconstruction enabling the spectator to recreate the sequence of ideas which gave rise to this enormous oeuvre. Lucie-Smith has compared Picasso's activity as the copyist of Delacroix and Velazquez to a kind of "unpacking process" in which the artist holds up various ideas or qualities from the original for our inspection while adding comments of his own.[22] Lucie-Smith's choice of the term "unpacking process" implies a certain type of orderly procedure; indeed, one can readily retrace the sequence of Picasso's ideas about these pictures, the problems he set himself to solve in his adaptations, as Leo Steinberg demonstrates in his essay devoted to the *Women of Algiers.* In contrast, Picasso's associations to the Manet picture seem to have tumbled out in a disorderly melee which defeats the spectator's attempts to effect a similar reconstruction of their etiology. Cooper suggests in his introduction to *Les Déjeuners* that one can subdivide Picasso's variations into four major categories: the Country Outing, the Baignade, the Nocturnal Excursion, and the Classical Ideal.[23] Although such categories may help the

viewer to order his sensations, they contribute little toward explaining the genesis and sequence of Picasso's obsessive fascination with this painting. Indeed, it would seem as difficult to uncover the core of his motivation as it is to force a logical pattern of evolution on the resulting opus. Cooper hypothesizes that Picasso was attracted to this picture because it permitted him to explore the spatial problems inherent in depicting figures in a landscape setting.[24] Manet's masterpiece certainly reveals ambiguities both in figure-ground integration and in the depiction of depth and aerial perspective. Whether these deviations on Manet's part were deliberate or inadvertent—an issue which seems far from settled—they may well have intrigued Picasso, whose cubist inventions rested on foundations which Manet helped to establish. This type of intellectual interest, however, seems insufficient to explain the artist's prolonged commitment to reconsiderations of Manet's painting.

Nor does Cooper's suggestion that Manet's painting presented Picasso with the opportunity to include characters from his own repertoire in new and challenging combinations with those of Manet entirely convince.[25] In fact, the truth appears to be the other way around: Picasso arbitrarily imposed his own phantasies on Manet's canvas, introducing characters who grew out of his quite private, personal associations to this picture, as when he substituted an elderly male artist resembling himself for the figure originally modeled on Manet's brother Eugène (Z., XX, 122, 126). Did Picasso arrive at this conception because Eugène, posed with his right hand raised as he gestures, recalled to the elderly artist the movement a painter makes while he paints, which led him, in turn, to associate to himself, the little old artist? Another substitution replaced the nude form of Victorine Meurand with a figure wittily parodying the *Grande odalisque* of Ingres, another great French celebrator of female beauty, and another instance, apparently, of Picasso's loose associative processes.

Although Cooper views such juxtapositions as challenges which Picasso issued to all the great artists of the French school from Poussin to the present, Daix drew a very different conclusion about the meaning of these interpolations:

In the last analysis, Picasso is conducting the dialogue with himself and with his whole world, assembled in the clearing which Manet has substituted for the open landscape of Giorgione. In any case, the plastic discussion which dominates the series of the *Women of Algiers* and *Las Meninas* seems to have been settled here right from the start. Picasso presents the adventure in his own language, and when he changes his language, when he returns to a more classic mode of expression, it is for reasons of his own and associations which have little to do with Manet. It is easy to imagine the various versions of *Las Meninas* assembled in a gallery. I believe that the *Déjeuners* will survive in every way, also in the form of a creative diary—a new kind of alliance between painting and printed book which is made possible by modern techniques, and which allows us to follow step by step the discussions and struggles of the painter.[26]

Daix greatly admired Picasso's art, and he undoubtedly intended this commentary as a positive assessment; nonetheless, it suggests a distressing vision of the aged artist trapped by his own uncontrolled facility into the creation of a vast, body of art which has little enough to do with Manet, let alone the entire history of French painting!

Perhaps the secret of Picasso's preoccupation with Manet lies in the latter's weaknesses rather than his strengths, the difficulties over which he triumphed to secure his position as the first modern artist. Particularly during the early phases of his career, Manet apparently experienced problems in inventing compositions, a difficulty which also plagued the aged Picasso. Like Picasso, Manet often turned to the great masters of the past for inspiration; he particularly admired the leading Spanish painters, Velazquez above all others. For his *Picnic,* Manet looked more deeply into the history of art, turning to the bright noonday of Venetian painting and combining ideas derived from Giorgione (or Titian?) with motifs culled from Raphael and ancient art. Thus equipped, Manet created one of the great monuments of the history of art. Perhaps Picasso believed that, as they worked together on *Picnic,* Manet would impart his secret for transforming weaknesses into strengths. If so, Picasso was doomed to disappointment; Manet maintained his silence, and no new masterpieces flowed from Picasso's brush during the course of his almost interminable variations after *Picnic.*

Another, still more personal reaction may have drawn him to the Manet painting, which became a tabula rasa upon which Picasso projected his very private phantasies. Boggs, apparently cognizant of such implications, notes that, during the so-called nocturnal variations, the artist substitutes Jacqueline and himself for Victorine and Eugène, then subjects their bodies to strange transformations: as the one shrinks, the other expands. "The *Causeur* [Cooper's term for the figure modeled after Picasso] shrinks in the final oil to an appropriate green shadow while across [from him] . . . sits the figure of Jacqueline predatorily in command."[27] Did the image of Victorine as Manet created her, so cool, bold, and self-possessed, somehow remind Picasso of Jacqueline, who reigned over his world just as the image of Victorine dominates Manet's canvas? Many of the pictures Picasso created during the final years of his life depict explicitly exhibitionistic nudes calmly confronting small, anxious males who pay them obeisance. The ambiguity which may really have proven crucial in attracting Picasso to this picture may have been precisely the ambiguity of Victorine's role vis-à-vis both her male cohorts and the spectator. The size transformations which Picasso portrays recall once again his childhood memories of the aunt with the strangely swollen limbs, a recollection which also colored his paintings from 1920–21 when he created the race of microcephalic giantesses modeled after his pregnant wife. Did Jacqueline share a fundamental trait with Olga, one which may also have characterized Picasso's mother: a fearful tenacity before which the artist felt himself dissolve like the green

shadow into which he transforms his *Causeur*? Such highly private associative trains may well have helped to determine Picasso's prolonged fascination with Manet's *Picnic on the Grass*.

After he finally extricated himself from this preoccupation, Picasso never again attempted a prolonged dialogue with a great painter of the past. He executed brief series of variations after paintings by Poussin, Rembrandt, and others, but he terminated all these sets quickly, after limited experimentation. Nearly every picture he would create during the final decade of his life referred to the art of the past, his own as well as that of others, but he seldom based these compositions on specific paintings. For example, the extensive series of cavaliers and musketeers which he invented between 1966 and 1972 all wear costumes reminiscent of those affected by the gentry peopling the canvases of Rembrandt or Velazquez, but they do not seem to derive from specific portraits by either of these artists. Did Picasso fear that if he became engrossed in another round of variations on a particular painting he might never extricate himself from the treadmill of his sticky associative processes? Whether he consciously experienced such anxiety or not, the danger appears to have been real enough, and he wisely avoided it.

The most original works Picasso completed during the years of his obsession with *Picnic* grew out of his renewed interest in the bullfights. He recorded his impressions and associations to this ritual in several series of powerful sketches. Many of these impressions later became the basis for lithographs, linocuts, ceramic plates, and the like. He even invented a sort of picador's version of the Human Comedy, depicting his bullfighter hero in a variety of situations, especially romantic encounters. The picador, young and virile, never seems disadvantaged in his relationships with women, unlike the little old men Picasso depicted during these same years, grinning nervously in their confrontations with powerful females (Z., XIX, 19, 108). In fact, women of all ages and stations seem intent on the bullfighter's seduction, but he remains impervious to their charms. Picasso produced this series while he enjoyed a close friendship with the famous matador Luis Dominguin and his beautiful wife, and the handsome Dominguin probably inspired this series in which he appears as hero, thinly disguised as a picador rather than a matador. A few years later, urged on by Picasso and aided by Georges Boudaille, Dominguin wrote the prefatory text accompanying the publication of these drawings under the title *Bulls and Bullfighters*.

The bullfight sketches of the highest artistic quality were dashed off one day in the spring of 1959 (Z., XVIII, 336–59). While executing a series of studies of the matador sweeping his cape before the bull, Picasso suddenly merged this theme with that of the crucified Christ. Jesus, his left arm miraculously freed from the cross, employs his loincloth to shield the bullfighter and his gored horse from the enraged bull (Z., XVIII, 352). Earlier in his career, Picasso had created crucifixion imagery only during periods of intense personal

conflict and anxiety, but there is nothing to indicate that he felt particularly upset at the time he invented this Christ who, unlike the artist's earlier expressionistic Savior figures, is a beautiful, Renaissance-tradition Deity. Later that same day, Picasso portrayed Jacqueline as Our Lady of Sorrows. Complete with glistening tears and the seven swords of sorrow piercing her heart, she is the most Spanish of Virgins (Z., XVIII, 338).

Blunt considered these drawings "among the few works executed by Picasso in the last ten years in which the imaginative power and intensity of *Guernica* are for a moment recaptured."[28] Despite their compelling power and beauty, these sketches again reveal the aged artist as the victim of his own uncontrolled associative processes, associations in which the bullfighter equals besieged mankind, who equals Christ, who, in turn, recalls the Madonna of the passion, the Mother of Sorrows. But where is Picasso in this whole train of ideas? He has left the center of the arena. In contrast to all his earlier representations of the bull ritual, in which he always assumed the leading role himself via his alter ego, the bull or Minotaur, he has become once again, as in his childhood, the passive peripheral figure who merely observes and records the exploits of the heroic matador.

The uncontrolled nature of his flow of ideas is further suggested by the drawings Picasso made next. Right after he had depicted Jacqueline as the Madonna, he portrayed her as a baroque equestrienne on a spirited horse, an ensemble which seems straight out of Velazquez (Z., XVIII, 360–67). He inscribed the most beautiful of these drawings "Jacqueline Reine." Did his image of the Virgin, the Queen of Heaven, lead Picasso to recall earthly queens? Or did the bullfight stimulate recollections of his father, who in turn brought Velazquez to mind? Some such ideational train seems to have been involved in the genesis of these drawings.

Perhaps Picasso also created so many flattering images of Jacqueline at that time because he felt discomforted, even guilty over recent nostalgic reminiscences of Dora Maar. At least, that sequence of ideas is suggested by the still-life paintings which he completed immediately after the bullfight group. These pictures depict the pitcher with a characteristic painted design which he had so often employed during the late thirties as a symbol for Dora Maar. Now he showed the pitcher in company with a stringed instrument hanging from a nail in a peculiar manner suggestive of tension. Midway in this series, Picasso suddenly inserted Jacqueline's head where the instrument had appeared, suggesting that the latter was, in part, a symbol for her. These pictures may reflect the surge of feeling for Dora which Picasso experienced while making the arrangements for the erection of a monument honoring Guillaume Apollinaire. Finally unveiled on June 5, 1959, it utilizes a bronze bust of Dora Maar cast from the plaster original which Picasso had fashioned in 1941. Although Dora had discreetly withdrawn from Picasso's life long before he met Jacqueline, she was still alive and he surely must have received occa-

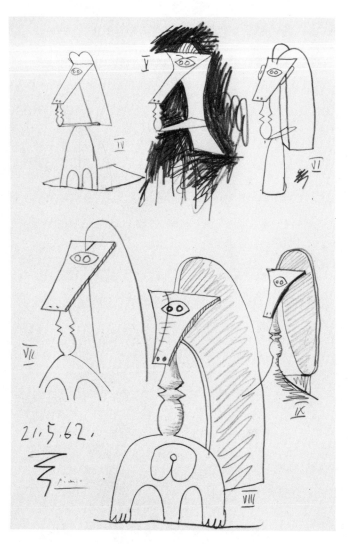

Sheet of studies for the *Chicago Picasso,* 1962, pencil, 41.7 x 27 cm. The Art Institute of Chicago. Gift of William E. Hartmann

Study for the *Chicago Picasso*, January 28, 1964, pencil, 26.8 x 20.8 cm. The Art Institute of Chicago. Gift of the artist

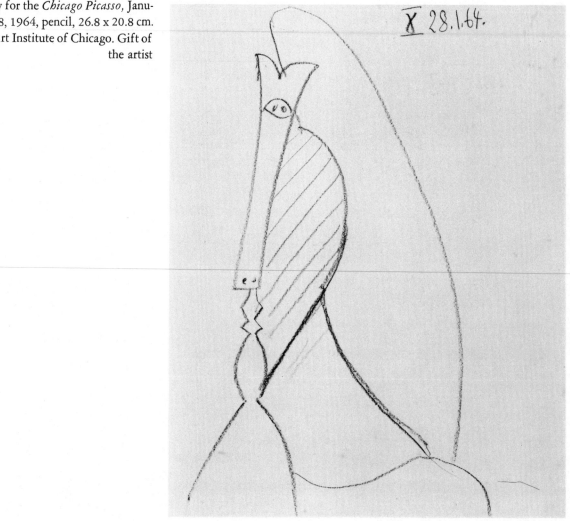

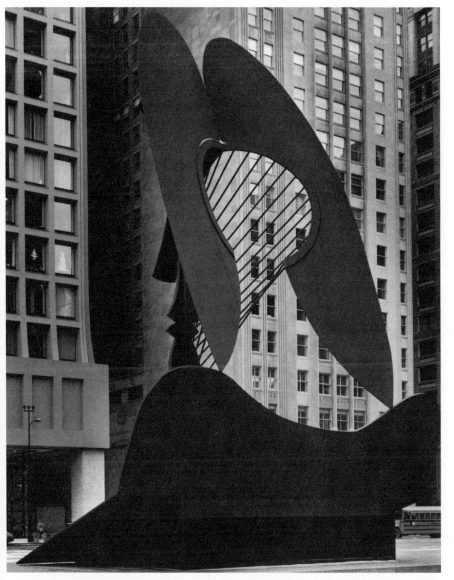

Chicago Picasso (Chicago Civic Center Monument), dedicated August 15, 1967, corten steel, 15.24 m tall. Photograph by Carol Ann Nishiura

Woman in an Armchair, 1961–62, oil on canvas, 162.2 x 129.9 cm. Private collection, New York

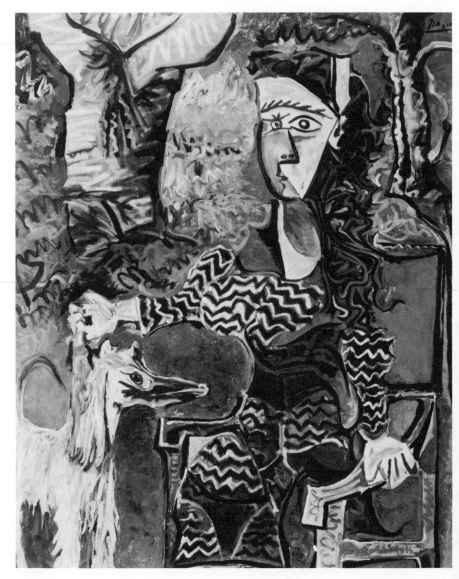

sional intelligences concerning her from mutual friends, like Aragon. Picasso may well have missed the stimulating intellectual exchanges he had enjoyed with Dora, exchanges which do not seem to have been so prominent a feature of life with Jacqueline.

On March 2, 1961, Picasso married Jacqueline Roque; he celebrated the event by presenting her with the deed to the château of Notre Dame de Vie outside Mougins, thereby continuing his established tradition of demarcating every important change in his life with a change of residences. He retained the other two châteaux he had acquired since 1954, converting them into warehouses for his personal collection of art (prior to moving to Mougins, the Picassos had lived briefly at the Villa Vauvenargues in Provence, but they found the climate there too harsh). Just before their marriage, the artist painted a flattering portrait of Jacqueline, soft, youthful, and veiled, in a reprise of Raphael's *La Donna Velata* (Z., XIX, 437). After the wedding, he composed a series of "official" family portraits in which he posed Jacqueline, her daughter, and an adolescent friend of the latter in the stiff manner fashionable in the daguerreotypes in vogue during Picasso's childhood (Z., XIX, 463, 464, 466).

Following their marriage and the move to Mougins, the Picassos lived an extremely quiet, private life, hermetically sealed off from the outside world by an elaborate security system which included guard dogs and electronic gates. In this protected environment, Picasso spent the final decade of his life. He remained remarkably productive as a draftsman, painter, and printmaker, but after 1964 he created no new sculptures, perhaps because his physical frailty made such labors too difficult. During these years, however, many of his earlier sculptures of 1954–64 were transformed into large-scale monuments, thus fulfilling his old dream of creating vast public sculptures, a dream to which he had given expression in paintings of 1929 depicting enormous monuments he wished to create poised before equally imaginary buildings.[29]

The *Chicago Picasso* remains the most famous of the large-scale sculptures which the artist actually realized, and its fame is fully justified. He began his first preparatory drawings for this monumental work in 1962 (Z., XX, 233–45), and he continued to participate actively in every later stage of the sculpture's development, working with William Hartman, the architectural consultant from Skidmore, Owings and Merrill, in planning the exact scale and location of the piece in the Daley Center Plaza, where it echoes against a severe Miesian building constructed of the same rust-colored steel as the monument itself.

Like so many of the artist's creations, the *Chicago Picasso* seems to have originated as a magical metamorphosis; in this case he fused the muzzle of his Afghan hound, Kaboul, with the features of his wife, Jacqueline. Earlier analogues for this transformation can be found in paintings of the late thirties which depict a similar merger between the face of his mistress, Dora Maar,

and that of an earlier Afghan, Kasbec. The *Chicago Picasso,* fruit of this synthesis, is a marvelous hybrid: at once feminine and canine, it derives its power not only from the varied visions it provides as one strolls around it, but also from the perfect ratio which exists between its size and that of its companion building, and from the subtle play between void and solid, transparent and opaque, which characterizes both structures and their interrelationships.

Despite Jacqueline's fierce protectiveness, grim reality occasionally managed to intrude upon the artist's insulated existence at Mougins and stay his hand, interrupting that long series of lacklustre pictures he produced so prodigally during his final years. In the autumn of 1964 the original English-language version of Françoise Gilot's *Life with Picasso* appeared. When the French, German, and Spanish editions followed early in 1965, Picasso erupted with agony and rage, an eruption which may well have been fed by Jacqueline's indignation—for the book presented an assessment of her character and behavior by no means flattering. Urged on by family and friends, Picasso sued to stop the distribution of Gilot's book; this lengthy, frustrating, and, ultimately futile procedure occupied all of his energy and attention, so that he created nothing in 1965 after April 30. Thus the aged artist suffered his penultimate creative paralysis; once more, Gilot had served as the catalyst to trigger this reaction.

Few content clues—aside from this hiatus in his production—serve to mark the rising level of Picasso's fury toward Gilot. A handful of paintings he produced in January 1965 seems to be the sole index of his attitude toward his ex-mistress. They feature a female cat grinning in ferocious anticipation as she stalks a group of shell fish (Z., XXV, 9, 10, 12–15). As the cat gingerly stalks her prey, the crustaceans silently menace her with raised claws, much as the artist himself must have longed to inflict reciprocal damage on Françoise for revealing to the world the intimate details of their joint lives. As usual, his passion fired Picasso, and these canvases possess more verve than most of his late oils.

Fate struck Picasso yet another hammer blow in 1965: in November of that year he underwent major surgery to correct a condition variously reported as prostate disease, gall bladder trouble, or stomach ulcer.[30] Such a procedure would have been a traumatic experience for any person of Picasso's advanced age of eighty-four; in view of his lifelong obsession with bodily health and his morbid fear of death, it must have been horrifying for him—and for Jacqueline as well. Nonetheless, he survived, recovered, and by June 1966 felt well enough to resume drawing again.

A few months later, he was back in high-gear production, turning out nudes, musicians, and musketeers by the score. None of these pictures tells us very much that is new about Picasso's self-image nor, for that matter, about the art of painting. The confused and broken body contours which so many of these figures reveal probably reflect his reaction to the surgical insult he sus-

ained. (O'Brian implies that this procedure also rendered Picasso impotent).[31]

Picasso's old friend Jaime Sabartés died on February 13, 1968; Braque and Cocteau had already been dead for several years; of the close friends of Picasso's youth, only Manuel Pallarés now remained alive.[32] Although several years Picasso's senior, Pallarés survived to cross over from Spain on the occasion of the artist's ninetieth birthday. Until he was incapacitated by a stroke, Sabartés had devoted his last years to helping to arrange for the establishment of the Museo Picasso in Barcelona, to which he gave his vast personal collection of works by Picasso. In memory of his dear departed genie, Sabartés, the artist presented his entire series of variations after *Las meninas* to the museum, as well as numerous other paintings. Until his death, he also contributed one example of each of his new prints to the museum in Sabartés's honor.[33]

Shortly after Sabartés' death, Picasso embarked on a major printmaking campaign. He had been planning for some time to carry out such a foray, so that he could put into practice some novel ideas he had developed concerning new grounds for aquatints, but the loss of Sabartés may well have transformed this plan into action. Certainly the content of the 347 etchings which Picasso created between March 16 and October 5, 1968, reveals a preoccupation with Spain and things Spanish which may have been the legacy of Sabartés' passing and Picasso's resulting preoccupation with Barcelona and the period of his youth.[34]

The artist carried out his experiments with the help of the Crymmelynck brothers, Aldo and Piero, master printers who established their press right at Mougins so that Picasso could study the results of his experiments almost as soon as he had completed them. He had always enjoyed close contacts with skilled artisans; perhaps he valued such exchanges all the more now that Sabartés, too, was lost to him forever. Picasso responded to the technical skill of his collaborators by devising a whole set of amazing new variations on standard techniques of aquatinting, variations so complex that many of them puzzled even the greatest contemporary masters of printmaking.[35]

Unfortunately, few of these 347 prints possess an intrinsic merit which matches their technical bravura. Rather, they remain empty virtuoso performances which demonstrate Picasso's mastery of all the tricks of the trade, here presented as a goal rather than a means to expression. His more successful etchings retain a certain charm, but his wit has a bitter quality which often seems directed at women. The female figures of these prints, nearly always presented in the nude, do little except exhibit themselves as explicitly as possible while awaiting the inevitable male adulation which they accept as no more than their due. Their fatuous, foolish indolence possesses a far different quality from the good-natured sensuality demonstrated by the comely girls who people the Human Comedy drawings of 1954, while those girls, in turn, seem less idealized and loving than the models who appear in the Sculptor's Studio series of 1933. Of course, during the late twenties and early thirties, Picasso

Plate 111 from the *347 Engravings Suite,* May 25, 1968, etching and aquatint, 36.2 x 47.2 cm. The Art Institute of Chicago. Henry Regnery Fund, Print and Drawing Fund, and Print and Drawing Club Fund

invented many female monsters, but their all-too-human anguish moves us, regardless of their frightening deformities. His ladies of 1968, though splendid and Junoesque in appearance, seem too smug and self-congratulatory concerning their sexual power over men. Cavaliers who might have stepped from paintings by Velazquez pay endless homage to these complacent recumbent females. The fact that so many of these scenes appear to take place in bordellos lends an additionally morbid twist to this depiction of the relationships between the sexes.

The "erotic" qualities of these etchings have been touted by the popular press and by advertisements peddling the expensive book of facsimile reproductions of the prints. Whether works which reveal so much bitterness toward women can really be considered sexually stimulating probably depends on one's tolerance for perverse sexuality. Their explicit quality indicates that the aged master had lost none of his cunning in gauging public taste—in this case, the current appetite for pornography.

The most explicitly erotic of the prints shows a great artist of the past—most often he can be identified as Raphael—busily copulating with his mistress while retaining a firm grip on his palette and brushes. Usually, a high-ranking voyeur—a king, pope, or czar—peeps at the couple from a secret hiding place. Did Picasso employ this motif to emphasize once more that art had the same significance for him that sex has for others? Or did the aged Picasso use this device to reveal that he found the public's curiosity over his late artistic struggles to be indecent, an invasion of his sacred privacy?

Apart from their titillating quality and their technical expertise, these 347 etchings offer little that is new. Both their style and their content support the conclusion also implicit in Picasso's late paintings and drawings: his autocritical abilities had suffered impairment; as a result, all his late oeuvre, including these etchings, represents an unending, self-indulgent rumination—a long, disjointed narrative which soon ceases to compel the viewer who studies these last pages of the artist's life journal in detail. Too many people, relationships, events, works of art—his own as well as those of others—now crowded in upon the aged painter and threatened to swamp him. In these prints, allusions to the history of art from the time of the Etruscans to the present mingle with the most personalized references in a disorderly mélange. In Picasso's final decade, then, chaos became the main quality of the self. Many critics, repelled by this chaotic quality, concluded that Picasso now tottered on the brink of senility. Not necessarily so. In his second wife, Picasso had acquired a helpmate who admired everything he produced. Entrapped with a loving misunderstander who held up a distorting mirror before him, the aged artist perceived only darkly—or not at all.

Picasso's production from 1969–70, much of it shown together in a special exhibition held at the Palace of the Popes in Avignon, reflected a further deterioration in both his artistic skills and his psychic functioning. Whether

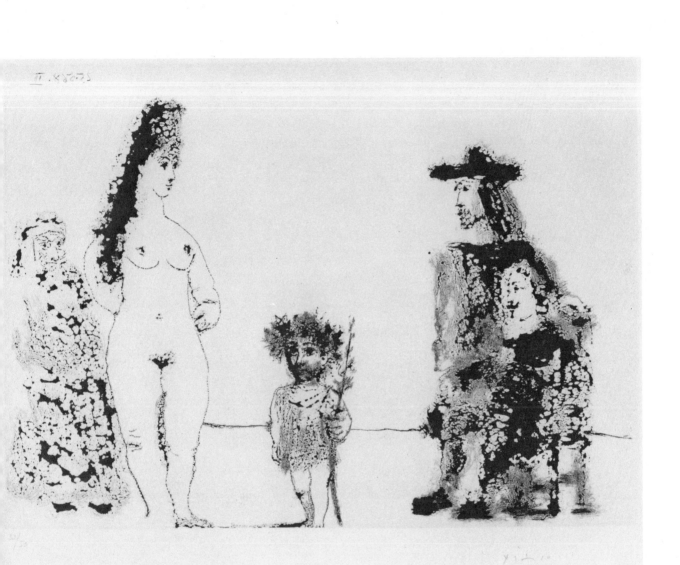

Plate 8 from the *347 Engravings
Suite,* March 25, 1968, etching, 61.5
x 50 cm. Photo courtesy of the Art
Institute of Chicago

Man and Flute Player, November 1,
1967, colored chalk, 49.6 x 64.2 cm.
The Art Institute of Chicago

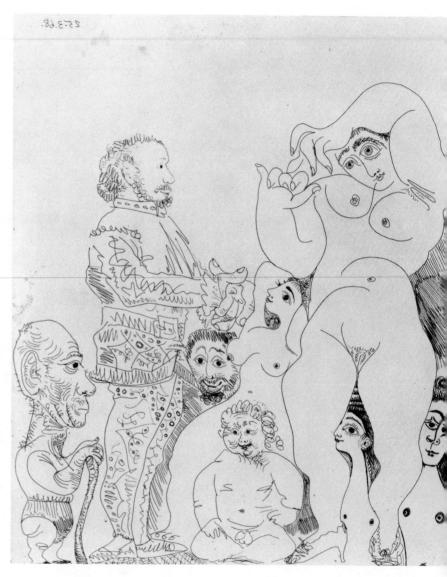

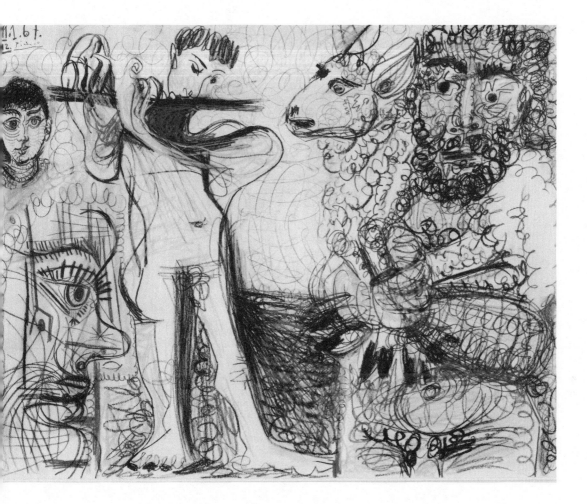

these pictures depict musketeers—a motif to which he now became quite addicted—nudes, or embracing couples, they all reveal over-simplifications, untidy brushwork, and muddy colors. Obscure, confused passages—doubtless indications of weakened boundaries of the self—become more and more evident in the figurative works which now totally consumed his interest. Many of his loving couples, depicted in explicitly sexual situations, appear to melt together less from ecstasy than confusion about self-other. These indications of body-boundary weaknesses may have been a continuing legacy from his 1965 surgery; however, O'Brian reports that Picasso had become quite deaf by this time and was also experiencing a distinct loss of visual acuity; the painted evidence suggests that this report is accurate.[36] Such changes are hardly a surprising development in a man on the threshold of his tenth decade, but they must have deeply disturbed and frightened Picasso, always so preoccupied with his bodily condition in general and his visual acuity in particular. The obsessive preoccupation with eyes apparent in the 1968 etchings may also reflect Picasso's anxiety about his vision.

Even after his painting techniques had grown summary and careless, Picasso's drawings retained their power. He had always been, first and foremost, a great draftsman, and the skill he demonstrated earliest remained with him longest. Around 1969, however, even his drawings began to go limp. The former child prodigy who had loved to boast that by the age of twelve he could draw like Raphael had outlived his own prodigious skill. The drawings he had completed a few years earlier showing the growth and progress of a musical prodigy from infancy to adulthood (his loving father resembles Don José, but the mother takes on Jacqueline's features) presumably should be read in reverse: he who had been the greatest artist of the twentieth century had deteriorated into an uninspired senile prodigy who lost, rather than gained, skill with each passing day.

Yet, during these last few years of his life, Picasso experienced an occasional miraculous resurgence of his old powers. Several of the pictures exhibited in that posthumous show of paintings from 1970–72 (once again at the Palace of the Popes at Avignon) depicted single male heads of an austere, disquieting majesty. References to the outside world fell away in these paintings. The nudes, dwarfs, cavaliers, and putti disappeared, leaving Picasso to continue his dialogue with the only personage who now seemed real to him: death, who stood looking over his shoulder while the artist painted furiously against time. In a series of symbolic self-portraits, Picasso fused his own image with that of death, creating an awesome, skull-like visage, barely covered with a taut layer of flesh, barely animated by the spark of life. After a long lifetime devoted to partnerships, Picasso had made his final merger.

Postscript
Time Draws on – I Remain

Throughout his long lifetime, Picasso changed artistic styles with bewildering rapidity, moving from classicizing to cubist to expressionist to surrealistic forms, producing bravura pictures in each mode. He alternated media with equal facility, excelling as painter, draftsman, printmaker, sculptor, ceramicist —a veritable artistic one-man band. Despite this changeability, however, the content of Picasso's art remained remarkably uniform. His oeuvre was always frankly autobiographical; his subjects were always himself, his loves, his partners, his admirers—in short, his private world. These constituted his constant subject matter, regardless of his chosen style or medium of the moment.

Jaime Sabartés, Picasso's lifelong friend, quite aware of the autobiographical quality of Picasso's art, suggested that if we could only reconstruct his itinerary step-by-step, "We would discover in his works his spiritual vicissitudes, the blows of fate, the satisfactions and annoyances, his joys and delights, the pain suffered on a certain day or at a certain time of a given year."[1] Sabartés' observation seems entirely accurate; indeed, if there were no lacunae in our biographical data about Picasso, there would be no lacunae in our interpretations of his art. The more information one has available about a particular phase of the artist's life, the more securely can one decipher the iconography of his work. To uncover the basic meaning of his imagery, however, we need to know a great deal more than the history of his day-by-day activities as a mature artist, for the indelible imprint of certain early life relationships, experiences, and visual memories forever etched themselves in his memory and in the imagery of his art. What Picasso saw and felt during his first years proved central in shaping the nature of his production as a mature artist. Needless to say, he was also profoundly affected by the fact that he was a child of contemporary society. The modern world and its upheavals—social, political, and cultural—all furnished grist for his artistic mill. Above and beyond these events, however, his unique personal experiences made his imagery unique.

253

Nothing demonstrates the complex interrelationship of all these factors more concisely than his greatest artistic feat: the invention of cubism. As Gertrude Stein wittily observed, cubism was born because pictures commenced to want to leave their frames, in other words, because the times were ripe for such a revolution.[2] The precise form this revolution assumed, however, reflected not only Picasso's reaction to our complex modern civilization—including the art of Cézanne and other relevant late nineteenth-century masters —but his response to the most frightening psychological experience of his early childhood: his susceptibility to repeated sensations of disintegration. Thus, the child who fragmented became the genius who invented cubism. No wonder he required a teammate for this undertaking. Picasso always insisted that he never could have managed this feat without Georges Braque, who contributed not only his own genius, but his companionship and support, which allayed Picasso's anxieties as he duplicated on canvas the fragmentation he had originally experienced within.

If cubism was Picasso's greatest invention, *Guernica* remains his most powerful single statement. This painting, too, depends from his earliest memories, his recollections of the dreadful earthquake which struck Málaga when he was three. Associations, evoked by photographs depicting the carnage and destruction at Guernica, stimulated Picasso's half-forgotten visual images of that holocaust in Málaga. The rage he had felt during the earthquake—which he connected with the birth of his baby sister Lola—apparently caused him to confuse inner fragmentation with exterior destruction. He made this confusion explicit in *Guernica,* where the bull—always Picasso's alter ego— becomes the agent of brutality, darkness, and destruction.

It is, of course, a truism that we are all the products of our pasts, the interaction of our cultural and personal experiences. The art of Matisse undoubtedly was shaped by his childhood experiences, just as Picasso's was. Matisse' early life must have been less dramatic or traumatic, for he was able to put greater distance between himself and his past. He elected never to share any unpleasant memories with his viewers, and he consciously censored, altered, and shaped his art so that it would reveal only beauty, communicate only joy. He transports us always to that magical realm where all is "*luxe, calme, et volupté.*" Picasso, by contrast, insists upon sharing his angst with his viewers, just as he openly identified the bull of *Guernica* as the agent of its destruction, although he knew his public connected this animal with his self-image.

Just as Picasso's artistic expression remained closer to his inner world than did that of Matisse, he also remained more obviously dependent on his relationships with various male and female partners to sustain his creativity. One cannot label this dependence pathological, for it enabled Picasso to create a great body of art. Rather, the repetitive, destructive nature of his relationships with women constituted his pathology. He both chose inappropriate female partners, and then could never definitely sever his ties to these women once

ey lost interest for him. His problem apparently lay in his unresolved primary ambivalence toward his own mother. He rejected her and turned to his father after his sister Lola's birth. Thereafter, he followed a pattern of loyal estrangement, distancing himself from his mother rather than resolving his mixed feelings toward her. As an adult, Picasso again and again chose inappropriate female partners, partners who echoed certain qualities of his mother and perhaps of himself as well. He selected vulnerable women, women with whom I could only end badly, to echo a line from his own play. Sometimes this vulnerability was masked by a veneer of rigid controllingness, as in the case of his first wife, Olga. Sometimes the vulnerability consisted primarily in the inequality which separated his age and status from that of his partner; this was the case with Françoise Gilot, in later life a strong personality, but then a girl young enough to be the artist's granddaughter. Most often, Picasso selected women who demonstrated psychological or physical fragility; indeed, this formula would seem to account for all his object choices except Olivier and Gilot. Even the artist's second wife, with whom he constructed the most durable alliance of his long career as a lover, suffered a prolonged nervous breakdown after Picasso's death. Also, one suspects—and certain eyewitness accounts support such a speculation—that Jacqueline's underlying fragility strongly affected the quality of the artist's daily life with her. Indeed, the details of the beginning of their affair suggest that Picasso yielded to her emotional onslaught because he realized that she desperately needed to be rescued. One suspects that the combination of fragility and controllingness which both Jacqueline and Olga demonstrated constituted part of the personality constellation to be found in the artist's mother. His repeated attraction to women who needed rescuing (even Gilot experienced problems with her rigid father which might have deluded Picasso into believing that she, too, needed rescuing) also recalls his own childhood experience, when his father rescued him. On another level, then, Picasso's treatment of these women mirrored his experiences with his father.

Indeed, Picasso's amatory history reveals that he was a tragedy addict; or, as Fernande Olivier put it, his was a nature which sought its own torment. Again and again, he made the same mistake in his choice of women, then compounded it by hanging on to them in a peripheral relationship which continued for many years after they had ceased to have real meaning for him. Picasso's life, like his art, might be viewed as a sum of destructions; perhaps the paralyzing horrors he experienced during and immediately after the Málaga earthquake left him with a perverse taste he could never dispel: an addiction to terrifying excitement and dramatic destruction. Such qualities his turbulent love affairs provided in abundance. The disturbed behavior demonstrated by his lady loves, the mixed reactions of rage and pity they elicited from him—all these became part of his art, the subject matter of some of his most powerful statements. At the same time, such events took their toll, and

whenever one of his relationships with women swung too far out of kilter, he
reverted to that state of fragmentation and paralysis to which he had been
subject throughout childhood. His addiction to tragedy made Picasso suffer
and suffer repeatedly; yet he was not a morbid, ghoulish tragedy addict
but, for the most part, a witty, often even a cheerful one. His response to
tragedy recalls the reaction of the bull in that final preparatory study of May
for *Guernica,* in which the beast wears a wreath of flowers and an innocent
detached childlike expression, or in the study from the following day which
shows him gamboling along like the nursery-rhyme cow who jumps over the
moon. Just as the bull ignores the tragedy or bounces back, so Picasso tri-
umphed over his domestic tragedies and remained productive as an artist to
the end of his long life.

Picasso's relationship with men showed no taint of this tragedy addiction.
His positive response to men can be traced back to his relationship with his
tender, maternal father, who led Pablo out of the darkness of his childhood ex-
periences, and who encouraged him in the development of his artistic genius.
Even as an aging artist, Picasso continued to experience nostalgia for his kindly
father; whenever his addiction to tragedy trapped him in a seemingly insoluble
situation, the artist returned in his phantasy to that period when he had felt like
father's beloved "little girl." Indeed, he could not definitively separate from
his parents until he made the relationship with Apollinaire which helped
him to bridge his maturation gap. For many years after his partnership with
the poet had ended, Picasso continued to reap the emotional benefits he had
gained in this relationship, a relationship which had enabled him to behave,
think, and emote in a more age-appropriate fashion than he had done in the
past or would manage again in later life. No wonder Picasso never forgot
Apollinaire and revealed his underlying preoccupation with the dead poet
during his own death-bed delirium. With Braque, Picasso enjoyed not only
his most fertile creative period, but probably the most contented time of his
life. Certainly his mistress of the epoch, Eva, appears to have been his great
love. Even in her case, Picasso's unerring taste for tragedy led him to select a
dying girl as the object of his affections.

Lesser male associates—the men I have dubbed Picasso's genies—also
played a constructive role in his life and art. Jaime Sabartés, Jean Cocteau,
Julio Gonzales, and Paul Eluard all helped influence him to effect changes in
style or subject matter and buttressed him against the devastating trauma he
incurred during his tragic love affairs.

Unfortunately, no one who possessed the power and magnitude of a Braque
or Apollinaire happened along to illuminate the artist's twilight years. After
the death of Matisse, the elderly Picasso turned increasingly to great artists
of the past for inspiration. He had become too famous, too powerful, too
important to enter a new artistic partnership with a mere mortal. He was the
last of the giants, so he turned to the giants of the past, to Delacroix, Velaz-

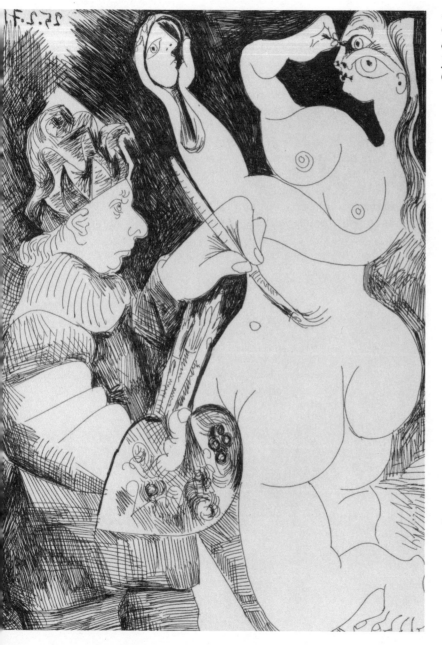

Artist and Model, February 25, 1971, etching, 21 x 15 cm. Photo courtesy of Stanley Johnson, president of R. S. Johnson International Gallery, Chicago

quez, Rembrandt, and Manet, alleviating his feelings of loneliness by estab
lishing phantasied mergers with these men, dialogues in which Picasso re
interpreted their greatest masterpieces.

In his final decade, the artist turned increasingly to yet another past maste
for inspiration: Pablo Picasso. Encouraged, perhaps, by the fawning, ingra
tiating behavior of the noncritical admirers who now surrounded him, by hi
dependence on a wife who unwittingly promoted his regression to a child-lik
state, Picasso all too often turned out pale pastiches of his own great maste
pieces. Well, it is not given to every man to go to Corinth, nor to every artis
to terminate his life in an outpouring of renewed creative genius like that o
the aged Titian, whose final paintings remain unmatched in the history of ar
The fact that Picasso failed to develop into a Titian should not blind us t
the miracles he did effect, to the fact that for so long he produced so muc
that was so magnificent, working against such terrible odds.

Notes

1. Harold Rosenberg, "Thoughts in Off Season," *The New Yorker*, June 24, 1971, 65. See also pp. 62–64.

2. Françoise Gilot and Carleton Lake, *Life with Picasso* (New York: McGraw-Hill, 1964), p. 123. Hereafter cited as Gilot, *Life*.

3. An extensive annotated bibliography of the Picasso literature was published recently. See Ray Anne Kibbey, *Picasso: A Comprehensive Bibliography*, Garland Reference Library of the Humanities, vol. 45 (New York: Garland, 1977).

4. Alfred H. Barr, Jr., *Picasso: Fifty Years of His Art*, reprint ed. (New York: Arno Press, 1966).

5. Wayne Anderson, with the assistance of Barbara Klein, *Gauguin's Paradise Lost* (New York: Viking Press, 1971).

6. Christian Zervos began to catalogue Picasso's paintings and drawings in 1932; to date, the catalogue consists of 33 volumes, one of which is in 2 parts, and covers the artist's career through 1970: Christian Zervos and Yvonne Zervos, *Pablo Picasso* (Paris: Cahiers d'Art, 1932–)—hereafter cited as Zervos. For the sculptures see Werner Spies, *Sculpture by Picasso*, trans. J. Maxwell Brownjohn (New York: Harry N. Abrams, 1971).

7. [Gyula Halász] Brassaï, *Picasso and Company*, trans. Francis Price (New York: Doubleday, 1966), p. 100.

8. Josep Palau I Fabre, *Picasso en Cataluña* (Barcelona: Ediciones Poligrafa, S. A., 1966), reinvestigated Picasso's adolescent years in Barcelona. The author discovered many discrepancies between Picasso's memories of events and the events themselves. Great geniuses also excel in creating their own mythologies.

9. David Douglas Duncan, *Picasso's Picassos: The Treasures of La Californie* (New York: Harper & Brothers, n. d.).

The quotation which appears as the chapter title comes from Apollinaire's poem "The Betrothal," which was expressly dedicated to Picasso and appeared in *Alcools*. For the translation used, see Guillaume Apollinaire, *Alcools*, tr. Anne Hyde Greet (Berkeley: University of California Press, 1965), pp. 170–97.

The drawings and paintings cited in this chapter appear, with few exceptions, in

Chapter One

Chapter Two

259

Zervos, volumes I, VI or XXI. In the body of this chapter, I specifically cite the most significant of these works. The interested reader should also consult Juan-Eduardo Cirlot, *Picasso: Birth of a Genius*, foreword by Juan Ainaud de Lasarte, trans. by Paul Elek, Ltd. (New York: Praeger, 1972). Cirlot reproduces the drawings from several early sketchbooks not available elsewhere. Pierre Daix and Georges Boudaille, *Picasso: The Blue and Rose Periods*, a catalogue raisonné of the paintings, 1900–1906, comp. with Joan Rosselet, trans. Phoebe Pool (Greenwich, Conn.: New York Graphic Society, 1967), reproduces some of the work from 1898–1900 on pp. 106–16. For the paintings which the artist kept in his own collection, see Duncan, *Picassos*, p. 203.

1. In medieval times, people believed that the lioness gave birth to stillborn cubs which were brought to life three days later when the father lion breathed the breath of life into them. The lion and his cubs often appear in medieval art as a symbol of Christ's resurrection.

2. Jaime Sabartés, *Picasso: Documents iconographiques* (Geneva: Pierre Cailler, 1954), p. 24. Sabartés pushes discretion to the point of mystification. One learns nothing specific about the nature of Don José's escapades; whether he was a Don Juan as well as a prankster is unclear. Sarbartés' account of Señor Ruiz Blasco's earlier life (see pp. 23–29) contains many other unexplained or inconsistent data; chronology is often puzzling. The author never reveals his source for much of this information, and it may be that Picasso served as his chief, or only, informant. Sabartés' reconstructions may thus involve numerous distortions and errors.

3. Again, Sabartés confuses. In *Documents*, p. 28, he states that Don José was left in charge of his two maiden sisters following Canon Pablo's death. One would assume that these were the ladies who later lived in his household. However, in Jaime Sabartés, *Picasso: An Intimate Portrait*, trans. Angel Flores (New York: Prentice Hall, 1948), p. 6, the author quotes Picasso, who gives the names of two maternal aunts who lived with the family. Perhaps various maiden aunts lived with them at various times. All the assorted female dependents, including the maternal grandmother, apparently remained behind in Málaga, for Sabartés p. 8 specifically notes that, at the time of the trip "they were five," Picasso, his parents and his two sisters.

4. Sabartés, *Documents*, p. 35. See also Sabartés, *Portrait*, pp. 24–41. I have checked Sabartés' version of the facts against the biographical data compiled for the artist by Rosa M. Subirana for the *Museo Picasso, Catalogo I* (Barcelona: Ayuntamiento de Barcelona, n.d.), pp. 17–24, and the information supplied by Cirlot, *Picasso*, pp. 13–47. Both Subirana and Cirlot apparently had access to family documents which Sabartés did not see. Most other Picasso biographies seem to rely on Sabartés for data about Picasso's developmental history.

5. Phyllis Greenacre, *Emotional Growth: Psychoanalytic Studies of the Gifted and a Great Variety of Other Individuals*, 2 volumes (New York: International Universities Press, 1971), 2: 479–574. Greenacre discusses the difficulties often experienced by creative children, with specific examples drawn from biographical literature, as well as from her own analytic practice. See also John E. Gedo, "On the Psychology of Genius," *International Journal of Psycho-Analysis* 53 (April 1972): 199–204. Both authors emphasize that the extra sensitivity of the gifted

hild can lead to his overstimulation and consequent disorganization in situations which would not disrupt the average child.

6. Ronald W. Clark, *Einstein: The Life and Times* (New York and Cleveland: World, 1971), p. 10.

7. Interview with Françoise Gilot, the artist's studio, La Jolla, California, September 3, 1977.

8. Eye-witness accounts suggest that the artist's second wife also exerted a strong influence on her husband. Indeed, as my text will emphasize, Picasso always disdained timidity and demanded tenacity of those he admired. He showed a marked proclivity for women at once fragile and controlling. Like Olga, they frequently seemed to exercise so much control over the artist precisely because their brittle personality integration made it seem too dangerous to countermand their wishes.

9. For information concerning the development of children with a narcissistic defect and their relationships with parents and others, I depended on the following psychoanalytic source material: Anna Freud, *Normality and Pathology in Childhood* (New York: International Universities Press, 1965). John E. Gedo and Arnold Goldberg, *Models of the Mind* (Chicago: University of Chicago Press, 1973). Otto Kernberg, *Borderline Conditions and Pathological Narcissism* (New York: Jason Aronson, 1975). Heinz Kohut, *The Analysis of the Self* (New York: International Universities Press, 1971). Margaret Mahler, Frederick Pine, and Anni Bergman, *The Psychological Birth of the Human Infant: Symbiosis and Individuation* (New York: Basic Books, 1975). Donald Winnicott, *Collected Papers* (New York: Basic Books, 1958).

10. Gertrude Stein, *The Autobiography of Alice B. Toklas* (New York: Harcourt Brace, 1933), pp. 271–72. One is reminded of the heart-felt cry which Nietzsche utters in the preface to his autobiographical *Ecce Homo,* trans., ed., and commentary by Walter Kaufmann, Vintage Books (New York: Random House, 1969), p. 217: "Above all, do not mistake me for someone else." His parents not only failed to recognize their son's unusual abilities, but feared that he might be retarded because he failed to develop normal speech at the expected age. See Carl Pletsch, "A Psychoanalytic Study of Friedrich Nietzsche" (Ph.D. diss., University of Chicago, 1977).

11. The tremors began on the evening of December 25, 1884. Thereafter, conditions worsened rapidly, for the quake continued for several days. On December 29, *The New York Times* reported that 600 people in Málaga province had been killed. Widespread property damage accompanied the quake; the Málaga cathedral, hospital, and other public buildings suffered extensive damage. Although the brunt of the earthquake was felt immediately after Christmas, rather than just before Christmas, as Picasso remembered it, the facts seem less important than his reconstruction of the events. The association between Christmas, the earthquake, and Lola's birth remained fixed in his mind forever afterward. See *The New York Times,* December 28, 29, 30, and 31, 1884.

12. See Oscar Seyffert, *Dictionary of Classical Antiquities,* rev. and ed., Henry Nettleship and J. E. Sandys, Meridian Books (Cleveland and New York: World, 1969), pp. 506–7. Poseidon, god of the sea, carried as his symbol the trident with

which he stirred up the sea; he initiated earthquakes by the same activity, both by stirring up the sea, which (so the Greeks believed) supported the earth, and by striking the earth directly. The bull symbolized the stormy flood to the Greeks, so they offered dark-colored bulls to implore Poseidon to calm the sea. He was also regarded as the creator and tamer of the horse, which he supposedly created by splitting boulders with his trident, causing horses and fountains to spring forth. For this reason, horses also were offered to him. Both horse races and bullfights were held in his honor.

13. Jan Ehrenwald, "A Childhood Memory of Pablo Picasso," *American Imago* 24 (Spring–Summer 1967): 129–39. Sabartés, *Portrait,* p. 9. Gilot indicated during our interview of September 3, 1977, that she is quite convinced that Sabartés dates the beginning of Picasso's artistic training and attendance at bullfights too early. She believes that Picasso must have been nearer six than three when these events occurred. Since both the biographer and his subject are dead, there is probably no way to check on the accuracy of Sabartés's account, which came from the artist himself. The visual evidence seems to me consistent with Sabartés's chronology.

14. Sabartés noted that the child found school so unpleasant that, without too much effort, he fell sick. The family consulted a physician, who suggested that the boy's kidneys probably were affected. Nothing in Picasso's subsequent history suggested that he really ever suffered from kidney trouble. What, then, can such a diagnosis have meant? Perhaps Picasso had panicked so much about school that he became enuretic, wetting himself there or at home before leaving for school. A peculiar incident which Penrose relates led me to speculate in "Art as Autobiography: Picasso's *Guernica*" (*Art Quarterly* 2, no. 2 [Spring 1979]: 205), that the artist might have suffered from fecal incontinence following the trauma of the Málaga earthquake, when he was three.

It should be noted that the most common physical symptom which phobic children suffer is nausea (often accompanied by vomiting) as the hour for school approaches. Picasso may have suffered from this symptom in addition to enuresis. We lack the facts which would enable us to move from speculation to certainty.

15. Sabartés, *Portrait,* p. 34; see also pp. 30–35. Heinz Kohut, "The Psychoanalytic Treatment of Narcissistic Personality Disorders: Outline of a Systematic Approach," in *The Psychoanalytic Study of the Child,* vol. 23 (New York: International Universities Press, 1968), p. 95, describes how patients with such narcissistic problems recalled reactions similar to Picasso's when separated from the parent they idealized; at such times, they experienced symptoms of physical discomfort (hypochondriasis), dissociation, and "deadness." See also John E. Gedo, "Notes on the Management of Archaic Transferences," *Journal of the American Psychoanalytic Association,* vol. 25, no. 4, 1977, and Kernberg, *Borderline Conditions.*

16. Sabartés, *Portrait,* p. 35.

17. Ibid., p. 39.

18. Gilot interview, September 3, 1977. She had not been consciously aware of the discrepancy between Picasso's recollection and the facts until we discussed these details during our interview.

19. Wilhelm Boeck and Jaime Sabartés, *Picasso* (New York: Harry N. Abrams, n.d.), p. 14.

20. Sabartés, *Documents,* pp. 298–99. One should not discount the possibility that Don José, like his son, had suffered from phobic fears as a child, and that these symptoms were reactivated by his relocation to Corunna. His behavior could also be consistent with symptoms of a depression, but his energetic efforts to promote Picasso as a professional artist do not accord with this theory too well. We simply lack the necessary information to decide which—if any—of these speculations apply. The biographers all relied on Picasso's account, which may be quite distorted.

21. Josep Palau I Fabre, *Cataluña,* p. 16. See also Ernst Kris, "The Personal Myth: A Problem in Psychoanalytic Technique," *Psychoanalytic Quarterly* 4 (1956): 654–681. Kris describes how some of his patients retrospectively and unconsciously falsified their life histories in order to make them more consistent with their prevailing self concepts.

22. Palau I Fabre, *Cataluña,* p. 30.

23. Duncan, *Picassos,* illustrates this painting in color and discusses it on pp. 40–41.

24. See Sabartés, *Portrait,* pp. 40–42, and Roland Penrose, *Picasso: His Life and Work,* rev. Icon ed. (New York: Harper & Row, 1973), pp. 40–41. Pierre Cabanne, *Pablo Picasso: His Life and Times,* trans. Harold J. Salemson (New York: William Morrow, 1977), pp. 40–41, claims that Picasso did, in fact, attend classes at the academy for a few weeks but quit because he was unwilling—or unable—to conform to the demands of the instructors there. Cabanne also states, without indicating his source for such information, that Picasso accompanied his class on a field trip to Toledo, where they were instructed to make a drawing after El Greco's *Burial of Count Orgaz.* Picasso "got the strange notion of replacing the faces of the real characters of the count's burial . . . with those of his classmates and even his teachers! Carbonero [the instructor in charge of the field trip], outraged at the joke, became violently angry, and Pablo decided never to set foot in the studio again" (p. 41). Whether this is a factual reconstruction of actual events or one of Picasso's retrospective mythical reconstructions of events remains open to question. Palau I Fabre, well acquainted with this period in the artist's life, notes: "But Picasso returned to Barcelona about the middle of June 1898 in very bad physical shape and, what was even worse for him, *having achieved practically nothing during his stay in Madrid"* (*Cataluña,* p. 50, italics mine.) Picasso's own description of the aimless way he wandered about Madrid recalls his similar description of his restless behavior in the classroom at Málaga. See Penrose, *Picasso,* p. 42.

Cirlot, *Genius,* pp. 65–66, reviews the works which survive from Picasso's Madrid period; these include a copy of Velazquez's *Portrait of Philip IV* from 1652–53, two little landscapes, and several small sketchbooks of pencil drawings. It is not absolutely certain that all five of the latter actually were done in Madrid. Cirlot notes that three of them have "uncertain dates in 1897 or 1898." Moreover, the subject matter of the drawings by no means invariably indicates that they originated in Madrid rather than Barcelona. Certain pages, such as the copy of an equestrian figure after Velazquez and another which records a Goya drawing, almost certainly were executed in the Prado. Other pages contain an admixture of scenes which obscures rather than clarifies their place of origin. The same confusion marks some of the sketchbooks evidently completed after the artist returned from Madrid, but which

may have been executed in Barcelona or Horta. See Cirlot's illustrations nos. 101–14 and 518–80 on pp. 65–8 and 213–23, respectively.

25. Sabartés, *Portrait,* pp. 42–43; Penrose, *Picasso,* pp. 43–44; and Cabanne, *Picasso,* pp. 43–44.

26. Palau I Fabre, *Cataluña,* pp. 60–64, implies that Picasso left for Horta in a sulking mood and refused to live at home after he returned to Barcelona, even though he was reconciled to his family by that time. Fabre also claims that Picasso lived in a bordello for several weeks after the student riots. The author does not explain how Picasso paid for his room and board while he lived apart from his parents. Penrose (pp. 55–57) seems to imply that the artist lived, as well as painted, in the studios of various friends, but fails to clarify whether this was the case. He does note that the artist saw his family "almost daily and would often stay to eat with them." Whether Fabre and Penrose depended solely on Picasso for this information or possessed other corroborative evidence is never clarified. Sabartés (*Portrait,* p. 43) mentions that he met Picasso for the first time soon after he returned from Horta. Sabartés notes that from the beginning of 1900 until September of that year, the artist shared a studio with his friend Casagemas, adding that this was the last of three studios which Picasso had in Barcelona prior to his first trip to Paris. However, Sabartés never mentions that Picasso lived in any of these studios, nor does he list any bedroom or other furnishings in the rather detailed description of the last studio provided on p. 43. Sabartés's account of the blue years strongly implies that the artist lived at home whenever he resided in Barcelona during the 1901–4 period. On p. 89, Sabartés describes an incident in 1902, when he called for Picasso "at home" one morning and the artist's mother ushered him into the room where her son still lay sleeping.

27. Sabartés, *Portrait,* pp. 18–20.

28. Penrose, *Picasso,* p. 55.

29. The Museo Picasso opened in March 1963. Several years earlier, Jaime Sabartés had offered his personal collection of works by Picasso to the city of Barcelona if they would provide permanent museum space to house the collection. The city accepted, offering two fourteenth-century palaces as possible sites. Picasso selected the Palacio Aguilar, which was magnificently converted into a museum. In 1968, following the death of Sabartés, Picasso bequeathed all of his juvenilia and some later works that had been in the collection of his mother and sister to augment the holdings of the museum. At the same time, the artist donated his entire sequence of paintings after Velazquez's *Las meninas,* some other late paintings, and a copy of every print he created between 1968 and his death.

Chapter Three The title for this chapter comes from Apollinaire's *La femme assise,* in which the poet constructs a derogatory portrait of a character obviously modelled on Picasso. See *Guillaume Apollinaire: Oeuvres complètes,* ed. Michel Decaudin, 4 vols. (Paris: A Balland and Lecat, 1965).

The pictures discussed below are illustrated in Zervos, volumes I, VI, XXI, XXII, and XXIII. They also appear in Daix and Boudaille, *Picasso,* pp. 118–236 (cata-

ogues II through X). See also Duncan, *Picassos,* p. 204; the early sculptures appear
n Spies, *Sculpture,* p. 301 (nos. 1–3).

1. Sir Anthony Blunt and Phoebe Pool, *Picasso: The Formative Years: A Study
of His Sources* (Greenwich, Conn.: New York Graphic Society, 1962), pp. 18–22.

2. Barr, *Picasso,* p. 22.

3. Sabartés, *Portrait,* p. 87. Interestingly enough, Sabartés nonetheless promulgated
he deprivation legend, although his own observations did not support it.

4. Daix and Boudaille, *Picasso,* p. 118.

5. Sabartés, *Portrait,* p. 46. Although Picasso told Sabartés that all three young
men were to share the expenses, Penrose notes: "Unlike most of his companions,
Casagemas had private means which helped to provide for the expenses of their trip,
and there is no doubt that Picasso, at least, left Barcelona in high spirits" (*Picasso,*
p. 58).

6. John Richardson, *Picasso: An American Exhibit,* April 25–May 19, 1962 (New
York: M. Knoedler). See also Daix and Boudaille, *Picasso,* pp. 25–51, for a more
extensive review of this period.

7. The fact that Picasso could respond so positively to the liberating atmosphere
of Paris, despite his great difficulties in separating from his family and home, may
seem contradictory or puzzling to some readers. The complexities of human motiva-
tion can never be overestimated and must be assessed in terms of whole hierarchies
of factors, a principle well established in biology. This application of systems theory
was introduced into psychoanalysis by John E. Gedo. For a full discussion of the
simultaneity of such inconsistencies, complete with illustrations drawn from psy-
choanalytic practice, see Gedo and Goldberg, *Models,* and J. E. Gedo, *Beyond In-
terpretation* (New York: International Universities Press, 1979).

8. Josep Palau I Fabre provides further data about Casagemas's peculiar behavior
both before and during the Paris interlude. See "1900: A Friend of His Youth," in
G. di San Lazzaro, ed., *Homage to Picasso* (New York, 1971), pp. 3–5 and passim.
The information about Casagemas's previous suicide attempt comes from Manolo
(Manuel Hugué), who witnessed his friend's death. A translation of his account
appears in an appendix to Theodore Reff, "Themes of Love and Death in Picasso's
Early Work," in Sir Roland Penrose and Dr. John Golding, eds., *Picasso in Retro-
spect* (New York and Washington, 1973), pp. 46–47. For a discussion of the
identity and significance to Picasso of the young woman Casagemas loved, see ibid.,
pp. 14–27, 33. He suggests that the artist himself later became involved with this
young woman, who was probably Germaine Pichot, although she is identified in the
police record as Laure Florentin, née Gargallo. That document is reproduced by
Daix and Boudaille, *Picasso,* p. 338. They also report (p. 209, VII-8) that Picasso
identified her as the subject of his 1902 painting *Woman with a Shawl.* Reff pro-
poses that she also appears in two other key paintings from these years, *La vie* of
1903 and *Au lapin agile* from 1904. See Reff, "Love and Death," pp. 33–34.

In his attempt to circumvent Casagemas's suicide by maintaining constant vigilance,
Picasso exercised a useless precaution; no one can prevent a person bent on suicide
from achieving his goal. Picasso's obsession with protective watchfulness undoubtedly
originated in his childhood (see p.146) and continued throughout his life. From

1904 on, it expressed itself in his art via the motif of the "watched sleeper." This theme and its significance will be discussed in detail in later chapters.

9. Sabartés, *Portrait,* pp. 48–50.

10. Daix and Boudaille, *Picasso,* pp. 46 and 338, provide previously unpublished details concerning the suicide of Casagemas.

11. Ibid., p. 34.

12. Penrose, *Picasso,* p. 61.

13. Sabartés, *Portrait,* p. 50.

14. Sabartés, *Documents,* p. 40. Kohut, *Analysis,* pp. 53, 58–61, points out that the collapse of the idealized father often forms part of the biography of people who, like Picasso, suffer from severe self-esteem regulatory problems.

15. Daix and Boudaille, *Picasso,* pp. 156–59.

16. Ibid., p. 46. The authors located the police report describing Casagemas's suicide. It revealed that Casagemas, Pallarés, and Manolo all lived in the building where Mañach maintained his apartment. They suggest that the latter permitted the young artists to use his space because it was part of Picasso's salary supplement, whether he used it or not. See also Manolo's account of the tragedy in Reff, "Love and Death," pp. 46–47.

17. Reff presents a convincing discussion of the iconography of *Evocation* in "Love and Death," pp. 16–20.

18. Ibid., p. 47.

19. Sabartés, *Portrait,* pp. 76–77, 80.

20. Ibid., pp. 80–82.

21. Daix and Boudaille, *Picasso,* p. 178 (V-53), assign *Le gourmet* to the early summer of 1901, chiefly because Picasso had shown an unidentified picture of a child in white in the Vollard show. The authors themselves point out that, technically, *Le gourmet* is scarcely distinguishable from the *Child with a Dove.* The simplest explanation probably is that *Le gourmet* and *Child in White* are two different paintings, and that the latter has disappeared. *Le gourmet* shows Picasso's autumnal blue tones and his new abstract background; neither of these characteristics appeared in his summer works. In fact, *Le gourmet* probably was painted a bit later than the *Child with a Dove,* which continues to show rich brushwork and a warm palette.

22. The knowledge that Casegemas's mother had died of shock upon hearing of her son's death may well have reinforced Picasso's fears about the disastrous consequences for his own mother if he definitively separated from her forever.

23. Daix and Boudaille, *Picasso,* p. 206.

24. Sabartés, *Portrait,* pp. 87–88.

25. Sabartés, *Documents,* reproduces this entire letter as one of his "Documents iconographiques." See his document (photograph) no. 70, n.p.

26. Gilot, interview.

27. Daix and Boudaille, *Picasso,* p. 206.

28. Penrose, *Picasso,* p. 88.

29. Reff presents an interesting alternative interpretation of *La vie* in "Love and Death," pp. 20–28. Both Reff and Palau I Fabre perceive allusions to Casegemas's

impotence in the way Picasso treats the former's figure in this painting. Xavier de Salas apparently was the first to suggest that Casegemas's depression and suicide resulted from his discovery that he was impotent. See X. de Salas, "Some Notes on a Letter of Picasso," *Burlington Magazine* 102 (1960): 484. In "A Friend of His Youth," p. 12, Palau I Fabre reports, without offering any documentation for his statement, that a postmortem performed on Casegemas revealed his impotence. This statement surely results from some misunderstanding, because an autopsy cannot evaluate genital function, but only genital anatomy. Even if the autopsy revealed an anomaly, the pathologist surely would not have assumed, in the absence of corroborative clinical evidence, that the defect caused Casegemas to be impotent.

Most often, impotence results from psychological, not physical causes, and the differential diagnosis between these two conditions is one which is extremely complex and difficult to make. In the absence of definitive proof that Casegemas's impotence really had a physical basis, it seems wiser to assume that it was a symptom, rather than a cause, of his depression, since severe depressions are invariably accompanied by loss of sexual desire. My own assumption is that Picasso, so intuitive about the human condition, would have understood very well the underlying etiology of Casegemas's sexual difficulties and would not have been unduly preoccupied with the latter's potency problems, certainly never an area of difficulty for the artist himself. For further information concerning the problems involved in making such a differential diagnosis of impotence, see F. Bentley Scott, et al., "Erectile Impotence Treated with Implantable, Inflatable Prosthesis," *Journal of the American Medical Association,* vol. 241, June 15, 1979.

30. John Berger, *The Success and Failure of Picasso* (Harmondsworth, Middlesex, England: Penguin Books, 1965), pp. 43–44. During our interview of September 3, 1977, Gilot indicated that Picasso had informed her that he had suffered a venereal infection during his youth. Gilot was not certain when this occurred but recalled that Picasso had stated that he was cured of it before his marriage in 1918.

31. Jung seemed especially impressed with the pathological implications of *Evocation* (1901), *Woman with Folded Arms* (1902), and *La vie* (1903). Works from Picasso's more recent periods were also shown, and it was probably some of the cubist-period works which led Jung to interpret what he called the "lines of fracture" he perceived in Picasso's paintings as "a series of psychic faults." Jung's article originally appeared in the *Neue Züricher Zeitung* on November 13, 1932. It can more readily be found, under the title "Picasso," in Carl Jung, *The Spirit in Man, Art, and Literature,* trans. R. F. Hull (Princeton: Princeton University Press, 1966), pp. 135–41. See also William Rubin's discussion of the Jung article on Picasso in "Pollock as Jungian Illustrator: The Limits of Psychological Criticism," pt. 2, *Art in America,* December 1979, p. 87. Zervos provided a partial translation and commentary in *Cahiers d'Art,* nos. 8–10 (1932), pp. 352–54.

32. C. G. Jung, *Memories, Dreams, Reflections,* ed. Aniela Jaffe, trans. Richard and Clara Winston (New York, 1961).

33. Daix and Boudaille, *Picasso,* p. 218.

34. Sabartés, *Portrait,* p. 93.

35. Ibid., p. 98.

Chapter Four The title for this chapter comes from Apollinaire's *Le poète assassiné,* where it appeared as an ironic pseudonym for a character modeled on Picasso; the Benin bird refers to the artist's interest in African sculpture, apparent in his works from 1907 and later. See Decaudin, *Oeuvres.*

The paintings and drawings discussed in this chapter appear in Zervos vols. I, II, VI, and XXII, and in Daix and Boudaille, *Picasso,* pp. 238–332 (catalogues nos. XI through XVI). See also Duncan, *Picassos,* pp. 204–6, and Spies, *Sculpture,* pp. 301–2 (nos. 4–23).

After this book was in press, an important new volume on cubism appeared. I could not include references to it as frequently as I would have liked, but the reader is urged to consult it, particularly because it offers significant revisions of the chronology of Picasso's 1912–13 works. The book is Pierre Daix and Joan Rosselet, *Picasso: The Cubist Years, 1907–1916, A Catalogue Raisonné of the Paintings and Related Works,* tr. Dorothy S. Blair (Boston: New York Graphic Society, 1979).

1. The building received its name from its resemblance to the laundry boats which plied the Seine during those years.

2. Although this man really hung himself, Picasso's sketches suggest that the victim jumped from the parapet of his building. See Daix and Boudaille, *Picasso,* pp. 64, 249 (D XI-9) and 344 (A-18).

3. Fernande Olivier, *Picasso and His Friends,* trans. Jane Miller (New York: Appleton-Century, 1965), p. 29.

4. Francis Steegmuller, *Apollinaire: Poet among the Painters* (New York: Farrar, Straus, 1963), p. 131.

5. At least, 1907 is the date given by Jacob's biographer, Pierre Andreu, *Max Jacob,* Conversions celèbres series (Paris: Wesmael-Charlier, 1962), p. 30. Other sources give other dates. Some even place Jacob in a nearby building, rather than in the Bateau-Lavoir proper.

6. Penrose, *Picasso,* p. 119.

7. Olivier, *Picasso,* pp. 26–27.

8. Ibid., p. 17.

9. Daix and Boudaille, *Picasso,* p. 247 (XI-22).

10. Steegmuller, *Apollinaire,* pp. 133–36, summarizes the conflicting statements concerning the date of the first Apollinaire-Picasso encounter. Steegmuller complains of the difficulties he experienced in obtaining precise dates for any of Apollinaire's activities, a problem with which anyone engaged in research about Picasso and his friends is all too familiar. Olivier gives a date of 1904 for this meeting, which seems more consistent with the intimate knowledge of Picasso's work which Apollinaire demonstrated in his review of April 1905.

11. Both these articles are reproduced in the Appendix of Daix and Boudaille, *Picasso,* p. 335.

12. Picasso's opinion was published by Steegmuller, *Apollinaire,* pp. 142–43. This statement, written by Douglas Cooper from Picasso's comments and approved by the latter, contains the following key sentence: "Discussing Apollinaire's collected art writings recently with Douglas Cooper, Picasso commented that it was sad to find how shallow they were, how little good sense they contained, *when one*

remembered how important they seemed to be at the time of publication" (italics mine).

13. Daix and Boudaille, *Picasso*, p. 74. John Hess, "Almost Every Place but Picasso's Town Noting His 90th Birthday," *The New York Times*, Saturday, October 23, 1971, p. 5. Hess quotes a close friend of Picasso's, a source who preferred to remain anonymous. He reported that Picasso seemed preoccupied with van Gogh and poet friends who had died young—Apollinaire. "He feels it keenly that they never won full recognition in their lifetime, while he . . ." (omission appears in the article). Patrick O'Brian, *Picasso: Pablo Ruiz Picasso, a Biography* (New York: G. P. Putnam's Sons, 1976), p. 469, describes Picasso's final hours.

14. John Richardson, *Picasso*.

15. See Daix and Boudaille, *Picasso*, chap. 5, pp. 87ff, in which they discuss the problems of dating these works. Also note the more logical sequence the pictorial evidence from their corresponding catalogues (XIII-XV, pp. 274–316) demonstrates.

16. Steegmuller, *Apollinaire*, p. 152.

17. Daix and Boudaille, *Picasso*, p. 74. They also note the very close relationship between the caricature of Apollinaire as the physical culture figure and the giants. They add: "And, in their turn, these giants are closely related to the athletes and fairground strongmen who were to take their place in the *Saltimbanque* series. . . . These athletes represent the same glorification of masculine power as the kings, and it is interesting that when Picasso designed an ex-libris for Apollinaire, it was on the theme of a drinking king."

18. Pierre Callier, ed., *Guillaume Apollinaire: Documents Iconographiques* (Geneva: Cailler, 1965), reproduces all of Picasso's pictures of Apollinaire which have remained in the collection of his widow.

19. Although several critics and biographers call this figure "the understander," no one explains its derivation or why it appears in quotations. Penrose, who also calls him the understander, notes the fusion of images which connects the fat jester of *The Family of Saltimbanques* with the Herod of Picasso's etching *Salomé* and the king of Apollinaire's book plate. See Penrose, *Picasso*, pp. 115–16; and Barr, *Picasso*, p. 39.

20. See chapter 5, p. 94 and note 29, p. 275.

21. Barr, *Picasso*, pp. 36–37.

22. Ibid.; Penrose, *Picasso*, p. 115. Daniel E. Schneider, "The Painting of Pablo Picasso: A Psychoanalytic Study," *College Art Journal* 7 (Winter 1947–48); 92. Edward Lucie-Smith, *Symbolist Art* (New York: Praeger Publishers, 1972) pp. 204–5.

23. Barr, *Picasso*, p. 37.

24. During our interview, Gilot confirmed my theory that Picasso's New Year's Eve drawings were almost invariably highly personalized, significant works.

25. Gertrude Stein, *Picasso*, Beacon Paperback ed. (Boston: Beacon Press, 1959), pp. 7–8.

26. Olivier, *Picasso*, pp. 94–95.

27. Barr, *Picasso*, p. 45. Perhaps this picture really should be compared to the art of Raphael rather than Praxiteles. At least, the attendant who holds Fernande's mirror

seems to derive from a drawing by Raphael for the Farnesina. This drawing, now in
the Louvre, shows a nude attendant holding a mirror. A drawing omitted from the
original Zervos catalogues for this period (perhaps because Picasso did not wish to
reveal his artistic source?) shows the mirror-bearer nude.

28. In a rich essay devoted to Picasso's circus period, Theodore Reff makes the
plausible suggestion that the rose, pink, and red color scheme of the Cirque Medrano,
which Picasso frequented during this period, helped to determine the prevailing rose
tone of so many of these pictures. He also offers the interesting hypothesis that
The Family of Saltimbanques not only portrays Picasso and Apollinaire but André
Salmon and Max Jacob as the two younger saltimbanques. Whether or not this is
correct, it need not invalidate my alternative interpretation that the figures represent
Picasso himself at crucial stages in his past. See Reff, "Harlequins, Saltimbanques,
Clowns, and Fools," *Art Forum* 10, no. 2 (October 1971): 31–43.

29. Barr, *Picasso,* p. 53.

30. Penrose, *Picasso,* notes: "The smooth type of canvas that he liked to paint
on would not have been strong enough for so large a surface. He therefore had a
fine canvas mounted on stronger material as a reinforcement and had a stretcher
made to his specified unconventional dimensions" (p. 132).

31. Barr, *Picasso,* p. 56 and note, p. 257. Many years later, in 1937, the artist
admitted the truth to André Malraux: the conception of the *Demoiselles* had been
deeply influenced by Picasso's initial experience with African art. He vividly re-
called that he had instantaneously comprehended why the Africans created such
fetishes and how they used them, because, "I too believe that everything is un-
known, that everything is an enemy! . . . They were weapons. To help people avoid
coming under the influence of spirits again, to help them become independent.
They're tools . . . I understood why I was a painter. All alone in that awful museum
[the old Musée Trocadéro in Paris, where such art was exhibited], with masks,
dolls made by the redskins, dusty manikins. *Les Demoiselles d'Avignon* must have
come to me that very day, but not at all because of the forms; because it was my first
exorcism-painting—yes, absolutely!" Malraux tactfully refrained from publishing
this material until after Picasso's death, thus preserving the secret of the artist's
image-magic intact. Apparently, to have revealed this secret to others would have
vitiated the magical protective quality of his two Africanized demoiselles, designed
to protect the artist himself against his private evil female spirits. (André Malraux,
Picasso's Mask, trans. and annotated by June and Jacques Guicharnaud (New York:
Holt, Rinehart, and Winston, 1976), pp. 10–11.)

32. Penrose, *Picasso,* pp. 133–34, describes the reactions of Picasso's friends.

33. Barr, *Picasso,* pp. 54–55, summarizes these many discrepant features.

34. To list just a few of such sources, see Barr, *Picasso,* pp. 53–54; Robert
Rosenblum, "The 'Demoiselles d'Avignon' Revisited," *Art News,* April 1973, pp.
45–48; Leo Steinberg, "The Philosophical Brothel," pt. 1, *Art News,* September
1972, pp. 20–29, and pt. 2, October 1972, pp. 38–47 (the latter presents a detailed
discussion of the relationship between the *Demoiselles* and Picasso's own art, as well
as comments about other sources).

35. John Golding, *Cubism: A History and an Analysis,* rev. ed. (Boston: Boston
Book and Art Shop, 1968), p. 50, and Reff, "Love and Death," pp. 43–44.

36. The studies for the *Demoiselles* are spread among several Zervos volumes, but the key self-portraits as the sailor occur in Vol. II, pt. 1: 6, 7; XXVI 10, 86, 92, 99, 100. For the medical student, see Z., XXVI, Nos. 14, 26, 45. A long series of self-portraits not specifically identified as the student are interspersed among various *Demoiselles* studies, for example, Z., XXVI, 45, 51, 54, 55, 63, 66, 67. It is extremely revealing to follow the sequence of studies presented in these two volumes; they appear to be in chronological order and present an interesting train of associations on Picasso's part. See note 44 below.

37. Steinberg, "Philosophical Brothel," pt. 1, p. 26, describes the sailor as "an effeminate personality." At the same time, the critic emphasizes that the "phallic" porrón is the sailor's attribute. This symbolism certainly seems valid, but the porrón may also be interpreted in another light, one which seems to me more congruent with Steinberg's own observations concerning the sailor's passivity: the porrón may also represent the breast. Usually made of skin, the portable form of this vessel is worn over the owner's shoulder when not in use. Whenever he feels the need of a drink, he shifts it into position to trickle the wine down his throat. The person thus equipped might, in effect, be described as nursing himself. See also note 44 below.

38. Steinberg, "Philosophical Brothel," pt. 2, p. 39.

39. Ibid., p. 38.

40. D. H. Kahnweiler, "Conversations with Picasso," in San Lazzaro, *Homage to Picasso,* p. 14, reports the following remarks which Picasso made on December 2, 1933:

" 'Les Demoiselles d'Avignon'—you've no idea how that title irritates me. It was Salmon [André Salmon, poet and art critic] who thought of it. You know that it used to be called 'Le Bordel d'Avignon' at the beginning. I've always known the name Avignon. It's been a part of my life. I used to live a stone's throw from the Calle d'Avignon. It was there I used to buy my paper and watercolor paints. Then, as you know, Max's grandmother came from Avignon. We used to make all sorts of jokes about that painting. One of the women was Max's grandmother, one was Fernande and the third was Marie Laurencin and there they all were in a brothel at Avignon.

"There ought to have been some men in it too—my first idea; you've seen the drawings, haven't you? There was a student holding a skull. A sailor too. The women used to be eating; that's where the basket of fruit came from which is still in it. Then it changed and became what it is now."

41. For details about the Laurencin-Apollinaire romance, consult Steegmuller, *Apollinaire,* pp. 156–64 and passim.

42. See, for example, Barr, *Picasso,* p. 57, and Reff, "Love and Death," p. 43. The latter connects this motif with a 1905 drypoint that Picasso made, showing himself as Harlequin presenting a skull to Fernande.

43. Quoted in Steinberg, "Philosophical Brothel," pt. 2, note 32, p. 47.

44. For a more complete discussion of Picasso's self-portrait as the little sailor, see pp. 187, below. It is interesting that the suppressed sketchbook shows many drawings of a bitch nursing her pups and tenderly licking them, interspersed with sketches of the sailor's head showing this figure wearing a cap and looking much

younger and more ingenuous than in the sketches published earlier. See Z., XXVI, 86–109 for this sequence. The dog with the pups reappears several times in this volume, always in conjunction with studies for the painting. One full compositional sketch, no. 73, includes the dog, jumping joyously on the medical student. The dog surely belonged to Picasso himself, and his association of those studies of her tender maternal activities seems especially provocative when we remember that the 1938 portrait shows Picasso as a child of three, the age Picasso would have been when his mother nursed his sister Lola. It seems likely that Picasso had a dress-up sailor suit when he was three, a fact memorialized both in the 1938 painting and in these studies for the passive, childish sailor of the *Demoiselles*. This sequence of associations also reinforces my hypothesis that the porrón in this picture refers to nursing one's self. Perhaps all these allusions refer to Picasso's comprehension, shortly after Lola's birth, that through his art he could sustain and comfort himself, and thus need not be so dependent on his mother as the source of nutritive gratification.

45. Palau I Fabre, *Cataluña*, pp. 62–64. According to Cabanne, *Picasso,* p. 47, Picasso's sexual experience began when he was fourteen, and he frequently boasted to friends that he began his sexual life while still "just a little fellow" who had not yet reached the age of reason. If Picasso did not exaggerate, the sailor image might serve as a symbol both of his childhood dependency and his very youthful initiation to the brothels.

46. Hilton Kramer, reviewing the "Picasso Erotic" exhibition in the *New York Times* on May 29, 1979 (sec. 3, p. 7), emphasized the explicit character of these drawings. Many of them featured Picasso's friends in action with the girls of the establishment.

47. Gilot reported that Picasso himself described this infection to her; unfortunately, she asked few questions and knew no details, except that he had received effective treatment for it long before his marriage. I am assuming that he suffered a syphilitic infection, since gonnorhea is not a life-threatening disease.

48. For a discussion of the history of this motif, see Erwin Panofsky, *Studies in Iconology: Humanistic Themes in the Art of the Renaissance,* Harper Torchbook (New York: Harper and Row, 1962), pp. 69–94.

49. Gertrude Stein, *Everybody's Autobiography* (New York: Random House, 1937), pp. 14–15.

50. Gerald Kamber, *Max Jacob and the Poetics of Cubism* (Baltimore: Johns Hopkins University Press, 1971), pp. xi–xii.

51. Steegmuller, *Apollinaire,* p. 224 and *passim.* Describing the rupture of her relationship with the poet to a friend, Marie noted, "At the beginning, there was a question of marriage. But Madame de Kostrowitzky, his mother, thought I wasn't rich enough. And after 1911 it was my mother who wouldn't hear of Guillaume. They took turns."

Chapter Five The quotation which heads this chapter comes, once again, from Apollinaire's "The Betrothal" (see Greet, *Alcools,* pp. 170–79).

For the works discussed in this chapter, see Zervos vols. II (parts 1 and 2), VI,

XXVI, XXVIII, and XXIX; Daix, *The Cubist Years;* Duncan, *Picassos*, pp. 206–8; and Spies, *Sculpture,* p. 302 (nos. 24–56).

1. Penrose, *Picasso,* p. 133, and Cabanne, *Picasso,* p. 119 provide varying accounts of Braque's remarks. Everyone agrees that he was startled.

2. Roger Shattuck, *The Banquet Years,* rev. Vintage Book ed. (New York: Random House, 1968), p. 266, is one of many sources who report this story. According to some sources, Apollinaire introduced Picasso to the Douanier Rousseau as well. Whether or not this is so, we know that Picasso purchased a Rousseau in 1908 and subsequently organized a banquet in honor of the elderly artist. I have not discussed Rousseau in the text because there is no indication that he ever exerted a strong influence on Picasso's painting. Picasso was charmed both by Rousseau's art and by his winning personality, as well as by his touching conviction that he and Picasso were the greatest contemporary painters.

3. See William Rubin, "Cézannism and the Beginnings of Cubism," in *Cézanne: The Late Work,* ed. by Rubin (New York: Museum of Modern Art, 1977), pp. 151–202, and William Rubin, "Pablo and Georges and Leo and Bill," *Art in America,* March–April 1979, pp. 128–47. See also Leo Steinberg, "Resisting Cézanne: Picasso's 'Three Women,'" *Art in America,* November–December 1978, pp. 114–33, and Leo Steinberg, "The Polemical Part," *Art in America,* March–April 1979, pp. 114–27. Rubin supports the view that Braque progressed more rapidly toward cubism, while Steinberg holds the opposite view.

4. Barr, *Picasso,* p. 61.

5. Pierre Daix, *Picasso* (Paris: Aimery Somogy, 1964) p. 79.

6. Barr, *Picasso,* p. 66.

7. See Douglas Cooper, *The Cubist Epoch* (London: Phaidon, 1971), p. 36, and Robert Rosenblum, *Cubism and Twentieth Century Art* (New York: Abrams, 1976), p. 37. Both discuss the significance of these works. They perceive the possible influence of the Douanier Rousseau in Picasso's foliage treatment in several of these landscapes. Rousseau's influence is mentioned only in this instance.

8. Olivier, *Picasso,* pp. 132–37. Even twenty-odd years later, when she wrote these memoirs, Fernande seemed unable to admit to herself how important Braque had been to Picasso. In fact, she consistently underemphasizes the significance of both Braque and Apollinaire for the artist. Picasso shared her ambivalence about leaving the Bateau-Lavoir; for several years, he continued to rent a studio there, which he used as a storage-house for his paintings. Gilot, *Life,* pp. 81–82, describes a sentimental pilgrimage to the Bateau-Lavoir with Picasso during the first months of their romance. His behavior there led her to conclude that the building had come to represent his "golden age" to the painter.

9. A detailed account of Jacob's conversion is provided by Andeu, whose *Max Jacob* is part of a series of texts devoted to famous conversions. The intensity of Picasso's relationship with Braque probably affected all his other relationships. Apollinaire and Picasso continued to be close friends, but it seems doubtful that their association was as intense as it had been. Apollinaire, for his part, had plenty to distract him. Between 1908 and 1914 he was at the height of his creativity as a poet. He was also involved in his lengthy, passionate, and maddening love affair with Marie Laurencin. Picasso remained close to Jacob and Stein, but he may have

seen less of other writer friends than formerly. At any rate, his circle of intimates now included several painter pals of Braque's, especially Derain and Vlaminck who saw Picasso frequently until the war erupted.

10. Gilot, *Life*, pp. 76–77.

11. See Kohut, *Analysis*, pp. 122–25 and passim.

12. Ibid.

13. Doris Vallier, "Braque: La Peinture et Nous," *Cahiers d'Art* vol. 1 (Paris, 1954), p. 14. The original French text reads:

"A cette époque j'étais très lié avec Picasso. Malgré nos tempéraments très différents, nous étions guidés par une idée commune. On l'a bien vu par la suite, Picasso est Espagnol, moi je suis Français; on sait toutes les différences que cela comporte, mais pendant ces années-la les différences ne comptaient pas . . . Nous habitions Montmartre, nous nous voyions tous les jours, nous parlions . . . On s'est dit avec Picasso pendant ces années-là des choses que personne ne se dira plus, des choses que personne ne saurait plus se dire, que personne ne saurait plus comprendre . . . des choses qui seraient incompréhensibles et qui nous ont donné tant de joie . . . et cela sera fini avec nous. [J'ai entendu ici la voix de Braque trembler un instant.]

C'était un peu comme la cordée en montagne . . . Nous travaillions beaucoup tous les deux . . . Les musées ne nous intéressaient plus. Nous allions voir des expositions, mais pas tellement qu'on la croit. Nous étions surtout très concentrés."

14. Gilot, Interview, September 3, 1977.

15. Barr, *Picasso*, p. 69; Richardson, *Picasso*. Picasso related a slightly different story to Daix. See *Cubist Years*, p. 252 (no. 330). Picasso told Daix: "It was painted in the studio without a model. Afterwards, with Braque, we said that it was a portrait of him. He wore a hat a bit like that."

16. Harold Rosenberg, "The Cubist Epoch," *The New Yorker*, May 8, 1971, p. 104. Rosenberg maintains that every cubist painting is a mask which covers the model or the still life, a mask "composed of the model's own vital substance, as was the case with the mask-portrait of Gertrude Stein from which Picasso moved on to cubism." Kurt Eissler's theory that the artist's most central conflicts and experiences may be so charged that they do not appear in his art probably is relevant to a consideration of Picasso's use of a substitute for Braque as a model for the latter's portrait. See Eissler; *Goethe: A Psychoanalytic Study*, 2 vols. (Detroit: Wayne State University Press, 1963), 2: 699.

17. Daniel-Henry Kahnweiler, *The Rise of Cubism* (New York: Wittenborn, Schultz, 1949). (Originally published as *Der Wëg zum Kubismus* [Munich: Delphin-Verlag, 1920]).

18. Olivier, *Picasso*, p. 144, comments that the artist spent a long time on these portraits, especially Vollard's. Penrose, *Picasso*, p. 168, notes that Kahnweiler clearly recalled the innumerable hours he was required to pose.

19. Barr, *Picasso*, p. 73. The drawing and the tracing with its underlying outline appear on p. 94.

20. Gilot, *Life*, p. 73.

21. John Golding, *Cubism: A History and an Analysis*, rev. ed. (Boston: Boston Book & Art Shop, 1968), p. 73.

22. Daniel-Henry Kahnweiler with Francis Crémieux, *My Galleries and Painters,* trans. Helen Weaver, Documents of 20th Century Art (New York: Viking, 1971), p. 94.

23. See chapter 7, p. 117, for a description of Picasso's reaction to Apollinaire's death and its effect on the artist's treatment of his subsequent self-portraits. Picasso's image magic rather recalls the behavior of primitive tribesmen who, believing that photographic images capture the soul, refuse to be photographed.

24. William Rubin, *Picasso in the Collection of the Museum of Modern Art* (New York: Museum of Modern Art, 1972), pp. 70, 206–9.

25. Ibid., pp. 72, 206. Gertrude Stein, *The Autobiography of Alice B. Toklas* (New York: Harcourt, Brace, 1933), p. 136.

26. Gilot, *Life,* p. 177, provides a hilarious account of the coded notes and oblique references that Picasso and Sabartés exchanged at a time when the latter was his secretary and they certainly did not need to exchange information by message. When one reads Gilot's description, one can understand why Sabartés's information in the biographies of Picasso often seems so unclear.

27. Georges Braque, Eugène Zolas, et al., *Testimony against Gertrude Stein* (The Hague: Surire Press, 1935), pp. 13–14. Italics mine. Kahnweiler, in *My Galleries,* pp. 45–46, insists that both artists always signed their paintings on the back so that there was never any confusion, a statement at odds with many other versions, including the statement by Braque quoted here. Daix and Rosselet, in the catalogue raisonné section of *Cubist Years,* provide details concerning the signatures on all the Picasso paintings catalogued, and it is clear that the artist's practices during this period were far less consistent than Kahnweiler remembered them.

28. Olivier, *Picasso,* pp. 129, 144, and passim. Whether Picasso really had an ulcer is difficult to ascertain in the absence of the necessary medical data.

29. Briefly, the facts of the complex story are as follows: In 1907 the kindly Apollinaire had employed a young Belgian n'er-do-well, Gery Pieret, as a kind of secretary. As a grandiose prank, Pieret stole some statuettes from the Louvre; subsequently, he sold two of them to Picasso, who must have guessed their origin. In 1911, shortly before the *Mona Lisa* was stolen from the Louvre, Pieret reappeared on Apollinaire's doorstep after an absence of several years. He had just stolen another Iberian statue from the Louvre. Apollinaire refused to keep it, although he did shelter Pieret for a few days, until the latter fled Paris. Before departing, he turned over his Iberian statue to the *Paris Journal,* which published the event. Shortly thereafter, the theft of *Mona Lisa* was announced. Apollinaire was sure Pieret had taken it; frightened, Apollinaire persuaded Picasso that they must return the latter's stolen statues to the Louvre. Finally, one of them took these sculptures to the *Paris Journal* office, too. Soon after, Apollinaire was arrested. The police evidently were convinced that Pieret belonged to an international art-theft ring and wanted to find out how implicated the poet was and how much he knew about Pieret. Picasso was called to the police station to corroborate Apollinaire's story about the statues. Apparently Picasso became so terrified that he disclaimed all knowledge and probably also denied that he knew Apollinaire. Although Apollinaire was never formally charged and was released from jail after a few days, the

incident left a cloud on his reputation and made it difficult for him to enlist in the French army in 1914. The most complete account appears in Steegmuller, *Apollinaire,* pp. 182–220, but see also Olivier, *Picasso,* pp. 148–50.

30. Olivier, *Picasso,* pp. 148–50.

31. Barr, *Picasso,* p. 273, reprints a 1935 statement by Picasso insisting that there is no abstract art.

32. Stein, *Autobiography,* p. 136. Vague about dates, as usual, Stein does note that the first time Toklas and she called on Picasso after he had reestablished his studio at the Bateau-Lavoir, he was working on the first of his *Ma jolie* canvases; most probably, he moved during the late winter of 1911–12.

33. In *The Cubist Years,* Daix confirms my hunch that *The Letter* probably was the first collaged canvas. However, he calls the *Still Life with Chair Caning* the first "intentional" collage. See pp. 275 (no. 451) and 278 (no. 466).

34. Picasso jokingly called Braque "mon cher Wilbur," the name of the older Wright brother. The history of genetically identical twins usually reveals that one of the pair assumes the dominant role, even though their heredity, and hence their abilities, must really be equal. Several hints suggest that Picasso may have awarded Braque this status. Not only did he address him as "Wilbur," but Stein, *Picasso,* p. 92, notes that he also called Braque "mon cher maître," in imitation of Gris' obsequious form of address for Picasso. The matter may have been more serious than Stein realized. Even the story that Picasso addressed Braque as "ma femme" does not contradict this theory—in Picasso's family, his mother was the dominant parent. Rubin, in "Pablo and Georges," p. 147, note 51, reproduces a newspaper clipping which reveals that a brief review of an exhibit of Braque's work in 1908 appears just before the heading "La conquête de l'air," an account of a prize "de la hauteur" won by Wilbur Wright that same year.

35. It probably is not a coincidence that during these same weeks, Picasso painted three still lifes featuring wounded or dead pigeons. In this period of crisis, when he changed mistresses, perhaps it was comfort he sought in returning to this motif so intimately associated with his father.

36. Cabanne, *Picasso,* pp. 147–53, presents some material about Eva not given by other sources. He claims that her real name actually was Eva, not Marcelle. Apparently Humbert was her married name, Gouel her maiden name, but no one seems too certain about this aspect of Eva's history. Cabanne describes her as a petite-bourgeoise who hated the Bohemian life. If so, it is interesting that she repeatedly allied herself with painters, seldom the most conventional men. Cabanne also comments that she was very practical minded, aiming first of all at security and quite able to manage a budget and household—unlike the spendthrift Fernande.

Daix, *Cubist Years,* p. 279, provides details about Picasso's brief, stormy sojourn at Céret, where the Pichots attacked him for his change of mistresses. Since many critics believe that Germaine Pichot had briefly been Picasso's mistress many years before—see chapter 3 for details—her indignation over Picasso's new love seems intriguing, particularly since most sources describe the artist as so madly in love with Eva.

37. Daix, *Cubist Years;* see particularly his discussion and catalogue entries for 1912 and after, beginning on p. 81 of the text and p. 274 of the catalogue.

38. Daix states (Ibid., p. 131) that Picasso did not see Braque at all for the six months or so that Picasso and Eva spent at Céret that summer. He also claims that Picasso and Gris were actually closer than Picasso and Braque by this time. Daix attributes the chill in the Picasso-Braque relationship to "the extraordinary revolution in painting which Picasso brought about by his increased use of *papiers collés*" (p. 131). Other sources place Braque in contact with Picasso that summer. Cabanne, *Picasso*, p. 165, states that Picasso had a large group of friends around him that summer in Céret, and he specifically mentions the Braques, a version of events which corresponds with that given by other biographers. Daix does not state his sources for his differing version, but he does note that it is difficult to reconstruct the chronology of this period. It seems to me quite unlikely that Picasso would really have spent six months without seeing Braque that summer; they summered together in 1912 and again in 1914. I have not discussed Picasso's relationship with Gris in any detail in the text because that entire relationship needs further investigation. Cabanne, *Picasso*, p. 165, attributes their eventual rift to Picasso's competitiveness, a version also espoused by Stein. Daix includes two landscapes in his catalogue of the 1913 works (nos. 612–13, p. 303) which he points out as examples of Gris' influence on Picasso. They certainly seem radically different from the latter's other canvases painted at that time.

39. Cabanne, *Picasso*, pp. 164–65. Brassaï, *Picasso and Company*, trans. Francis Price (New York: Doubleday, 1966), p. 253, reports the information about Matisse, given to him by the artist's daughter. Gilot, *Life*, p. 365, reports the incident involving Picasso's son. While the latter lay ill in Paris, his mother died alone; although Picasso had remained in contact with her and made her funeral arrangements, he evidently refused to visit her on her death bed.

40. Stein, *Picasso*, p. 12.

41. Daix, *Cubist Years*, pp. 164–66 (no. 763), 333.

42. This young man does bear a generic resemblance to André Derain, an enormous man who did wear a moustache similar to that depicted on Picasso's figure. Picasso was quite close to Derain and his wife, although not influenced particularly by the French artist. In chapter 6 I mention other pictorial references to Derain which occurred in Picasso's work that summer at Avignon.

43. Gilot, personal correspondence, February 21, 1978.

44. Spies, *Picasso*, pp. 48–49.

Chapter Six

The quotation for this chapter comes from Apollinaire's "Rhenish Night," *Alcools*, Greet translation, pp. 142–43. For works of this period, see Zervos, vols. II (pt. 2), III, IV and VI; and Spies, *Sculpture*.

1. Kahnweiler, *My Galleries and Painters*, p. 54.

2. See Zervos, XXIX, 107–10, 122. The dog appears to be a German shepherd, a breed Picasso owned during this period, and which appears in a contemporary photo with Eva. Zervos illustration no. 112 shows this dog with another canine identified as André Derain's dog. Did Picasso sketch their two dogs as a substitute for a joint portrait of Derain and himself? These pictures, dated 1914, were almost certainly executed at Avignon, perhaps shortly before Derain left for army duty

(assuming he did not leave his dog behind in Picasso's care, which is also possible).

3. Picasso wrote Gertrude Stein on January 8, 1916: "Ma pauvre Eva est morte . . . une grande douleur pour moi . . . elle a été tout jours [sic] bonne pour moi." (My poor Eva is dead . . . a great sorrow for me . . . she was always so good for me.) Elizabeth Sprigge, *Gertrude Stein: Her Life and Work* (New York: Harper, 1957), p. 110.

4. Barr, *Picasso,* p. 93.

5. Ibid., p. 261.

6. Olivier, *Picasso,* p. 138.

7. Golding, *Cubism,* pp. 85–86.

8. Cooper, "Cubist Epoch," pp. 104–5.

9. Sprigge, *Stein,* p. 110.

10. Ibid.

11. In response to a query, Gilot wrote on February 21, 1978, that when she asked Picasso about Eva, he showed Gilot Eva's photograph "and said that he had loved her deeply but would not make any further comments." Gilot also noted that she did not discuss Eva in her book because she chose to relate only what she had directly witnessed.

12. In *Le poète assassiné,* published in 1916, Apollinaire castigated Picasso, who appears in the guise of "l'oiseau du Benin" as a false friend and fickle lover. Prophetically, Apollinaire describes how the Benin bird carves a monument for the assassinated poet (who apparently represents Apollinaire himself); many years later, Picasso did receive the commission to create a sculptural monument for Apollinaire. In *La femme assise,* published posthumously, the poet made further unflattering references to a Spanish painter "with the celestial blue hands" who appears in one segment of the story.

13. Francis Steegmuller, *Cocteau: A Biography* (Boston: Atlantic Monthly Press, Little Brown, 1970). p. 137.

14. Ibid., p. 138.

15. Stein, *Alice B. Toklas,* p. 208, alludes to Picasso's promiscuity during this period.

16. Steegmuller, *Cocteau,* p. 174.

Chapter Seven The title for this chapter comes from Apollinaire's poem "Sign." See Greet, *Alcools,* p. 165.

The paintings and drawings referred to in this chapter are illustrated in Zervos, vols. III–VII, XXIX, and XXX. See also Duncan, *Picassos,* pp. 208–11. For the sculptures, see Spies, *Sculptures,* p. 302 (nos. 57–65).

1. Steegmuller, *Cocteau,* p. 177.

2. Picasso explored the artistic treasures of Rome, Naples, and Florence with characteristic energy; like his idol Ingres, he apparently was most impressed with Raphael. For descriptions of his Italian journey, see Boeck and Sabartés, *Picasso,* 52.

3. The most satisfactory photographs of the original *Parade* curtain and costumes (the latter have disappeared and exist only in copies) can be found in Douglas Cooper, *Picasso Theater* (Paris: Editions Cercle d'Art, 1967), illustrations 72–212.

Boris Kochno, *Diaghilev and the Ballets Russes,* trans. Adrienne Foulke (New York: Harper and Row, 1970), p. 123, reports that when Diaghilev revived *Parade* in 1923, he asked Picasso to retouch the curtain, which had suffered mildew damage. After examining it, the artist refused, explaining that in its deteriorated state it seemed more like the Pompeian frescoes and was the better for it. Recently, the Joffrey Ballet has revived *Parade* with duplicates of Picasso's curtain and costumes; many of the latter, rendered in modern synthetic fabrics, surely must create quite a different effect from the originals.

4. Frederick Brown, *An Impersonation of Angels: A Biography of Jean Cocteau* (New York: Viking Press, 1968), p. 142. Brown documents his theory about the Picasso-Cocteau rivalry by referring to Picasso's famous statement that Cocteau was merely the tail of his (Picasso's) comet. However, the artist made this statement many years after he had collaborated with Cocteau on *Parade.* Brown also alludes to material presented in Serge Lifar's *Serge de Diaghilev: His Life, His Work, His Legend* (New York: G. P. Putnam's Sons, 1940), but this account reveals much more about Lifar's attitudes toward Massine than about the Picasso-Cocteau rivalry. Lifar's description does emphasize the important role Cocteau played in the evolution of the choreography for *Parade,* but since the choreographer was Massine, Lifar's recollections may be somewhat biased. He says relatively little about Picasso's role in *Parade's* creation, except to praise his avant-garde costume designs. See pp. 214–15 and passim.

5. Poor Cocteau was simply ahead of his time in introducing extraneous noises into ballet music. Satie, incidentally, never came to Rome; he planned to do so but at the last moment felt unable to leave Paris. He hated Cocteau's noises, however, and his sentiments were well known to the other collaborators.

6. Steegmuller was unable to determine who had commissioned Apollinaire to write this note. The biographer suggests that this commission could have originated with Picasso, Cocteau, or Misia Sert (an influential figure in Parisian artistic circles of the period; she much admired the ballet). See *Cocteau,* pp. 182–83. Steegmuller reproduces a translation of Apollinaire's brief note in its entirety as Appendix 7, pp. 513–14.

For a more balanced account of Cocteau's contributions, see the unpublished paper, "Parade: Reflections on a Cubist Ballet," presented by Richard Axson of the University of Michigan at the graduate seminar held at the Art Institute of Chicago, April 17, 1971.

7. Steegmuller, *Cocteau,* p. 191, believes that *Parade* transformed Picasso into "the most famous painter in the world." Cocteau, at least as gifted a creator of personal mythology as Picasso, apparently exaggerated the extent of the public's negative reaction to *Parade.* Neither Steegmuller nor Brown could uncover evidence of the near-riot and threats of bodily harm with which Cocteau retrospectively embellished his accounts of the première. Like many other appealing myths, however, Cocteau's account has become the accepted version of reality. See Brown, *Cocteau,* pp. 147–48, and Steegmuller, *Cocteau,* pp. 186–87.

8. It seems unlikely that Picasso actually saw as many dancers in commedia dell'arte costume as his work would suggest. The Ballet Russe concentrated on "modern" works, and on ballets with exotic Near-Eastern settings. *Carnival* was probably the

only ballet in their repertory which featured Harlequin until Picasso's own *Pulcinella* had its premiere in 1920. Perhaps Picasso had Massine pose in Cocteau's old Harlequin costume. In 1923 Picasso painted canvases of Harlequin posed by the Spanish painter Salvado, who wore Cocteau's costume. See Kochno, *Diaghilev,* for extensive discussion of the ballet's repertory during these years. Cooper, *Theater,* pp. 43–44, indicates that Picasso and Stravinsky haunted the Neopolitan commedia dell-arte performances during the weeks the troupe spent in Naples during the spring of 1917.

9. Steegmuller, *Cocteau,* p. 181, reports that Cocteau felt like an outsider intruding upon the new intimacy of Picasso and Stravinsky.

10. For a similar reaction to this painting, see Penrose, *Picasso,* p. 225.

11. Ibid. The symbolism of the gored horse occurred often during Picasso's marriage to Olga. Beginning in 1933, Picasso used it in a more deliberate way to symbolize the destructive aspects of his relationship to Marie-Thérèse Walter, as well as to Olga. Françoise Gilot relates that after she left Picasso, the latter requested that, as a final gesture, she open a bullfight given in his honor by riding a horse into the ring and executing a complex series of maneuvers. He reportedly explained, "For me the bull is the proudest symbol of all, and your symbol is the horse. I want our two symbols to face each other in that ritual way" (Gilot, *Life,* p. 362). The fact that Picasso sometimes depicted the horse as a stallion need not contradict its female symbolism. In fact, in Olga's case the choice seems especially appropriate because she showed such masculine aggressiveness and ferocity of character. Perhaps Picasso felt he dominated their situation only when they had intercourse, and he could become the stud bull. He executed another series of such bull-horse drawings on March 25, 1921. One wonders whether they commemorate the date on which Olga and he resumed their sexual relationship following Paul's birth.

12. Sabartés, *Documents,* photo no. 118.

13. Apollinaire, as we have seen, underwent a marked personality change after he suffered the head wound, probably as the result of both psychic and physiological trauma. Braque, who suffered a temporary blindness following his injury, also required a long convalescence. When he resumed a more active routine, he behaved, appropriately, as a middle-aged man; he settled into a quiet bourgeois existence which he maintained for the remainder of his life.

14. For a discussion of regression and the manner in which it can affect certain areas of functioning while sparing others, see John E. Gedo and Arnold Goldberg, *Models of the Mind: A Psychoanalytic Theory,* foreword by Roy R Grinker, Sr. (Chicago: University of Chicago Press, 1973), pp. 113–14, 166–67, and 186. For a more extensive discussion consult Arnold Modell, *Object Love and Reality* (New York: International Universities Press, 1968).

15. Gilot, *Life,* p. 148. Jean Paul Crespelle, *Picasso and His Women,* trans. Robert Baldick (New York: Hodder and Stroughton, 1969), pp. 121–22, and Penrose, *Picasso,* p. 225, both imply that Olga was extremely stubborn and determined to settle for nothing but marriage. Both Diaghilev and Bakst tried to apprise Picasso of the truth about Olga's personality. Later, Picasso acknowledged to Stein how weak he always felt before the intractable Olga (Stein, *Everybody's Autobiography,* p. 14–15). Paradoxically, Picasso probably also admired Olga's

persistence, at least during the first years of their marriage. He always respected those who ruthlessly pursued their goals, despite any obstacle.

16. One should not ignore, either, the coincidence between Picasso's behavior and that of his father. Both men led lively bachelor's existences into their late thirties, when each entered into a stultifying marriage. Although no one has discussed this possibility, Olga actually may have been the first of Picasso's mistresses who was eligible to marry. Fernande was separated, but not divorced, from her psychotic husband when she met Picasso. She apparently never apprised the latter of her husband's existence, and several biographers report that Picasso wanted to marry her and could not understand her stubborn refusal to accept him. Eva's maiden name was Gouel, not Humbert. It is not clear whether Eva ever divorced Humbert or not. Cabanne's statement in *Picasso* (p. 150) that she alleged "not quite truthfully" that Humbert was the name of her divorced husband seems enigmatic. One doesn't know whether she invented the marriage or the divorce. Other sources, however, claim that she was married.

17. Picasso first made extensive use of the monkey in circus-period pictures of 1905, where it appears a number of times. He made the monkey-self fusion explicit in drawings of 1954, in which a monkey replaces the artist at the easel, a conceit he may have borrowed from Goya, although the latter was not the first to portray the artist as nature's ape.

The descriptions of Olga's behavior which led me to suggest the connection between her activity and the reiterative quality of the commedia dell'arte derive primarily from the period after the Picassos had separated. According to Gilot and others, Olga haunted her estranged husband, popping in on his life unexpectedly, exactly like a character from the commedia dell'arte. Picasso and she replayed the same scenes endlessly until her death put a stop to the performance. See Gilot, *Life,* pp. 207–11, in which Gilot describes Olga's bizarre behavior and Picasso's amazing tolerance.

18. Hess, "90th Birthday," p. 5. Picasso's magical beliefs were legend, and Gilot cites many examples. For just one, see *Life,* p. 229, in which she describes how furious the artist became because she gave away some of his old clothing to their crippled gardener. Picasso accused her of doing this to turn him into a hideous, aged cripple like the gardener (who was actually many years Picasso's junior). Such anecdotes reveal, again, the instability of Picasso's body image.

19. Stein, *Alice B. Toklas,* p. 74, makes the interesting suggestion that, had Apollinaire lived, he might have kept the group together, but "now that he was gone everybody ceased to be friends."

20. Picasso also dressed in dandyish fashion during the height of the blue period in 1902–3. As an elderly man, he indulged in picturesque clothes and often donned costumes and masks. One suspects that this love of play acting coincided with his regression to a more child-like role during his last years. Such interests also fit with his earlier preoccupation with the circus and theater, as well as the commedia dell'arte. His fascination with alterations in identity through such props again reflects his profound vagueness of self-concept and body image.

21. Barr, *Picasso,* p. 106.

22. Penrose, *Picasso,* p. 245. The first instance of this new type of body distor-

tion appeared, significantly enough, in drawings Picasso created during his honey-moon. He sketched the toddler daughter of his dealer, Paul Rosenberg, as a gro-tesquely fat little being with much longer limbs than a child that age would normally have (Z., III, 238, 240, 242). Many other examples also occurred in the drawings after photographs and postcards which he made in 1919; for example, the sketches showing a Neopolitan fisherwoman (later the basis of the *Pulcinella* costume designs) transforms this lady into an Amazon with beefy arms and huge hands (Z., III, 243–46).

23. Barry Farrell, "His Women: The Wonder Is That He Found So Much Time to Paint," *Life*, special Picasso double issue, December 27, 1968, p. 72.

24. Penrose, *Picasso*, p. 245.

25. Gilot, *Life*, p. 119.

26. Ibid., p. 148.

27. Barr, *Picasso*, p. 118.

28. Gilot, *Life*, p. 149.

29. Barr, *Picasso*, p. 120.

30. Willard W. Misfeldt, "The Theme of the Cock in Picasso's Oeuvre," *Art Journal* 28, no. 2 (1968–69): 148.

31. Pierre de Champris, *Picasso: Ombre et soleil* (Paris: Librairie Gallimard, 1960), pp. 59–63, argues that this picture represents an amalgamation of a detail from Poussin's *Rebecca and Eliezer*, with a section of the Louvre's Parthenon frieze fragment showing the procession of the maidens.

32. Barr, *Picasso*, p. 115, discusses the conscious sophistication which seemed to be involved in Picasso's return to classical forms.

33. During 1923, Jean Cocteau composed *Plain Chant*, modeled on sixteenth-century French Renaissance verse forms. It may not be a coincidence that, during the same year, Picasso painted so many pictures which seemed to de Champris reminiscent of works by Leonardo, Holbein, and so forth. See de Champris, *Picasso*, pp. 79–84. Nor was this return to classicism confined to Picasso and Cocteau; this revived interest in classicism swept the fine arts following World War I.

34. De Champris, *Picasso*, pp. 77–78.

35. In 1929 Picasso painted two additional versions of Paulo as Pierrot, but these pictures apparently were not painted from the living model. In fact, they probably derive from the 1925 version; at least, Paulo appears no older in these works of 1929 than in the 1925 picture.

36. Gilot, *Life*, offers many examples of Picasso as a father. On p. 257, she notes specifically that the two children "almost never saw their father."

37. Penrose, *Picasso*, p. 258, reports that Picasso never approved of the title *The Three Dancers*, acquired by this painting, because "for him it was above all connected with his misery on hearing of the death of his old friend the painter Ramón Pichot, whose profile appears as a shadow against the window on the right of the canvas."

38. This new expressionistic quality was apparent in nascent form in a pair of pictures Picasso painted in 1924. The complexity and intensity of *The Birdcage* (Z., V, 84) might justify labeling it proto-expressionist. This motif of the caged bird was repeated in another canvas (Z., V, 456), which showed a bird helplessly

chirping and flapping his wings at a plaster female head resting impassively near his cage.

39. Penrose, *Picasso,* pp. 259–61.

40. The tenuous nature of Olga's adjustment and responsiveness must have been at least preconsciously evident to Picasso from the very beginning of their relationship. Even these early portraits of Olga, whether more realistic or more idealized, often portray her as seemingly preoccupied or withdrawn. Instances of these self-absorbed, perhaps even depressed, depictions of Olga abound in Zervos volumes IV and V, which the interested reader should consult.

Chapter Eight

The title for this chapter comes from Guillaume Apollinaire's poem "Autumn," again from the Greet translation of *Alcools,* p. 129.

The works referred to in this chapter may be found in Zervos, vols. VII and VIII; Duncan, *Picassos,* pp. 212–18; Spies, *Sculpture,* pp. 302–4 (nos. 66–169). The prints discussed are reproduced in *Picasso's Vollard Suite,* Introduction by Hans Bolliger, trans. Norbert Guterman (New York: Harry N. Abrams, 1977).

1. See for example, Robert Rosenblum, "Picasso and the Anatomy of Eroticism," in Theodore Bowie, et al., *Studies in Erotic Art* (New York and London: Basic Books, 1970), pp. 339 ff. Rosenblum addresses himself to the threatening aspects of the image of female sexuality, which he believes dominates the artist's work during the late 1920s. John Golding, "Picasso and Surrealism," in Roland Penrose and John Golding, eds., *Picasso in Retrospect* (New York: Praeger, 1973), pp. 77 ff., also relates this imagery to Picasso's difficulties with Olga.

2. Berger, *Success,* p. 146.

3. Gilot, *Life,* p. 154.

4. See Rosenblum, "Anatomy of Eroticism," pp. 341–42; and Golding, "Surrealism," p. 100.

5. Gilot, letter, February 21, 1978.

6. Farrell, "His Women," p. 74. Marie-Thérèse provided a somewhat more prosaic—and probably accurate—account to Pierre Cabanne, who seems to have interviewed her extensively for his book *Picasso.* According to Cabanne, the historic meeting occurred on January 8, 1927, and the painter said, "Miss, you have an interesting face. I would like to paint your portrait. I am Picasso." Cabanne states that it was not until their second meeting, which occurred by pre-arrangement at St. Lazare subway station, that Picasso uttered that immortal line, "We will do great things together" (p. 265).

7. Rubin, *Picasso,* p. 130.

8. The book contains thirteen etchings by Picasso and sixty-seven wood engravings made by Aubert from Picasso's drawings, including sixteen of these abstract sketches plus a wide selection of other sketches, both cubistic and classical.

9. Penrose, *Picasso,* p. 261.

10. Josephine Withers, "The Artistic Collaboration of Pablo Picasso and Julio Gonzalez," *Art Journal* 30, no. 2 (Winter 1975–76): 107.

11. Ibid., p. 112. See also, Spies, *Sculpture,* pp. 73–74.

12. Compare, for example, his total output in 1931 with his much greater pro-

ductivity in 1932. When Picasso was in top form, he could turn out quantities of works in a variety of media.

13. See Withers, "Collaboration," pp. 111–12, and Gilot, *Life,* pp. 323–24.

14. Quoted in Withers, "Collaboration," p. 112.

15. Serge Lifar notes, without explanation, that in 1929 Olga was so "exceedingly ill" that Picasso could spend little time with his dying friend, Serge Diaghilev. See Lifar, *Diaghilev,* p. 343.

16. The most complete discussion of this picture is provided by Ruth Kaufmann, "Picasso's Crucifixion of 1930," *Burlington Magazine* 111 (September 1969); 553–61.

17. Leo Steinberg, "Picasso's Sleepwatchers," in *Other Criteria: Confrontations with Twentieth Century Art,* reprint ed. (New York: Oxford Press, 1976), pp. 103–4.

18. If Picasso did not know the references to the bull as earthshaker in Greek myths and dramas, especially the *Hippolytus* of Euripides, he almost certainly knew the French version of the latter drama, the *Phèdre* of Racine.

19. Sabartés, *Portrait,* pp. 87–89; Olivier, *Picasso,* p. 53.

20. Gilot, *Life,* pp. 255–56.

21. Ibid and passim.

22. One wonders whether Picasso was also attracted to this painting because its peculiar motto (John the Baptist points to Christ as if saying the words which appear imprinted on the picture, "He grows, I shrink") so closely parallels the content of the artist's childhood nightmares.

23. Penrose, *Picasso,* p. 277.

24. In a letter to Gilot, I mentioned the prevalence of the rescue theme in conjunction with images of Marie-Thérèse. She responded on September 2, 1979, with a description of Marie-Thérèse's athletic abilities. Gilot noted, however, that despite Marie-Thérèse's exceptional swimming skills, she had once fainted in the water and nearly drowned. Picasso, evidently present at the incident, later wrote "something cryptic like 'Ophelia is drowned in a drop (or a cup) of water.' " Picasso's comparison of this incident with the drowning of Ophelia makes one wonder whether he suspected—or knew—that it had actually been a suicide attempt? At any rate, physicians assure me that one cannot "faint" in the water; indeed, an old-fashioned remedy for a fainting spell consisted in dashing water in the victim's face to revive her.

25. In medieval manuscripts and stained-glass windows, the ancestry of Christ is frequently depicted by showing the sleeping figure of Jesse, from whose abdomen a tree with his progeny, including the ancestors of Christ, sprouts.

26. Berger, *Success,* p. 158.

27. Ibid., p. 155.

28. Ibid., p. 160.

29. *Picasso's Vollard Suite,* Intro. by Hans Bollinger, trans. Norbert Guterman (New York: Harry N. Abrams, 1977), plates 37–82.

30. My interpretation that Marie Thérèse's limitations eventually frustrated and enraged Picasso is based first and foremost on the visual evidence present in his work. However, I also possess a good deal of unpublished information about her

which I am not at liberty to divulge. I can only ask the reader to trust me when I assert that Marie-Thérèse was a deeply troubled individual whose behavior often betrayed her lack of reality testing. She possessed to a remarkable degree the ability to cling tenaciously to the artist, or at least to her image of what he was really like.

31. Palau I Fabre, *Cataluña*, p. 194. O'Brian, *Picasso*, pp. 296–97, claims that Marie-Thérèse was Picasso's companion on both trips. One might cite additional sources for each theory.

32. Farrell, "His Women," p. 74.

33. Ibid. Cabanne, who evidently interviewed Marie-Thérèse extensively, provides further details about her personality and characteristic mode of speaking (*Picasso,* pp. 265–67 and passim).

34. Frank Perls, "The Last Time I Saw Pablo," *Art News* 73, no. 4 (April 1974): 38. His description of Marie-Thérèse's peculiar behavior correlates closely with the description which my source provided. See also Gilot, *Life,* pp. 208–9.

35. Roland Penrose, *The Sculpture of Picasso,* with a chronology by Alicia Legg (New York: Museum of Modern Art, 1967), pp. 15–16. Spies, *Picasso,* p. 304 (Nos. 156–59).

36. At the time of their marriage, Olga and Picasso signed a community-property agreement which specified that the couple would share all assets (including Picasso's unsold paintings) in case of a divorce. Several biographers suggest that this document acted as a strong impediment to Picasso's determination to secure a divorce. The fact that the artist signed such an agreement certainly reveals how prescient, as well as how formidable, Olga was. However, the document also provided the artist with a built-in rationalization to support what I am convinced was a deep-seated reluctance to sever his marriage.

After their separation, Picasso evidently continued to supply Olga with support money until her death, but he elected not to provide such sums in an automatic, impersonal manner. Gilot, *Life,* p. 208, describes how Olga followed Picasso, demanding to speak to him, frequently only to reveal that her hotel bill was in arrears and, again according to Gilot, to threaten the artist with bodily harm if he failed to pay up immediately! The fact that Picasso arranged his affairs in this manner provides another indication of his reluctance to sever all personal contact with Olga. Cabanne claims that in 1939 Picasso began to visit Olga regularly again, even though these visits put him into a terrible mood, "[d]espite his delight in seeing Paulo, the official reason for the renewed contacts" (*Picasso,* p. 335). When she left their apartment, Olga and Paulo took up residence in a hotel very close to their old home. Perhaps Picasso visited her much earlier in their separation than 1939. We have no firm evidence about this, but it seems likely that Picasso would have maintained regular contact with Paulo just as he later regularly visited his daughter by Marie-Thérèse.

37. Quoted in Boeck and Sabartés, *Picasso,* p. 214.

38. Brassaï, *Picasso,* p. 42.

39. Sarbartés, *Portrait,* pp. 103–6. Gilot, *Life,* pp. 166–67, says that Sabartés brought his new wife to Paris, a childhood sweetheart he had married just before leaving Barcelona. If so, she certainly saw little of Sabartés once they moved to

Paris, although, again according to Gilot, Mme. Sabartés supervised the household for Picasso. Sabartés himself, always the soul of discretion, does not mention his feminine companion.

40. Sabartés, *Portrait,* pp. 105–6; Gilot, *Life,* pp. 153–56.

41. Stein, *Everybody's Autobiography,* p. 37, and Stein, *Picasso,* p. 46.

42. Sabartés, *Portrait,* p. 127.

43. Duncan, *Picassos,* p. 87.

44. Earlier, in August 1932, Picasso had portrayed Marie-Thérèse as a ball-player on the beach (Z., VIII, 147) in a delightful, yet not altogether flattering, presentation of her as a surrealistic, balloon-like figure. Many sources describe her mania for athletics; she was an avid bicyclist and gymnast.

45. Duncan, *Picassos,* p. 111.

46. Sabartés, *Portrait,* p. 130.

Chapter Nine The title for this chapter derives from Guillaume Apollinaire's poem "Flower Picking," as translated by Roger Shattuck, *Selected Writings of Guillaume Apollinaire* (New York: New Directions, 1971), p. 205.

The works referred to in this chapter are illustrated in Zervos, vols. VIII through XII; and in Duncan's *Picassos,* pp. 79–115 and 218–43. For the sculptures, see Spies, *Sculptures,* pp. 304–6 (nos. 168–200).

1. Penrose, *Picasso,* p. 291.

2. Paul Eluard, *Les yeux fertiles* (Paris: G. L. M., 1936). The etching plate consists of a portrait of Nush Eluard, a vision of a grotesque bird-woman who stares at the sun (a self-image of the artist, who believed he could look directly at the sun?), an imprint of Picasso's hand, and a portrait of the sleeping Marie-Thérèse, crowned with a floral wreath.

3. Brassaï, *Picasso,* pp. 42–43. Everyone emphasizes that Dora was a difficult personality, subject to irrational outbursts of temper and to strange moods. It seems likely that she was a borderline person long before she had her overt breakdown of 1945. Penrose, *Picasso,* p. 298, points out that Dora Maar's father had spent many years in the Argentine, and that she was fluent in Spanish as well as in French, so Picasso could converse with her in his native language.

4. Penrose, *Picasso,* p. 301.

5. Duncan, *Picassos,* pp. 219–28.

6. This detail is reported by Cabanne, pp. 291–92 and passim.

7. Gilot, *Life,* pp. 210–11, describes the pleasure with which Picasso related watching Dora and Marie-Thérèse wrestle over him. The similarity between her description and a drawing by Goya from 1797, showing two Majas wrestling on the ground while their Majo laughs, make me wonder whether Picasso did not invent this particular story, after the Goya drawing. This work belongs to the Hispanic Society of America, New York, but Picasso may well have been familiar with reproductions of it. His work throughout his life intermittently reveals his thorough knowledge of Goya's drawings as well as paintings. Whether this particular story of Picasso's was truth or fiction, Gilot and other sources present ample evidence that the artist did, in fact, enjoy playing his women off against one another. One

wonders whether, as a small child, he similarly manipulated the many women in the household. See Gilot, *Life,* pp. 236, 241, etc.

8. Penrose, *Picasso,* pp. 303–4, and Cabanne, *Picasso,* pp. 266, 291–93, describe these living arrangements. Cabanne asserts that Picasso spent every weekend, from Friday afternoon until Monday, with Marie-Thérèse, a practice Cabanne says the artist inaugurated "in Olga's day." Marie-Thérèse acted as Cabanne's informant, but one wonders whether her information was totally reliable. At least, it seems difficult to imagine that the fierce Olga would have docilely allowed Picasso free rein every weekend. More plausibly, Marie-Thérèse also claimed that she wrote the daily letters she sent Picasso for many years at the artist's insistence. Since Olga also sent him a daily missive and the artist himself saw to it that his sister in Barcelona received a daily letter from his household, Marie-Thérèse's story is probably accurate. Part of the artist's policy of loyal estrangement evidently involved exchanges of letters. According to Gilot, Marie-Thérèse fulfilled her role wholeheartedly and wrote the artist the most detailed letters every day (p. 129).

9. Ashton, *Picasso Documents,* pp. 136–37, reproduces portions of the two interviews which Jerome Seckler, a reporter for the *New Masses,* held with Picasso in November 1945. In response to Seckler's questions, the artist identified the bull of *Guernica* as synonymous with brutality and darkness, the horse as a representative of the people. When Seckler suggested that the bull's head shown in a still life the artist painted a few years after *Guernica* represented fascism, the artist denied this, saying that the bull represented brutality and darkness, but not fascism. Did he make the same dichotomy concerning the bull of *Guernica?* Seckler evidently did not ask this crucial question, but it seems difficult to imagine that, in the context of the imagery of this painting, the bull could represent brutality and darkness, yet not also symbolize fascism, unless Picasso considered both sides in the Spanish War equally guilty of these crimes, a contention probably not totally without merit.

10. Penrose, *Picasso,* p. 306.

11. Herschel Chipp, "Guernica: Love, War, and the Bullfight," *Art Journal* 33, no. 2 (Winter 1973–74): 109.

12. Rudolph Arnheim, *The Genesis of a Painting: Picasso's Guernica* (Berkeley: University of California Press, 1973), p. 51.

13. Ibid., p. 52.

14. Ibid., p. 50.

15. Sabartés, *Portrait,* pp. 5–6. Italics mine.

16. Arnheim, *Guernica,* p. 34.

17. Ibid.

18. Chipp, "Guernica," p. 109.

19. Sabartés, *Portrait,* p. 7.

20. Gilot, *Life,* p. 137. Cabanne also indicates that Eluard, "who could truly possess only what he shared and love what he offered another, gently eased Nush into Pablo's arms" (*Picasso,* pp. 287, 289–91).

21. Ashton, *Picasso Documents,* pp. 135–36.

22. Barr, *Picasso,* pp. 212, 265; Misfeldt, "Cock," pp. 151–52; he reports that Douglas Cooper believes that this figure bears a general resemblance to Dora Maar, Picasso's current mistress, a suggestion which in no way negates my interpretation.

Barr notes, "The American sculptress, Mary [Meric] Callery, a friend of Picasso and the [former] owner of *Girl with a Cock* recalls that either Picasso or Zervos explained to her that this picture symbolized the destruction of helpless humanity by the forces of evil" (p. 265). Misfeldt suggests that such an identification equates the woman of this painting with the bull of *Guernica,* the cock with the horse. Such an equation offers further proof that the woman represents Picasso's savage (self-) destructive aspect. Misfeldt points out that we may gauge the importance that this painting held for Picasso by his reluctance to sell it to Mrs. Callery (he apparently agreed only out of friendship) and by the fact that he chose to pose with this painting in a photograph made in his studio the year it was painted (p. 150).

23. Misfeldt, "Cock," p. 152.

24. O'Brian, *Picasso,* p. 333.

25. Sabartés, *Portrait,* pp. 143–58; and Penrose, *Picasso,* p. 330. Sabartés, with characteristic discretion, does not reveal what caused the quarrel (see pp. 136–37). Cabanne, *Picasso,* pp. 293–94, claims that Dora Maar got rid of Sabartés despite Picasso's attempts to hold out. If this tale is accurate, it constitutes another instance in which Picasso yielded to the demands of an implacable woman.

26. Ashton, *Picasso Documents,* pp. 136–37.

27. Sabartés, *Portrait,* pp. 158–60.

28. Barr, *Picasso,* p. 223.

29. Sabartés, *Portrait,* p. 184.

30. Barr, *Picasso,* p. 223.

31. Ibid., p. 226.

32. It was published in the original French as *Le désir attrapé par la queue* (Paris: Gallimard, 1945).

33. Cabanne, *Picasso,* pp. 339–40.

34. Barr, *Picasso,* p. 238.

35. Steinberg, *Criteria,* pp. 121–22.

36. Dr. Oscar Legault reported on his unpublished findings in a letter to the author dated July 19, 1978.

Chapter Ten The title for this chapter comes from Apollinaire's poem "Frisian Horses," as translated by Roger Shattuck in *Selected Writings of Guillaume Apollinaire,* pp. 188–89.

The drawings and paintings referred to in chapter 10 are illustrated in Zervos, vols. XIII, XIV and XV; Duncan, *Picassos,* pp. 243–46. For the sculptures, see Spies, *Sculptures,* pp. 306–10 (nos. 281–487).

1. Barr, *Picasso,* p. 232.

2. Max Jacob, although born Jewish, had converted to Catholicism during World War I. He lived at the monastery at St. Benoit-sur-Loire throughout World War II; he was arrested there on February 28, 1944, and taken to a camp at Drancy, where he died on March 5 of pneumonia. Ironically, then, Max's prophecy of death in 1944 came true, but he, not Picasso, was the victim. According to Cabanne (*Picasso,* pp. 357–58), Picasso dropped Jacob a note at Drancy but took no other steps to attempt his friend's rescue.

Picasso's composition shows a close relationship to several of Goya's preparatory drawings and prints from the *Disasters of War* series. See Pierre Gassier and Juliet Wilson, *The Life and Complete Work of Francisco Goya*, ed. by Francois Lachenal, Preface by E. L. Ferrari, trans. C. Hauch and J. Wilson (New York: Reynal and William Morrow, 1971), pp. 217, 268, 275. Note how many of the Goya pictures depict similar heaps of dead bodies. Rubin, *Picasso*, pp. 166–69, 236–42, presents an extremely interesting discussion of this painting. He proposes (p. 168) that the face of the man resembles Picasso's own features, while the woman's face recalls Dora Maar—a hypothesis quite in keeping with my own interpretation of the significance of this painting.

3. Gilot, *Life*, p. 90.

4. Ibid.

5. Rubin, *Picasso*, p. 238, note 8, indicates that we simply do not know when Picasso finally stopped work on this painting. "When the picture was exhibited—in its present state—in the large Picasso retrospective at the Palazzo Nazionale of Milan in 1953, the catalog entry indicated that those final changes were made as late as 1948." The Museum of Modern Art, however, officially dates the painting 1944–45.

6. Penrose, *Picasso*, p. 366.

7. Cabanne, *Picasso*, p. 353. Gilot, *Life*, pp. 27–31, 108–9, describes her conflicts with her father. On page 257 she relates an anecdote in which the artist calls her "the woman who says 'no.'"

8. Gilot, *Life*, p. 110.

9. Ibid., pp. 131–32.

10. Anthony Blunt, *Picasso's Guernica* (New York: Oxford University Press, 1969), p. 5.

11. Gilot, *Life*, pp. 164–65, 178–79. On page 183 she describes Picasso's restless behavior during the summer following Claude's birth, until Georges and Suzanne Ramie, who owned the pottery at Vallauris, where Picasso later worked, interested him in making ceramics.

12. Berger, *Success*, p. 180.

13. Gilot, *Life*, pp. 254–56.

14. Ibid., pp. 253–54.

15. Daix, *Picasso*, pp. 206–7; Gilot, *Life*, pp. 335–41 and passim.

16. Gilot, *Life*, pp. 273–74.

17. Ibid., p. 320. Like *The Charnel House*, the subject matter of *Massacre in Korea* shows a strong admixture of ideas derived from Goya. The latter frequently portrayed the rape and massacre of innocent women and children. See Gassier and Wilson, *Goya*, pp. 263–64, 268–73, for examples.

18. Gilot, *Life*, p. 340.

19. Ibid., p. 332.

20. Ibid., pp. 347–48.

21. Anthony Blunt, "Picasso in Rome and at Lyons," *Burlington Magazine* 95 (1953): 331–32. Paul Eluard died that year, on November 18, 1952. Picasso attended the funeral, held in Paris, but one can see little or no evidence in his work

that this loss affected him very keenly. He certainly felt less close to Eluard after the latter's remarriage, so his death may have come as less of a shock.

22. Boeck and Sabartés, *Picasso*, p. 303.

23. Gilot, *Life*, p. 358.

24. Daix, *Picasso*, p. 215; Berger, *Success*, p. 202.

25. Boeck and Sabartés, *Picasso*, p. 316; Berger, *Success*, pp. 186–92.

26. Gilot, *Life*, p. 232.

27. Michel Leiris, *Picasso and the Human Comedy: A Suite of 180 Drawings by Picasso*, Preface by Tériade, "Picasso and the Human Comedy," with an appreciation by Rebecca West; trans. Stuart Gilbert. American edition of a special double issue of *Verve* (29/30) (New York: Harcourt, Brace, 1954).

Chapter Eleven The title for this chapter comes from Guillaume Apollinaire's poem "Sign," Greet, *Alcools*, p. 165.

For works from this last period of Picasso's life, see Zervos vols. XVI–XX, XXIII–XXVII, XXXI, XXXII; Duncan, *Picassos*, pp. 242–46; and Spies, *Sculpture*, pp. 310–14 (nos. 488–664). The prints referred to are reproduced in the catalogue, *347 Gravures: 16-3-68 to 5-10-68* (Paris: Draeger Frères, 1968).

1. Gilot, *Life*, p. 360.

2. Ibid., p. 352. Gilot misdates the Sylvette series, recalling that Picasso painted these pictures a year before he actually did so. This need not invalidate her theory that Picasso began them to arouse her jealousy, however, for he apparently started them when she visited with their children during the spring of 1954.

3. Spies, *Picasso*, pp. 223–26 (nos. 490–96).

4. Gilot, *Life*, pp. 361–63. O'Brian, *Picasso*, p. 421, and Cabanne, *Picasso*, p. 452, both mention works which Picasso created during his vacation at Perpignan, notably portrait drawings of his host and other friends and one painting of Mme. de Lazarmes. If so, these works must have been presented as gifts to their subjects, for Zervos did not catalogue them. Certainly the artist did far less work than he typically accomplished while on holiday, and my assertion that he suffered another paralysis seems to me quite valid.

5. O'Brian, *Picasso*, pp. 423–25, and Cabanne, *Picasso*, pp. 452–53, both present essentially the same version of these events; someone present during those weeks at Perpignan evidently talked.

6. Cabanne, *Picasso*, p. 452. David Douglas Duncan, *The Silent Studio* (New York: W. W. Norton, 1976), presents a view of Jacqueline's recent history. A Swiss woman artist who requests anonymity reports that Jacqueline frankly discusses her nervous breakdown with even casual acquaintances.

7. It must be stressed that neither Gilot nor Maar attempted to contact the artist. The chief targets of the embargo were Marie-Thérèse Walter, Maya, Claude, Paloma, and Pablito and Marina, the children of Paulo Picasso by his first wife. Pablito later committed suicide because Jacqueline and Paulo prohibited him from attending the artist's funeral.

8. Gilot, *Life*, pp. 261–69 and passim.

9. Brassaï, *Picasso*, p. 253.

10. Penrose, *Picasso,* p. 406.

11. John Lucas, "Picasso as Copyist," *Art News* 54 (November 1955): pp. 54–56; Blunt, *Guernica,* p. 5; Steinberg, *Criteria,* pp. 125 ff.

12. Richardson, *Picasso.*

13. Gilot, *Life,* p. 366; and Perls, "Last Time," p. 41.

14. Jean Sutherland Boggs, "The Last Thirty Years," in Penrose and Golding, *Picasso in Retrospect,* pp. 213–14.

15. Ibid., p. 214.

16. Ibid., pp. 225–26.

17. Berger, *Success,* p. 185; Edward Lucie-Smith, *Late Modern: The Visual Arts Since 1945,* 2d ed. (New York: Praeger, 1976), pp. 53–54.

18. Berger, *Success,* p. 185.

19. Sabartés, *Portrait,* pp. 7–8.

20. Hélenè Parmelin, *Picasso: Women, Cannes and Mougins, 1954–1963,* Preface by Douglas Cooper, trans. Humphrey Hare (Paris: Editions Cercle d'Art; Amsterdam: Harry N. Abrams), p. 162.

21. Penrose, *Picasso,* pp. 404–5.

22. Lucie-Smith, *Late Modern,* p. 53.

23. Douglas Cooper, *Pablo Picasso: Les Déjeuners* (Paris: Editions Cercle d'Art, 1962), p. 33.

24. Ibid., pp. 17–18.

25. Ibid., p. 33.

26. Daix, *Picasso,* pp. 240–41.

27. Boggs, "Last Thirty," p. 227.

28. Blunt, *Guernica,* p. 58.

29. Several of these pictures seem remarkably prescient; both the sculptures and the buildings before which they appear sometimes bear a striking resemblance to the *Chicago Picasso* and the Daley Center.

30. O'Brian, *Picasso,* p. 467, says that the artist was "seriously ill with prostate trouble among other things." Penrose, *Picasso,* p. 467, says that Picasso was operated on for gall bladder trouble, while Cabanne, *Picasso,* p. 527, says that the surgery was for Picasso's old stomach ulcer. Possibly the surgeon corrected multiple problems in one operation.

31. O'Brian, *Picasso,* p. 475.

32. According to Cabanne, Braque's death, which occurred on August 31, 1963, caused Picasso deep suffering. He did not attend the funeral but invited Mme. Braque to visit him at Mougins afterward; she came, and they spent a long time reminiscing together. In 1964 Picasso contributed a drawing of a nude for a special edition of the magazine *Derrièrè le miroir* (Behind the mirror) published by the Galerie Maeght in honor of Braque. Above his drawing, the master wrote the following message: "Braque, you said to me one day, a long time ago, on meeting me as I was walking with a girl of what is known as classical beauty, whom I had found very pretty, 'In love, you have still not gotten far enough from the masters.' At any rate, I can still say to you today, 'I love you.' You see I still cannot get far enough" (pp. 519–20).

Cocteau died on October 11, 1963. Although Picasso always felt rather am-

bivalent toward the poet, he saw a great deal of Cocteau during his last years, for Jacqueline approved of him.

33. Picasso also eventually contributed a vast number of early paintings and drawings to the museum, works which had hitherto remained in the collection of family members in Barcelona. The Museo Picasso has not yet issued a complete catalogue of its collection. To date, only volume 1 of the catalogue is available.

34. For a more extensive exploration of this autobiographical imagery, see Beryl Barr Sharrar, "Some Aspects of Early Autobiographical Imagery in Picasso's Suite 347," *Art Bulletin* 54, no. 1 (March 1972) : 516–33.

35. Misch Kohn told me in a personal conversation on March 13, 1970, that he had attended the exhibition of these prints accompanied by fellow printmaker Mauricio Lasansky. These two artists are among the most skilled contemporary printmakers; each is famous for his technical innovations. They could not, however, identify many of the technical innovations Picasso had developed for his aquatint grounds. Kohn reported that they spent hours at the exhibition, arguing about Picasso's secrets.

36. O'Brian, *Picasso,* pp. 467–68.

Chapter Twelve 1. Boeck and Sabartés, *Picasso,* p. 38.
2. Stein, *Picasso,* p. 12.